ART, CULTURE, AND ENVIRONMENT
A Catalyst for Teaching

June King McFee
University of Oregon

Rogena M. Degge
The Ohio State University

Wadsworth Publishing Company, Inc.
Belmont, California

ART, CULTURE, AND ENVIRONMENT
A Catalyst for Teaching

**To Harry and Edna Degge
and to Danny and his peers**

Printed in the United States of America

1 2 3 4 5 6 7 8 9 10—81 80 79 78 77

Library of Congress Cataloging in Publication Data

McFee, June King.
 Art, culture, and environment.

 Bibliography: p.
 Includes index.
 1. Art—Study and teaching. I. Degge, Rogena M.,
joint author. II. Title.
N85.M24 707 76—42286
ISBN 0—534—00472—5

Education Editor: Roger S. Peterson
Production Editor: Catherine Aydelott
Designer: Ann Wilkinson
Illustrator: Judith McCarty
Cover: Based on a painting by
 Herbert Siebner

CONTENTS

FOREWORD

Although one might first react to *Art, Culture, and Environment* with admiration for its encyclopedic review of art education, except for the broad scope of material, the book is not at all an encyclopedia in format. Rather it is a unique handbook for the teacher of art. Young teachers who are trying to strengthen their grasp of the arts in education and experienced teachers who are seeking fresh insights in aesthetic organization will both find the book useful.

Art, Culture, and Environment does not offer a final or definitive method of teaching the visual and plastic arts. It does describe basic art processes in terms of what students can learn from seeing and making art. The title for Part One, Seeing to Draw and Drawing to See, is a clue to the direction of the authors. They analyze how drawing and the individual's development of perception go hand in hand. And they compare perceptions that are reinforced in words, in writing, and through drawing.

In the section on drawing, as in each following section, they suggest four levels of development based on perceptual-intellectual understanding, manual skills, and/or age. These levels make it easy for readers to find and suit the information to the children and the school in which they are teaching.

The parts of the text have been selected to give an overall view of the essential qualities of art education, including Organizing and Designing, Creating Art, Art and Environmental Design, Exploring the Cultural Meaning of Art, Theory and Research, and Teaching and Assessment.

To make best use of this book, readers should approach it by first of all reading through it as a whole, to fix in their minds the structure of ideas. The contents have been carefully planned and prepared. The structure is a unique, innovative presentation of education in the arts.

Second, readers will find that they can refer to particular areas in the text in specific teaching situations. For example, in the section on How Cities and Towns Evolve, the authors propose strategies for students to start with and for the teacher to build upon. Though different from what I might decide upon, the activities are open-ended, filled with clues that could be followed toward a variety of goals.

McFee and Degge have created a valuable source book. North America, with its hundreds of smaller cultural subunits, possesses a culture in process. Its art forms, as always, are inseparable from its people. The authors of this volume have contributed generously to making "school arts" more significant in the cultural environment we all share.

Frederick M. Logan
Professor Emeritus: Art and Art Education
University of Wisconsin-Madison

PREFACE

Our purposes in this book are to extend the range of what is considered to be art, to study art as cultural communication in our lives, and to make this material relevant to teachers in training so they can put it into practice in their classrooms. It is designed to provide a basis for suiting learning to readiness and experience rather than just to grade and age level. We suggest activities both for beginning art students of all ages and for individual students from various cultural backgrounds, experiences, and aptitudes. We have combined creating art with understanding and criticizing art. Inquiry, we think, stimulates students' growth in each area.

In the book we stress that art education needs to encompass a concern for design. Reduced resources, higher costs of materials, and increased population require that all people realize the implications of their design decisions. The material on design also addresses many people's concern for controlling their personal environments and asserting their uniquenesses.

With a basis of drawing, designing, and creating art, students then can learn to relate the qualitative aspects of art to solving environmental problems as well as to cultural understanding and appreciation. We combine an analysis of psychosocial research on seeing, drawing, designing, and creating with a model for teaching and key performance objectives.

This book differs from *Preparation for Art,* a previous text by McFee, in several important ways. That book emphasized the foundations of art and their implications for teaching art. This book focuses on responding to and criticizing art as well as teaching it. The first book was for elementary teachers. This book emphasizes the elementary years but also provides activities appropriate for beginning and advanced junior and senior high school students. *Preparation for Art* also was directed mainly at teachers in training, while both inservice and preservice teachers will find this book a useful guide in the classroom. We have also included more recent and more broadly based research, with particular emphasis on ethnic and cultural influences.

We appreciate the museums and presses that have provided prints and permission to use works from their collections, in particular: The American Museum of Natural History, The Cleveland Museum of Art, the Field Museum of Natural History, Gemeentemuseum's Gravenhage, Illinois State University, The M.I.T. Press, The Museum of Modern Art, The Museum of Primitive Art, Presses Universitaires de France, the Seattle Art Museum, the Sidney Janis Gallery, the Smithsonian Institution Press, the University of Oregon Museum of Art, and the Whitney Museum of American Art; and architects Harris and Shefelman, Carlin Pozzi and Associates, and Takenaka Komuten Co., Ltd.

We thank the reviewers of the manuscript for their critical analysis and encouragement: Harold McWhinnie, University of Maryland; Gene Mittler, Indiana Uni-

versity; Julia Schwartz, Florida State University; and Autumn Stanley of Wadsworth. We thank the many artists whose work appears here and are most grateful to the students who listened critically to our ideas.

Finally, we have a special debt to our husbands, Malcolm McFee and Steven Cannon, for their encouragement and support.

FOCUS

This book is concerned with art as an integral part of people's lives and with the ways art enhances and influences the human experience. It analyzes the searching and expressing functions in creating art. It studies design as an ordering process of human existence and analyzes ways the built environment expresses people's values and how these long-lasting formations influence life styles.

These functions of art are made operational through sequential levels of inquiry and activity, which can be used by beginners in art whether they be children, adolescents, or adults. A section on individual differences at the end of each Part explains some of the reasons people have trouble creating or understanding art and shows ways to extend their potential to respond to art. The last two Parts of the book deal with the psychological and sociocultural foundations that underlie the teaching of art, a theory for relating the foundations to practice, and performance objectives for each complexity level covered in prior Parts.

The book is designed to help elementary classroom teachers, art specialists, and junior and senior high school art teachers in their preparation for teaching and later classroom practice.

The objectives are to help:

Figure F.1 *Lee Bontecou (United States). Untitled, 1959. Relief constructed of welded steel, wire, and cloth, 58$^1/_8$" × 58$^1/_2$" × 17$^3/_8$".* (Collection, The Museum of Modern Art, New York. Gift of Mr. and Mrs. Arnold H. Maremont.)

1. Make your ideas and feelings more expressive to others and more meaningful to you.

2. Increase your perceptions of visual qualities in art and in hand-crafted, manufactured, and natural things.

3. Create functional, meaningful, aesthetically pleasing objects to enhance your life style.

4. Learn about other people through the ideas and qualities they express through their art and the ways they design their homes and neighbor-

hoods to create environments that reflect their values and beliefs.

5. Design ways to make your own environment, your classrooms, homes, and communities, more humane places to be visually, socially, ecologically.

6. Select activities that will help children and young people of different backgrounds and aptitudes for art work towards those goals appropriate for their readiness.

FUNCTIONS OF THIS TEXTBOOK TEACHING GUIDE

There are seven Parts; each is a different approach to aspects of art. Part One, *Seeing to Draw and Drawing to See*, is designed to help you increase your ability to see and draw as a basis for helping students. It provides you with an understanding of how people learn to see and with ways to increase students' awareness and drawing ability. It approaches drawing both as a means for creating art and for exploring and analyzing experience. Part Two, *Organizing and Designing*, introduces you to the ways people sort and organize what they see as a basis for creating order and variety in art. Part Three, *Creating Art*, identifies two key reasons why people create art: for their own reflection and to communicate to others. Part Four, *Art and Environmental Design*, relates what has been learned about art to evaluating and redesigning the environment. Part Five, *Exploring the Cultural Meaning of Art*, places art appreciation and art criticism in a cultural context by ask-

ing how art functions in people's lives and communicates their values, attitudes, and beliefs. Part Six, *Theory and Research*, shows the basis on which the book was built and provides a foundation for teaching art to individuals. Part Seven, *Teaching and Assessment*, relates theory to practice and provides a performance objective for each key concept at four levels of complexity that teachers can use to identify their students' readiness and progress in art.

In the first five Parts, activities that encourage the development of art abilities are clustered into four levels of complexity. In some ways they parallel early primary (Level 1), late primary (Level 2), intermediate (Level 3), and secondary school (Level 4). But since much of art activity is learned, many adults have to start at the beginning, just as they would in learning other new subjects. The drawings by the four college graduates in Figure 1.9 indicate that they would need to start learning to see and draw at Level 1. In your classroom, you may have some students at each level. This text is designed to help you meet their different needs for instruction.

Abilities are stated in terms of things the teachers can observe, so that changes and growth can be identified. Activities are suggested for each level of complexity and can be adapted for individual differences in readiness and cultural background. In general, activities that are presented earlier help prepare for later activities. The levels of complexity are based on the art task com-

Figure F.2 a. b. *Effects of culture on drawing. Drawings by nine-year-old boys show differences in background experience and cultural symbols. Each uses detail in his own way.* (© International Collection of Child Art, Ewing Museum of Nations, Illinois State University, Normal, Illinois.)

plexity. Level 1 tasks require less complex perceptual discrimination, designing ability, and numbers of variables than those that follow. Each of the behaviors used in art — percepts, concepts, intuitive or analytical abilities to design, ability to respond and express emotional qualities, and psychomotor coordination — are, in large part, dependent on the kind of social and physical environment in which a person grows up. Heredity plays a part, but experience is such a strong influence that age alone is not a good indicator of a child or young person's readiness. One child can be very advanced in drawing, but have little developed design sense or ability to express feeling. Another child may have a strong sense of design and not be able to draw in fine detail because his or her perceptions of detail are undeveloped. Figures F.2a and b are examples of the abilities of two children from different environments. Their designs show the influence of the fine detailed Korean tradition and of the larger, bolder Mexican tradition. Both children are nine years old — one is more analytical, one more emotional; one more descriptive, one more interpretive. As you use each of the five areas during a school year, you will find some children or youth working at the same level in each area while others vary the levels they are ready to work in.

So much of art activity depends on opportunity and learning that many intermediate and secondary students, and even teachers, have missed the lower complexity learnings. Elementary children who have accelerated aptitudes can develop in any of the areas, provided their teachers have guidelines for more advanced work. Late primary, intermediate, and secondary students who are developing more slowly than other students can proceed at their own rate.

The book is designed to be used in teacher education and as a classroom guide.

Elementary teachers in training can develop readiness for art, while those who have art backgrounds can usually increase and broaden their readiness for teaching art. Art students tend to develop those areas in which they have excelled and to leave other areas somewhat undeveloped. But teachers of art need a wide range of abilities. Both elementary classroom and secondary art teachers need help in extending the scope of art education to include the understanding of art, the study of human beings through art, and the solution of environmental problems through art. Tying a curriculum guide to teacher training helps bridge the gap between theory and practice.

Some activities are suggested to help a teacher assess where a class is in its general readiness to produce and understand art as well as to help the teacher see which students need more simple and which need more complex experiences. As the work proceeds, the teacher can identify the effectiveness of his or her teaching by the changes in student performance at given points in the school year.

The performance objectives in Part Seven will help relate the individual development of students based on personality and culture to the objectives in the field of art. The guiding idea is to help teachers have an effective program, but not so fully developed that innovators will be inhibited. The structure and the objectives in Part Seven may very well enable them to keep their program in the school as more and more accountability is required. Further, the areas parallel the growing concern in education that each content area concern itself not only with the needs of the individual but with the needs of society and of the environment as well. Teachers need to understand how art functions in people's lives in order to help make it of value in the lives of their students.

ATTITUDES TOWARD ART

People have widely different attitudes toward art. Some people enjoy all kinds of art, surround themselves with it, and make it very much a part of their lives. Others like only specific kinds of art. Still others see little use for any art. However, art functions in all our lives most of the time. Design in clothing, household goods, cities, buildings, television, movies, magazines, books, and advertising affects people constantly even if they never see a painting, a sculpture, a hand-woven fabric, or a hand-thrown ceramic pot.

Take an inventory of your attitudes toward art now; then see if they change as you use this book. What do you think of as art? What kinds of art do you like best? Least? Do you know why? What periods and styles of fine arts most appeal to you? What past experiences have made you feel as you do? To help with your inventory, we will briefly explore different functions of art in human life to see if you have considered them before. The rest of the book should help you consider them in greater depth.

ART AND THE INDIVIDUAL

Art is an individual means of communicating. Artists express their experiences through art. Everyone sees and reacts differently from everyone else. Through drawing, painting, and sculpting, people relate their ideas, values, and feelings. They show how they respond to the world and to other people. By looking at their art, we can share to some degree their visions of the world.

As we look at and think about the meanings of our own art work, whether we are children or adults, we learn about ourselves. Everyone can learn to draw or paint ideas and feelings to express reactions to experience. *Art provides us with a record of our experience and a springboard for new learnings.*

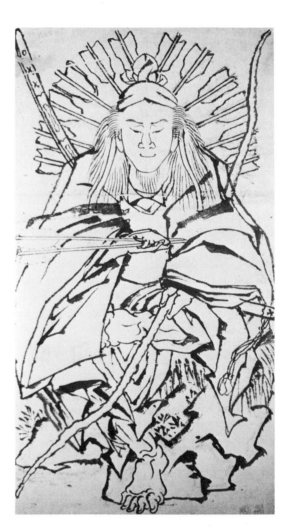

Figure F.3 *Hokusai Katsenshika, 1760–1849 (Japan). The Archer. Sumi ink drawing on paper, 22″ × 11¹/₂″.* (Museum of Art, University of Oregon. Murray Warner Collection of Oriental Art.)

Figure F.4 *Graffito art is the immediate expression of feelings to others.*

ART AND SOCIETY

Although art starts with individuals, it takes forms that have meaning for many people. Thus, art becomes a communication system. A people's values and beliefs are expressed through their art. The subject matter of art illustrates the status and roles of people, what is important to observe in nature, what critical ideas need to be considered. The

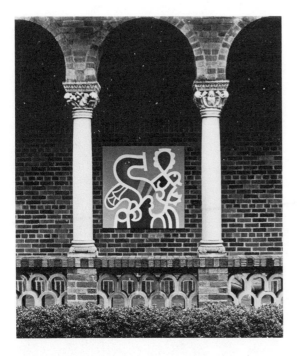

Figure F.5 *Harold Balazs (United States).* My Garden, *1972. Enamel on metal. The importance of the painting is enhanced by its setting. The columns identify it as an important place. The designs of the 1930s building and the 1970s painting are related through similar form.* (Museum of Art, University of Oregon, Campbell Memorial Court.)

Figure F.6 *A community center is enhanced by a mural that communicates what the place is about.* (Photo courtesy Leeann Agost.)

style of art tells us whether people are more objective or subjective in their view of the world. The setting and condition of art tell us how it is valued. A lifelike sculpture in a city park and graffiti on a subway wall may depict the same hero but express different values. One values history, one immediacy. One values a traditional view, one a noncon-

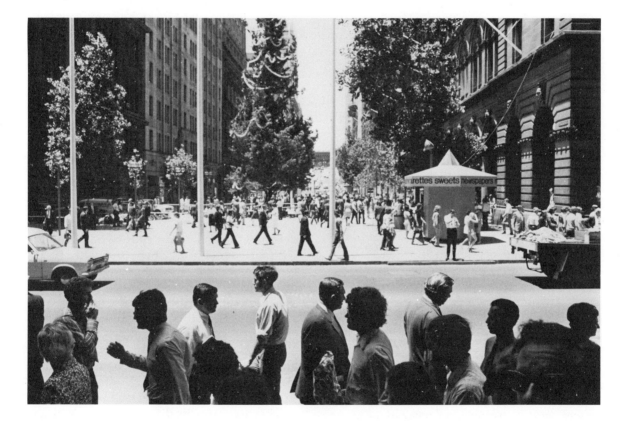

Figure F.7 *Cities are full of cultural information. Look for the people's gestures, dress, the styles of architecture, the signs of seasons, the width of the central plaza, spelling, and language to identify who built and who lives in this city.*

formist view. One relates to the value of the hero in the past, the other the value of the hero in the immediate present. One is objective, one is subjective. One is set in a formal situation and assumed to be permanent, the other is informal and transitory.

Paintings, drawings, sculptures, and films are the reactions of the individual

artist to life experiences. Art communication is clearest when both artist and viewer share the same values, have similar life experiences, and have similar modes of attending to those experiences: subjective-objective, formal-informal, past-present. But as we learn the languages of other people's art, we learn to understand their experiences and their ways of viewing the world.

Through art forms such as architecture and design, cities carry the message of people's values and ideas. The shape, size, color, materials, location, and kinds of buildings, streets, parks, open spaces, landscaping, all communicate their function. For example, a building's design may indicate its history. An old building in run-down condition shows it is no longer valued as it once was, but an old building in good repair may mean it still has an important function. All people need basic understanding of art's communicative roles to understand our society and the many cultures that are part of it.

ART AND ENVIRONMENT

Everyone influences the quality of the shared environment. The ways people relate things to each other and to nature creates the patterns within which they live. As populations increase and resources decrease, the need for humane places to live and work becomes more critical. Because the natural environment and the built environment—buildings, spaces, and transportation networks—affect each other, careful consideration of their combination is essential. Restoration and recycling of older buildings and streets and new development alike must be planned to harmonize with the live styles of people and the natural environment. The quality of the environment depends on people's ability to use their design sensitivity, their social responsibility, and their ecological concerns together to solve environmental problems. When this is done, art is not an appendage, but an integral part of decision-making.

ART IN SCHOOLS

Every person has a responsibility to learn how to deal with his or her environment, and since design is a key element, it is important that everyone learn how design qualities relate to the function of things. This is the most critical point in education in multicultural societies: to equip children of varied cultural backgrounds to cope in the mainstream of the society without causing them to devalue their own cultural background. We must remember that a people's identity is developed in relation to their background, and that the art in it helped them learn and develop concepts of who and what they are.

Teachers have the task of trying to understand their students' cultural backgrounds without stereotyping them and without letting stereotyped expectations get in the way of students' progress. Teachers who are aware of the complexities of culture should be more open to their students' cultural variability and state of change.

Likewise, teachers must understand the effects of growing up in their own culture, and should be tolerant of children who grew up in different cultures or who learned the teacher's culture in different ways. You will find your own cultural background becoming clearer as you study other cultures: how much you may have changed as you have grown up, and what you have retained and why. All of this will help you understand how other people learn their values, and develop their attitudes toward art.

SEEING TO DRAW
AND DRAWING TO SEE

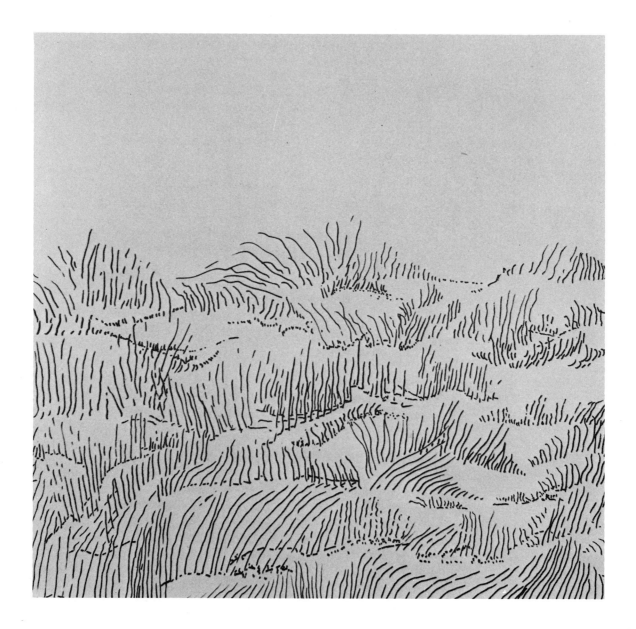

A BASIS FOR LEARNING

Drawing and seeing are closely related. Our seeing sharpens our drawing and our drawing sharpens our seeing. People who think they cannot draw probably do not realize how little they attend to the things they look at. This chapter discusses helping people learn to see so that they can draw more effectively and helping them learn to draw so that they can see in more detail. It will help students use drawings as a tool for learning and analyzing as well as for creating art.

Seeing is not limited to the usual viewing of things. It includes creative and inquisitive looking as well: seeing things from unusual views and distances, in uncommon lights, in new groupings, and in rare juxtapositions. People who see creatively look for the emotion-provoking qualities in things, the moods produced by the ways the colors, shapes, and textures are used. They are aware of the sensory feelings one could get if one touched what one saw.

Children and young people who develop their ability to see creatively and analytically and draw what they see have a much wider potential for learning and experiencing. Yet, so many people would like to draw, but cannot. Is the ability to draw a special gift as so many people believe, or is it a matter of learning? In large part, it is a matter of learning—learning to observe. As people become more acutely aware of the diversity and variety in the visual world, they can become more open and creative. The motor skills needed to put marks on paper are easily learned with practice. And so are the vis-

Figure 1.1 Boah Nut Drawing. *An Australian Aborigine, visually aware on the hostile, arid earth, skillfully drew on this huge nut with a sharp tool.*

ual thinking and creative looking that can lead to insightful drawing.

Perhaps you, like many other people, have not realized how much seeing involves learning. Look across the room at a familiar chair. Look away from it and try to draw it. Do you like your drawing? If you are not completely satisfied, then this chapter should help you develop the abilities you need to be better satisfied with what you do. If you already draw very well but have trouble helping others learn to draw, this material should help you be more effective in helping them.

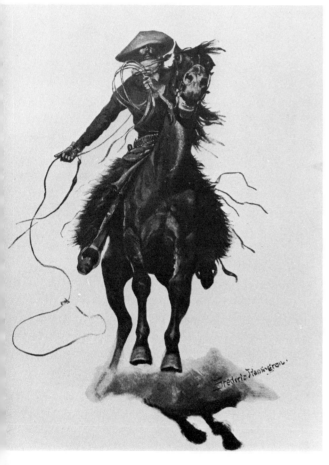

Figure 1.3 *Le Chi-Mao.* Running Horse, 1974. *Drawn in Sumi ink on paper. Compare what is different and what is alike in the two drawings in expression, detail, and use of medium. (Collection, Museum of Art, University of Oregon.)*

WHY DRAWING IS IMPORTANT

Perhaps you wonder why improving your ability to draw or see is important. You have gotten along very well up to this point seeing as you do—and without trying to draw very often. Since you have not needed it, you wonder what help it will be to the children or young people you teach.

The reasons for learning to see more are many. First, most of the words we use to

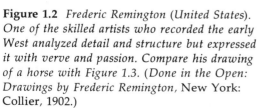

Figure 1.2 *Frederic Remington (United States). One of the skilled artists who recorded the early West analyzed detail and structure but expressed it with verve and passion. Compare his drawing of a horse with Figure 1.3. (Done in the Open: Drawings by Frederic Remington, New York: Collier, 1902.)*

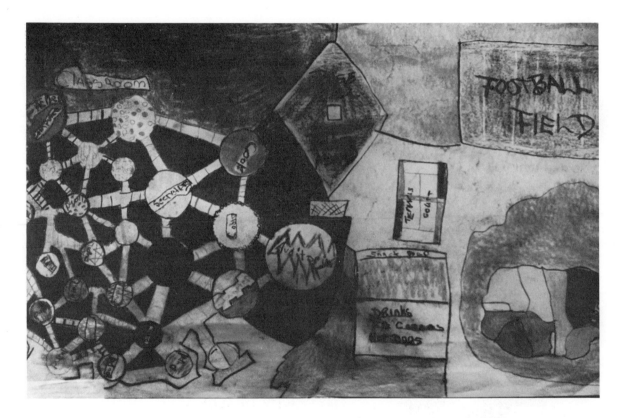

Figure 1.4 *Imaginative mapping. A collective chalk drawing of children's cognitive maps—a plan for a school they'd like.*

communicate derive from things we have seen, felt, or heard. If our perceptions of things are wrong to begin with, then all our words will be wrong, too. They cannot describe what we have seen poorly. Second, people miss so much that is intriguing, beautiful, and exciting in their environment simply by failing to see. It is not just a matter of eyesight. People with limited eyesight can sometimes see, as we are using the word,

a.

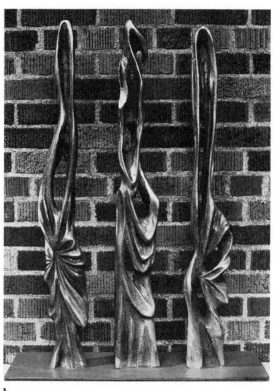

b.

Figure 1.5 *Jan Zach.* Three Forms, *1956. A Czechoslovakian-born American sculptor uses drawing to develop plans for a sculpture. The drawing* **a** *is in charcoal and pastel; the sculpture* **b** *is cast aluminum.* (Collection, Museum of Art, University of Oregon.)

better than people with good eyes. A third reason is that people who pay little attention to visual details can pass by ugliness until it is so bad they are forced to look at it. If they had paid attention to it earlier, they could have remedied it before it got so bad. A fourth reason is that to understand our environment we need to *see* how the parts are alike and different, how systems work, or what is wrong when they do not work.

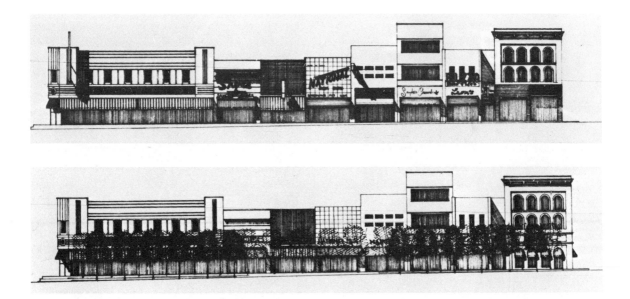

Figure 1.6 *Architects, planners, and designers use drawing as an analyzing tool—in this case to see how trees will work to provide order, shade, separation of sidewalk and street, and softness to a city block.* (Courtesy Harris and Shefelman, Architects, with Michael Utsey.)

Fifth, most people develop cognitive maps—mental images of the layouts of neighborhoods and towns. They can walk through their living quarters in the dark, having a view in their minds of where things are. Some people have very clear maps, and others are quite vague about how things are laid out in space. People who can draw their images or cognitive maps can compare them with the outside environment and thus improve their ability to map mentally. Maps are systems for getting around. If a person who drew a map of a place did not see it very well, the person using the map would get lost. A sixth reason is that a drawing can communicate many subtle and emotional qualities of things that are difficult to communicate in words (see Figure 4.6). Drawings can sensitively communicate the quality of artists' experiences in their viewing of

things. Drawings may be based on artists' inner lives, on the unique ways in which they see, and the particular kinds of experiences they remember. The richer their perceptions, the richer their inner lives.

A seventh reason is that drawing is a basic tool for planning and refining the ideas for a painting, a sculpture, a building, or a garden. It is used in science to symbolize structures of things. Finally, drawing can be the vehicle for seeing new patterns and relationships, for thinking creatively in both art and science. As new intuitions and insights come to people, they can quickly record the pattern or design that is emerging so that they will not lose that idea as they take off in new directions.

Why Are Learning to See and Draw Neglected in Education?

Several misleading ideas and practices about seeing and drawing have been in force for a long time. Educators have stressed learning through thinking, writing, and speaking with words almost to the exclusion of learning to see and draw. Yet in both systems we identify, separate, relate, analyze, organize, and express ideas and feelings. We use our intellect and our emotions in both. Most teachers take for granted that students need to learn verbal and writing skills to get along in our society, but few think students need to develop visual skills as well. Many teachers assume that all one has to do to see is to open one's eyes, that learning is not involved.

Also many teachers and school administrators assume that drawing ability is mainly innate or merely a motor skill. Motor skills in our system of education generally have a lower priority than mental skills, so drawing has had a low priority. Eye-hand coordination contributes to drawing ability. But the fundamental and indispensable part of drawing is the ability to see and think in detail,

to think in terms of three-dimensional space, to see the relationships between details, and to coordinate what we see with the images we draw. This is a cognitive process in which we use mental images and perceptions as well as words to think, record, and develop our ideas.

DRAWING AS A LEARNING TOOL

It takes a great deal of learning from infancy onward just to learn to identify and interpret the things we see, what they are, what they do, what to avoid, and what is valuable. But many people's perceptual learning stops there. They do not learn enough about how things look to see how they can change their appearance in space or to draw them. They have to learn to see beyond what things are and do and learn to see what they look like. Therefore, they begin by seeing in order to learn to draw. Other people have to start to increase their seeing by first trying to draw. When their drawings do not look right to them, they are forced to do more seeing to find out what they missed before. In this way, they improve their drawing in the process of developing their ability to see.

Learning to see all the details of lights and darknesses, the myriad textures, the shapes of flat things and forms of three-dimensional things, and all the kinds of lines going in all directions takes time; but it is marvelously enriching for the one who learns to look for them.

Drawing is also a method for recording learning. We learn something, record it, and then take off from our record to learn more. Academic learning is similar: one studies, records, and analyzes what one learns in writing and then takes off to learn in greater and greater detail. The ability to remember what one has read is helped by taking notes. The ability to remember what one has seen is helped by visual note-taking—drawing.

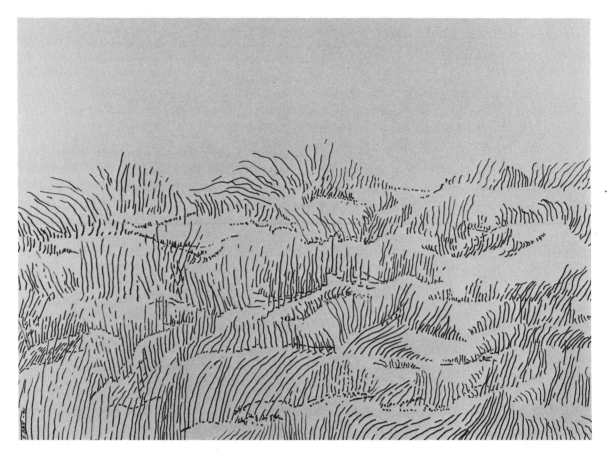

Figure 1.7 *Stan Day.* Sand Grass, 1974. *Artist uses simple lines to show the contour of sand dunes through the directions of grass growing out of it. Such drawing requires careful analysis and sensitive awareness.* (Permission of the artist.)

If children and adolescents are to learn to understand their experiences, they must do both kinds of analyzing and recording, that is, both drawing and writing. Children usually face more new and unfamiliar experiences than adults. Drawing these experiences gives them not only a record of their experiences, but a basis for understanding them. If they are encouraged to save their drawings, to think about what they did, then they can use these drawings as a take-off point for new learning with drawing. They will be able to make their subjective experiences more objective. Some preschool children were asked to talk about their drawings, that is, think out loud about them for a three-month period. When these children were compared to similar children who had not been asked to reflect on their drawings, they were found to produce much more complex drawings (Dubin, 1946).

We learn about the natural and the created environment through observation. But as soon as we give the things in our environment names and make verbal descriptions of them, we lose much of the information we learned through observation. We have reduced them to abstractions. A detailed drawing is much closer to the reality of our visual experience than even the most detailed written description. If we make drawings in order to learn about things, we have to go back to look at the thing itself over and over to see all the details. To give something a name we have only to put it into a category, for almost everything has already been named. Children who grow up solving problems with *words* rather than dealing with the things miss much of the problem. They tend to be undeveloped in the ability to do visual thinking. Thinking with abstract words is quicker because words are easier to manipulate than complex visual images. Children who grow up not only learning many words but also having many looking, seeing, ana-

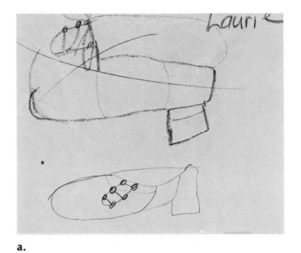

a.

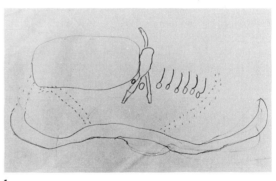

b.

Figure 1.8 *Drawing development. These two drawings by a third-grade girl show an eight months progression in drawing ability. Learning to see is encouraged by the teacher. This child who was having difficulties with other types of learning was learning to see and draw structure, perspective, and detail.* (Courtesy of Kay Masek.)

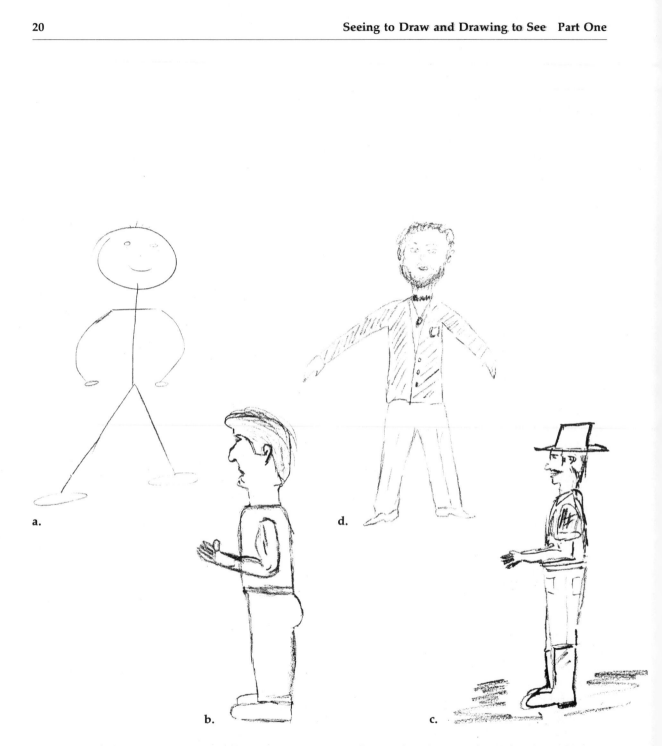

a.

b.

c.

d.

Figure 1.9 *Differences in adult drawing development. Four college and graduate students' drawings of a man illustrate differences in seeing and drawing ability, but all show a lack of experience in seeing.* (Courtesy of Elwyn Hawthorn.)

lyzing, and drawing experiences will have greater understanding and awareness as a basis for solving problems about objects.

This ability to symbolize and record experience so it can be remembered and shared with others is a key factor in the development of civilizations. We could say that all art is a history of what people have learned intellectually, emotionally, and visually. It is one of the many ways we store information and use it as a take-off point for new understandings. Archeologists recover the art of past civilizations where no written records exist. They study these visual records of people's lives to try to reconstruct their activities, the quality of their lives, and their values. We learn about the past through art history as well as through written history. Both areas of study are records of human experience.

HOW PEOPLE LEARN TO SEE

Where We Grew Up

Our ability to talk and read depends on the language habits of the people among whom we grew up and on the kinds of books we had to read. In the same way, each of us has learned to see in terms of where we grew up, what was around us to look at, and how much we needed to pay attention to how things *looked*. If we grew up in a busy city and paid attention to everything we saw, we would have been overwhelmed by the flood of information. To avoid this confusion we learned to pay attention only to what we needed to get around (Bruner et al., 1966). This daily experience built habits of "seeing" things in terms of word labels — cars, lights, trees, buildings, signs, people. It became easier and faster to recognize what a thing was and label it than to develop clear visual images of how it looked. In the fast pace of the city, labeling was often all we had time

to do. But if we grew up in the slower-paced country where the same things were repeated over and over — trees, fields, fences, desert expanses — we did not have to block out so much detail, and we learned about things in terms of how they appeared. We developed habits of seeing by depending more on *what things looked like* than *what kind of things* they were.

Most of us also develop mental images of our percepts of things. If we close our eyes, we have a "picture" in our mind. Close your eyes and see if you can recall images of things. Think of a person you know well. Can you see "in your mind's eye" what that person looks like? You may have a very clear visual memory image, but most likely you will have a rather fuzzy general impression (Haber and Haber, 1964). But if we have carefully studied something visually and drawn it many times, our memory of it is much clearer, because we not only have perceived it carefully, but also have a memory of the drawing analysis we have made of it.

Conflict Between What We Know About Things and What We See

More of us tend to see things in terms of what we *know* about them without much observation rather than as they appear when we see them at different distances, in different lights, and from different viewpoints (Turnbull, 1962, pp. 260–265; Rock, 1965). Take, for example, a very familiar object — a pencil. If we have learned to see only in terms of what things are and how they are used, we probably know that pencils are long but get shorter as we sharpen them, are painted various colors, and have soft or hard leads. Some have erasers with a metal casing, and some bear the name of the manufacturer and a number indicating the hardness of the lead. We know we hold it in one hand to write or draw on paper.

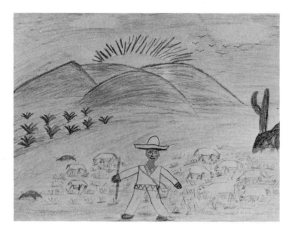

a. *Mexican male, age 7.* Benito Juarez Como Niño.

b. *Japanese female, age 7.* Rice Field.

c. *New Zealand male, age 10.* Cow Paddock.

d. *Japanese female, age 9.* The Market.

Figure 1.10 *Influence of environment and culture on drawing. They all show objects in three-dimensional space, but the things the artists see in their environment are different.* (© International Collection of Child Art, Ewing Museum of Nations, Illinois State University, Normal, Illinois.)

Figure 1.11 *A Remington drawing of an American Indian. An example of the way drawings force us to see some kinds of details over others. The structure and mood expressed are powerful, yet small details are left out. This economy helps our memory of the drawing. (Done in the Open: Drawings by Frederic Remington, New York: Collier, 1902)*

But if we have learned to observe a pencil for its *visual* detail, we know its color gets darker on the side away from the source of light; it changes its shape as we rotate it as if it were the radius of a sphere. Sometimes we just see one end. It appears longer or shorter depending on which axis we see it. Also, it looks bigger or smaller from any one angle depending on how far away we are from it.

The same is true of most things we see in our environment. Their shapes, colors, and sizes all seem to change as we move into different viewpoints, get nearer to or farther from them. Yet we know their actual sizes, shapes, and colors do not change. The visual qualities are what affect the visual design of a place. A tall, black building in the distance does not affect us the same way as when we are close to it and see its impact on its environment.

Urban dwellers who block out so much of what they see and whose habits of seeing are so strongly based on categories of things miss the visual richness of being in a city. The shapes of buildings seem to change as we walk around them. There is an infinite variety of pattern of lights and signs: we see them get bigger as we walk toward them, change their shape as we walk under them, and change their color throughout the day and night as the source of light moves across them. Crowds of people move, changing patterns of colors, sizes, shapes: getting smaller as they move away from us, getting bigger as they get closer, changing shapes as they go past.

We all know people do not actually change size and shape within seconds, but they can appear to. Rooms are not smaller at the far side, but they look that way. The edges of a road do not actually converge at the horizon as they seem to do. But *to our eyes they do change!* Visual reality and physical reality are not always the same. And chil-

a.

b.

Figure 1.12 *Learning to see and draw differences in size. The third-grade child who drew these heads and figures was looking at them through a paper tube. The closer the view, the less of the figure shown.* (Courtesy of Kay Masek.)

dren do have to learn that that little thing in the distance and that big thing close by are really the same thing. Unfortunately, when they learn this (physical reality), they tend to forget about the visual reality: that if they want something to look far away they have to draw it little, as they *see* it and not as they *know* it to be.

Many people with adequate eyesight walk around in their environment blinded by their concepts, not responding to the visual world. They receive the visual information through their eyes, but they do not respond to it. Even though city people see things for what they are when they hurry along their way, they can also learn to see the changing visual qualities which contribute so much to the enjoyment of the city. A man who had been a civic leader in a town for many years was shocked when he viewed a photographic analysis of the town's main street. "I've gone down that street almost

will not grow up with one-sided learning, and they will learn to enjoy what is visually enriching and to evaluate what is not.

The activities that follow in Section Two should show you how seeing relates to drawing. In order to use these activities with children, you will have to work through them yourself. They are examples of ways to approach perceptual and drawing learning. You may find that you or your students must work much longer on some activities than others. You may have to vary an activity by using different drawing media such as felt pens, ink and brushes, crayons, chalks, or watercolors to keep up interest until the idea is fully developed. After a period of time, you may feel your students have to go back and refresh their memory of earlier learnings. The areas of drawing presented — each at four levels of complexity — are:

A. Learning to See and Draw Details and Relationships in Space.

B. Learning to See and Draw the Sizes of Shapes in Space.

C. Seeing and Drawing Multiple Images of the Same Things.

D. Learning to See and Draw Shapes Changed by Viewpoint.

E. Learning to See and Draw in Different Lights.

F. Learning Perspective Systems.

G. Seeing and Drawing the Emotional Qualities of Things.

c.

To understand how all the parts work together, read through Part One to the Section on Individual Differences in Drawing Aptitudes. It may help you to understand where you are in your own drawing development as well as to understand your students.

In each area there are opportunities for developing creative awareness. Students are exposed to more ways to see and should develop richer imagery.

every day for twenty years," he exclaimed, "and I *never looked at it before!*"

Although people who grow up in the country tend to use what they *see* to solve problems, they, too, can develop more sensitive visual skills. Children and adolescents can enrich their vocabulary of words and of percepts if they both draw and write as they learn. Not only in art activities but in most other subjects, visual images and words make each other clearer. In this way, children

SEEING AND DRAWING

The activities in this section are designed for you to use with individual students or with groups of similar students. There are two directions of increased complexity. First, the areas build one upon another in logical sequence. Usually they should be undertaken in this order. But sometimes you will find students who can succeed with later activities more easily, so be flexible in this sequencing. Second, each area provides you with four levels of complexity so that you could have all your class working in one area with students with more or less readiness working at different levels. Section Three on individual differences—and your own growing familiarity with the material—will help you adapt activities at each level even more closely to individual differences.

AREA A:
LEARNING TO SEE
AND DRAW DETAILS AND
RELATIONSHIPS IN SPACE

Part of learning to draw is learning to see the relationships of parts to the whole of objects—what the details of things are or how they work. Haven't we all wanted to draw a particular thing and found that, even though an image formed in our mind's eye, we did not know it in enough detail to draw? One reason this happens is that, although we may have looked at the object many times, we looked merely to identify it rather than to learn about its form or structure, its function, and the relationship between the two.

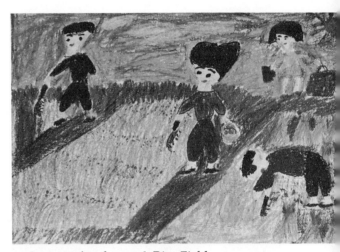

a. *Japanese female, age 6. Rice Fields.*

Figure 1.13 *Visual and verbal learning differences. Drawings of two six-year-old children; one growing up where verbal learning is stressed, the other where perception as well as verbal learning are stressed. Both symbolize things in three-dimensional space but in drawing* **a** *attention is paid to visual details; in drawing* **b** *stereotyped symbols are used.* (© International Collection of Child Art, Ewing Museum of Nations, Illinois State University, Normal, Illinois.)

For example, some adults who for years had poured tea from the same pot found that, not until they looked at the structure of the pot (where the handle and spout were attached, the shape, how the lid fit, the angle held for pouring, etc.) and drew it, could they

b. *Australian male, age 6.* Untitled.

later draw it with self-satisfying accuracy from memory.

Another reason for our inability to draw some things as we would like is that certain things have not been part of our immediate experience. Rural people generally put more detail in their drawings of familiar things than do urban dwellers. Because cities contain a bombardment of visual and other sensory input, urbanites tend to shut out certain details in order to function in that environment. Rural people, by contrast, encounter aspects of their environment at a different pace and with less than a barrage of input; consequently they notice more and include more detail in their drawings. You may want to see how your students fit this generalization.

Since part of drawing depends on knowing the details of things, the earlier we can help students become alert to careful looking, the more many of them will be pleased with what they draw and later will be able to draw objects either from memory or from a model with more satisfying results.

Level 1
Exploring Details

Students at Level 1 might spend some time outside doing some careful looking. On a warm, sunny day, take your students to a grassy, pleasant area nearby—preferably a park. Ask them to just walk around for five or ten minutes within a designated area and see how many things there are to see. Ask them to look up and down as well as straight ahead. Then gather them together to talk about what they saw:

What are some of the things you saw? Were most of them big things?

Can you describe the things you saw? Were they tall, short, round, pointed, colorful, delicate, ugly, beautiful, unusual, ordinary? What else?

What were some little things you saw? What was the littlest?

Did you see any beetles, ants, or other insects?

Where would you need to be to see those things?

Because the students were walking around, they probably noticed the larger, easier-to-see things around them. Chances are few of them noticed the life under their feet. Explain that on this drawing excursion you would like them to learn more about the small, hidden things around them.

To direct their attention to the tiny world beneath their feet, give each student a wire circle about 18 inches in diameter, wrapped in a bright color of crepe paper to separate it visually from the color of the grass (or use a circle of brightly colored yarn). Ask them to select a spot of grass, lay the wire there, sit down or lie down beside it, study everything that happens within their circle, and draw what they see. Encourage them to watch insects come into their circle and leave again and observe all that the insects do. Urge them to notice the different kinds of grasses and weeds and anything else that might be within their circle and, if they are using colored pencils or crayons, to show some of the colors they see. After making some drawings, some of them may wish to follow one of their insects for a few minutes to see how fast it travels and where it goes and draw about that. Others may move their circle to new areas to draw.

When they have finished their drawings, gather the students together to share what they experienced. Again, invite them to describe what they saw in detail:

What was the biggest thing you saw? The littlest?

What words describe the tiny thing you drew?

Does an ant have parts?

What are the details on an ant, a spider, a weed, a large blade of grass, a clover, a pebble?

Were some easier to draw than others? Why?

When some see what others have drawn they may want to go to that spot to see and perhaps draw what is there.

These wire circles can be used to focus on other things, too. They can be laid over a bush, on a path, against a large tree trunk, or a textured wall or fence. By using various sized circles and searching for things to encircle and draw, students can increase their awareness of their surroundings and their ability to draw what they see.

Level 2
Going Beyond
Stereotyped Images

At Levels 1 and 2 you may notice students will often draw *symbols* of things most familiar to them rather than drawing how they actually appear. Young children may draw pictures of houses, animals, friends and family, trees and flowers, pets and toys. Some of these symbols they learn from books and from other children's drawings, as well as what they learn by looking. They will draw with varying amounts of detail—some even in stereotyped ways learned from adults that look very little like what they saw. Without some experience in paying attention to the actual details of what they see, adults will often produce drawings containing these learned symbols or stereotyped characteristics as well.

To help students of any age at Level 2 learn to see and draw familiar things by attending to the actual details, you might begin with these kinds of questions:

When scissors are open, what is their shape? Is each half of a pair the same?

How many eyelets are in your shoes? How thick is the sole? Are the shoes more than one color? Do they have a pattern or special design?

Why does a cap screw on a bottle? Why does a door swing? A rocker rock? A sprinkler spray water?

How many windows are across the front of your house or apartment dwelling? Are they all the same size? If not, how are they different?

Does the front door face the street? Is it in the middle of the house? To one side?

How much space is there between the top of the door and the eaves of the roof? Is that space different for the windows?

Is the roof flat or pitched to a point? What kind of roofing does it have? Is there a chimney or other object like a cooling unit or a TV antenna on it?

Is your home made of wood, stucco, plaster, or brick? How would you draw that?

Students involved in any art work may need to be asked individual questions that relate to the structure or spatial arrangement of things so that they understand the way these aspects affect the ways things look. *Students' drawings of things do not need to be photographically representational to show visual understanding.*

Level 3
Exploring Surfaces

At this level, students can focus on physical qualities that define what something is made of by carefully looking at and analyzing the particular characteristics of different *materials* and then exploring drawing techniques that will produce the material illusion desired. You could begin by asking students:

What words would you use to describe how the surfaces look on the following objects?

an old shoe with laces
a wet fish

wood with chipped paint
a kitten's nose, fur, eyes, paws
a dried apple
a dirty car
a slice of salami
a light bulb
an oatmeal cookie
a freshly washed head of hair

For example, words such as wet, rough, smooth, dark, light, multicolored, bare, furry, or dull may be used to describe a kitten's nose, depending on which kitten is being looked at or recalled from experience. Light bulbs may be described as shiny, transparent, translucent or opaque, dark or light, or illuminating. Different materials and surface qualities to view and touch will help students in their descriptions. As they build a vocabulary of words for different surface appearances, let them explore with drawing techniques and tools to create the visual effects of these various qualities. These kinds of questions may get them started:

How would you draw the visual qualities in a grainy piece of wood, on an old shoe, a hairbrush?

How would you show the texture of a porcupine, a lion, a snake?

What drawing techniques and tools might you use to create the illusion of shiny, transparent, soft, wet, crinkled, slick?

Working with chalks, charcoal, inks, crayons, pencils, and felt pens in various amounts and pressures on different textures and color values of wet and dry paper as well as exploring such techniques as stippling, shading, cross-hatching, solid and broken lines will give students some options. Hopefully, these media and techniques will entice them to create their own techniques and to find other, less conventional tools and methods.

You and your students will discover that light is an important element in determining

how the surfaces look. As you work in this area, give students the opportunity to explore some of the activities in Area E, *Learning to See and Draw in Different Lights.*

Most students at Levels 3 and 4 will have art teachers who are familiar with various drawing techniques and tools and who will be able to develop interesting drawing experiences to help them look more carefully. Thus, they can develop personal techniques that will produce a desired visual quality in their works. Those of you who lack this background can learn to see along with your students, studying artists' drawings and sharing new knowledge and skills.

Level 4
Applying Other Areas
and Levels of Drawing

Throughout Part One, the areas of learning are given separate attention at Levels 1, 2, and 3 so that seeing and drawing skills can be developed. However, at Level 4, students are expected to include in their drawings more than one aspect learned at previous levels and in other areas. The Level 4 activities are designed (1) to show the interrelatedness of *all* the areas: seeing and drawing details, size changes, and different viewpoints, structures, lights, and perspective systems, and (2) to be used as a guide to help your students apply what they have learned in all the parts. For example, students might consider these kinds of questions to determine what their drawings of such three-dimensional objects as a tree, a house, or a human will or will not include:

Are there parts of the form coming toward you or going away from you? Can you draw these views as they would actually be seen? (Areas A,B)

Does your drawing reflect what you actually see? Where is your eye level or viewpoint? Why would it

be important to maintain a single viewpoint when drawing something? (Areas C,F)

What structural or anatomical aspects of the form allow it to be drawn in certain positions and not in others? (Area D)

How can you use shading to show the volume and structure of the form? Is there a light source to help you? Can you create your own light effects in the drawing? (Area E)

What emotional or rhythmic quality do you see or might you give this form as you draw it? How does changing foreshortening or lighting affect the emotional impact? What media and drawing technique would you choose? Why? (Area G)

If students were drawing a landscape, these questions would need consideration:

How do the sizes of things drawn reflect their distance from you? (Area B)

Are you drawing what you actually see? Do you want to? Where is your eye level? Have you considered where the vanishing point(s) would be? (Areas A,F)

How might you give light, middle, and dark values to your drawing? Where is the source of light? What deep shadows do you see? How could you use what you know about light and shadow to model the forms you draw? (Area E)

Is the landscape stark, ominous, cheery, undulating? How might you express that in line quality and media? (Area G)

Whether their drawings record what they see, demonstrate what they know, express what they feel, or all three, what students may find most beneficial at this level is your ability to help them consider these various aspects as they develop their works for a personally desirable and satisfying visual quality. After you have read Areas B through F, you may want to review these questions to see how you can ask similar questions at Level 4 in each area.

AREA B
LEARNING TO SEE AND
DRAW THE SIZES OF
SHAPES IN SPACE

In drawing or other two-dimensional art, our ability to create the illusion of reality depends partly on creating the illusion of distance or space. Students will increase in their ability and enthusiasm for drawing by learning that distance or space can be represented, in part, by varying the size and placement of objects they draw.

Level 1
Comparing Sizes

Students at this level might begin by comparing sizes of their classmates. Repeat this exercise by comparing sizes of objects or other people. Have three children go out on the playground, one to the very end, one in the middle, a third near the classroom windows. Ask the other children to draw all three on one piece of paper. If they draw them the same size, ask three more students to take the positions on the playground. Then ask a student to draw around their image on the window glass with tempera paint to see what sizes they are at those distances.

Obtain a slide of a field of flowers. Project it and ask students to help you measure with a ruler the sizes of closer flowers and of those farther away. (Very young students may not yet read rulers; different-sized sticks or cardboard strips serve as well for comparing the flower sizes.) Explain that, even though we know these flowers are much the same in size, those farther away *appear* smaller in photographs. (If you cannot get a slide of flowers, you might use a picture of receding poles, trees, or houses.)

Then ask students to draw three flowers on one piece of paper: one very large, one

smaller, and one very small. Ask them to determine which flower seems close and which seem farther away and compare this to what they observed in the slide. Discuss how, as with photographs, drawings of objects at different distances need to be different in size in order to represent how far away they are from each other and from the viewers.

Next, provide magazines with pictures and ask each student to select one picture that has something very far away and something else very close in it. These pictures can all be put on the wall. Then, cut out one large arrow and one small one from construction paper for each student and ask the students to attach their *big* arrow to their picture pointing to something near and the *little* arrow to something far away. Collectively, you can have them develop a sentence or paragraph that explains how close things look bigger and faraway things look smaller and that the arrows indicate what they have learned about size and distance. This could all be arranged on a hallway bulletin board for others to see.

To transfer this learning to images the students might draw, invite each of them to draw a person's face. If several are participating in this activity, encourage some to make big faces and others to make little ones. Explain that different sizes are needed to create a crowd of people. If only a few students are doing this, each one might make three or four faces of different sizes. These may be done in felt pen, chalk, paint, crayon, or other drawing tools they may prefer and then carefully cut out with scissors. Ask students to help you arrange the faces on the bulletin board to look like a crowd:

Recalling the picture of the flowers, which flowers look the biggest — the ones close or the ones far away? How does the size of the flowers change as they get farther away?

Are some people in a crowd closer to us than others?

Which faces are larger; which are smaller? How would you arrange these faces from small to large to appear as if they were in a crowd?

This same kind of experience can be gained by making houses, trees, animals, or other forms in different sizes, cutting them out, and arranging them on the wall with tape.

You can help students extend their learning by providing them with the opportunity to do drawings of things they have experienced:

Have you seen a yard filled with people, a crowd at a circus or ballgame, a road with many cars, a countryside of many trees, a shelf filled with your favorite toys or food, or animals in a herd?

How would you draw that, now that you have learned that things closer are drawn larger than those farther away?

Another approach would be to have students work as a group. Some might enjoy planning a large picture or mural filled with objects drawn, painted, or cut out that change in size as they get smaller. Perhaps an adventure in outer space or people at a carnival would be a challenge.

Very young students at this level will probably not carry these activities in concept as far as older ones. But students of all ages should be able to begin learning to see and draw things of different sizes and understand that there is a relationship between their apparent size and their distance from us.

Level 2
How Things Look
and How They Are

To extend the learning acquired at Level 1, students should think about and discuss their own experiences in seeing:

Figure 1.14 *Seeing and drawing different sizes. Third-grade children observed people at different distances, drew them on paper, cut them out, and then pasted them on another sheet of paper using overlapping size and distance from the bottom of the page to show distance.* (Courtesy of Kay Masek.)

When you see a plane high in the sky, can you tell how big it is? Have you seen a plane up close?

Is the moon bigger than it looks as we view it from the earth? Why does it look so small?

A locomotive is far away but coming toward us. Does it seem to be larger when it gets very near and passes in front of us? Why?

When a bird flies farther and farther away, does it seem to get smaller? Why? If you drew a picture of a bird close to you and another one far away, would you draw them the same size? Why?

There are several ways you can help students transfer these discussions to actual experiments:

1. Have them measure the side view of a distant car between their thumb and finger and compare that size to a much nearer car.

2. Have each student hold a ruler at an arm's length and measure the height of a faraway door, building, or tree. Ask them how much bigger the same object looks when it is closer: two times, three times, four times bigger?

3. Provide each student with a cardboard cylinder from paper towels. Take the students out in the hall and have one of them walk far down a hall until he or she can be seen full length through the cylinders. Then ask this student to walk toward the other students. Have them tell how much of that person they can see through the cylinder as the distance between them decreases.

4. A simple camera can help clarify these kinds of differences. Have the students photograph the same object from several distances, then arrange the photos in a sequence to demonstrate distance and size. Film and videotape can also be very effective by moving closer and closer to an object and noting how much of it fills the frame as the distance changes.

In each of these experiments, students can make drawings, the more distant object smaller than the closer one. For the cylinder experiment, students can draw three circles on a piece of paper, then draw a person very far away, closer, and very close in consecutive circles, showing how much of that person would be seen through a cylinder at various distances. Some students may have difficulty on their first try, even though they understand the concept. Repeated looking through the cylinder as they draw will help them draw what they see.

There are other ways to learn this. Students can each draw one shape and cut it out of paper as many as 18 times, each one a little smaller than the one before, but each looking like the other. Using a super 8 movie camera equipped to shoot single frames, shoot six frames of each shape as they graduate in size. When projected, each set is one shape moving in space getting smaller or larger. If each shape is filmed at a slightly different position, the shape will not only create distance but do so with added movement of a swish, a spiral, etc. Possible variations are numerous. Students might do two or three sets at once, make forms in clay that can be added to or subtracted from to change size, try more radical kinds of movement, and vary the number of frames shot of each image to alter the visual rhythm.

Another element of distance and size is the one we encounter when we look up at very tall things. Remind the class that when we stand on the sidewalk beside a tall building, we have to raise our eyes or tip back our head to see the top. Using a picture of tall buildings photographed or illustrated from the ground, ask the students to measure the width of these buildings at their bases and at their tops.

Why does the base measure larger? Does the building actually taper or does it only seem to?

How would you draw a building from this position?

If a tall building is drawn from this view, getting smaller and smaller toward the top, how would a person look to an ant or other insect? How would a giant look to you?

If you were the size of an ant, how would you draw a normal-sized person? How would this drawing compare to that of a tall building viewed from the ground? How big would the feet be compared to the head?

Students might draw a large inverted "V" on their papers to guide them in drawing an insect's view of a person. This concept may take some practice since it is based on their imagination and their limited experiences of seeing and drawing graduating sizes to achieve the illusion of distance on a two-dimensional surface.

Level 3
Creating Illusions of Space

In Levels 1 and 2 students became familiar with changing size as a way of creating the illusion of space. Students at this level can learn that the *placement* of images as well as their size can contribute to this illusion. To help students see how placement as well as size can create a three-dimensional effect, have them go outside or look through windows that allow them to see some distance. Ask students to hold a pencil horizontally at an arm's length on the horizon and notice that things far away on the earth's surface are nearer the pencil and smaller than those things closer and larger. (If the horizon is obstructed by trees or buildings, have them hold the pencil where they imagine it would be.)

When something is closer, is the base of it lower than the base of things farther away? Why?

Do some large objects fill part of the sky as well as sit firmly on the earth? Is this because they are taller than your eye level?

Do some trees and buildings far away also extend into the sky? Are the tops of these trees higher or lower than the tops of those closer? Why?

Figure 1.15 *An ant's eye view of a man. A third-grade boy drew this view in a class where perceptual learning is stressed.* (Courtesy of Kay Masek.)

If a flower is closer to you and smaller than a large tree farther away, where would you place the flower in a drawing to show it is closer?

How do distance and size relate to the horizon line? Some landscape paintings by De Chirico, Kirchner, and Rousseau (Haftmann, 1971) can provide students with examples they can analyze for size and placement to show distance. Photographs and prints are also useful examples. Give students the opportunity to draw landscapes as they see them or as they would imagine them to be in a realistic portrayal of an environment. Direct the students to use both placement and size as clues to distance or space. Offer suggestions and individual help, if necessary.

Show students some Marc Chagall paintings such as *The Fiddler* and *I and the Village* (Haftmann, 1971) to give them an idea of how an artist with knowledge of size and placement can manipulate images to create unusual spatial relationships, resulting in fantasy or dreamlike imagery:

If a very large image were placed in the upper part of a drawing or painting, would it appear to be close or far away? Why?

What visual effect does this large size and high placement of images create in Chagall's works?

If you wanted to have images appear to float in the air, where might they be placed in a drawing?

How could you use this information to create your own fantasy or dream-like images?

Ask students to recall an unusual dream and to express it visually in a drawing using size and placement to create an unrealistic effect. They can share these drawings and discuss the various ways individuals chose to manipulate size and placement of images to arrive at an unusual three-dimensional effect on a two-dimensional surface.

Level 4
Analyzing Space Changes in Film and Videotape

Here students can continue to experiment with drawings, film, and videotape to increase their familiarity with using distance and size to create a three-dimensional illusion. Group discussions can accompany the careful study of a comic book story, a televised cartoon or other program, or a film, noting the way the artists changed sizes and placement in telling a story or creating a mood.

Some students may want to make drawings for animated cartoons or draw moving, live subjects such as people and animals to explore different ways of changing the size and placement of their imagery to show movement. They will have to consider the relationships between these methods and the development of a mood. If, for example, they wanted to create exciting and fast-paced images, shapes and sizes have to move and change in space more rapidly than if they were developing a tranquil mood:

When something rushes closer to you very fast in film or on TV, what do you see? What do you feel?

If you see a form getting smaller or larger very slowly, does that create a different response in you than when the movement is fast?

When a form repeatedly becomes smaller, then larger, smaller and larger, what kind of effect might that have for a viewer?

How might you create these effects in drawing, in film, using videotape?

This kind of exploring should extend students' range of choices in future drawings or other works. It ties the making of art to *ideas*, in this instance by showing that the development of an idea and the viewer's response to it may depend partly on the placement and the size of images changing in space, regardless of the medium.

AREA C
LEARNING TO SEE AND
DRAW SHAPES CHANGED
BY VIEWPOINT

Most of us carry images in our minds of what things look like. If we were planning to draw a tree, car, animal, person, or building, we have an established image we would draw. We don't ask "Shall I draw a profile, a front view, a three-quarter view, a view from above, behind, or underneath it?" Because of these limited images, we become frustrated at our inability to draw when we try to visualize an idea. We think that we have no "talent." One way for students to overcome this feeling about their art "talent" is first to add quality and excitement to their seeing. Teachers should provide them with ample opportunity to look at things around them, to view critically, to discuss, and to draw what they actually see from various angles and viewpoints as well as help them discover they can draw what they are seeing.

Level 1
Looking for Multiple Images
of the Same Thing

At this first level, seeing and drawing things changed by viewpoint can be approached in several ways. Offer all students a cardboard cylinder. Ask them to hold it vertically out in front of them and describe what it looks like in this position—its length, its width, its shape. Then ask them to hold it as they would to look through it:

How does it now look different from the way it looked before?

Can you tell how long it is now? Could you see the round hole before?

Can you see through it now? Could you before?

Discuss with them that even though they know it is a cylinder in both positions, it looks different depending on what angle or viewpoint it is seen from. Let students look at their cylinders again as you discuss this and give them paper to draw what they see in each position. Emphasize how the drawings in each position are different, even though the object is the same. Many items would change shapes like cylinders—bottles, cars, lampshades, silos, cups, rings, wheels, cucumbers, baseball hats, an oats cereal box, a piece of chalk.

Bring an automobile tire to class. Position the wheel so that students can see it in its circular form. Have the students draw the tire in this position. Then lay the tire on a stool or table that is level with students' eyes (their "eye level") and ask them to describe and draw how the wheel appears from this view.

Do you see the tread? Did you see it in the first position?

How is the shape you drew of the wheel in this position different from the first drawing?

If a car was drawn from a side view, how would the wheels be drawn?

If you drew a car coming toward you, how would you draw the tires?

Demonstrate, using short, rolling motions of the tire toward individual students.

What part of the tire do you see? What is the tire's outline shape?

Ask the students to draw the tire in this position. They should have three drawings—one circular showing the roundness they saw, one showing the wheel and a tread on a horizontal plane and a third one in a vertical position also showing tread. Emphasize that in future drawings of tires and similar shapes, such as donuts, they should remember the different viewpoints and choose the

one best suited to the picture they are developing.

Another exercise of seeing and drawing from various viewpoints could begin by asking students how they would draw a book. A few may wish to demonstrate on the board or on paper.

Are there different sizes and shapes of books?
Do books look the same from various angles?

Ask each student to select a book to draw, to hold the book out in front with the front cover facing him or her, and to describe in words the outline shape of the book.

Is it tall, wide, square, longer than it is wide?

Ask the students to draw the outline of the book as they see it, then turn the book to view its lower end, describe its shape, and draw it. Finally, ask them to look carefully at the bound edge and the opposite, open edge, discuss their similarities and differences, and draw each view.

If you see books on a shelf, what part do you see? How would you draw that? Are there examples of this in the classroom?
How would you draw books stacked?
How would books displayed showing the cover be drawn?

Invite students to make these kinds of drawings and share their drawings with others, to discuss the different sizes and shapes of books they drew, and to think of and name other objects that would be similar to and change shapes like a book. Boxes, suitcases, boards, and tables are a few forms that could be provided for students to draw using similar procedures.

Some students at this level will be very young. Their abilities to draw what they see will vary, but even the simplest shapes they draw can reveal what they see, so encourage them to do many drawings of things from different angles. A seeing-and-drawing corner filled with items that are changed regularly could be set up in your room. Students could come there often for short periods of time to make viewpoint drawings of things in the corner or of whatever they may choose to draw. For this level we selected cylindrical and rectangular forms because of their simple outline shape and because of the obvious differences in the angles observed. Forms such as cereal boxes, jars, books, a football, a cup, or a piece of chalk provide shapes that are simple to draw and that look quite different from different angles.

As students do these kinds of drawing and seeing, suggest to them that whenever they include cylinder or boxlike forms in their drawings, they will have different options of how to draw them, depending on what they want to portray.

Level 2
Drawing Objects from Different Viewpoints

At Level 1, students placed objects in different positions to see and draw their differences, but the questions suggested for them were limited to seeing only one side at a time from an eye-level position. At Level 2 students can become familiar with the term *eye level* and the effect of a level on how things are seen. Explain that seeing at eye level means simply viewing something with our heads level looking straight ahead. If we must *raise* our head or eyes to see something, it is *above* our eye level. If we look *down* on something it is *below* our eye level. This concept will become clear to students as they move through Level 2.

Provide each participating student with a round container—a jar, glass, cup, flower pot—to study and draw.

When you stand above this container, can you see inside it?

Where is your eye level?

How is the top shaped? Is it a circle or an oval?

How much of the bottom can you see? How is it shaped? Can you draw that shape?

Have students hold the container so the *bottom* of it is even with their eyes, appearing as a straight line.

Where is your eye level this time?

How is the top shaped? Which way does it seem to curve?

How would you draw the container at this angle?

Then ask them to hold the container above their eyes.

Do you see the bottom? Why? How is it shaped? Would it be drawn as a circle or an oval?

Can you see the top? How would you draw that?

Does the shape of the bottom change as you slowly lower the container? Can you draw that change?

Discuss how their drawings change when they change viewpoints and remind them that whenever they are drawing an object they must think about how it actually looks from particular angles in order to draw what they see.

You may use paintings, prints, drawings, or photographs that have containers in them and ask the students to decide where the person's eyes were—above, level with, or below the objects. Students might want to take black and white photos of containers from different eye levels and then draw the shapes they find in these pictures to help them see how shapes change.

Analyze a shoebox and a suitcase. Have the students look at the box with its lid on, drawing the sides, the ends, the bottom, and the top at eye level and comparing the similarities and differences. They can continue by placing the box at eye level and turning a corner toward their faces.

How many sides do you see? Can you draw that form? If you hold the box above your head and eye level, what sides do you see to draw?

If one of your drawings had a box positioned above eye level so the bottom and a side or two were seen, what would the box seem to be doing (floating or sitting on a glass shelf)? Why?

Can you see the bottom of the box when it is at or below your eye level?

If the box were upside down and below your eye level where would you draw its lid? Can you see the bottom now? The top?

Now present the suitcase for students to study:

If the suitcase were a shoebox, would you see the same number of sides? Would drawings of it be similar to those of a box?

Place the suitcase on the floor a short distance from you. How many sides do you see? Why? Where is your eye level?

How would you draw a suitcase carried by a person walking left or right across your paper? Would you see the top as well as a side? Why?

If the person were coming toward you, how would the suitcase be drawn? What parts of it would you see? The top and one end? Why?

How many views of a suitcase can you draw?

Have students individually select a three-dimensional object in the room they would like to draw in several positions—from the sides, the front, the back, from above and below—attending to the details they see at each angle or eye level and the way the outline of the object appears and

Figure 1.16 *Arthur Hansen.* Tree, *1963. An eye-level view of a tree. Usually artists draw trees with most of the tree above eye level, but Arthur Hansen shows us a close-up view of bark and needles and barbed wire fence at eye level.* (Collection, Museum of Art, University of Oregon. Gift from the Haseltine Collection of Pacific Northwest Art.)

changes. When they seem to see and draw one object with understanding of viewpoint, help them choose a slightly more complex object to draw. All their drawings of one object can be placed on one piece of paper to help everyone in the class see the various ways one object can appear. Display these drawings periodically and ask students to identify the position of the viewer. Urge

them to think about what angles or viewpoints they use through habit.

Level 3
Analyzing and Drawing Shapes
Changed by Viewpoint

Levels 1 and 2 taught students how to view changes in the appearance of simple forms

depending on the viewpoint. Students ready to study at Level 3 should be able to describe and draw these changes and to point out examples of them in their own and others' art. The study of single objects from many viewpoints prepares students to analyze more complex forms.

Ask the students to carefully analyze an object such as a car from various viewpoints to see how differently the forms that come from the structural elements of the car appear and how the shapes of details change as they change viewpoints. With your students, take drawing tools and pads and a tall stool to a nearby parking lot.

When standing directly centered in front of a car what parts do you actually see? How are the head-lights shaped, the bumper, the wheels? Does the hood appear shorter than you know it is? Why? With your pencil held at arm's length, how does the height of the car compare to its width? How much of the height is window? How much of the height and width is hood? Grille?

If you draw the car from this view, could you draw it more accurately by comparing how much each part of the car takes up to make the whole form as seen from this viewpoint?

Now stand at the same spot but several feet higher on a ladder or tall stool. What parts of the car do you see now that you didn't see before? Is the outline shape different? Why? How do the shapes of things on the car look now? Are the headlights still round or are they eliptical? Do the hood and fenders look longer now? Does the bumper take on a different shape from this elevated view? How is the roof different? Do you see part of the trunk or rear fenders? How much? Did you see these when standing on the ground?

Looking broadside at the car, can you tell how wide the car actually is? Do you see the fenders on the opposite side? How wide would the hood and trunk be drawn now? How are the bumpers, wheels, and lights shaped now?

Stand opposite the corner of a fender so that one side and the front are clearly visible. How long does

the car look now? How wide? How many lights, windows, wheels, and fenders do you see? How do the shapes of the headlights look now? The bumpers, fenders, grille, windows? How would you draw the wheels from this view? Does the car seem to get smaller as you get farther away from it?

What might be a mechanic's viewpoint? A driver's? How would cars look if you were in a plane or heli-copter?

What other views can you find to draw?

Give students the opportunity to select and draw a car from at least three viewpoints — any three they choose. Their drawings can be put on one piece of paper (or done sepa-rately and later all traced onto one large piece) to make them easier to view and dis-cuss by a group. Have students look at each other's drawings and try to determine the precise viewpoints. Urge them to consider how these different viewpoints of a car might suit different ideas they could develop in a print, painting, or drawing. For example:

How could different viewpoints be used to show different aspects of an auto race?

Would the drawing have a different impact if the cars were coming toward the viewers than if they were seen from the side or rear?

This detailed study of a car from various viewpoints is intended to help students be-come actively aware that three-dimensional forms, whether human, natural, or manu-factured, will look different from various viewpoints (with the exception of perfect spheres that are without surface patterns or designs).

To extend this awareness, students could study the human form in detail, notic-ing what parts of a person they would ac-tually see from a particular view. One ap-proach to this activity would be to seat a model and have each student do a drawing from his or her specific viewpoint. As they

study and draw, you can provide individual help by having students talk about what they really see and do not see. When their drawings are finished they can organize them on the wall showing the gradual change in viewpoint as they were seated around the model.

Another approach is to have the model make a ⅛ turn every three minutes and ask students to make rapid drawings from each changing viewpoint. All these can be done on one paper so they may be more easily compared. By discussing the differences in what was seen and drawn from these various views, students become more sensitive to the appearance of the human form from different views and can use this sensitivity in their future drawings of people. Show several drawings or paintings of people so students can see how other artists use knowledge of viewpoint.

The variety of things to look at and draw from usual and unusual viewpoints is nearly endless. There are manufactured forms such as chairs, can openers, typewriters, bicycles, staplers, transistor radios, and musical instruments. There are natural elements such as mountains, trees, and flowers. There are animals at a zoo, pets at home, and so on. As students draw, you can see where they may need to consider viewpoint and can ask them individual questions. You might suggest that they do viewpoint studies of forms they are including in their imagery. The more aware students are of seeing things as they actually look, the more flexible they will be in developing ideas in art.

Level 4
Learning to See and
Draw Foreshortening

At this level emphasis can be placed on *foreshortening*. Foreshortening is a technique in which the object is drawn so that it ap-

pears to be extended in space receding or coming toward the viewer. Show a simple form, perhaps a baseball bat, so that its large end is seen as a circular shape tipped down and the opposite end of the bat is barely visible to a student:

How long is the bat?

Holding your arm straight out and using thumb and finger to measure, how does the length and width measure at this viewing angle compare to its actual length and width? Can you draw the outline shape of the bat tipped in this position? How is that different from drawing its appearance when vertical?

Does this drawing seem distorted to you?

In what instances might we see a bat this way?

Have students position their hand at a side view—fingers straight, thumb straight and snug against their hand. This view will allow them to draw the fingers and thumb the length they are. However, if they open their thumb toward them, the view of it is a *foreshortened* view. The length we know our thumb is and the length we would draw it in this position will differ. To draw this foreshortened thumb, have students first attend to its actual outline shape seen from this viewpoint. Its drawn shape will be much different from the first position and may look strange to them at first. Then ask them to note the shape of the nail and the amount of thumb flesh that surrounds it on all four sides, and draw it into the thumb outline where they *see* it.

How much space do you see between the nail and knuckles, between the thumb outline and the hand outline?

When the thumb was snug against your hand, where did the tip of it come along side the first finger? How does the thumb line up now?

This kind of exercise will take much practice for some students. It can be applied

to several positions of the body as well as to other three-dimensional forms. This kind of activity will help students see and draw objects with more facility and will prepare them to see and draw objects as they are less commonly seen or recognized. To encourage the students to think about unusual viewpoints, the following questions may be helpful:

If you lie under a tree and look straight up through the branches to the sky and draw what you see, what kind of patterns might result? Would they be different for different trees? Can you describe the differences? Do sizes change in space as the branches get farther away? Can you draw that change?

Could you draw a typewriter from the viewpoint of a piece of paper rolled in the carriage?

How would you draw a flag pole from a flag pole sitter's viewpoint?

What view would an ant have of a person in the midst of stepping over it? How would you draw that considering viewpoint, sizes changing in space, and dramatic impact?

Students can discover how a knowledge of viewpoint and of sizes changing in space can be useful in creating visual impact or emphasis. As a result of these kinds of experiences, students will become quite versatile in analyzing and drawing objects from simple to complex in form and from a vast range of viewpoints.

AREA D
LEARNING TO SEE AND DRAW
THE STRUCTURE OF THINGS

To learn to see the structure of things is to notice *how* and *why* objects are formed, hold together, fit together, and work as they do. Once students are aware of these aspects of things they can draw them much more easily. Students who have difficulty drawing objects usually have not considered struc-

ture. How something is put together and how it works, how its parts relate to one another and to the whole object are very important elements for your students to study.

Level 1
Using Drawing to
Analyze Structure

Students can start by analyzing familiar objects with simple form. That way they can concentrate on relating what they already know about objects to the new questions you will be asking. The following examples of activities will not all suit all students. Instead, they vary somewhat in depth of inquiry in order to suit the range of aptitudes of your students. You might start with very familiar objects like cups or mugs with handles. It would be best to have several kinds to study.

What do people use this kind of object for?

How does its size and shape let you know how to use it?

How does the size of the hole in the handle fit your fingers? What is the shape?

Does the form of the cup get wider or smaller? Where?

What would happen to the contents if the bottom wasn't flat?

How does the lip of the cup fit your mouth?

Ask students to hold a cup at eye level and draw it carefully, showing the sides as they may taper or curve, the flatness of the top and bottom, and the size and form of the handle. Then ask them to make one or more drawings of other cups or mugs in order to make comparisons between structures.

Small children can explore visual qualities they may not be able to draw realistically, but their drawings may show they see

differences. At this level, exploring differences in the ways things look so that the structure, the way it is put together, can be seen is most important. Any fruit or vegetable that has separable parts can also be used. An orange can be looked at whole, sliced through the middle, peeled whole, and peeled and divided into halves, quarters, and individual segments. By observing all the ways an orange looks, students can develop a feeling for its structure. Some children and other beginners will be able to draw some aspects of how oranges look to help them understand its structure. Similar experiments can be done with pomegranates, honeycombs, and even brick walls.

The emphasis in all these early inquiries into structure is to have students notice the parts of a whole form, how they fit together and how these parts—and their fit—can be defined in drawing. Continued opportunities to analyze things with interesting structures will enable students to draw objects as they see them rather than as they imagine them and with more detail and accuracy as to how they are put together and how they may work.

Level 2
Using Drawing to
Remember Structure

Students at this level can begin to consider more closely *why* the structure is as it is. Invite your students to draw a tree without looking at one. This will give you—and them—some notion of what they know about trees and how carefully they have looked at them. Those who have climbed trees, built a tree house, or picked fruit in an orchard may have more detail in their drawings of trees than those who have not. Trees may be seen as something to swing from, play in, cool off under; as something that grows naturally; or as something that people preserve

and control to enhance buildings or line streets.

Select a specific tree that a group of students can walk around, draw, and discuss the different structural aspects.

How does a tree grow?

Have you ever started to draw a tree the way it grows, up and out?

Where is the trunk biggest?

How does the trunk change as it goes up?

What pattern do the branches make as they grow out from the trunk?

How do the roots help a tree hold its balance in the wind?

If the tree has leaves or needles, how do they grow out of the branches, singly or in clusters?
How do blossoms, fruit, or cones grow?

How does the bark protect the wood?

When viewed at a distance, what outline form does the tree have? Does that change as you move around the tree?

Students can study this tree, draw it, and then use these questions to assess their drawings. After they have repeated the task with different kinds of trees they will have learned to see and draw trees with more understanding.

These drawings can be shown or repeated at several times during the year noting the changes in a tree at different seasons, and students can evaluate what they have seen. They will see that their drawings of the same things are different because each has seen and drawn the tree from varying viewpoints and at various times of the year.

This kind of activity can be done with other things familiar to students. Your class might visit an automobile graveyard, a construction site, or a dairy farm. Students can consider the shape of a car, where doors and handles are attached, how big windows are and where they are located, the number and

a.

b.

c.

d.

Figure 1.17 *The effects of opportunity to learn. Ability to draw bicycles depends more on opportunities to learn than age. Drawings **a** and **c** were drawn by sixth graders, drawings **b** and **d** by college students. Which drawings use stereotyped flat views; which show the bikes from other view-points? (**a** and **c** courtesy of Fred Fraser; **b** and **d** courtesy of Jay Steele.)*

shape of front and rear lights, and the comparative shape and size of the trunk and hood and how they look open in various positions. They should notice the curves, angles, and straight lines and discuss *why* the structural elements of a car are as they are. Drawings can include detailed studies of lights, grille, bumpers, hinges, handles, etc., showing how and where they are connected to the car. At a construction site, students at this level could concentrate on the vertical, horizontal, and diagonal forms that are combined to create a structure and which parts hold others up. At a dairy, students could study milking apparatus and draw the elements the milk travels through from the cows to a final container.

As students do other artwork during the year, you can observe where they may need help in seeing and drawing the structure of things and can focus activities on these areas. This kind of drawing as a means of seeing can be practiced over and over as the structure of things become clearer to students and as they become more facile in their drawing.

Level 3
Analyzing How Structure Affects Form

At this level students should be ready to study more complex forms to see how the structure determines the form, to understand how structure and function are related, and to use drawing as a tool to help them visualize what they see and understand in natural as well as in manufactured forms.

You might begin, as was suggested in the Level 2 study of a tree, by having them first draw something from memory. This will help you determine whether students are really at Level 3. For example, if students drawing a bicycle from memory show some understanding of how a bike looks, its com-

parative proportions of height and width, the position and size of seat and handlebars, but seem to lack the understanding necessary to show structural and functional relationships between its parts, such as the angle and length of the wheel braces, the point at which the weight of the rider is supported, the relationship among the back wheel, the chain, the cogs, and the pedal, and the paths taken by brake and gear cables (on multiple-speed bikes), then Level 3 students might focus on a bike with these kinds of questions. Bring a bicycle to class and place it so the class sees it from a side view:

How is the bike held together? Where is there stress, strength, fragility? Can these qualities be shown in a drawing?

How does the brake system seem to work? Can you show how it works in a drawing?

How are the handlebars and seat shaped from this side view? Why do you think they are made this way?

What things are circular, angular, flat, round, smooth, rough, shiny, dull?

What kind of pattern do the wheel spokes make? Why do you think they are made this way?

What other patterns or designs do you see?

What lines are vertical, horizontal, diagonal?

What do you see close up that you don't see at a distance?

How does the bike look from the back? The front? What structural elements are visible that were not before? How do the handlebars, pedals, seat, and wheels look from this view? Can you tell how long the bike is from these views?

Have someone mount the bike as if riding:

From the side view, how are the feet placed, the legs positioned? Are the torso and head straight or tilted? How are the arms and hands held?

How would you draw this person on the bike from side, front, and back views?

Students can analyze a car using the same kind of process, looking at all its parts and how each relates to the other. Be sure to have them consider to what extent a car's frame, axle, and chassis affect the exterior form. Shoes can also be studied for structure. Supply a range of sizes and styles of shoes for students to compare and use as models to draw on and off feet. Place emphasis on how the shoes are made, what their characteristics are, how they are similar and different, and how these characteristics can be shown in drawing.

To help students learn to see and draw structure in nature, lead them into observing the structure of a small plant in three-dimensional space:

What shape are the leaves? Draw one.

Most students will draw one flat to show its *known* shape rather than its visual shape from their viewpoint. Then ask them to look at the ways the different leaves appear—those that turn away, up or down, left or right, or directly toward them—and compare them with their drawing.

How do the branches grow out of the main stem? How do they look from different viewpoints?

Can we see how the plant really grows looking at it from just one side?

How does a main branch change its form when a secondary branch grows out of it?

Does the plant as a whole seem balanced? Is there an order to the structure—that is, are some things repeated?

Ask students to make drawings of parts as they go through this inquiry, and then to draw the plant from various views. More detailed plant forms can be used for variety. The focus should be on the structural form and the ways the individual parts are related.

The human form has almost endless possibilities in drawing. Knowing some of the structural characteristics of a human form will increase students' ability to show the physical characteristics of the people they draw and to express emotional qualities. At this level, students should be ready to analyze the proportions of the body and be able to transfer this learning to some of the ways a person might move or hold a position. Just as the plant leaves appear different as they grow in different directions, so the human form changes its form and appearance by the way it moves and the way we see it.

A similar pattern for learning can be done with the human body. Students can draw it full face, standing directly in front of them. To learn basic proportions, have students observe a model. Ask them to hold their pencils at an arm's length. They can measure the top and bottom of the head by sighting the tip of the pencil at the top of the head and marking the tip of the chin with their thumb down on the pencil. This measure of head height can be used to see how many heads high the whole figure is, how many heads different widths are, and what proportion of height is above and below the waist. All the proportions of hands, feet, legs, and arms can be measured.

After the students have analyzed this front view, ask the model to move one limb at a time so that students can see and draw how body parts appear foreshortened. Have the model kneel, keeping the arms to the side, and bring one leg forward, bent but with the foot on the floor. Ask the students to draw this position from both a front and a side view.

How do you determine the length of the legs in this position? Are both legs still the same length?

Can you use the head measurement to help you with this drawing?

How close to the ground is the body now?

If the hands are placed on the forward knee, does the person need to lean forward? Are the arms straight or bent? Can you see both arms?

Ask the model to assume simple poses, and the students to draw the poses from different viewpoints. If it is possible to get overweight and underweight models who are not self-conscious and some tall as well as short models, students can begin to recognize the characteristics of different body forms.

A next step could be to analyze the structure of parts of the body. It will help if students can compare delicate, brawny, thin and heavy body parts to see the different characteristics of form. Begin with basic proportions and then see how these are changed by individual characteristics.

How far down on the head are the eyes positioned? How does this change as the head is tilted up or down?

How far apart are eyes among different people? What different shapes are there among eyes?

The same questioning can be applied to the study of ears, mouths, and noses. The varying widths of the space between eyes and the width of noses and mouths can be compared both in looking directly at them and in foreshortening.

How does the width and height of each part change as the head is rotated left or right or up and down?

What different shapes do heads seem to have? Are the shapes different from different viewpoints? What do jaw lines and hair lines do as the head is rotated? Do they really change or do they merely appear different?

How can you tell people apart in drawings? Describe and draw the differences you know when comparing facial features and head characteristics.

Notice that in these series of questions students are being asked to study the face and body from a front view and the way it appears differently as either they or the model change positions. In traditional drawing, students often learned specific positions that inhibited their seeing as things move in three-dimensional space, with the straight becoming curved and the curved becoming angular.

Level 4
Seeing How Form
Changes with Movement

The structure of the human form, studied in depth at Level 3, can be analyzed further as suggested in the following areas of focus:

1. As the body moves and takes various positions, the flesh—the skin, the muscles, and other tissues—stretches, folds, creases, flattens, wrinkles, and bulges. When we bend forward, our stomach flesh folds and creases and our backs stretch. When we sit on a chair, our thighs and buttocks flatten. A doubled fist has deep creases where the skin folds and a smoothness as it tightens over the knuckles. A smile or frown changes the structure of our cheeks, lips, eyes, forehead, and, perhaps, our nose and chin. Students can use each other and themselves as models to study the structural changes that occur in the human body as it moves, stretches, and bends.

2. As they draw from models in various positions, emphasis can be placed on where the center of gravity is in the figure; in other words, how the weight of the body is distributed. Models can stand with their weight slightly over one leg so that students will be challenged to see and draw this slightly asymmetrical stance. Or models can assume exaggerated poses for short times to allow

students to make quick sketches, attending to the distribution of weight.

Providing figure studies done by Michelangelo, Delacroix, Rubens, Matisse, da Vinci, and Picasso (Mendelowitz, 1967) to analyze carefully can increase students' ability to see structure as well as the expressive qualities given to those forms.

3. Have the students look carefully at botanical drawings to learn their structural interior so that they can capture the external structural qualities in their drawing with greater understanding and facility.

As students work through these areas, they will become more and more able to see whether they or their fellow students are capturing these structural elements in their drawings as well as in their painting and sculpture.

4. Determining the effect of outside forces on subjects may help students give their drawings and other art works the quality of structure that is present in the subject matter. This should also help students to develop a sensitivity to structure that will allow them to use the knowledge creatively. For example, have them consider how a tightrope walker distributes his or her weight, what happens to a car's front end when it screeches to a halt, and what effect gravity has on the boughs of trees.

5. Human anatomy can be studied to see how bones join and allow certain body movements, what shapes and sizes muscles are in different areas, and how these and the skeleton determine where the body will be angular and where rounded. Making drawings of these aspects of the human structure and adapting this learning to the human forms they choose to draw will increase students' ability to draw figures with and without models.

Figure 1.18 *Understanding body movement. This nine-and-a-half-year-old Australian boy understands how bodies work in a soccer game with the push and pull of players.* (© International Collection of Child Art, Ewing Museum of Nations, Illinois State University, Normal, Illinois.)

AREA E
LEARNING TO SEE AND
DRAW IN DIFFERENT LIGHTS

Part of the pleasure of seeing is recognizing the qualities that forms take on in different kinds and amounts of light. On a very bright day, outdoor light may be *harsh* and *intense,* causing bold shadows and washing out colors; an overcast day may produce *subtle* or *drab* light, indistinct shadows, and rich color. A flashlight at night gives off a *shaft* of light; the moon produces a *beam;* through trees and clouds come *rays* of sun. Sunsets may turn the terrain a gold or rosy *hue;* moving or different-colored lights may produce different dramatic effects.

The source of light upon or the amount of light that surrounds a form will determine or alter the way it looks to an observer. Candlelight illuminating a face from below the chin can produce an eerie effect. A skyscraper lighted from within at night looks different from one lighted from outside. The rich texture of bark may show in detail or may lack definition, depending on light intensity and direction. The sun travelling east to west will hourly change the appearance of sand dunes. The full moon will define forms and create-shapes and shadows on a snow-covered landscape. Light reflecting off, through, and around surfaces creates different appearances and qualities.

We can add quality to our drawings by attending to the amount, type, and direction of light that affects the appearance of things — in fact, allows us to see them *at all.*

Level 1
Looking for Lights and Shadows

At Level 1 students can begin to recognize the kinds of light that may affect what they see by asking questions like these:

Figure 1.19 *Pearl Wesley (Tlinghet Indian, Canada). A contemporary Indian using traditional techniques. Relief carving is a form of drawing using light and shadows on the incised planes to create the lines.*

Why are there shadows?

Can you see shadows in the classroom?

On the school grounds?

Have students observe their own shadows in the school yard early in the morning, at noon, and at the end of the school day to see how shadows change.

Describe your shadow in the morning. How was it different at noon, later in the day?

What caused the difference? Where was the sun in the morning, at noon, in the afternoon?

They can make drawings of themselves and their shadows and compare the way they look on a sunny day with the way they look on a dark, cloudy day.

Which day were your shadows easier to see? What made the difference?

To practice paying attention to differences in what can be seen at night and during different times of the day, students might look through magazines for daylight and nighttime photographs of landscapes, cityscapes, rooms, or people. They can note what the light sources are and the directions the light comes from. They can assemble a collage or bulletin board illustrating the effects of different kinds and directions of light.

Bring a jack-o-lantern to school and ask students to compare seeing the form in ordinary daylight and seeing it lit in a darkened room. Then ask students to draw a picture of what takes place at night. Perhaps they could illustrate a spooky story that took place at night. Encourage them to think about what could actually be seen in the darkness.

Is there a building?

Are lights on inside?

How would you show this?

Is there light anywhere outside? What kind of shadows does it make?

What things can be faintly seen?

To practice paying attention to light and dark, the classroom itself can be darkened and a student with a flashlight can move around the room focusing the light on different things at different angles to help students see how the source of light changes the ways things look.

You may want to demonstrate how white chalk on dark paper can illustrate light in the dark or how the tip and side of charcoal or crayon can be used with various pressures to achieve degrees of light and dark. By using chalk, pencil, charcoal, and crayon, as well as dark and light values of paper, students can explore ways to develop their pictures.

Very young students and those with few media experiences will probably have some trouble drawing night scenes because it requires skills with media that may take time to explore. As they work through their drawing experiences with shadows as well as darkness, you can help them evaluate what they do. Have them describe their drawings and their intentions to you and help those interested increase their abilities to render personally satisfying drawings by continuing to verbalize and incorporate what they see and know about the effects of light.

Level 2
Creating Forms with
Lights and Shadows

To help students recognize how they can define form and determine its appearance by shading, start with a simple form like a ball placed on a table in a darkened room. Shine a single light on the form, illuminating the *left* side seen by students.

What part of the ball do you clearly see? Can you see the right side of the ball at all? Does the lighted part abruptly change to darkness on the right side or is this change a gradual one? Why do you think this happens?

Is there a bit of light reflecting off the table, lighting the under, right side of the ball?

Is there a shadow? What is its shape?

Raise the room lights and have students draw a circle.

How can you change the circle to make it look like a ball or sphere? Can it be done by shading?

What is shading?

Let students practice shading on a separate sheet of paper using charcoal or a soft pencil. Have them start with a lot of pressure and gradually ease up, so that as the dark area grows, it gets lighter and lighter, fading out. You may demonstrate this to the group; show examples of shading by artists and then offer individual help as needed. When they seem to have a feeling for shading and some control of the medium, let them return to their papers and, looking once again at the illuminated ball, shade their circle to look like a sphere lighted from the left side, casting a shadow.

Move the light to above the ball, then to the right side, discussing the change in its appearance as you do so. Have students notice how the shadows change and move depending on the direction of the light, and ask them whether the shadow is always very dark and hard-edged. Let students draw other circles and, drawing an arrow outside the circle to show the light source on each circle, shade them to become spheres, each different in appearance. This kind of activity can be done using cones, boxes, cylinders, or other simple forms to help students see how shading can create the illusion of three dimensions.

As they gain in experience, you can demonstrate how the line defining the lighted side of the forms can be eliminated or the outside of the objects shaded up to the drawn line, so their drawings will look even more like three-dimensional objects in space.

Level 3
Changing the Source of Light

Get some masks that have holes in the eyes and perhaps in the nostrils and mouth. In a room that can be totally darkened, mount or hang the masks and, with the lights out, shine a single source of light directly on the mask faces. Then shine the light from behind the masks and discuss with students the differences in the way the masks look:

In which light position do you clearly see the color and detail of the mask faces? Why do the holes of the eyes look dark?

In which light position do the masks appear as silhouettes? How do the eyes look now?

From what position might you shine a light on a mask to create facial shadows?

Have students draw a mask showing how it would appear in different lights by noting the shadows created and using and improving their skills in shading.

Invite a person to model and, using a light as the single source of illumination, discuss the differences in what can be clearly seen on the person's face and what cannot.

What direction of light would cause a nose shadow to the left of the face? With the light in this position, which part of the face is clearly illuminated? Which is in darkness? Are there parts of the face that gradually change from light to dark? Why? Do you see other shadows? Can you draw this slow change with shading?

What light position would cast a shadow under the nose? Would there be a shadow on the neck? Why?

Would there be shadows around the eyes? Where are the shadows darkest on the face? Why? What is illuminated? The tip of the nose? What else? Does the hair reflect light? Where? Does it cast shadows? Where?

What differences can you see when comparing the face lighted from below the chin and above the head? How would you draw that difference?

How would a face in overhead light be drawn differently than one illuminated by a side light?

What light position would produce the least face shadow?

What light position would create a silhouette? How would you draw this?

Students can practice their skills in shading by drawing faces in different lights. Using various drawing tools, such as charcoal, chalk, pencil, and pen and ink, they can pay attention to the areas reflecting the most light, areas partially shaded, and very dark areas. They will soon notice, or you can remind them, that the medium used to illustrate a form may change its appearance as well.

Students can see and draw the effects of light on things outside by doing light and dark studies of trees, buildings, fences, cars, grass, or whatever is around. For example, rather than drawing a building by outline, they could look for all the dark areas on it and define its form by drawing only the dark parts of it, being sensitive to the degree of darkness. A tree's shadow cast across the side of a house might, for instance, be a lighter value than the dark window within the shadowed area. Some might try to define an entire landscape by attending only to the shaded areas.

In the classroom, a single light can be used to define the human form and, using chalk, charcoal, or ink, students can render the form by including only the dark areas seen—carefully noting the degree of darkness on various parts of the form. On dark

Figure 1.20 *Tom Anderson. Drawing with light. A photogram (an object distorts light on photographic paper) of a drinking glass creates patterns of lines. (Courtesy of the artist.)*

paper, the reverse can be done using white crayon, chalk, or paint to define only the illuminated parts of the form and the degree of intensity that the lighted parts take on de-

pending on the position of the light and the structure of the form.

In Level 3 of Area A, *Learning to See and Draw Details and Relationships in Space,* emphasis is placed on developing skills in rendering various surface qualities. Light is an important element in how these surfaces might look at a given time. As you concentrate on light with students, give them the opportunity to see how different directions, amounts, and kinds of light will affect or define the surface or textural qualities of things they draw.

Evaluating what students did in each activity should be done as a group as well as individually, attending to how each person saw objects in light and how they chose to illustrate that. Students at this level, given guidance and a range of media with which to explore, will learn to use light as well as drawing techniques to portray images for a specific visual effect.

Level 4
Creating Expressive Qualities with Light

Different lights in amount and kind can create different moods or give drawings different expressive qualities. If your school has a stage with banks of lights, invite your class to spend some time creating different visual effects or moods with different colors and amounts of light, stationary and moving. If a stage is not available at your school, perhaps you can make arrangements for students to take a field trip to make use of a stage nearby. If colored lights are not on the stage you select, use various hues of cellophane over the white lights.

As some students work to set a particular mood in light, others can strike poses and move to various positions to see how the same light may alter with the kind of drama or the position of the players. Single dramatic poses can be lighted differently for various effects. For example, a stark white light coming from the stage floor illuminating the front of a stately dark figure can add mystery or eeriness to the character. The same figure seen lighted from the back may appear ghostly. A flood of red lights may give a sense of heat, anger, or excitement; a flood of blue ones may seem chilling or lonely.

As different moods are developed, students can draw what they see, employing their skills in shading and furthering their experiences with different light and dark values of paper and drawing tools, selecting the media and controlling them to render the mood as it appears to them.

This exploratory method of seeing things in different lights to create different effects can be pursued using strobe lights, flickering candlelight, and other moving light as well as stationary lights. Students may feel it is difficult or even impossible to capture this quality in drawing. To help them see that it can be done, and some of its potentials, show and discuss paintings by Giacomo Balla, Joseph Stella and Franz Marc (Haftmann, 1971). In many of the works of these artists (from the Futurist and Blau Reiter movements) there is a combined use of space, structure, color, and light that gives a viewer the sense of seeing translucent forms in a barrage of lights, a strength or power that draws the viewer to respond to the expressive qualities contained there. Invite students to analyze what they feel these paintings represent in terms of light and form and then direct their attention to what is happening on stage as moving lights pass over forms:

Do you see the same aspect of a form each time a moving light strikes it?

Is there an illusion of movement with a strobe light? Why?

Is that illusion of movement present in candlelight?

What kind of mood is created with lights that move slowly over forms? Rapidly?

How might you capture the mood and the form as you see and feel it in each of these lighting situations?

AREA F
LEARNING PERSPECTIVE SYSTEMS

The term *perspective systems* may conjure up a disciplined, rigid kind of drawing that tends toward imitating what is seen, leaving the artist in minimum control of imagery. Perspective systems, however, are a group of tools that can increase our ability to represent three-dimensional forms on a two-dimensional surface. Rather than restricting our freedom for expression, they increase it by increasing our ability.

Learning perspective means learning that forms change with viewpoint, that sizes change in space, and that overlapping, amount of detail and texture, and light and dark values are all distance cues. Being able to incorporate these aspects where desired in drawings, prints, or paintings will give students at all four levels greater facility in producing images that represent what they wish to portray. Many of the elements that are part of perspective are covered in other activities at each of the levels.

Level 1
Looking for Perspective

The term *viewpoint* is one key word that can be given further emphasis at Level 1. For example, if you are high on a mountain overlooking a valley or plain, you can see farther —more of the land below—than if you were standing on a street on the plain. By giving students the opportunity to notice this, you will further their knowledge of distance and size and introduce them to the horizon

Figure 1.21 *Joseph Stella.* Pittsburgh, *1933–1940.* (Courtesy of Museum of Art, University of Oregon. Gift from U.S. Government WPA Art Project.)

line. Some Japanese prints by Hosukai and Hiroshige provide excellent examples of landscapes seen from a high viewpoint (Longstreet, 1961). If these artists' works are not available to you, use photographs or (better yet) slides taken from an airplane, a mountain top, or a high building. They will support the following kinds of questions quite well:

What are the biggest things in the picture? Do these seem closer to you or farther away than other things in the picture?

Can you see tops of houses, boats, trees, hills? Where did the artist (or photographer) see this from?

Can you see down on rooftops when you are on the ground next to the building? Must you look up to see them?

In the pictures was the photographer or artist looking up or down?

Where do the earth and sky meet in the different pictures?

Do objects on the ground look bigger or smaller on the horizon?

What happens to roads when they go off toward the horizon? Do they really get smaller or just look that way?

Then give your students paper and drawing tools and ask them to describe and draw a horizon line, dividing their paper into earth and sky. Ask them to select something to draw — a tree, house, animal, or road — and draw it in three different sizes, each time getting smaller, as if farther away. Some students will tend to draw all the objects on the horizon line because their learning to write letters on a line overrides what they have learned to see about objects in space. Have them compare what they drew to the landscape pictures that show things getting smaller as they get closer to the horizon. In later drawings help them notice whether their roads, rivers, fences, and other objects are smaller near the horizon and why they may or may not prefer that. As they learn to see in space, it is well to remind them that artists can always exaggerate or draw things unrealistically if it suits what they are expressing; but not being able to draw things in space because one has not learned to see how things change in space is a hindrance.

Students at Level 1 can also become familiar with "detail" as a clue to distance.

Pose the following kinds of questions as students look at pictures of animals in herds such as giraffes, zebras, or cattle, where some are closer and their markings clearly visible while others are far away, their markings less visible:

Do some of these animals show more detail than others? Why? Are they nearer or farther away, bigger or smaller than other things?

When we look at things very far away, is it more difficult to see all the details? Why?

What does this tell you about putting details in your drawings?

If some things are far away and very small, could you have less detail on them?

Would this be another clue along with size that tells you something is far away?

Some students may have earlier drawings of animals or groups of things that they can look at now and analyze for distance, size, and amount of detail. Perhaps they will want to change a drawing to show more detail on closer animals and less on those smaller and farther away. Others may want to make drawings of animals near and far, putting varying degrees of detail on them, depending on size and distance. Help them work on these kinds of drawings, returning to the examples as necessary to clarify the concept.

Overlapping forms is another clue to seeing in perspective. The pictures of animals, as well as landscape pictures, can be helpful to learn how forms that overlap suggest distance.

What does the word "overlap" mean? Are there examples of overlapping in these pictures?

When one object overlaps another, which one would be closer to us? Why?

Students can look out the windows or go outside to observe buildings, cars, or

trees. Where they see objects or forms over-lapping, they can say which are closer and which are farther away. As they look around the classroom, they will discover more and more things overlapping others and notice that they often see only parts of some things but all of others. You might set up boxes or other simple shapes on a table they can reach and ask them to make overlapping arrange-ments of them and to draw them as they see parts or all of the objects.

To help clarify this concept, you might cut out five colored paper circles of graduat-ing size, attach them to the wall in a hori-zontal line from small to large, and ask students to pretend they are five planets all the same size.

Which one seems closest? Why? Which seems far-thest away? Why?

Turn back as necessary to the first pic-tures they discussed to remind them of distance and size clues. Then ask them to overlap these planets to convey the same idea, the smaller ones being overlapped by larger and larger circles. Then present them with five circles of equal size, overlapped, and ask them which seems closest.

Do some look bigger than others because of the over-lapping, even though we know they are cut the same size?

How far you extend the concept of over-lapping and other aspects of perspective at this level will depend on the age and readi-ness of your students. Some may quickly grasp these notions and move on to Level 2. Others may need more of similar kinds of experiences to make the connections be-tween what they see in three dimension and what they draw in two dimension. Drawings of things within their experience such as animals grazing in a field or valley, people

in a long line at the theatre, a row of trees along a street, or a mound of oranges in a market can help students become more aware of the horizon line, size and overlap-ping shapes as elements that determine distance in what they see and draw.

Students will vary in their abilities to draw likenesses because of their lack of experience in accurate seeing and drawing. At Level 1 in each of the perspective activi-ties, emphasis should be on understanding concepts rather than on capturing visual likenesses. As students progress to other levels in perspective, they can recognize and consider how many elements affect their satisfaction with their images.

**Level 2
Making Things Look
Farther Away**

At Level 1 students were introduced to the concept of viewpoint, size, and overlapping as elements that affect seeing and drawing in perspective. They became familiar with the term *horizon* and they learned that things farther away look smaller. At Level 2, you can extend this knowledge by helping them see that the farther away an object is in a drawing, the higher it is usually placed in the picture.

Discuss with students whether the ob-jects they drew far away in previous draw-ings were higher on the page than close objects. With those students who lack this concept, you might use balloons as an ex-ample. Ask them to discuss what happens to the size of balloons when they float higher and higher in the sky:

Do they get harder to see? Why? Does their size seem to change?

Cut out several colored paper circles of the same size, tie strings on them, and

pin them to the wall as a cluster of balloons held together at the string ends. Discuss with students how it would look if the balloons were released and began to float up in the air. Let them move some balloons higher up the wall to simulate this:

Do they look farther away?

What if the higher ones were smaller?

Which colors would seem farther away, the duller or the brighter ones?

To further build on what students have learned about visualizing distance through size, have them cut some of the balloons smaller and smaller, use the colors they think would express greater distance, and place these higher and higher on the wall to achieve the visual effect of balloons floating into the sky. If possible, demonstrate this outside with real balloons:

What happens to things when they get farther away?

In addition to getting smaller, do they get less intense in color or value?

Would the outlines and details be clearly visible on some and not on others as they float higher and higher? Why?

Then have them look back at the pictures from a high viewpoint used in Level 1 perspective activities, or provide new ones such as two Van Gogh paintings, *The Harvest* and *Boats on the Beach at Saintes-Maries* (de la Faille, 1939). Ask them to compare where the high things are with where the closer things are in the pictures:

Are distant mountains or boats higher in the pictures than close mountains or boats? Why?

What does this suggest for your own drawings of things near and far? What would be larger, smaller, higher, and lower on the paper?

You might ask students to pretend they are high on a mountain, in an airplane, or in some other high place and to draw what they would see from this position. Encourage them to think about what the tops of things look like. Then make arrangements to take them atop a high building or hike to a hilltop in or near their community to study and draw how things look from there. A two- or three-story building would be adequate, but a higher spot would show them a clearer difference in what they see from there as compared to standing on the ground. Discuss with them:

Where is the horizon line? Can you see more of this area from this viewpoint than when on the ground? Why? Where is our eye level? High or low?

What new things do you see that you have not noticed before about this area you live in?

Can you see rooftops? How would you describe and draw buildings from this viewpoint?

Are some roads clearly visible? Which ways do they go? Can you draw the roads (rivers, railroad tracks) going away from you and getting smaller and higher on the paper as they near the horizon?

Can you see people, cars, trucks, trains, buses, animals? What sizes do they appear as compared to when you stand on the ground near them?

Do you see the treetops, yards, fields, mountains? What else?

Give students time to make drawings of what they see from this viewpoint. Remind them to determine carefully how things *actually* look from this viewpoint rather than what they have previously known about them from another, more familiar, viewpoint. Some students will be able to develop their drawings in more detail than others. Back in class, they can compare their new drawings to the ones they did as they imagined things would look from high above. Some students may be able to talk about and recognize the differences but have trouble transferring them to their drawings. Various themes can be offered from time to time that

will encourage students to think about horizon lines, overlapping, placement, and size as clues to distance in drawing. They might develop a drawing of what an eagle would see below when soaring in the sky; what a giant standing in a crowd would see that we couldn't; what a mountain climber or window washer on a high building would see below; or what a trapeze artist might see when daring to look down.

Level 3
Seeing Up and Down,
Left and Right

Level 3 students can begin distinguishing among things above, at, and below their eye level, recognizing that where the horizon line is in relationship to objects drawn depends on where their eye level is. They will be able to see and draw simple forms in perspective by noticing the relationships among distance, size, eye level (or horizon line), and viewing position.

You might begin by noting that no matter at what level our eyes are—from lying with our stomach on the grass to being in an airplane—as we look straight ahead, the horizon line will be *at* our eye level. The closer we are to the earth, the shorter the distance we can see since more and more things obstruct our view and overlap the earth's actual horizon. As we go higher and higher from the earth's surface, the distance we can see and the number of things we can see increase. The horizon line becomes more clearly visible because most obstructions are below our eye level, i.e., below the horizon line.

Let interested students search magazines (including art magazines) for pictures that present images from a variety of viewpoints. One picture may be a plane approaching a runway; others may be a still life, furrowed land, a street of a large city, a country

Figure 1.22 *Francis Greenway (Architect). Angelican Church (Sidney, Australia). One-point perspective on a city street. Where do all the lines converge?*

Figure 1.23 *Determining a horizon line.*

road, etc. Urge them to look for things that clearly recede to show distance. When several are collected, they can be displayed on a bulletin board or assembled into a collage that is organized to show different eye-level views of things receding, perhaps with similar eye levels arranged together. Students will, with encouragement, find a clever and effective way to combine these images, providing themselves and fellow students with a reference for studying viewpoint.

To help students understand how to draw objects using eye level or horizon line as a reference point, set a large box in front of them, slightly to the right, so their eye level is somewhere between the bottom and top of the box and so *two* sides are visible. Urge them to discuss where their eye level is, how many sides they see and which side of the box is closest to them. On the right

side of a 12 by 18 inch sheet of newsprint, ask them to draw a two- to three-inch shape (square or rectangular) that is parallel to the paper's edges and that represents the *right side* of the box as they see it. Then ask them to determine where their eye level is and to draw a horizontal line entirely across their paper through the box shape at the appropriate point (Figure 1.23). Next, have them place a very small X on the eye level line near the center of the paper, draw one straight line from the top left corner of their box to the center of the X, and a second line from the bottom left corner to the X (Figure 1.24). Let them imagine that within this space is the *left* side of the box:

Where would you draw a vertical line to indicate the length of that side of the box? Should it be perpen-

Figure 1.24 *Finding a slide plane in perspective.*

Figure 1.25 *Determining the back plane in perspective.*

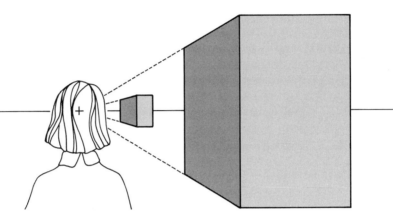

Figure 1.26 *Recognizing the vanishing point.*

dicular to the vertical lines of the rectangle? Are the edges of the box parallel? (Figure 1.25)

How does this drawing reflect distance and size? Does the left side appear to get farther away? Why?

Do you feel you have approximated the dimensions of the box as it would appear in this kind of drawing? Does your drawing represent how you actually see the box from where you are? If not, can you find the position to view the box from that would more accurately approximate your drawing?

To help students understand that they have now drawn something in one kind of perspective, explain that the *X*, called the *vanishing point*, represents the point at which receding parts of three-dimensional objects would converge. A single vanishing point

assumes we are positioned in line with that point and see everything from that position. This is called one-point perspective (Figure 1.26).

To make this kind of drawing, they must assume that one side is being seen straight on while the other is seen receding, as when seeing the front and one side of a house, store, garage, auto, for example. Ask them to pretend the box drawing is a garage with a big front door and one side window. Help them to understand how to draw the door parallel to the front of the box, to determine the height and length of the window receding in size to the vanishing point (as in Figure 1.27) and to discuss why some of their lines are perpendicular and others are diagonal.

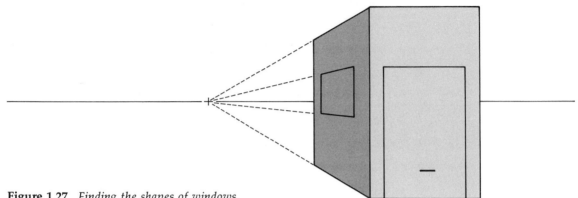

Figure 1.27 *Finding the shapes of windows.*

Then ask them to make another box in a similar position on the *left* side of the paper, using the same vanishing point. Let them make a building out of it and then consider where the street would be if these two buildings were on either side of it. Have them drop a perpendicular line from the vanishing point to the bottom of their paper and regard this line as the center of the road. Ask them to draw the left and right side of the road as they think it might appear.

Where must you be standing to see this view of things?

On another piece of paper, let them first draw the horizon line and the street from the vanishing point and then place a building on each side close to the road:

When you draw a building by a road, why would you first draw the corner of it closest to you?

If part of the building is above your eye level, will it pass through the horizon line? Why?

Which lines are perpendicular? Which converge to the vanishing point?

If there are other buildings on this street, where would you draw them?

After the students have the concept of buildings along a street from one viewpoint (perhaps using pictures collected earlier as references), return to drawing the box. Have them consider this box at other eye levels:

If the box were entirely below your eye level, what parts of it would you see?

Where would you place the eye-level line?

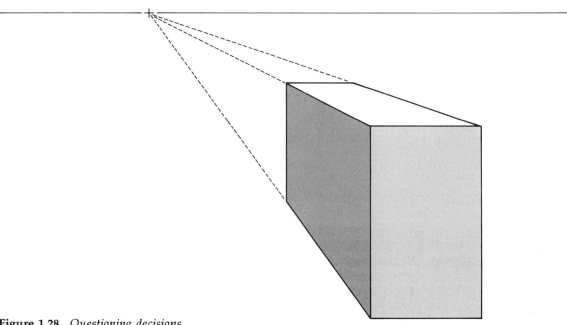

Figure 1.28 *Questioning decisions.*

How many lines would converge to the vanishing point?

How would you indicate the top and the side of the box with lines?

In drawing this view, how do you determine where the lines will be placed indicating the total size of the box? (Figure 1.28)

Is it guessing? How can you tell when you've guessed wrong?

Students can make drawings of boxes in many sizes and shapes from various viewpoints by placing the horizon line in different positions from above the box to below it

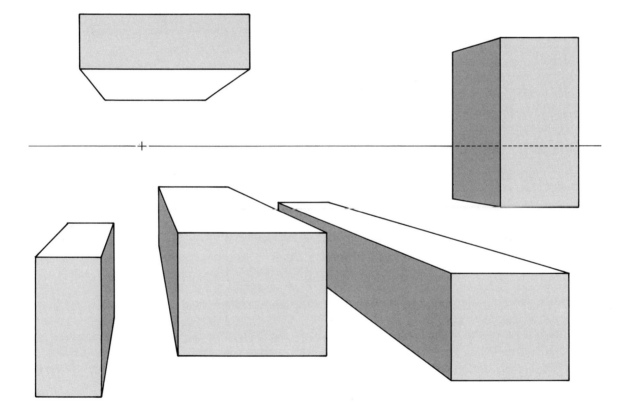

Figure 1.29 *Drawing many forms with one vanishing point.*

and placing the vanishing point at varying positions on that line from left to right (Figures 1.29 and 1.30). You might suggest they make forms that would represent the proportions of such things as a box car, a tele-

vision, a table, a match box, an automobile, or a trailer seen from different viewpoints.

As they become adept at this, you can help them learn to add detail to their forms so the forms will actually represent objects.

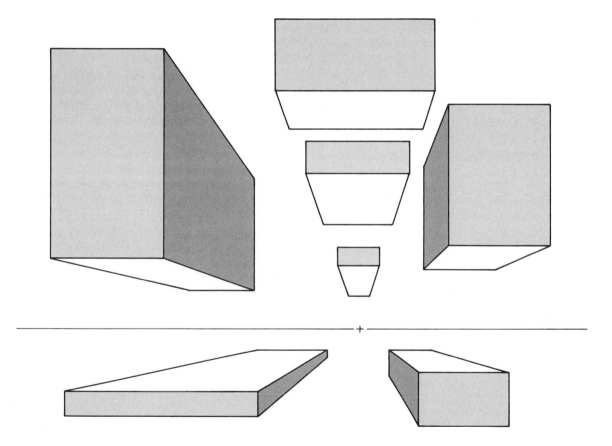

Figure 1.30 *Another view of many forms with one vanishing point.*

For example, putting words along the receding side of a box car would require lines going to the vanishing point to define the height of the letters. Beyond this, students would need to recall that, as things get farther away, not only do they appear to become smaller, but also closer together. A magazine picture of some kind of box with words on it in perspective would be useful to demonstrate this concept. They can then

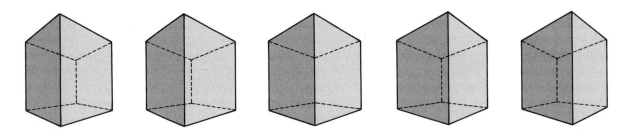

Figure 1.31 *Viewing cubes in different positions from one viewpoint.*

go on to draw the details on a television set, a table, or whatever they choose.

As they gain experiences in thinking about size and distance, viewpoint and structure, they can learn to add various sizes of boxes to others for more complex forms, enabling them to visualize and more accurately draw such things as automobiles, a locomotive attached to an entire train, or complex building structures. With your guidance, they can learn to draw one-point-perspective aerial views of streets and houses, cars on roads, trains on tracks, as well as drawings from a low eye level as we might see skyscrapers from the sidewalk of a city or as a fence post might appear to an insect.

These kinds of activities will clarify the concept of one-point perspective. Students should be encouraged to explore the vast potentials of this new skill rather than restricting themselves to its traditional uses.

Knowing one-point perspective can be useful to students, not only when they want to capture reality, but also when they want to distort or exaggerate reality to create fantastic, unfamiliar imagery.

Level 4
Using Perspective Systems

Students working at Level 4 in perspective will be those who are interested in exploring the potentials of two-point perspective as a tool for drawing intuitive, imaginative ideas and those interested in having the technical drawing skills often associated with design. In both instances, students will be concerned with accurately drawing view, scale, and proportion, and judging convergence and depth. These kinds of skills require that students (1) observe the three-dimensional forms in their environment with careful scrutiny, consciously analyzing distance, size, space,

viewpoint, and structure, and (2) use these observations and the systems of perspective to control and manipulate the illusion of three dimensions on a two-dimensional surface whether they are doing an accurate drawing of an AM-FM stereo radio or creating a provoking illustration of a science fiction tale.

The activities provided at this level will offer your students additional basic skills and will refer to art works that demonstrate a range of applications of these skills and will stimulate new and creative explorations.

Learning to draw objects in two-point perspective is not complicated if students learn to measure the proportionate lengths and distances between things in their field of vision and then use the same proportions in their drawings. By holding a pencil at an arm's length and observing an object in their field of vision (what they see when they hold their head steady and look out straight ahead of themselves). The horizon line is what they would see on an open plain where land and sky meet. People tend to relate things in their visual field in terms of this line even if other things are in the way. They can see objects in their field of vision that are above and below the horizon line or to the left or right or centered on it. The vanishing points in two-point perspective represent the two ends of the horizon line in anyone's visual field, or the ends of the horizon line used in their drawing.

Students can begin to use two-point perspective by analyzing a cube on a table in front of them in terms of their visual field in viewing it. They need to find the horizon line and how far the cube is below it (or above or on it in other situations). They need to see if the cube is to the left or right or centered along the horizon line. To do two-point perspective the cube needs to be at an angle with one of the vertical edges closer to them than the other two they can see. If

it is below their horizon line they will see the top as well as two sides. The line on the closest edge will be used for comparing the proportionate sizes of the parts of the cube and dimensions of the visual field. Although what they see may be bigger or smaller than what they draw, they will keep the same proportions between the different parts. Point out two critical proportions by asking:

How long is the horizon line in your field of vision from one vanishing point to another?

How long is the front vertical edge of the cube compared to the length of the horizon line?

How long is the front edge compared to the distance from the top of it to the horizon line?

When these dimensions have been measured and the same proportions repeated in the drawing, the students can draw lines connecting the top and bottom of the vertical front edge with the left and right ends of their horizon line, where the vanishing points indicate the edges of their field of vision.

Their next problem is to see if the two sides of the cube are the same or if the left or right side is wider and what proportion these two are to each other. When they make this determination, the same proportions can be used in the drawing and the back edges of the two sides drawn. Then lines can be drawn from the top of the left edge to the right vanishing point and from the top of the right edge to the left vanishing point. When students understand this, they can move the cube into different positions in their field of vision and draw it quite accurately (Figure 1.33).

If students cannot draw cubes from observation—and many cannot—they can use a mechanical system. Many who learn a mechanical system can then learn to see cubes better. But by either means, students can learn to multiply cubes in perspective.

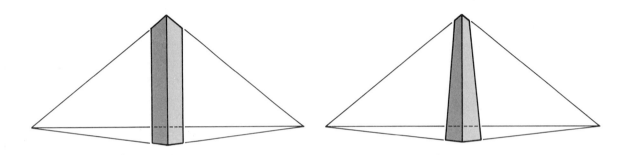

Figure 1.32 *Towers from two- (l) and three- (r) point perspectives.*

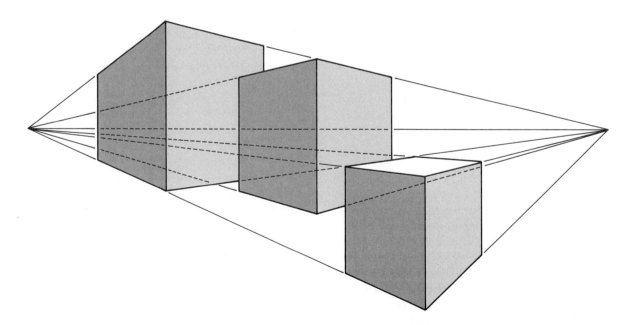

Figure 1.33 *The widths of planes change with different positions but the same viewpoint.*

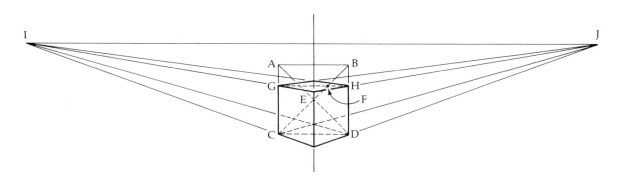

Figure 1.34 *Drawing a perfect cube.*

A cube can be drawn accurately by a very simple process if you view it directly in front of you. If you have drawn it correctly, you can build out left and right and up and down, creating a whole field of cubes. By tracing over this, you can draw objects of various proportions that will all lie in the same perspective field.

To create a perfect cube: (1) Draw a square (*ABCD*). (2) Find the midpoint (*E*) by drawing lines from opposite corners. (3) Draw a line vertically through the midpoint; this becomes the front edge of the cube. (4) Measure from point *C* along the cross line the same distances as line *CD*; (5) Make point *F* there. (6) Draw a line through the point parallel to the top of the square. (7) This line (*CH*) and the bottom line (*CD*) are the horizontal cross lines of the top and bottom plane of the cube. (8) Draw a horizon line (*IJ*)

above, below, or through the cube (depending on how you wish to view it), with vanishing points equidistant from the center of your square. (9) Then connect the left and right points on each of the top and bottom plane cross lines. You will see a cube emerging. Once you have a cube you can multiply it in perspective.

When your students have learned to draw cubes quite accurately they can multiply the cubes to create combinations of multiple proportions. Just as you cross a square on the flat plane to find its midpoint and the center of each edge by drawing true vertical and horizontal lines through each edge, so you can divide the square side of a cube drawn in perspective. By drawing *AD* and *CB*, you find the midpoint. By drawing vertically through the midpoint, you find the top and bottom lines' midpoints (*E* and *F*). By

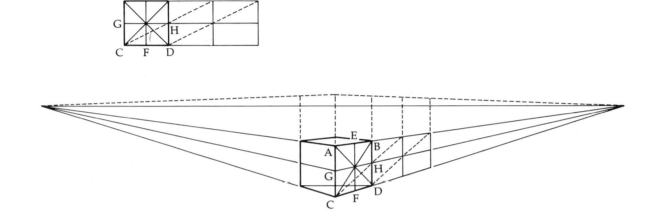

Figure 1.35 *Multiplying cubes.*

Figure 1.36 *Creating forms with cubes.*

drawing through the midpoint to the vanishing point, you find the midpoints along the sides (*G* and *H*). By drawing a line from point *C* through point *H* and continuing it to the extension of line *AB*, you find point *B* of the next square. By repeating this procedure, you get the width and height of decreasing sized squares in perspectives.

You can multiply squares vertically by extending line *AGC* above or below to points

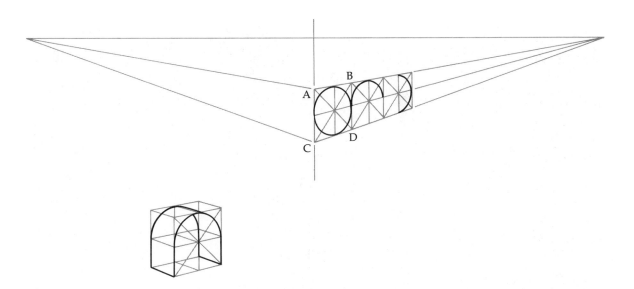

Figure 1.37 *Creating ellipses and arches.*

equal the distance of *A* to *C*. Use vanishing points left or right to connect the tops of cubes. Extend the vertical lines you created from the vanishing points to complete the added cubes. Then lay tracing paper on your drawing, and you can pick up lines to create open and closed cubes and continuations of cubes.

To draw circles in perspective, select a plane of a cube you have drawn in perspec-tive (*ABCD*). Draw cross lines from the four corners. Draw a vertical line through the center point and to the vanishing point. Then draw a circle touching the four points. It will be an ellipse because it is a circle seen in perspective. Arches and circles can then be drawn wherever you want them.

If students want to draw objects very accurately through perspective, the Doblin geometric system will help. It is designed

Figure 1.38 a. *Grant Wood.* Midnight Ride of Paul Revere. (The Metropolitan Museum of Art, Arthur H. Hearn Fund, 1950. Courtesy of Associated American Artists.)

b. *William Hogarth.* Satire in False Perspective.
Frontispiece to Kirby's Perspective Engravings.
(Courtesy, Museum of Fine Arts, Boston.
Harvey D. Parker Fund.)

for industrial designers who must accurately render objects as they will appear (Doblin, 1956). Our purpose is to help students see perspective because if they can see it, they can draw it. Learning perspective systems when one cannot see them is very frustrating.

In learning about perspective, it may be of value to students to look at art works that range from the more traditional applications to those that create visual challenges and even a psychological experience for the viewer. Show Gauguin's *Jacob Wrestling with the Angel* and Seurat's *Sunday Afternoon at Grand Jatte* (Hoftmann, 1971) and discuss the artists' understanding of perspective, which allowed them to control the sizes of people in order to create the special effect of sloping terrain. Grant Wood's *Midnight Ride of Paul Revere* (Braizell, 1966–67) is an example of aerial perspective, the vertical lines angling up and outward. Charles Sheeler's lithograph *Delmonico Building* (Goldstein, 1973) is a view of skyscrapers from their base, which demonstrates three-point perspective, the vertical lines converging to a point high above the horizon line. An extraordinary work is William Hogarth's engraving *Satire on False Perspective* (Goldstein, 1973) which will delight students who are learning perspective as they recognize the understanding Hogarth must have had of space and perspective in order to manipulate imagery as he did in this work. Other examples of optical manipulation can be found in op art works. Studying these, along with Hogarth's work, will provide students an opportunity to more fully appreciate and delight in works by M. C. Escher such as *Another World* (see Figure 2.19), *High and Low, Balcony, Print Gallery,* and *Ascending and Descending* (Escher, 1973). These works will also challenge and stimulate your students to new ideas and give additional pleasure to their seeing and drawing.

AREA G
LEARNING TO SEE AND
DRAW THE EMOTIONAL
QUALITIES IN THINGS

Through the careful observations of writers and artists over hundreds of years, we are better able to recognize the expressive or emotional qualities in our environment. There are subtle to blatant, delicate to harsh qualities in people that set them noticeably apart. We have assigned emotional characteristics to things in nature with such references as "weeping willow" or an "angry sea." Students learning to look for and recognize the expressive qualities in things will find themselves responding to various emotional qualities of things based on their own experiences. Their drawings, consequently, will be a combination of those qualities they've learned to see, what they feel about what they see, and how these qualities and feelings may be expressed visually with various media.

Level 1
Analyzing How Drawings
Affect Us

Students can begin to notice emotion expressed through drawings by looking at illustrations in some children's literature books they are familiar with. In Lewis Carroll's *Alice in Wonderland* and *Through the Looking Glass* (Carroll, 1946) are some expressive drawings by John Tenniel which students can respond to and compare. These questions may give you clues on how to proceed in this kind of inquiry:

What kind of emotion does the Cheshire cat convey? How would you describe the look on his face?

When you look into his eyes, how do they make you feel?

Does he have a friendly smile or does it seem a little scary? Why?

What kind of look does the Queen have on her face when she orders, "Off with her head!"

If you were Alice and saw the Queen like this, how would you feel?

What kinds of feelings do the Queen's eyes reveal? How has the artist helped you see that?

What parts of the drawing of Alice and the Queen tell you whether they are happy, scared, angry or sad, whether they are bossy or kind, lovable, or unlovable?

How does the shape of Tweedledum and Tweedledee match the expressions on their faces? How would you feel if you met them?

Students can use their favorite illustrated books to compare the different ways the characters are drawn, to discuss how they are able to recognize the emotions expressed, and to describe their feelings when they see these different drawings. *Duffy and the Devil* (Zemach, 1973) and *Where the Wild Things Are* (Sendak, 1963) provide excellent illustrations of expressions in body gesture as well as in facial expressions that students can respond to when learning about emotion through drawing.

After they have had some experiences in seeing and comparing, select a book that they have not read and ask them to determine what the book may be about just by looking at the illustrations carefully. Finally, reverse that approach by reading the students an expressive story they are not familiar with, show them *no* illustrations, and then have them illustrate the emotional aspect of the story, offering them a choice of drawing media. They may want the story or portions of it reread while they work to recall a part in greater detail. This could be an individual or a group activity. Some may choose just one aspect of the story to illustrate, while others may want to develop the

whole story in a cartoon-strip format or as a collage. Encourage them to try to show the feelings expressed in their story. Giving individual attention to students as they work and inquiring about their drawings can help you see whether they need to do some more thinking about the story, or part of it, to identify emotions. As the works are completed, students can share what they illustrated and, perhaps, combine the written story with the illustrations to display for others to see and enjoy.

This kind of inquiry can be developed with more sophistication and depth through all four levels as students develop skills in seeing and drawing in other areas. It is important to note, however, that without these initial experiences at Level 1 in seeing and comparing emotions, students may find the activities developed in Level 2 abstract and meaningless.

Level 2
Drawing Lines to Affect Feeling

A basic tool that can be used to express emotional qualities in art works is line. The kinds of lines we use in making a drawing can help portray the kinds of mood or emotion we are developing. Early in students' drawing experiences, they can begin to compare qualities of lines by trying to get lines to express emotions.

What kinds of lines delight you? Do they have curves or move gaily on your paper? What do happy lines look like?

If you wanted to express anger, what type of lines would you make? Would they be forceful, heavy, curved, angular, hard, straight? What directions on your paper would they take?

How do you describe confusion? How could confusion be conveyed in line? Sadness? Fear? Loneliness? Strength?

Let students use pencil and/or dark crayon to make lines that demonstrate different emotions. Discuss with them how their hands and arms may move lightly, heavily, quickly, slowly, boldly, or angrily as they create these lines. Put a large sheet of paper on the wall for each emotion they can name and let interested students put lines on the papers that portray that emotion. Other students may wish to work individually, using one or many pieces of paper to make their various lines. Urge them to try using their pencil or crayon in several ways—sharp, dull, on its side, heavily, lightly.

Then display all their experiments with lines and ask students to describe the various results. With the following kinds of questions, urge them to give reasons why they chose certain lines and made them in certain ways:

What kinds of feelings do you get from thin, hard, sharp-edged lines; from lines that change their width from thin to thick; from slowly winding lines; from jagged lines with rough edges; from faint lines that go in many directions?

How do you feel when you make these lines?

Why did you use the crayon or pencil boldly sometimes and lightly other times?

Do some lines express more than one emotion? Why?

Did some of you express an emotion differently than others? Why?

Give students the opportunity to notice the similarities and differences in lines chosen to express each emotion. Some may have used bold lines to express fear, while others used them to express strength. Jagged lines may express anger for some and exuberance for others. Some may use curved lines to express sadness, while others use them for joy. How are these similar, how different? Students may want to determine which kinds of lines were most often (and least often) used to express which emotions.

Figure 1.39 *Geoffrey Hawkins, age 9. Lines used to express emotion.*

This exercise might give them an idea which kinds of lines they would choose to express an emotion so that others would be most likely to understand what they meant.

To help students transfer this learning to their drawings, discuss how they could draw *faces* to express emotions:

How would you draw a joyful face? What kinds of lines would you use? What kind of line might you draw for a happy mouth or for eyes that express delight? Can you make hair look as if it belongs to a happy person?

What kinds of lines might you use to draw a sad face? What happens to our mouth when we are sad? Could you use sad lines to draw sad eyes?

Do lines in the forehead or cheeks show emotions?

What kinds of lines can be scary lines? How would you draw a face that looked frightened? Would lines used to draw hair on a frightened person be different from lines used on a sad or happy person?

What other emotions could you express by drawing a face?

Give students the opportunity to draw as many different faces and emotions as they wish. Let them choose pencil, crayon, felt pen, or other tools as they draw these faces. Some may choose to use the same tool for each drawing, others may change tools to suit their image. For example, a dark crayon might be chosen to express sadness or remorse, a bright-colored felt pen for anger or joy, and pencil for tranquility. There are no rigid rules for these choices, but discussing the possibilities of choosing tools to enhance their expressions can offer those interested students a greater potential for expression.

As drawings are completed, you can display them, grouping similar emotions together, and have students identify lines used to convey the emotion. Have them notice the similarities and differences in kinds of lines used and how similar lines were used to express a similar emotion in different ways by different students. For example, even though curved lines may express joy in several drawings, each drawing would be different because each artist has her or his own notion of what a joyful face would look like. Those who varied the media used might like to share with others why they chose certain media.

Level 3
Projecting Emotions with Drawing

The concept of line qualities as agents of expression can be extended at this level by focusing on emotions more specific than those discussed at Level 2. Words such as frenzied, agitated, remorseful, hysterical, fragile, explosive, aggressive, pensive, languid, dignified, calm, compassionate, and tranquil are all words that may describe the expressive or emotional qualities of things contained in some drawings and other art works. In order that students may have the opportunity of expressing one or more of these emotions in their works, they might explore, as they did at Level 2, making lines that have the expressive qualities of these new words and others they may come up with. As they do so, they can look at drawings by artists such as Kâthe Kollwitz, Renoir, Matisse, Beardsley, da Vinci, Daumier, Shahn, Van Gogh, Modigliani, and Wyeth (Mendelowitz, 1967), attending to the drawing techniques, the quality of line used, how these lines define the expressive elements of the works, and how they *feel* when they look at them. Students might, for instance, study the textured, subtle qualities that model Kâthe Kollwitz's *Head of a Woman*, and compare these to the bold, heavy, deliberate lines used by Ben Shahn to render *Dr. J. Robert Oppenheimer*, discussing how these techniques give the works the different expressive qualities the artists intended.

Several drawing exercises can be provided following the above inquiries:

1. Several quick gesture drawings of human figures can direct student focus to the character or overall expression being conveyed. Have models take various action or gestural poses, giving students no more than 60 seconds sometimes and as little as 15 seconds other times, to draw the expressive movement seen on the form. You might have them start just by drawing stick figures of the poses to capture the gesture and attend to how the weight is distributed for balance. Then switch to their drawing the entire form with as few lines as possible. Have them focus on what the pose suggests. Does it suggest free, spontaneous pencil lines; bold, broad strokes of a crayon; deliberate, fluid brush lines? Because of the limited time, they must concentrate on the overall expressive nature of the figure—what major lines will convey the gesture and what line quality will best depict that expression.

2. After the students are experienced in gesture drawing, models can then take longer, expressive poses depicting such human states as frenzy or tranquility. Students can carefully analyze the characteristics of the pose as they see them and select line qualities or drawing techniques from those they have explored or studied that they feel will portray that expression.

3. Animals or other forms of nature can be analyzed for their expressive qualities. Students may want to determine what various kinds of expressive qualities these might be given that would convey different meanings. For example, a bouquet of wilted flowers might be rendered with emphasis on downward, drooping lines depicting defeat or resignation to death. Or they might be portrayed emphasizing the struggle to main-

Figure 1.40 *Steven Cannon. Gesture studies of the human form made in a university drawing class.*

tain life with upward lines of strength and determination. A horse seen rearing might be interpreted either as threatening and fierce or merely as frightened.

4. Emotional qualities need not be expressed only in recognizable or familiar ways. The qualities of lines themselves can be organized into statements that reflect a particular personal expression and elicit a response from the viewer. Works by Kline, Pollock, Kandinsky, Hartung, and Motherwell (Haftmann, 1971) will serve as examples that students can respond to for their emotional qualities. To give students experience in this kind of expression, they could select a poem, song, story, or experience that has personal meaning to them and, using what they consider appropriate media, express the feeling or emotion through line qualities only, without relying on recognizable images. An alternate or second approach could be that they develop their expression incorporating a symbol or recognizable image that would, along with the use of line, express the emotion.

The emphasis in all these approaches to seeing and comparing emotional qualities should be on developing students' ability to see and use drawing as a means of capturing a particular expression and assigning it to images in art works. Individual help may often be solicited in these activities, especially if students become frustrated. When this happens, or when you see someone quietly struggling, you might review the inquiries in any or all of the levels as they may seem appropriate. As you do this, help students focus on specific drawings they've seen or made, and then have them re-analyze the qualities that they want to express.

As they work through these kinds of activities, evaluation should be individual as well as in groups. Learning what others see and express will extend students' knowledge of how people of similar age and experience may see and interpret, and how they may choose to express these visions and interpretations. Hopefully, this will give students the opportunity to see and draw more than they might otherwise.

Level 4
Drawing Subtle Qualities and Nuances

At this level students can extend and improve their abilities to see and respond to expressive qualities by building on the experiences of the previous three levels and incorporating skills gained in other drawing areas. For one such example, refer to Area E, *Learning to See and Draw in Different Lights*, Level 4.

The quality of their own expressive drawing and reflective thinking should enable them to express profound ideas, as well as subtle nuances of the qualities of human experience or the environment. Thus the images are given characteristics that help convey emotional as well as conceptual meaning. Students' drawings can express the *impact* of what was seen or felt so the viewer shares the artists' emotional experience.

INDIVIDUAL DIFFERENCES IN DRAWING APTITUDES*

Differences in children and young people's ability to draw come from several sources: (1) their potential to learn, to see, think and draw, (2) the opportunity to learn to see, think and draw, (3) their rewards and motivation to develop in these three areas, and (4) their overall readiness as the first three interact at any given time in a young person's life.

POTENTIAL AND EXPERIENCE

A child or young person's readiness to learn is not a constant given at birth. Children have a potential to develop, but the opportunities they have to use their potential affects their readiness at any given time. Children with keen eyesight and intellectual curiosity about their environment, but raised in a visually dull environment, will not develop the same readiness to learn as if they had been raised in a stimulating environment. Children with less potential to learn, but living in a stimulating environment and encouraged to look, may develop a higher readiness at the same age as the first kind of child.

A young woman of mixed Eskimo and white European ethnic backgrounds, who was raised by white-culture parents in the harsh visual environment of northern Alaska tundra country, took a workshop on visual perception and drawing. Obviously intelli-

* Parts Six and Seven provide a theoretical and research basis for each of the individual differences discussed in this section.

gent and curious, she was appalled by how little she had learned to see. Her potential for seeing had been limited by her early experience. As a child, she had not learned to appreciate the art of the Eskimo because of the culture of her family. She had not learned to see and create as an Eskimo, whose detailed visual analysis of animals and decoration of tools and apparel are highly refined. She had only been exposed to imported objects.

Personal traits affect how people see and draw. Traits are often learned as children grow up in a given environment. Students with similar traits are often quite different in their responses to seeing and drawing tasks because they learned to draw in different social environments. For example, rigid or anxious children may be able to draw something quite well because it is something they can do without getting in anyone's way, but they may resist changing their way of drawing, or what they can draw, because of the security their drawing gives them. But other fearful children who were taught that their drawing wasted time, or was poor, may be afraid of trying any more.

Before you can help such children see and draw more expansively, you need to reduce their fears and patiently encourage their efforts. If they are drawing at all, you have some idea of what interests them. By introducing similar but somewhat different things you can stimulate their curiosity to look at the ways their drawing are like the objects. This leads them to see differences.

By contrast, highly motivated, nonanxious, creative children may be turned off if the tasks are too simple. Such children are apt to start off drawing things that are interesting, but too complex for them to analyze at first. Your role is to help keep them from getting frustrated and giving up. They can study parts of something at first without drawing the whole thing. Or they can squint their eyes and look first at the overall form and then put in details. Encourage them by reminding them that it takes time to see in detail — to make many minisketches as they learn about something before they try a whole drawing.

These are only two composites of types. Each student in a class is somewhat different. If your own mind is open to these differences, you can be more flexible as you modify tasks for individuals.

Habits of reflectiveness and of impulsiveness become more established as children get older. Reflective young people will want and need more time. Impulsive children are harder to get to stay with a learning experience long enough to go beyond a mere overview. You may find that you will have to repeat activities for such children in order for them to get beyond a very superficial look at things. They will need to look at their own drawings more than reflective children who already have observed their own work. Impulsive children may dash off a drawing with little awareness of what they have done. Ask of them why they drew as they did, get them to verbalize about the differences between one of their drawings and another. In this way you are encouraging them to be more reflective.

Artists use both *global* and *analytical* approaches to drawing. A global drawing stresses the overall impression of a thing; an analytical approach shows its structure and detail. The person who can use either approach as it fits the kind of idea being expressed has a broader readiness for drawing. Both kinds of information are useful, and either can have artistic quality.

DEVELOPMENT IN DRAWING

There are several ways of studying children's art to find out how they develop in their drawing. One is to collect drawings done at various ages and identify what the average kind of drawing is for a given age range (Lowenfeld and Brittain, 1975). People who study drawing this way assume that drawing is more closely related to biologically determined growth patterns than to the experiences children have in living. Furthermore, this approach is mainly based on children's drawing from memory rather than actively looking and then drawing (Lark-Horovitz, Lewis, and Luca, 1967). The role of the teacher, according to these theorists, is to allow children to work in art at their own stage of development. Two types of individual differences are stressed by Lowenfeld: the children who get their information more from their "inner" experience,

Figure 1.41 *Primary children's observations of open doors. Learning to draw by looking.* (Courtesy of Kay Masek.)

called *haptic,* and those who observe it going on "outside" themselves, called *visual.*

Other studies of child art analyze drawing ability in relation to intelligence, or aptitude for performing well in school. Florence Goodenough and later Dale Harris correlated scores on intelligence tests with children's drawings of a man. Their purpose was to find a way to test the intelligence of children who had not had the kind of middle-class European-American experiences on which most I.Q. tests were based. They found that children's drawings did relate to I.Q. tests well enough to use the

drawings as indicators of mental abilities. But Harris also found that norms for scoring drawings had to be developed for each culture to make them valid, because the culture children grow up in influences the kinds of details they include. Children tend to stress the parts of the body or the details made more important by their culture's style (Harris, 1963).

Generally a child of higher I.Q. draws more details; the parts of the body are correctly connected and the proportions are more lifelike if a child is more intellectually able. Harris' work (1963) shows that children

of a given age can be quite different in their drawing ability because of differences in their intellectual development. The details and styles of drawing may also be quite different depending upon the culture in which a child is growing up. Children's average intellectual development is lower at younger ages than later. A seven-year-old's drawing of a man that scores as high in I.Q. as a twelve-year-old's drawing will be less complex. The research shows how patterns of development change with age and how they vary at any one age. A child's drawing of a man or woman can provide the teacher with some idea of his or her development. It lets the teacher know how much visual detail the child is presently able to handle compared to others in his or her age group. It also alerts the teacher to look for differences in the symbols of dress and details that indicate the children have learned to see in a different culture.

It is difficult to separate a lack of opportunity to learn from a slowly developing capacity to learn. Two children who draw very much alike may be very different in capacity to learn. In other words, children's drawings can tell you a great deal about children's readiness, but they don't necessarily tell you what has influenced that readiness. A child with a high I.Q. score on a written test and a low score on a Draw-a-Man test has probably had little opportunity or reward for seeing. A child with a high Draw-a-Man score and a low I.Q. score from a written test probably has had many opportunities to develop perceptually but may have been deprived of the verbal stimulation needed to respond well on written tests. Individual children such as these are found; however, the majority of children's Draw-a-Man scores and written I.Q. scores are more alike than in these two hypothetical cases.

Kenneth Lansing (1969) has studied the relationships between children's drawings and Jean Piaget's theories of cognitive development. Piaget's basic idea is that the elements of people's mental life become more complex as experience goes on. The reason for this is that we are motivated to take in or assimilate the new ideas we receive in our experience. But when the new information doesn't fit with what we already know, we have to make an accommodation to it and form new schemata, changing the ones we have, or making a combination of elements. In children's art these elements could be new images of things seen in the child's mind and a shift or change in the way he or she draws these things. Thus with new experience, new images and new details and organizations appear. Children's art evolves from their interaction with and accommodation to new learnings. But if children learn mainly through words, they will draw what they know about things; if they learn more from what they see, they will draw more visual details and not stereotyped images.

Other kinds of development can be changed as well. Some theorists assume that children's drawing objects on a baseline is an age-related stage of development. The use of a baseline for organizing drawings is most often found at the same time children are learning to put letters and words along lines—in first grade and at age six. So perhaps this is where the baseline is learned and used in drawing as well as writing. But children in first grade can learn other ways to organize things in space if they are encouraged to observe objects in relation to the sky line and see how differently trees, buildings, people are standing with relation to that skyline.

Children's ages do influence how they will draw. Their perceptual motor development progresses with age. But the longer they have lived, the more they have been able to see and learn. The ways they have

Figure 1.42 *What shape is a circle? Do we always see it round?* (Courtesy of Tom Anderson.)

learned to see at any one time will affect how well they see afterwards. If they are encouraged to draw from what they see as well as from memory, they will develop faster than if they only work from memory. Drawings done from observation are more detailed than drawings from memory. People never stop learning from sensorimotor input or from concrete experience.

Concrete experience for many people is what they *know* about the size, shape, and color of things rather than the way they appear. Many adults do not go beyond the concrete stage in seeing and drawing. They can't

separate how things look from how they know them to be—until they discover the difference through learning. They block out new visual information that contradicts what they know about how things are. Since they know the ceiling lines of rooms are parallel to the floor lines, they refuse to recognize that in perspective the lines at the far end of a room converge. They stay with their concrete knowledge and cannot see that the two facts are both true even though they seem contradictory. Such people know circles are round and ignore cases in which they appear as ellipses or even straight lines, until such phenomena are forcefully brought to their attention. These people may be flexible in other areas of their thinking, but perceptually they are very underdeveloped. People can be at one stage of development in some of their thinking processes and at another stage in their other thinking processes.

If you collect drawings from children in most classrooms you will find wide differences in the amount of detail, the organization of objects on a page, the logic of the way the parts go together. Some older children's drawings will indicate that they have studied how objects look, but their drawings will show evidence of some influence of other drawings such as cartoons and fashion illustration. Students from different cultural backgrounds may have learned to pay attention to different kinds of details and have learned to see in different kinds of environments.

You will also find that children will vary widely in their ability to learn from what they see at a given age. Some may be able to see quite early that sizes, shapes, and colors of things change depending on how they look at them. Others may resist learning this until later. Since many adults do not have this ability either, we can guess that it

is influenced more by lack of learning than by not achieving a stage at which they can manipulate visual symbols of ideas mentally. But it could be also based on a biologically patterned growth rate, and the resistant child could simply not be ready to learn it.

An important theory of children's learning to draw comes from the studies of Wayne Dennis (1966). In studies of six-year-olds' drawings from 11 countries on three continents, representing many different cultures, the scores on the Draw-a-Man test were higher in societies that had a highly developed detailed art and lower where the art was undeveloped or not detailed. He found that children learn to draw from the art around them more than from looking at objects. All children see people but apparently they can draw them better if they have been exposed to art that depicts people.

He reports that in societies where boys are rewarded for drawing and girls are not, the boys' scores are higher than the girls'; but where drawing and art are considered feminine, girls score higher than boys. Hopi boys scored 25 points higher than Hopi girls and American Middle West girls' mean scores were 11 points higher than boys from the same area.

In a study of drawings of their city by fourth-grade inner-city, low-income children and by middle-class children from the same six cities (Portland, Phoenix, Minneapolis, Atlanta, Honolulu, and Los Angeles), one researcher found that these two groups of children drew differently. The middle-class children had travelled more throughout the city and more of them drew overviews, freeway systems, and different areas; whereas the low-income children had had more experience on one street and drew more one-street-level views. These children had lived about the same length of time, but their drawings already showed differences in experience (McFee, 1971).

ORGANIZING AND DESIGNING

A SEARCH FOR MEANING AND STRUCTURE

Artists, architects, and designers use the word *design* somewhat differently; yet there is a common meaning they all share: it is the order or organization that makes the parts of something work together as a whole. The quality of a design depends on how well the whole and its parts work together for the intended purpose.

When we are lost in a city, or can't find where a spare part goes in a machine, we don't understand the design of how the city or machine is put together. Things are usually only partially designed; some parts work together better than others. For example, some cities may be clearly designed for finding one's way around them but not be very well designed for using the way the land lies to create interesting views from more of the buildings. Good designers have to consider all the parts and their relation to each other, how these together affect the working of the whole, and the influences on the use of the whole in some given context.

In this part of the book we focus on design as used in art and in creating useful things to enhance our way of life. In Part Four we will study design for the environment.

Designers ask different kinds of questions about their work depending on whether they are designing paintings, crafts, or machine-made objects. Artists creating paintings or sculpture use design, which traditionally is called composition, to organize all the formal qualities—lines, textures, shapes, colors, spaces, forms—so that they carry the message and emotional impact to the viewer. Some artists, particularly muralists, have to consider the nature of the site in which their work will be seen. All artists have to consider the media and the techniques they use as they affect the message and overall aesthetic quality of their work. Designers or crafters creating pots or furniture have to ask how and where these objects will be used, in order to decide upon the techniques and materials they will use, the appropriate forms and surfaces, and the relation between the way the objects look and their meaning. Each thing that influences the object is part of its design system.

People who use designs also ask questions to find how complicated places and things are organized. They need to find the parts that are alike and those that are different. They need to find out how they all fit together. They need to know the patterns of relationships and of the overall design in order to know how to use it.

These kinds of information are needed by people trying to find their way around a city; they need to anticipate how to reach their destination. They need to know where places are located in relation to each other and what distinguishes one place from another. Cities are created designs with different parts that have a pattern. If we know the pattern, we won't get lost.

Places in cities are designed as systems of their own. Shopping centers, department stores, self-help marts are designed with varieties of color and shapes to help tell peo-

Figure 2.1 *How would the quality of your experience vary in using these two streets?*

ple where to find what they want, to help them understand how the place is designed for them to use. Visual excitement is often used to entice people into going through the whole store. Libraries, schools, theaters all have different spatial and visual organizations to help people know how to use them. Most of these places tell you what kind of places they are in their overall design. But some of them have drab, dull, uninteresting designs, whereas others are exciting, colorful. Both may clearly tell you how to get from one part to another and the kinds of activities you can expect there, but the *quality* of

your experience will be influenced by the nature of the design.

People ask questions about paintings and sculptures. Sometimes they can't make sense of them or find much meaning in them. They get lost trying to see what is there. The work may have a meaning that would be familiar to them, but it is organized in an unusual way. Indeed, the artist's purpose may have been to force the viewer to see a familiar thing from different points of view. A painting of a city street may tell you the period of history, the climate, and the time of day and year. But the way the artist designs

the painting may also express to you visual and emotional qualities. The work may consist of images that make the viewer feel that he or she is in the midst of an active, vital place. It may be a street of haunting emptiness, devoid of human interaction, with only the traces of where people have been. The organization of images does much to give us the "feeling" of the place.

Sometimes an artist's selection of design qualities has a more powerful impact on us than the ideas expressed. The ways in which things are grouped and organized in relationship to each other, the use and quality of line and color, affect our emotional response.

DEFINITIONS

"Good order" or "good design" has never been satisfactorily defined for all peoples of the world. Styles change with time and between cultural groups. What makes some people see elements of beauty may make other people cringe. One person may see beauty in the order and variety of the forms, colors, lines, and spaces used; the other may be reacting to the symbolic message conveyed. Some people look for and enjoy the beauty of balance between order and variety, delighting in their sense of change between these two. They can enjoy a work of art if there is enough order to reveal the parts clearly and enough variety to be stimulating and interesting. Other people will not even pay attention unless the work contains a message about a human event of something they are familiar with.

All of us are affected by our environment whether we are consciously aware of it or not. If we don't understand design effects, we can be influenced without our consent.

Since the ordering of visual elements— line, form, shape, color, texture, space—is used to design almost everything we use or look at, we need to understand the basics of

design, the processes through which we create order and variety. Designs range from complete order where everything in a given space is the same, to complete variety where everything in a space is different. A designed object achieves more order as more things about it are alike, or more variety as more things about it are different. Order and variety are matters of degree. Most ordered designs have some variety, and most varied designs some order.

We all need some degree of order to help us understand things and find our way among them quickly; but if things are completely ordered, most of us tire of them quickly. If we tried to dance to music where everything was kept the same—not only the rhythm, but the pitch and the chords—we would soon want to sit down. But many people can dance for hours if the pitch, chords, and volume change even though the rhythm stays pretty much the same. It is the shifting variety within order that keeps them dancing.

By contrast, if every measure of the music changed and nothing was repeated, we would exhaust ourselves trying to make some kind of order out of it. We couldn't anticipate at all what was ahead. The same is true in our visual environment, whether in the art work of an individual or the social art of a city. Unrelieved monotony bores us; confusion, because of no apparent ordering pattern, frustrates us.

The task of the designer is to create enough order and variety for the way the thing will be used. Sometimes we want a great deal of variety with just enough order to make the variety show up. Other times we need as much order as possible to find our way quickly and efficiently. The same balance of order and variety can have different meanings for different users. For example, a marketplace with hundreds of small shops and street vendors is a bonanza for the tour-

bus driver. He can drive slowly and save money on gas yet keep his travelers entertained with all the variety and excitement of being in a busy place. But the fire-engine driver in the same place faces a nightmare of confusing signals trying to find where a fire has started until smoke or flames stand out from all the other colors and shapes to show just where the fire is.

INTERRELATING DESIGN FUNCTIONS

To make design clearer, let's take some very common objects and analyze their design processes—in this case, shoes for people. We can recognize shoes for people because of the repetition of a kind of order—the soles are similar in shape to the shape of people's feet. We know by looking at them what their use is—to protect the feet. We also know from experience that there are many kinds of shoes throughout the world with varying forms because they are designed to be worn in different climates. In cold climates and where the ground is rough, shoes are heavier. Thicker materials are used in soles and tops. In warm climates only enough top is used to hold the protective sole onto the wearer's feet. But shoes have a symbolic meaning as well. The color, the amount of ornamentation, the expense of the materials used, and the condition tell us something about who is wearing them and the social role the person sees him- or herself playing in the community. When we go for job interviews we select the shoes appropriate for the image we want to project. If the position is one that requires conservative dependability we probably select our best, simplest shoes, make sure the heels are repaired, and polish them thoroughly.

If we want to show how young we are, or how masculine or feminine, or how much a part of the "return to nature" movement

Figure 2.2 *What does the design tell us about who would use these shoes? Where?*

we are, we select shoes appropriate to that particular image. Since styles in pattern and ornamentation change over time we can often tell when the shoes were made—and where. All of these forms of variety in shoe design have a common orderly base that is derived from their function.

We could probably agree that shoes are of "good" design if they serve us well for walking, are made of materials appropriate for the climate we live in, and have the right degree of order and variety for the kinds of things we will be doing. They fit not only

our feet, which they protect from the ground and the weather, but our image of ourselves as well. The designer needs to consider all of these functions together.

The design quality not only affects how well the object will serve our human needs, but serves as an important communication medium. When we think about how much we learn about people from the design of their shoes, and add to this all the other things people wear, we begin to realize how important design is to communication. As you go through this book, you will see how much we depend upon the design quality of things to understand people, places, and things.

In Section Six we will also discuss individual differences in people's ability to design. If you should have trouble understanding some of this, that section on individual differences may help you see why. Some of you may have grown up in an environment that was full of visual detail, others where the emphasis was on visual order. Our taste for simple or more complex design is strongly influenced by our environmental background.

GOALS IN DESIGN EDUCATION

Educators have studied a great deal about how children learn to read *words,* but not very much about how they learn to see *things.* They have emphasized what children learn through words, but neglected the visual information they get from their environment.

One of our key goals in art education is to help children and people *learn to read their environment more clearly.* Another goal is to help them *be able to modify and change their environment so that the quality of their experience in it fits their values about what is important in their lives.* A third goal is to help them *assess their own values to see whether*

Figure 2.3 *Pima Indian coil basket designs. What is the first thing you notice? How many variations can you see?* (**a** and **d** courtesy of Smithsonian Institution Press, Washington, D.C., **b** and **c** courtesy of The American Museum of Natural History, New York.)

their personal styles and preferences are what they most enjoy or just what they are accustomed to.

When we look at objects, whether in drawn space or painted on a flat surface, we tend to see the things that are alike first. Then, if we are observant, we begin to see things that are different. If we are *very* observant, we will see all the subtle ways things are alike or different in shape and form, in color, texture, and line. But many times we are not looking at our environment with concern for its visual qualities. When we hurry across a heavily traveled street we only look long enough to keep out of the way of moving vehicles. If we stand beside the street and watch traffic, we may still not concentrate upon its visual qualities. Many of us are so conditioned to look at *things* in terms of their names that we would be mentally rattling off the names of the makes, years, and models of two- and four-wheeled vehicles. But to respond to the visual impression of things, to see the design in a place, we need to watch for the visual qualities as well.

The same is true in looking at works of art and at the design of cities and of objects.

a.

b.

c.

d.

Figure 2.4 *A powerful prehistoric symbol. Some believe it is a serpent's head. Whatever its meaning, it is hard to ignore.* (Symbol from Mound Builder Hopewell Type, Ohio Prehistoric Plate 43, Pub. 211, Field Museum of Natural History, Chicago.)

We can pass them by with little attention as when we are hurrying down a street, or we can look just long enough to recognize what is there. But we can also look at art, cities, and architecture for their design qualities. When we look to *see* what is there rather than just to recognize things, the visual qualities begin to play upon our sensitivities.

Sometimes the designer or artist designs the message so clearly that people are forced to look at it. When we, as teachers, work to make bulletin boards more attractive, we are trying to capture our students' visual attention. Actually, some kinds of visual qualities are there influencing our experience

most of the time, sometimes covertly, sometimes blatantly, whether we are consciously aware of them or not.

The uses of different kinds of order and variety create the pattern of the design. But *design* is a much more inclusive term. It refers not only to the visual order and variety, but also to a concern for how a thing is going to be used, by what kinds of people, and for what purpose. It includes the kinds of situations it will be used in and the kinds of materials that are appropriate to make it. These functions should influence our decisions about the form, color, texture, materials needed to serve all these functions. The sum of our concerns produces the meaning things have when we look at and use them. It communicates their purpose, their function, and how they are valued.

In this introduction we have tried to orient you to some of design's functions in art and in our lives. The purpose of the next part of this chapter is to help you understand how to create order and variety—to help you become designers as well as viewers and consumers of design. We want to help you express your ideas more easily through different forms of art and different media. To do this, we need to break the subject of design down into very elementary parts so that you can work your own way from the simplest to the more complex aspects of design. Such an exercise will enable you to help your students design at their particular stages of design development.

Seeing and Designing

Seeing is a process of sorting and organizing visual information. We tend to look for likenesses and compare differences between colors, lines, shapes and forms, textures and spaces. What we see as similar and what we see as different produce feelings of orderliness or variety for us.

Figure 2.5 *Where can your eye rest?*

Figure 2.6 *What is different comparing this figure and Figure 2.5?*

Perception (the process of making sense out of what we see) underlies design. When things make no sense to us, it is because we cannot make out enough order and variety in the visual elements (form, line, color, textures, etc.) to find a recognizable pattern. It is the pattern that helps us learn what things are and to recognize them when we see them or similar things again.

Either too much variety or too much order keeps us from recognizing the pattern. If we look at a flat, white surface and nothing else, we see no pattern. We don't know whether it is the side of a wall, a sheet of cardboard, a snow-bank or part of a paint-

ing. But a bit of varied texture provides us with enough pattern to recognize that it could be canvas, snow, or a painted plaster wall. If we want to find a certain shop on a street with no order among the signs, we have difficulty finding that shop's sign. The organization of design is based on these processes of organizing colors, shapes and forms, textures, lines, and sizes into meaningful patterns of order and variety.

Perceptual Process 1 *We look for variety in order and order in variety.* Look at Figure 2.5 for several seconds. What did you find yourself trying to do? Did you keep looking for

Figure 2.7 *Similarities and difference in values and textures camouflage or differentiate shape.*

differences or patterns? Did you try to find something there? Do you think you could look at it for a long time? Turn to Figure 2.6. Here some pattern has been provided for you, because both similarities and differences have been included. Do you see any pattern? Does the pattern have shapes? Is the pattern on the page or are you making it?

In Figure 2.5, you looked for variety among similar things, and finding none became restless. There was no place for your eyes to stop. Everything was the same. There was no pattern of shapes that helped you recognize anything. In Figure 2.6 the two kinds of circles looked like lines. You found variety in the patterns, so you could probably look at this one longer. The circles were the same in shape and size and were the same distance from each other, which makes

order; but some circles were black and some white, which makes variety. The pattern they created made you see lines.

This same viewing can be done in any field of similar things. If we change some of the things in size, shape, color, or texture, they will look different; and the viewer will see them as shapes separate from the rest of the field. For example, if the textures inside a shape are alike enough and those on the outside different enough, we recognize the likenesses and differences that, in turn, make us see a shape. But if the texture of an object is the same as the area surrounding it and if no lines or varied colors are used, the object is lost in its background. The same effect can be achieved with lightness and darkness if the area inside the shape is lighter or darker than the area outside. (See Figure 2.7.)

Perceptual Process 2 *We see order or variety among things to the degree that they are similar or dissimilar.* If you lay an assortment of different sized, textured, and shaped papers on a plain surface, you will have some difficulty seeing a pattern of relationships among the different shapes. You probably will feel disorder. If you lay out similarly shaped papers, all the same size, texture, and color, you will probably find that each is related to each of the other shapes. In this case, order and similarity are the same. Now if you mix the two sets of shapes, those that are all alike and those that are all different, you will find another visual effect. The repetition and pattern produced by the like shapes contrasted with the variety produced by the dissimilar shapes creates a pattern. You will probably find the third arrangement the most interesting because it has both order and variety.

You can vary the degree of order by decreasing the number of similar shapes and increasing the number of dissimilar shapes or vice versa. Or you can change the shapes themselves. If the different ones are made all the same size, color, texture, or shape, you can increase the feeling of order. You can make more variety by changing some of the colors, textures, sizes, or shapes of those shapes that are alike. Thus, you have many ways to create order and variety. Experiment with many possibilities to find one that works well at communicating your ideas. When just the right balance of order and variety is achieved for a specific purpose, we achieve what artists call "unity in diversity."

Very confusing, disordered situations can be made more orderly by adding some forms of repetition. A busy street full of dif-

Figure 2.8 a. *Creating interest by combining order and variety.*

b. *M. C. Escher.* Butterflies. *Escher creates order through shape and variety with size and pattern.* (Escher Foundation, Haags Gemeentemuseum, The Hague.)

ferent sizes, shapes, and colors of signs looks more orderly to us when flags are put up at equal intervals, or trees are planted evenly along the sidewalk. They provide an orderly division of all the confusion. Because we tend to look for things that are alike, we block out the confusing signs to some degree, and we get more sense of order. But if all the signs and buildings were the same, the function of the trees or flags

would have little effect. They would reinforce the order.

If you haven't looked for order and variety before, this can be the beginning of many intriguing visual experiences for you. Look for the order that artists, designers, and architects have created for you by using repeating and varying forms, shapes, colors, textures, and lines. Notice that in nature every leaf, rock, branching system is both alike and different. Study paintings and sculpture to see how the artist or sculptor is attracting your attention by using order and variety.

Shapes that are clearly the same in several ways are the most easily related. Likenesses among shapes with only one similarity usually take longer to see. Shapes with similar lines may be different in shape, color, and texture. Two curved shapes may be different in every other way. Our eyes and minds are like computers, collecting and comparing all this information. The more variety, the longer the computer takes to announce a result. The way we respond to order and variety depends not only upon our purpose, but on our familiarity with the things, our preferences for more or less variety, and the nature of the design we are looking at.

When we are designing, we can change the visual qualities of the things we are arranging to get the degree of variety and order we want. We can get messages across more clearly or make our environment more ordered or varied as we wish. We may want to have our message come across quietly, subtly, or we may want to be blatant and bold. When we look at other artists' and designers' work, we can usually see what their message is — the qualities they want to express through the way their work is designed.

Perceptual Process 3 *The impact of one visual element influences the impact of other visual elements.* Things like color, texture,

shape, and three-dimensional forms are rarely seen in isolation. Their effect on us depends on how they are used with other things. For example, if all the flags along a parade route are white, one red one will show up clearly. But a red flag among many is lost. One light on a darkened building shows up from a great distance. If all the lights are on, it is just another light. Neither the red flag nor the single light can produce variety when its field is similar to itself.

If our houses' walls, floors, window coverings, and furniture were all the same color, we would probably feel that we needed some degree of variety. But if every surface and piece of furniture were a different bright color, we might well feel a need for more order. To solve the first problem, we could experiment with different-colored paints or fabrics, until we had just the amount of variety we wanted. To solve the second problem, we could group objects of the same or related colors together. This would create larger groups of color and reduce variety in the overall pattern. Or we could select a color and paint several of our furniture or room surfaces that one color. The repetition would produce order within the variety of colors.

In both of these cases, none of the colors existed alone. The effect of any one bit of color depended on how it was used with other colors. The same principle operates with the other visual elements of line, shape, form, texture, and size. Things look bigger or smaller depending on their *context*. A big man getting into a car makes the car look small, a small child getting into the same car makes it look big. A big church with a tall steeple rises high over a village. When the village becomes a metropolis and the church is surrounded by highrise buildings, the visual impact of its steeple changes. No longer dominating its surroundings, it seems to be searching for space to point upward.

Figure 2.9 *The qualities of shapes and sizes of things depend on their environment.*

One round shape among rectangular buildings stands out. Any shape loses its impact in a sea of similar shapes.

The character of a poster depends not only on its own design but on the surface on which it is hung. A dramatic black-and-white poster with many straight lines will look different on a black-and-white-striped wall than on either a white or a black wall. A painting full of rich textures in dark, foreboding colors will look different on a dark, textured wall than on a smooth, light wall. Within the design or composition of a painting, changing one color, or texture, or kind of line, or size of shapes, or the amount of any one thing will change the impact of the whole painting, because *each part alters the effect of every other part.* We can increase our appreciation of and response to a painting by being sensitive to the interaction of all the parts and the impact the whole has upon us.

The painting in Figure 2.11, by a Canadian artist, is at first glance a somewhat simple painting. But after analysis we see that its overall impact of simplicity is based on a great deal of variety. We quickly see a great mass of people. The artist uses only minimal features to tell us that. But he also varies the simple eyebrow-nose line by drawing it from opposite directions and by combining it with open or solid facial ovals and one or two eyes. The impact of the ovals suggesting heads is varied by the particular lines used with them. Such variety in the relationships and placements of things is the key variable in this painting. Imagine how much less interesting the painting would be if all the features were painted the same way.

By changing the size of things, the artist lets us know that this mass of people goes far back in space. This feature leads us into the next key area of design—developing order and variety through the way things are placed in space.

Figure 2.10 *Backgrounds affect foregrounds.*

Figure 2.12 *Do you see pairs on the left or right? Why?*

Figure 2.11 *Herbert Siebner (Canada). Crowd. This artist uses similarities and subtle differences. The nature of the design speaks the message directly. (Courtesy of the artist.)*

Perceptual Process 4 *We categorize things closer together as being more similar than things that are farther apart. We categorize things farther apart as being more dissimilar than things closer together.* This tendency to group things that we see close together as similar and things farther away as separated and dif-

ferent is called "grouping by proximity" by Gestalt psychologists (Koffka, 1935). To demonstrate the tendency, try to force yourself to see pairs of lines starting with the two on the left in Figure 2.12. Most of you will find this somewhat hard to do.

In this case, the objects are similar, but even when the objects in a group are different, they seem more related to the group than to things outside it (Figure 2.8a). Their proximity produces a pattern that we see as a unit, and this influences us to see the objects as more alike than those objects outside.

But this visual tendency can be changed if some of the objects in a group have some of the same elements as objects outside the group. One red ball in each of two piles of silver jacks may seem part of its group. The red balls are the same in size, shape, and color and are different from all the silver jacks. If the two balls were different sizes and different colors and some of the jacks were the same color as the balls, the grouping would be the most powerful pattern maker. This Perceptual Process is also related to Perceptual Process 7.

Figure 2.13 *Ways of creating variety. Changing shape, texture, value and space, but maintaining size.*

Figure 2.14 *Changing sizes and shapes of spaces to create variety, but the repetition of shape creates order.*

Perceptual Process 5 *We see things as a group, if their position in space suggests a known shape or continuous line.* If we see a part of a familiar shape, we tend to "see" it as if it were all there. Look at Figure 2.11 again. If asked, "What is it a picture of?" you would probably say, "A large crowd of people—mainly the tops of people's heads." When forms are suggested, we mentally finish what is not there. Scientific illustrations give every detail and leave as little as possible to individual interpretation. Often in art the purpose is to suggest only enough

to set the viewer's interpretation in motion. Symbols may be used rather than detailed drawings, because the details would produce too many differences and make the design too varied.

Perhaps the easiest way to make order is to place things along a continuous line. Children who learn to read on horizontal lines, left to right, tend to order symbols the same way. But we can also make order along continuous lines that move in directions other than left to right, and are curved rather than straight.

Perceptual Process 6 *We see order among dissimilar things if the spacing between them is equal. We see variety among similar things if the spacing between them is unequal.* We see different shapes, textures, colors, and lines as more alike—and thus more orderly—if the spaces between them appear to be the same. We see similar shapes, textures, colors, and lines as more varied if the spaces between them are different.

When very different things need to be made more orderly, the space between them may be the only organizing process possible. If you can't change the colors, shapes, or textures so they are more alike, then maybe you can move the items, using space to create order. In Figure 2.13, the figures in the top row are all somewhat different in shape, though all have rounded and straight lines and are generally the same in size. But the centers of the figures are equidistant, and this arrangement makes them look ordered. Slide a strip of white paper over one of the three central figures and see how destroying the even repetition breaks up the pattern of similarity among all the shapes.

In the bottom row of drawings each figure is the same, but by varying the spaces between them, variety can be introduced and contrasted with the similarity.

If things are all in neat rows as well as all being alike in every other way, we can suggest variety by making the spaces between them even a little bit different as in Figure 2.14. Sometimes such variation suggests the shapes are moving. Things in motion usually look more varied than static things because they appear to be changing their spatial relationships to each other and to us.

Perceptual Process 7 *When two or more perceptual processes are operating in the same design, some will become dominant.*

In Figure 2.15 there are several processes

a.

b.

Figure 2.15 *Which clusters are most related,* **a** *or* **b***?*

in operation. The designer has organized the shapes in terms of the ways people see and organize what they see. Look at the visual qualities and not at what the shapes may remind you of. You will discover some things about how you organize visual qualities. What do you see as similar? What is different between the top and bottom groups of

Figure 2.16 *Pablo Picasso.* David and Bathsheba, *1947. The lithograph is full of repetition and variation of shapes. The shapes of foliage and scallops are repeated throughout to hold the complex design together. Straight lines are repeated at angles, and vertically. Round heads, breasts, and bodices provide an overall pattern of roundness. Contrasts of dark and light also create an overall pattern.* (Collection, Museum of Art, University of Oregon.)

shapes? Do you find your eyes jumping from one group of things to another? Where? What is it you see that makes you do this? Which seems stronger to you: the ways things are grouped or the ways things are alike? Not everyone will pay attention to the same things first. What people look at depends on what experiences they have had before becoming aware of their seeing processes and on how much they have learned to look for details.

Works of art that sustain our attention often force us to do many kinds of visual groupings as we attend to colors, sizes, shapes, form, textures, and lines, and to their relationships with each other. These create for us the mood or feeling of the work of art.

The only way many people can respond to complex works of art is by recognizing and naming the things they see. But people who can also respond, either intuitively or intellectually, to the complexities of design functions have much richer art experiences. They may be much more aware of why they like or dislike something, or why parts of a work of art or the design of a city are exhilarating and others are not. For example, which of the compositions in Figures 2.16 and 2.17 appeal to you most? Do you like them as abstract forms or because they remind you of something? Do you prefer one because of its variety, its order, or its balance between the two? Do you respond to all these functions? As teachers, you must know what criteria your students are using so you can understand their judgments and their art.

Perceptual Process 8 *We translate dynamic images into kinaesthetic feelings. Strong contrasts, extended distances between similar things, and lines meeting at acute angles appear as tensions, movements, and directions.*

Designs that have strong contrasts between the likenesses and differences require

Figure 2.17 *Manuel Izquierdo.* Plant-Cross-15, 1967. *The watercolor is similar in linear essence to Picasso's lithograph. What are the key differences in the kinds of ordering used?* (Collection, Museum of Art, University of Oregon.)

us to shift our responses from one part to another more than designs where the parts are only slightly different. If some lines are hard, straight, and strong in color, the design will seem dynamic. If the lines are light, wavy, and weak in color, the design will seem passive. If a design has a few very strong forms which are intense in color and contrast strongly with their surroundings, the distances between these forms will be like taut wires. The farther they are stretched without breaking (i.e., without moving the

form so far away that it becomes part of something else), the more tense the relationship between the two forms.

We live in a gravitational field. Our muscular activity has been learned as a response to gravity. We transfer this feeling to things we see. We expect leaning poles to fall, and we see lines as indicating direction. For these reasons, designs using lines, shapes, and forms that meet at acute angles look more dynamic to us. When all these elements are vertical or horizontal, by con-

Figure 2.18 *Seiichi Shirai (Japan). The interior of a chapel. The architect uses repetition of straight lines and round shapes to hold together the strongly contrasting symbols of heaven and earth. The great circle of the ceiling is made up of straight lines at all angles, and the building itself circles the space for people on earth.* (From *Approach*, Winter 1974, p. 33. Used by permission of Takenaka Komuten Co., Ltd.)

Figure 2.19 *M. C. Escher. Another World, 1947. Escher is a master at pulling us against our habits. He has things hanging as if gravity were working in three directions; birds stand upright against gravity three ways, perspective moves off in two planes yet this whole confusion is held together with the powerful dominant perspective of the parallel planes going off in one point perspective to a point in the center of the work.* (Escher Foundation, Haags Gemeentemuseum, The Hague.)

trast, the design seems at rest. We tend to see lines that are slightly off vertical as having the farthest to fall and, thus, being the most dynamic. Arrowlike forms, a triangle with two sides longer than the third, or lines that are thinner at one end appear to be moving in the direction of the smallest point. They can make the design appear to have movement.

When a very controlled design is full of dynamic parts, the pressures that hold it together and the pressures that pull it apart are so perfectly balanced that we go back to look at it over and over again. We are as enthralled as when we watch a tightrope walker.

FUNCTIONS OF ELEMENTS

In traditional design classes, students analyze each of the elements of design or composition and then relate these elements to each other. We start by analyzing the patterns of order and variety that are developed with line, shape and form, color, texture, and space. By such analyses, students learn to see how things operate in relation to each other rather than as separate entities. But it is also important to explore how the elements themselves can be used to make order and variety. Remember that order and variety are matters of degree. A highly varied design usually has some order, and a highly ordered design usually has some variety.

Functions of Line

The impact of *line* in a given design, composition, or space depends on whether the lines are the same or varied. If they are repeated unchanged, they increase order; if they are different, they increase variety. Lines can be similar or different in their length, width, texture, color, and distance from each other. Even if all of these elements

Figure 2.20 *Variations in line.*

are the same, the lines can still be different. Lines can follow an even or uneven pattern of direction. Each part of an uneven line must be carefully observed before you can look away from it and draw it. The patterns of uneven lines are not predictable. An even line repeats a pattern, and its patterns are more predictable. You see a part, and you can predict what the rest will be like.

When lines are used to outline shapes and forms, their design impact is affected by the order and variety of the shapes used as well as by the repetition or variety in the kinds of line chosen.

Functions of Color

To talk about the functions of pigment color in design, we need to understand words used to describe color qualities. The *hue* of a color means its position in the circle of colors from red to orange, to yellow, to green, to blue, to violet, and back to red. You can work your way around the circle by adding a larger and larger proportion of the next color until the prior one disappears. A color's *value* means how light or dark it is. A group of colors could all have the same hue but be different because of value; lightened with white or darkened with black in varying degrees. Also color may vary in *intensity*. A weak intensity color has little pigment in it and more agent such as water, oil, eggyolk, acrylic. A strong intensity color has lots of hue pigment and is not diluted with much agent. Most paints have to have an agent to make them flow onto a surface and then stick to it. As the agent dries it adheres the pigment to the surface.

Exploring the likenesses and differences to be found in *color* can help students become more flexible and creative in their use of color. They will be less apt to use colors according to stereotypes. Painting five apples red and three lemons yellow may help in learning to count, but it tends to stereotype both the way children see color and the choices they will make in designing with those objects.

Color can be used to separate a shape from its surroundings. If the area inside a shape is one color and the area outside is another, the shape can be clearly seen. But there are other ways to show shape with color. Because of our tendencies to group similar things as units, there can be variety achieved with one color inside the shape and variety achieved with another color outside, and we will still see the shape. For example, if all the inside hues were variations of yel-

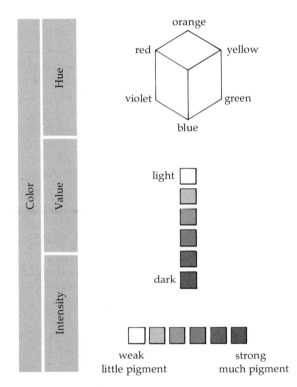

Figure 2.21 *Color properties.*

low, from yellow orange to yellow green, and all the outside hues were variations of blue, from blue green to blue violet, we would still see the shape. But if hues of green and blue green were mixed into both areas, the outline of the shapes would begin to blur because there would be likenesses inside and outside the shape. Sometimes this blending is ex-

actly what the designer wants to express: that the differences between things are not clear, that sunlight filters through leaves, or that grills soften the edges of things.

We can make shapes show up by changing the value of a hue inside or outside a shape. To make this change we can mix a color with white to make it lighter and black to make it darker. We can use any two of the many variations from lightest to darkest value of the same color and show a shape by using one inside and the other outside the area of the shape. You can make colors lighter or darker by using other lighter or darker colors with them, but this will also change the hue. A slight difference in value between inside and outside will outline the shape. But the similarities of hue and value will create a very ordered relationship. If the lightest and darkest values of a hue are used, the differences will create variety, but because they are values of the same hue they will still look related.

A third way to show shapes with color is to change the intensity by the amount of pigment, the substance that gives color, in the agent—oil, water, egg yolk, or plastic— that lets the color be spread onto a surface to dry and that names the medium—oil colors, watercolors, tempera, acrylic, respectively. If only a small amount of the pigment is put into the agent, we say the *intensity* of the color is weak. If there is a great deal of pigment in the agent, the intensity of the color is said to be strong. If we use a strong-intensity color inside the shape and a weak one outside (or vice versa) we will see the shape. If the differences in intensity are small, there is more order; if they are large there is more variety.

But the hue, value, and intensity of a color can also be affected by the color's environment. Yellow next to green looks different from yellow next to red or violet. Blue next to orange looks different from blue next

to green or red. Yellow against a dark background looks different from yellow against a light background. Colors are affected by each other depending on (1) how much of one is used compared to another, (2) how much of one color is in its agent compared to the other, (3) how light or dark one color is compared to another. Colors are also altered by textures as they cast shadows, making some of the colors darker than others, and the strength and hue of the light the textures are seen in.

The amount of order or variety created with color depends on the degree to which the hues, values, and intensities in a design or composition are varied. Variation can be achieved by keeping the hue and intensity the same but varying the value, by keeping the hue and value the same and varying the intensity, and by keeping the value and intensity the same and varying the hue. Order can be achieved by keeping hue, value, or intensity always the same.

In the section on activities, we will discuss both simple and complex ways you can explore with dimensions of color. Rather than learning traditional color wheels that stereotype students' thinking about color, students can learn more options for solving color problems in their designing work.

Functions of Shape and Form

The most orderly looking form is the sphere. From any angle it looks the same. The only way you can change its visual appearance is to change the direction and color of the light on it or change your distance from it. The next most orderly and similar sided forms are circles, squares, and cubes and equilateral triangles and tetrahedrons. All their sides are the same, and we have a strong sense of order about them. But our perspective changes as our position in relation to them changes, and we create variety as we

change our perspective. A tension is created between our movement, which changes our perspectives, and our knowledge of the shapes of forms. There is infinite variety and order in nature produced by the similarities and differences in shape and form. Whether we look at forms under microscopes or with the naked eye, we can see many kinds of relationships between order and variety. These relationships help us understand the functions of nature, and respond to its design. As we study how function and visual design are inseparable in nature, we see how they affect our lives. This awareness is not achieved suddenly, but grows as we continue to look for and enjoy these patterns of design and function.

Functions of Space

Space is also an element of design. We can manipulate space to change the impact of a design and affect the other elements. We create patterns of order or variety in space by grouping lines, shapes, or forms with similar or different amounts of space between them. The more similar the spaces, the more order; the more different the spaces, the more variety. We can reduce the effect of proximity of one element to another by increasing the space between them so that it is similar to the space between other elements. Or we can increase the variety of spaces so no pattern of order is apparent until the group is lost. If spaces between every line, shape, or form of a design are equal there is a high degree of order. If the spaces between elements are all different, there is a high degree of variety. If spaces vary, order can be achieved by repeating shapes, forms, lines, colors, and textures.

Functions of Texture

Textures are created by surfaces and the ways light shines on them—the shadows

a.

b.

Figure 2.22 *Jeanne Marie Leitschuh, 1975. Textures create images. View these photographs of a curtain and peeling paint from several angles to see how differently they can appear.* (Courtesy of the artist.)

and the varied surfaces create the visual effect. Textures also create gradients. When textures are farther away, we see them in less detail than when they are close up. When surfaces curve, the texture is spread most at the point of greatest curvature, decreasing as the surface flattens out (Figure 2.22a). This phenomenon is the reason curved textured surfaces have so much appeal to us, the gradual transition from close to separated surface forms creates variety within the order of the similar forms. The forms are the same, but the spaces between them vary with the degree of curvature of the surface.

There are myriad textures in nature and in art. We often ignore them in trying to see what things are, but subliminally we respond to the softness, sleekness, fuzziness, sharpness, etcetera, and get information about qualities of different textures.

Turn Figure 2.22b at several angles. See how light and shadows change the ways it appears. One time as flat textured patterns, another as peeling paint. When the visual information differs from the tactile, tension is created. Order and variety are produced in proportion to the similarities and differences of textures.

FUNCTION AND USE

At this point we must go beyond the visual aspects of design and relate the looks of things to their function. Design is an integral part of our lives, not only in objects we use, but in our total environment as well. The quality of the design varies widely. Design decisions are made when people buy objects to serve some function in their lives. If people are thoughtful about the things with which they surround themselves, they will consider how they use those things, how such objects function, how they feel and look in terms of the ways and the places they will be used. If people buy impulsively ac-

cording to fads, short range desires, or the pressure of advertising, their environment may never satisfy them and they won't know why. The design decisions people make create the environment in which they live and, in large part, determine the quality of their own and other people's lives. Current environmental psychologists are finding that the impact of the built environment on people's sense of who and what they are is critical to social and individual well being (Ittelson et al., 1974). Therefore, design should be part of everyone's education.

Students can study the look and function of objects to evaluate the overall design quality. They can design and create objects for specific purposes by using design decision-making processes. Objects need to be designed in terms of their meaning and function in people's lives: tools to work with, equipment to play with, instruments to eat with, handcrafts to enrich daily living, fabrics and clothing to protect from weather and create a personal image, and jewelry to dramatize a desired image. All of these serve to celebrate and give special meaning to important events in human experience. They also serve to identify the roles of people in society in their daily round of interactions with others.

In an earlier example, the way the shoes looked was not the only consideration in evaluating their design. The structure, the materials, the visual shape or form, the size, the craftsmanship all need to be related to the way the shoes should function for different kinds of people in different kinds of situations. Situations include climate and surface as well as cultural values. What do shoes say about who the person is? What role do shoes play in society? Function also has to be related to the visual context in which the shoes will be used, how they fit within the visual design of the other clothing the person wears.

The most common cause of poor design is neglecting these considerations. For example, take a common object you own and ask yourself the following kinds of questions:

Why did I select it?

Does the way it works fit with the ways I use it?

Do the materials it is made of fit the way I use and maintain it?

Is it put together so that it will hold up under use?

Does the way it looks fit my values?

Does the amount of visual order and variety make its use and meaning clear?

How does its cost relate to its overall design quality?

How does possessing it affect the quality of my experience?

How does it fit in with the other things I have?

If you are going to make something for yourself, you can ask questions such as:

Why do I want it?

What will its function be?

What is the context in which I will use it?

How can I design its function so it will work for me?

What qualities do I want to express through its design? How can I use order and variety to express them?

What do I want it to say about me?

What materials will look and function best for its purpose and use?

What skills do I need to develop to make it skillfully?

What will it contribute to the visual quality of my environment?

How do all these decisions fit with the cost of materials and my time in making it?

If you are making the object for other people, you should know their values, their uses of the object, their preferences for order and variety, and where they will use it. These questions apply to what are called fine arts when they are to become part of the public view as well as to objects that have operational functions in people's lives. For example, if a sculptor were to create a composition for a public place, the following questions could be asked:

What are some of the more important ideas shared by the people who use the space? What could I say through sculpture that would give a new meaning to those ideas?

What scale (the relationship of the size of an object to the things around it) would be appropriate to the message of the sculpture? (If the idea expressed is an important issue and is expected to remain so, the sculpture may be much larger than everything else around it. If it is to call to people's attention their relationships to natural things, it might be a small piece quietly set in a natural environment.)

What contrasts of order and variety must be made for the sculpture to fit into its environment? Can it be clearly seen without adding too much visual confusion to the area in which it is placed?

How will the space it occupies break up the pattern of people coming and going around it?

What will it communicate to people looking at it from different angles?

What materials are appropriate for the kinds of weather? Will it maintain its message with a snow mantle and in the sunlight?

We have used only two examples, but you can evaluate all kinds of things by asking similar kinds of questions. New designs can be created by asking questions and by establishing some guidelines for the design decisions needed to make the objects.

If objects have practical uses as well, you should ask a different range of questions. To see how this works, let's analyze an actual space need for a particular group of people. You need a work place for small groups of students. You want the place to be flexible enough to allow for a variety of activities. After asking questions about the

Figure 2.23 *Variation among pots. These pots all suggest how they are used—for cooking, boiling, or serving—as well as how they function socially. They come from England, Japan, Holland, Mexico, and the United States. Some are old and some contemporary.*

needs for the space, you set up guidelines for the design.

1. The place must be flexible enough so that a variety of activities can go on.

2. There must be space for individual and group work, for storage of materials, for work in process, and for students' personal tools and materials.

3. The structure must support the energy of students working on it and their weight sitting at it.

4. Surfaces need to be smooth, resistant to media, and easy to clean.

5. The proportions must be adjustable for students of different heights.

6. Its form must clearly express its design.

7. It should be very ordered because the activities going on there will provide variety.

8. The overall impact of the space and its objects must fit into the overall design of the space the whole class occupies. In an open school the work space is clearly part of the general working space of the class. In a closed classroom the working space becomes part of the design of the whole room.

If students make pots just to make pots, they are missing out on important designing experiences they could translate to other aspects of their lives. If they need something to put things into, they can analyze the need, how they will use the object, what it will mean in terms of their values, what surfaces will help it serve its purpose, how much order and variety are needed to serve the use, the social function, and the message. For example, most pots are used as containers. Each kind of pot has a specific use as well: it may be a flowerpot to hold soil around the roots of the plant where water is absorbed and drained off at the bottom. It may be a cooking pot to provide an area for heat transfer and to hold the food. The pot's design gives us information about its social function. It may tell us whether to put food or flowers in it. The materials, their structure, and embellishment tell us whether the food to be eaten or the plant to be contained is for a special celebration or for everyday use. All of these contribute to the meaning we derive from looking at any one pot.

As students go on with their designing, they can ask these questions of each other:

How does the material fit the proportions and the form?

How do both of these fit with the way the object will be used? Will it fulfill its function?

What meaning will the finished object convey about how it is to be used?

When these questions are answered, the overall design quality of the object can be evaluated. Generally speaking, the more all the aspects of an object work well together, the more beautiful we consider it.

Students who are aware of the kinds of decisions that they have made in designing an object will be better able to make comparisons of their progress as they continue to design similar things. The strengths and weaknesses of each piece will be more easily observable, and they will be able to learn more from each of their designing experiences. The student who thinks that one of his or her pieces is superb, but does not know why, will probably have a difficult time taking off from that success to others and will be confined to making identical objects.

Most of the reasons for poor design in our society are that too few of the design processes are considered. Some objects that look good do not work very well; things that work efficiently may not be visually compatible with their environment. If an object's design does not fit its function, the object confuses us. If an object does not express our values, we are in conflict with it.

We can analyze the relationship of art forms to society and cultural values by organizing our questions into five areas:

1. *Use:* How is the art form used? Does it contain, separate, sustain, enclose, transport, extend, cover, support, or express ideas and feelings?

2. *Function:* How does the way it functions support social organizations and enhance cultural values, attitudes, and beliefs?

3. *Meaning:* What does it mean to members of social organizations and to people who share a given cultural value system? What meaning does it have universally to humankind?

4. *Visual Quality:* How do the visual elements interact together to produce the amount of order and variety that fits with the object's use, function, and meaning in a given context?

5. *Information:* What does the art form communicate about the nature of the culture in which it was produced—its values, technological development, resources, and complexity of symbolism?

Chairs are used to support people in sitting positions. The design, structure, and materials serve different functions in people's lives: sitting while eating, watching movies, listening to sermons, typing, riding buses, presiding over meetings, being crowned. The design, structures, materials, and condition also indicate the quality of the experience one is supposed to have in using it—formal, informal, elegant, gross, cared for, neglected—which reflect cultural values about events and activities. The form of the chair—the organization, materials, colors, and textures—communicates the nature of its functions and meaning, and all of these design elements contribute to a cohesive whole. The design elements also communicate information about the culture of the people who create and use them.

To make art education more vital, we must extend students' creation of arts and crafts to include the relationship of their products to their own and other people's lives. They must become more aware of how interdependent we all are in the environment to which we are all contributors.

SUMMARY

The overall visual impact of a design—the organization of space, lines, shapes and forms, colors, textures as well as objects—depends on how all of them together create, through their similarities and differences, patterns of order and variety. The nature of the pattern creates the mood which is part

of the message itself. The interplay of order and variety produces the tensions and excitement of art. The shifts from variety to order to varieties to new orders which create patterns underlie the structure of art.

The most ordered forms—circles and squares—draw our attention from free forms; yet continuous viewing of circles or squares bores us. To sit alone for a long time in a windowless, soundproof, square room would tax all but the most introspective of us. To sit in an area with no parallel walls, no pattern to multicolored shapes, textures, lines or forms, and unstructured sounds in the background would drive most of us out of there in a short time. Yet all of us live in a continuously shifting stream of visual forms and shapes in environment that affect the quality of our lives. But most of us take the information in through our senses without evaluating its effects upon us.

The visual aspects of design are inseparable from our use of objects. An object that is visually confusing is harder to make work than an object whose function is clearly defined by the way it looks. When functions are clearly studied and forms designed to fit the function, they usually appear in good order to us. Both the sterile, boring room and the visually confusing one could be redesigned to allow for different kinds of functions. The design would have to fit the function. Where many functions are to be carried out, the visual design of objects must be planned so that individuals can see the many possibilities for using them.

Solving design problems depends not only upon how all the different colors, sizes, and shapes relate to and affect each other, but also upon how we respond to them as well. Most of us spend our lives adapting to environments we do not create. If we do not like them, we develop habits of *not* looking. If there is visual confusion, we create our personal order by ignoring our environment.

For this reason many of us do not know what really pleases us. Our likes and dislikes become vague when we try to explain them. This means that we need to experiment with our environment to sharpen our awareness and discover what we really like and why. As we become more observant and critical, we can make analytical judgments. We do not necessarily have to accept or reject designs because of their age, but because we can evaluate how well they function for people in a given situation at a given time. As we have more visual experiences and experiment more, our likes and dislikes change and become eclectic.

As teachers, we can help our students develop design sensitivity as they are growing up. As they become more experienced, they can not only be responsive to more visual information, but they can learn to modify and change their environment to suit their values. This, in turn, may lead them to analyze their values as well as the things they create and change in their environment.

Learning to see how the visual elements that make up design interact with each other is an important part of learning to live in a complex world where so many different elements are so interrelated. Very few things take place in isolation. What happens in one place or in one part produces an effect in the ways other things function. The way one child uses his or her space at a table affects the use of space of all the children at that table. The site of a new building in a city not only produces an effect in a whole neighborhood but on the traffic patterns of the whole city as well. Visual design is a means for a person to begin to see how complex systems work. If people learn to think in patterns of interrelationships, they will be better able to find workable solutions. Art cannot be separated from other aspects of life; it is an integral part of life.

DESIGN ACTIVITIES

The following activities are designed to help any individual increase his or her understanding and ability to manipulate design. The activities are arranged in four levels of complexity which allow for individual differences in prior experience with design.

The activities are not set up in a rigid curriculum, but, rather, examples of activities are given for each of the processes of design at the four complexity levels. Adaptations of activities allow for both differences in students and limitations that you may find in a given classroom. In general, activities have been selected because they appear to be interesting enough to involve a wide range of students. But they may not be always the answer for you and your particular group of students. It is hoped that the activities will stimulate your own ingenuity in helping students become aware of and be able to use the basic functions of design.

Emphasis is not on media so much as processes. The activities have been selected by cost for materials: most of the materials are easily obtained and inexpensive. As costs and supplies fluctuate, the activities can be adapted to a wide range of materials.

Section Six discusses individual differences that may help you select and modify activities from each complexity level that are more appropriate for different individuals.

The sequence of levels in this part is different from Part One. In drawing, different areas can be developed from simple to more complex tasks somewhat independently of the other areas. In design, the integration of all the areas is critical for learning, so each level has to include broad aspects of design. Level 1 is an introduction of experiences. Basic design concepts are introduced at Level 2. Experience with a concept should come before analysis of it; then the analysis will have more concrete meaning. Level 2 covers the broad area of design with key basic design concepts that are derived from the perceptual processes. Advanced students can use it as a refresher, and new students can use it as a second stage. It may be the area more students stay with longer because it applies a wide variety of design problems. Level 3 is an extension of more complex activities based on Level 2. Level 4 is a synthesis of Levels 2 and 3 and illustrates how the basic concepts can be used with film and other media.

LEVEL 1
SEEING AND DESIGNING
ORDER AND VARIETY

Students with limited awareness of visual order can begin by identifying the similarities and differences of objects according to shape or form, size, color, and texture. Often these students are young children, but many adolescents and adults have not developed much perceptual discrimination. This is a good time for students to learn that *shape* means the outside edges of a flat surface, and *form* means the outside surfaces of a three-dimensional object.

Learning to See Similarities and Differences

Collect an assortment of objects of different sizes, colors, shapes or forms in a large box. Include some that are of similar sizes, shapes, forms, or colors. Put a large sheet of colored paper on a table so the objects show up clearly against this background. With groups of students around the table, ask one student to select an object, put it on the paper, and then describe how it *looks*. You will probably get many *use* answers, but continue questioning until the color, shape, or form is described. Then ask a second student to select another object of the same color, shape or form, and general size. Ask that student to tell how it is like and how it is different from the first. Ask a third student to select an object that is the same color as the first two but different in shape or form. Now there are three objects on the colored paper and you can ask more questions:

Which two of the three objects appear most alike?

What makes them seem most alike?

How are they different?

Is there another combination in the box that is a different color? Are two objects the same shape or form and one different?

Let them make groups of all the objects collected according to similarities in color. Help them see how they use the same ways to group objects other places. If you have organized some things you use in the class-room by color, such as construction paper, paint, or crayons, ask them to look about the room for these examples:

Why are things sometimes organized by color?

Can we find things in stores more easily because of their color?

Why does each kind of gum have its own color wrapper? Does the color tell about the flavor?

Have the students identify objects that are similar in shape or form. Let them arrange as many objects as they can into groups of similar shape and then name the shapes:

How many shapes or forms are there?

Are there other familiar shapes or forms that are not included in these groups? What are they?

Did all the objects have shapes or forms that could be grouped with others? Why or why not?

Are certain objects organized by form in your kitchen at home? Are the forks separated from the knives? Are dinner plates stacked separately from the saucers? Are the glasses grouped together? Why are these forms grouped separately?

What similarities are there in toothbrushes and hairbrushes? What differences are there?

If the objects can be organized by similarities in textures, have the class feel them and group them according to how they feel.

How does sandpaper feel? A pillow? A kitten? A wooden block?

When you see an object that gleams and reflects

light, is it shiny or dull? What things in the group of objects are shiny, dull, bumpy, smooth? Which things are soft, hard, rough, furry?

Review with them the different ways the objects were grouped and *why* they were grouped.

You may have students who have difficulty seeing the visual qualities of things with which they are familiar. The use and function of the thing is so important for these people that they cannot look just for the visual qualities. Ideally, students should be aware of both.

Some students may be better able to use this information in future art experiences if they are allowed to explore seeing and making order and variety by organizing abstract shapes on a flat surface. Abstract shapes or forms are not recognizable as symbols of things so their visual qualities are more easily seen. Select various colors of paper, and cut out a few circles, squares, and triangles from each color. Pin these shapes to the wall randomly and ask the class to suggest ways to organize the shapes by shape and color. Then list the following groups on the board and discuss how your shapes might be arranged to match each of the groups:

1. one color — three different shapes
2. two colors — two shapes
3. three colors — one shape

When you feel they understand the three categories of groups listed, remove all your shapes from the wall to discourage their using your arrangements as models.

Creating Designs with Similarities and Differences

Give each student three pieces of colored construction paper to cut up and one larger piece of white paper. Ask each student to pick *one* of the three categories and to cut shapes out of the colors of paper to make a design on the white paper that fits one of the descriptions. Ask them to leave room for another design when they glue down the first one. Then give each person a piece of shiny paper and a piece that has a pattern. To focus their attention on the next task, erase the first three categories you listed and write the following:

1. one shiny, one dull — two shapes
2. two patterns — two shapes

Discuss with them what papers they have that match the words *shiny, dull,* and *pattern.* How can arrangements of shapes be made from these papers to match the two new descriptions listed? Ask them to choose one of the two, make a design like that description, and place it on the same paper with their first design.

When the designs are finished, display them all. Put the first three categories back on the board so all five categories are listed. Ask the students to identify which design matches which description. Ask them to identify specific examples of similarities and differences in color, shape, and size. If there are many designs, you may not be able to discuss them all, but you should emphasize how many different ways the same category can be done.

Provide students with various kinds of materials and have them continue the activity either individually or in small groups. The designs might be quite small or very large, out of cut and torn paper or paint, yarn, crayons, chalk, or a combination of materials. If a good supply of small wood scraps is obtainable, they can be arranged and glued onto a flat surface and painted.

Your main objective is the students' design learning so you don't want to hinder

them by either uninteresting or too complicated media. By having choices, more students can select media appropriate for themselves.

As they work, you can remind them to consider repeating shapes or forms, colors, and sizes because as the designs become more and more complex, similarities are likely to not be as visually evident as the differences. The purpose of this design activity is to help students become actively conscious of both. When their designs are completed, ask them to identify similarities and differences in color, shape or form, and size.

Relating Similarity to Order
and Dissimilarity to Variety

The students' designs can then be analyzed by introducing two new concepts—order and variety:

Which designs appear the most orderly?

What makes them appear orderly?

Which designs appear the most varied?

What makes the variety?

Do some designs appear to have both order and variety?

Do we sometimes want things very orderly? When? Why?

Making Order by
Increasing Similarity

Start with flat objects, such as paper plates, frisbees, tin can lids, plastic coffee can lids, or cardboard box tops which can be trimmed, painted, textured. Ask the students to see how they are different and then devise ways to make them look more alike using color, shape, or size.

Then use a three dimensional problem with more variation, and have each student select three objects that he or she feels have no obvious overall similarities. By changing or adding a similar design element to all of the objects, students can make visual order. For example, if an old shoe, a ginger snap, and a red apple were all painted with yellow and purple stripes, they would look more orderly together because of the similarity of their colors and striped patterns. Visual order is made even though the forms are different. Demonstrate this kind of ordering to your students, and see how inventive they can be at making order by changing or adding more similar design elements to their three objects. If they use objects that can be cut, they can change shapes or forms and sizes.

Making Order with
the Space Between Objects

Let groups of students choose many small objects in the room at random and place them on a large table. Ask them to experiment with ways to make the objects appear orderly. The students will probably put objects in lines or clusters; some may group the objects by color, shape, or function. Some may feel there are too many different objects to make any kind of order, but as they see others working they may start. Encourage them to continue experimenting. When there are some kinds of order available, ask questions so that the students can see the different ways order is being made:

What is the difference between the spaces of things in a group and things not in that group? Which are bigger?

What happens when some groups of things have equal spaces between them and other groups have unequal spaces? Which looks most like a group?

Encourage each student to make order with space on straight or curved lines by equal spacing or by clustering. Help them see that order with space depends on what is around—how other things in that area are spaced. The space within a group must be different from the spaces outside the group unless the group is made by a different element—a color or colors, shape, texture.

Draw three- to six-inch squares on a large sheet of paper. Ask the students to put one object in the center of each square. Then ask them how they would move the objects to make three or four groups without actually moving the objects out of their squares. They may discover that they can push the objects to one side of the squares and make the spaces larger or smaller between objects. If they do this in rows, they will be dividing the objects into groups. They can make horizontal or vertical lines and angles, each of which can form a group. Lead them into further exploration with questions. If the use of different objects makes the activity too complex, use bottle caps, poker chips, or similar objects to get them started:

How can groups be made without making lines and without taking objects outside their squares?

Can lines be made that go around in rectangles by moving objects in their squares?

Give each student ten to fifteen pieces of paper cut the same size and shape and of the same color. Ask them to use all of these pieces to make a very ordered design by spacing the shapes equally apart in lines or in groups with equal space between them. Once the pieces are fastened into place, discuss their various solutions and how these designs could be used for surfaces that need to look orderly such as walkways or bookshelves.

Ask them to look for places in the class-

room that need to appear more orderly. How could this kind of design make these places appear more ordered?

Repeat this activity. Provide the same kind of similar cut papers, only this time ask them to create some variety using the spaces between the shapes:

Compare this result with the first one. What has happened?

What is the difference in how they look?

Where could you use these designs?

Help students relate this abstract designing to designing with familiar objects. Discuss the spacing between things around the room and how groups are formed as a result of spacing:

Why are the chairs in lines or groups?

How are the paint brushes organized?

Are the windows organized by spacing? (Discuss.)

Would the light in the room be even if the lights were not evenly spaced?

When you are outside with students, take the opportunity to study order by spacing. Fences, parking spaces, and rows of trees are examples.

Relating Look to Use

It is important for students to apply what they are learning about visual design to the uses of objects. The similarities and differences and the order and variety objects make are related to how well they function. They can begin by sorting objects by the ways the objects are used. When the objects are sorted into groups by use, the students can take turns describing how the objects in the groups are alike in shape or form in order to do what they are supposed to do. Examples might be:

Things to apply paint or ink with
Things to fasten with
Things to clean surfaces with, etc.

Each group has *some* like elements because of their similar uses, but they have different elements, too, because of their particular uses: cleaning blackboards compared to cleaning floors, putting on paint or putting on thin lines of ink. Your questions can go on to other design functions:

How is the size related to use?

Another way to continue this activity is to take objects such as fasteners and look at the different ways they work. See what problems students have with fastening some objects and what solutions they can discover.

Ask your students what a safety pin's function is. Then ask them to compare the pin to a paper clip, then to a stapler.

How are their uses similar?

Why are they shaped differently?

Let them think of as many fasteners as they can with helpful hints as they need them. Allow them to draw as many as they can from memory as you name them. Talk about how they look so that the students can add as much detail as possible and discuss what purposes these details serve.

Have them bring fasteners of any sort they can find to school. Bring them yourself if this request is not appropriate. Many fasteners will be needed. Discuss their many shapes and purposes.

Why do some fasten certain things better?

Why don't we use safety pins to fasten paper, or straight pins to hold diapers on babies?

Provide the class with discarded materials—anything that lends itself to being fastened to something else. In a large group or in small groups, have the students fasten together lots of items into one large shape. They may need to invent a new fastener or alter some to fasten some of the items. Point out that many fasteners have been invented in this way. Inventors have to study the problem to see what form and size the fastener must be. It is important for students to recognize that the design of a fastener is related to its use. The shape they fashion could reach an enormous size and, when completed, be "fastened" from the ceiling, to the wall, or flown as a banner. Ask the students what it could be fastened to and where?

Fasteners are only one example of objects designed to serve functions. Containers are another possibility for students to explore. With a little imagination, your entire classroom could become "contained." The point is to encourage your students to notice an object's use as it relates to its size, color, shape or form.

As your students develop at Level 1, arrange a trip around the community. With paper and pencil they can record, illustrate, and categorize objects with similarities in size, shape, color, and texture. Prior to the trip have them study some magazine pictures of towns or cities and their buildings and landscape, looking for similarities in the design elements. Or, if cameras of any workable sort are available, students can record on film portions of their community that show examples of similarities in design elements. Arrange these drawings, slides, photographs, or movie films into categories of various sizes, shapes, textures, and colors and combinations thereof, and display them with written accounts of the observations.

Any student, regardless of age, whose experience is limited can participate in these activities. The important thing is that your students become actively aware of design all around us.

LEVEL 2
INTEGRATING BASIC
DESIGN CONCEPTS

The perceptual processes are the basis for the basic design concepts. People use the perceptual processes to sort what they see in their environment. Designers use the basic design concepts to sort and organize the visual qualities of things so they can more easily be "read" by viewers. For most people, perceptual processes operate at a preconceptual level. This means people do not think about the process with words. But most people can become aware of their own perceptual processing and use it in design.

To describe the perceptual processes in terms of design, our language needs some changing and extending to be useful in solving design problems. In these activities, students are involved in solving a real problem in their classroom and led, through inquiry, to see how they have used basic design concepts with the art elements.

Learning to Design
for Order or Variety

This extended activity is broken into seven areas of related experiences. The emphasis is on how basic design concepts have practical application in the decision-making process of designing. Because designing often requires planning in relation to things or objects around us, it is important to have students doing art where these direct relationships can be experienced and enjoyed. At this level students can use basic design concepts during the activities. If the concept is explained after students have learned to see it in operation, it may be clearer than if they learn it by rote before they have a basis for understanding. The central concept is provided with each group of activities. More

than one concept is often found in any one activity. As students become more aware of the concepts, they will recognize how the concepts interact.

If you have windows in your classroom, use them as a place to let your students experiment with ways order and variety can be made using design elements and concepts. Rows of similar windows are examples of a kind of order. They are often treated with different kinds of design to add interest or to better function visually with their surroundings. Your students would probably welcome the chance to do something with the windows in their classroom or school area. Unfortunately, there are some schools which have been designed without windows. We hope you may find some windows somewhere. If not, have the students do this activity on classroom walls, in halls, or on a dividing screen between work centers within the class area. It can be done on paper, but then it lacks relationship with real space that can be considered in its design.

Throughout this activity your role will be to ask questions, and your students' roles will be to create, recognize, and evaluate variety within order by actually making changes in the original design of each window. Students should participate in all the discussions because the design of each window affects the others. Carefully encourage each group's chance to make design decisions in relation to the other groups' decisions. It may require preplanning, trial, and retrial. Early in the project ask the students:

How much variety is there outside the windows and inside the room?

Does the room need more order or more variety? What about the view outside?

If the outside is drab and uninteresting, how can you make the view more interesting without making too much variety in the classroom?

Begin with large sheets of one bright color of construction paper or tissue paper. Tissue is preferred because it lets light through, but it is delicate and may tear if not handled with care. If paper is too expensive, you can use tempera paint mixed with detergent. It sticks better and, when dry, wipes off clean. Have your students cut several strips of equal width that are long enough to fill much, if not all, of the window. Lightly tape these strips to the windows, spacing them evenly apart so some light comes through. Ask what kind of order they have made. Discuss ways to repeat spacing, size, shape, and color to make visual order.

All students cannot cut straight lines. Give them choices of tools: scissors for those with a lot of motor control, rulers and scissors for others, and for some you may have to provide precut strips. Design learning is important, not cutting skill. But poorly cut strips can be visually confusing. Students can experiment with torn paper and compare it with cut paper to see which adds an element of texture.

Talk about what variety can be achieved and ask them to add their own visual variety to this order by changing some of the visual elements, *one at a time*. Be sure all the students understand what the words *space* and *variety of size, shape,* and *form* mean. You may have to demonstrate this to some students until they clearly recognize the differences.

There are several ways you can use this activity: all the children can change their window in each suggested way; they can work with different combinations such as size and shape, shape and color, color and texture, and spacing and texture; or each child or group can experiment with one of the changes so it is clearly understood and then go on to others. Different sequences of change can be going on at the same time, creating more interest in the work. Students will have to take down their taped strips and change them as they work.

Colors That Are Similar Appear More Orderly; Colors That are Dissimilar Appear Varied Variety can be achieved by replacing some strips with other colored strips, and texture can be achieved by punching, scoring, folding, overlaying, or painting to make opaque/translucent patterns, or whatever else the students can discover. Some may find that backlighting during some times of the day changes the effect of the color more than they wanted. They can experiment with thinner paper, lighter colors, or by drawing more detail to cut out light. Intense opaque colored strips may appear as dark lines when the light outside is greater than light inside. They can experiment by turning the classroom lights off and on.

The following questions can help you stimulate your students' problem solving:

How many ways can you think of to vary the color?

Do you need strong contrasts or subtle differences?

What colors of paper could you combine to make the strips lighter or darker?

How much color variety is there in the room already? Do you need more variety or less in the room?

If you need less variety, what colors can you repeat to make more order? If you need variety, what colors can you change?

Where is your attention focused when you look at the entire design? Is that the best place to call attention?

What colors do you see outside the windows?

Do the window light screens need to be more like the inside or the outside?

Is there too much variety outside or too little?

How does the design affect what you see when looking through the windows?

What do the colors make you feel?

Is visual order still maintained?

If students feel too much variety of color has occurred, encourage them to make more order.

Keep an envelope of color chips on hand that include red, orange, yellow, green, blue, violet. Spread the chips out on a white sheet, and ask students to pick up the colors by name. If they can do this, they are neither color blind nor unaware of color names. If they can recognize some colors but not others, they have a limitation around which you need to plan. If testing is available, the results would tell you more about their knowledge of color.

Students who are not responding may not know the language you are using for color. A few students may not be able to work with color in the abstract. They need to use color with recognizable things.

Sizes That Are Alike Appear More Orderly; Sizes That Are Different Appear More Varied What will happen if some of the strips are different sizes? Which ones should or could be altered? What happens to colors when changed sizes are in order? Why? What would the different effects be?

Let your students experiment with altering the sizes of the strips, and then ask more questions:

When sizes are varied, where do your eyes focus?

Is your attention at a different place now than when only color was changed? Why? Is that what you want?

How much size variation is enough to add interest and still maintain visual order?

Remember, size variation can include how wide something is as well as how tall and whether it is two or three dimensional.

The activity sharpens perceptual as well as design awareness. Be sure all your students can compare differences in sizes and spaces. Some may need special help.

Shapes That Are Alike Appear More Orderly; Shapes That Are Different Appear More Varied

Are all the strips still the same shape?

How can the strips be changed and still be strips?

Cut the edges of some strips; replace them with newly shaped ones such as curved strips, torn paper strips, or circles in a row that make a dotted strip. Let the students decide how shape can be changed to add visual variety.

Does the shape of the entire design appear different than when you began? Why or why not?

Do the spaces have different shapes because of the shapes or angles of some strips?

Textures That Are Alike Appear More Orderly; Textures That Differ Appear More Varied

Did texture already exist when other previous changes were being made?

Could texture be attached to the existing strips or cut out of some of them in an ordered way?

How does texture change the colors?

Does texture have to be touched to be texture?

How can the addition of texture affect the shape, size, and color of the design?

How does texture make the design more interesting?

Is there still visual order in the design?

Order or Variety Can Be Achieved by Making the Spaces Between Things Similar or Dissimilar As you move on to variety by *spacing*, ask the students how spacing has already been altered by changing the size of some strips.

How can the spacing between the strips be changed still more? For what effect?

As students vary the width between the strips on the window, ask them to evaluate each change in terms of the other kinds of order.

Are all the strips still in a straight line?

What happens when you change the angles?

Things That Are Grouped Together Are Seen as Similar, Separate, and Different from Things That Are Farther Apart

Would raising or lowering some strips alter the space?

Has the spacing caused groups of strips instead of a row of strips?

Which do you prefer?

How can spacing affect the amount of light that is cut out?

Is it desirable to reduce a glare or let in as much light as possible?

How is the order changing? Is there still order?

What does opening the window do to the order?

Do the same areas still maintain the same degree of interest?

Allow questions to be pursued continually, and consider all students' responses to those questions carefully. Their responses may lead you to new questions.

Any Visual Element Influences the Appearance of Order and Variety of Other Elements Used with It
Finally, when all these experiences in making order and variety have been explored, have the students carefully analyze how each of the changes has affected the other changes. Review with them what they have done to see how all the elements work together:

How have changes in size affected the pattern of color?

How has the spacing affected the pattern of color?

Has the change in shapes changed the order of the spacing?

What makes too much order and not enough variety?

What makes too much variety and not enough order?

Why do you like or dislike the design?

Have you employed so much variety that there is no longer order?

If visual order is no longer evident, can you recover order by returning some of the original strips to the design?

Can you remove a texture, shape, or color to create the balance of order and variety needed?

Are some of the designs producing too much variety in the whole room? How can they be changed to produce more order?

What happens when you try to see through the windows? Is seeing through the windows still important?

Does the design complement the other objects and colors in the room? The outside view? When would such complement be important?

Things Exist in Relation to Things Outside Them
As students are planning their variations, and again at the end of the project, introduce the basic concept that things always are in a variety of contexts. Their window treatment not only affects what they can see outside and the variety and order in the room, but it is affected by the weather outside, the amount of sunlight, the time of day, and the season of the year. This concept reminds them that designing is a changing process.

How would you design window screens that could be put up and taken down as the light and heat outside make shade more or less desirable?

Would these window screens be used at only certain times during the year or day? When? Why?

Students can measure a window at home for which they want to make a light and privacy screen. They will have to analyze

the space, light, colors, the inside and out-side environment, the relation of the win-dow to the sun, and changes in weather and seasons, and then plan a screen that is appropriate for that place.

Learning to Transfer Design Concepts to Other Art Work

The questions and decisions that are part of the window designing are the kinds of experiences that should be part of other design endeavors. The same inquiries apply to sculpting, painting, weaving, a graphics display, and jewelry making. Students can also make important decisions for drawing or painting a mural by applying these questions:

What is the message you want to express?

What are the main ideas?

How do the ideas relate to each other so that rela-tionships will be clear?

How do you get and keep viewers' attention?

How do you want people to feel when they look at it? Can design elements help achieve that? Which ones are needed?

If you are working with a familiar subject matter, how can you change it to help people see it in a new way by changing its design?

The answers to the questions in the window designing are helpful in answering these questions. By considering order and variety, similarities and differences, students can add more meaning and visual interest to their art and their environment.

Applying Design in One's Own Life Style

If someone in class is wearing a bold-striped shirt (have one available, just in case), ask the class to identify the different kinds of order in the shirt's design:

Is the color repeated? Are shapes repeated?

Do shapes (or stripes) change size?

Do the spaces between the stripes change size?

Is there any variety in shapes, color, size, or space?

Discuss each variation individually. Have them look at other fabric designs that classmates or you might be wearing to find repetition of color, shape, size, and space. All these elements may not be evident on all the garments.

Are certain kinds of patterns more acceptable for shirts, dresses, pants? Why or why not?

Why do referees wear striped shirts and police of-ficers not?

Cut out some similar shapes, repeating color and size, and ask the students to help you make a repeating pattern as you pin the shapes to a wall, spacing them carefully. Do another, if necessary. Discuss what was done and then take down your design.

When you think your students clearly understand repetition as a means for de-signing, ask them to each cut out of butcher paper a life-size shirt, blouse, dress, or pants on which they can plan a design emphasiz-ing repetition.

On the board list the words *size, color, shape,* and *space.* Explain that their design, which will be made from cut paper shapes, should include and repeat all of these ele-ments.

Let them select two colors of construc-tion paper. Ask them to cut out shapes to make their design and to consider the *kind* of garment they are designing when they choose colors and patterns. Remind them to repeat the shapes in each color. Simple shapes are easier to repeat than complex shapes. Suggest that two different sizes of shape might be enough. As they begin to cut, ask them to lay out the shapes and move them around until they have achieved the

order they want. If they glue down shapes before the design is all laid out, they may not achieve their goals. Waiting to glue gives them more opportunity to explore new possibilities and to check their design with the criteria they were given. Before they glue, ask:

Are both colors repeated?

Is size repeated? Are the sizes of the shapes too large for the garment?

Is the same shape used more than once?

Are spaces the same between shapes?

Display the finished work and discuss the various ways each student used repetition of color, size, shape, and space. If time permits, ask:

Which of these clothes can be matched to others? Will some shirts match other pants?

What types of people might wear these various garment designs?

Let them combine some of the clothes and make additions or changes for others so these can be combined.

They can make paper heads, hands, and feet for each outfit to represent the type of people they think would wear these garments. Discuss what different people wear and why.

Select some objects that are quite plain and have little visual interest. Plain white boxes, clear drinking glasses or plain paper cups, paper bags, and straws all have potential for surface enhancement in terms of some particular use and social function. Paper cups for celebrations and drinking at work both have the same use, but if they look the same we cannot tell their social function.

The design decisions people make create the environment in which they live. Discuss how order and variety in color, line, shape, texture, and size can be used to increase the visual interest and meaning of objects. Let each student select one of these plain objects, plan, and apply a design that will enhance the surface quality to suit their own tastes and show how it is used. Paint will probably be the most adaptable medium. Suggest that some designs may vary on different portions of an object but that the entire object should have visual continuity.

When the objects are finished, have the students exchange objects and write an analysis of the elements of design used:

Where is repetition evident?

What examples of variety were used?

Does the design continue around the entire object? Is it effective?

Is one element of design emphasized more than the others? How is that effective?

What does the design tell us about the object's use or to whom it belongs?

Have them write whatever they feel is a part of the object's design. Then display all the objects and discuss the variety of surface enhancement and how the designs suit the objects and their intended uses:

Would the object be used more with or without the added design?

How is the designing on a two-dimensional surface different from that on a three-dimensional form?

The activities in Level 2 are particularly relevant to simple lettering. If words are spelled with each letter a different type, color, or size, they are very hard to read. There is too much variety. The same is true if letters are sloppily made. The letters themselves have enough variety to make type or lettering interesting, so all the straight lines need to be straight and the curved lines similar so there is enough order to make them easily read. Students can compare different kinds of lettering to see which ones

are the most orderly and which have the most variety. For some purposes, we need much clearer lettering than others. Students can experiment with different kinds of letters to find ones that most clearly help the message come across. Words like *stop, danger, quiet, festival, enormous, cold,* and *green* all can be expressed differently by different sized, shaped, and colored letters.

Designing in Three-Dimensional Space

Ask students to bring in boxes of varying sizes. Set them all together in a group. Ask which is smallest and which largest. Take away a few of the smaller boxes. Help students see that things look bigger or smaller depending on their context. Ask:

What size boxes look small?

What happens when you take away the biggest box?

What makes a given box look big or small?

How can you make a big box look smaller, a little one bigger?

Ask your students for examples of when things have changed size as things around them have changed size. Remember the example of the church and skyscrapers in Part One?

Have students put all their boxes into one large group and then look for some new size groupings. Introduce defining words such as *long, short, wide, narrow,* and *tall.* Perhaps various arrangements in stacks or rows can be made with the boxes by some students as you ask these kinds of questions:

Which box is the tallest? Shortest?

Which is widest?

Can some wide boxes also be tall if they are in another position?

Is the narrow box narrow from all angles?

How many boxes do and do not change shape as you view different sides?

Viewing from one side only, what kind of order can you make using the narrow sides of boxes?

Once you have explored order and variety in size, shape, and space, let four or five students form groups with all their boxes. Ask them to build a structure with the boxes. Each group may have a different emphasis. One structure may be as tall as the students can make it, while another might be wide.

The boxes will probably be of various colors with images and words which will cause visual confusion. Have students roll white paint on all the boxes to eliminate all color or pattern distractions.

Have the students construct the structures on the floor or large tables so that they can walk around them and view them from all angles. Encourage the students to fasten the boxes together in a temporary and non-damaging way with pins, tape, and staples or whatever else works so that they might be altered later on. All the boxes need not be used.

When the structures are completed, ask everyone to walk slowly around them and study them very carefully. Ask:

Where is repetition and variety of size evident? Of shape?

Which is more attention getting: the repetition or the variety? Why?

Is the repetition purely decorative or is it also essential for making the boxes hold up?

Is repetition evident in the shapes created by the spaces as well as by the boxes?

How does planning with these design elements contribute to the overall design of each structure?

Do the designs of these constructions change as you move around them? Why? Did you consider this element as you were designing? In what ways?

If cameras are available, photograph the boxes from different perspectives but from ground level. The slides will give the appearance of real buildings. Students will be learning that what they are doing is related to design of buildings and buildings' relationships to each other. They can critique their design from the slides with more awareness of the effects of one volume or another:

Are some shapes more clearly seen than others because of what is behind or around them?
How does this change as you move around the structure?

We rarely see any one visual element alone, because the impact of one is influenced by the impact of the others. As students are standing around the structures, ask them to study the total design of one from their angles. Then ask someone to move one box on each structure to a different position.

If one part is changed, what happens to the way the entire structure is seen from your various angles?
How is this important in three-dimensional designing?

LEVEL 3
DEVELOPING DESIGN
SENSITIVITIES

The activities at this level provide opportunities for students to use the basic design concepts more subtly and with greater flexibility. The activities have many possible outcomes. They are designed as take-off points rather than as conclusions. Each individual uses design problems somewhat uniquely. Although the basic perceptual processes and the basic design concepts derived from them are important for each student to understand in order to be aware of and use design, their use provides unlimited possibilities.

Exploring the Basic Characteristics of Color

Ask students how many variations of color they can make. Lead them to experimenting:

How many different kinds of red (blue, yellow, green, violet, or orange) can you make by changing the value?
How many different kinds of red (blue, yellow, green, violet, or orange) can you make by changing its intensity?
How many different kinds of red (blue, yellow, green, violet, or orange) can you make by changing its hue?

Increasing Color Sensitivity

Any color may become more important or more subtle depending on how much of it there is and on other colors with which it is joined.

Provide an extensive assortment of colored chalks. Ask students to pick any one color they like. Next, have them identify one shape or object they feel is easy to draw. Have them draw it in at least five different sizes spaced out on a large sheet of paper, and, with the same chalk, color in what they draw. Then ask them to surround each drawing with other colors that will make the smallest drawing most noticeable or intense and the largest one appear least noticeable.

What have the likenesses and differences between hues, values, intensities, and textures done to create these effects?

Discuss each of these aspects individually: those between shapes and those between backgrounds and shapes.

Relating Color to Shape

Color may determine how a shape functions with other shapes in art work. Select a few

paintings recently done by your students that have clearly different colors and sizes. Have the students look for large and small *subtle* shapes and large and small *strong* shapes. As these shapes are identified, discuss with them how specific combinations of colors and sizes may have determined a shape's impact on the whole painting:

Does the amount of one color (the size, the hue, the value, or the intensity) affect the impact of the other colors around it?

Whether in a painting, a poster, or a sculpture, a color can be a decisive element that determines a student's success in reaching an intended visual effect. Repeat these color questions with other art forms: prints, or slides of paintings, graphics, book illustrations.

Symbolizing Use Through Color

We see and use an infinite number of objects each day. However, we are seldom aware of the design elements present or part of their various intended functions. The color of an object may help convey to us that object's use.

Ask your students to make up a long list of all kinds of familiar human-made objects. These can be listed on the board and later duplicated on paper for each student. After a substantial list is developed, ask them some color questions about the objects:

What kinds of things are the same color?

Are there reasons why certain objects have a certain color?

Why are fire alarms almost always red?

What other human-made objects are usually red? Blue? Yellow? Green? Black?

How do the colors of specific objects help express an intended meaning or use? In some parts of the

United States, police car emergency lights are red, but in other parts they are blue. Do you know why?

Would you feel differently seeing blue flashing lights than seeing red ones? Why or why not? What feeling does the color blue give us?

Analyzing Traditions of Color Use

The color of many things is determined by traditions or habits:

If you saw a pink and green police car, what would your responses to it be?

Would you have an appetite for a blue ear of corn?

Why do you feel so strongly about color?

Ask your students to choose an object, manufactured or from nature, that is usually a particular color. (Their original list of objects might be helpful.) Have them draw or construct it finished in a color not characteristic of that object. No one media approach is best. Use whatever is appropriate to your students and in supply. Once they have completed their objects in the new colors, have them do a small survey by asking:

How do these colors affect people's response to the objects?

Which ones are acceptable, and which are not?

Help your students devise very short questionnaires about their objects, and try the questions out as they show people the objects. They may be a little shy about showing their objects to the people they question, and it really may not be necessary if the questionnaire is explicit. When they have made their brief survey, take some time in class to discuss their findings and how this knowledge can affect a designer's choice of colors when making an object for people to use.

Using Color to Make the Ordinary Extraordinary

Have students select a painting they have done previously that has all the objects or things of nature painted in their natural colors. Ask them to paint the same picture again, but this time using colors that they feel are unnatural to the subject matter.

After they have completed their paintings, display them—the original ones with the newer ones. Get their reactions to the differences. It is possible that certain objects appear natural in any color. We have seen houses of almost every color imaginable. Some house colors might be totally offensive to the neighbors, yet quite pleasing to the dwellers.

Which objects in the paintings are acceptable and natural in the new color? Which are not? Why?

Are some shapes in the painting more important in a different color? Less important? Why?

Using Design in Public Environments

Poster making and sign painting takes place year after year in most schools. Students should be provided with the tools to analyze what can be effective in conveying a message so they might apply this knowledge to what they design.

Bring into class examples of posters and slides of billboards that are topically of student interest to study for their design qualities. Select posters and signs that exhibit variations of style and approach in order to avoid teaching them that *one* design is best. Ask questions that will extend students' awareness of the effects of design in conveying messages. Some murals may be good illustrations, too. Ask these kinds of questions, using several different examples at a time so that comparisons can be made:

What attracts your attention?

What is the major part of each message?

Is color essential to the message in any of these? If so, how?

Would changing the color or size of some words or images change the message? Would these changes in size and color alter the total design organization? Why?

What evidence is there of similarity in shape? In color?

Why might repeating certain elements of design be important?

Is the order subtle or obvious?

What other evidence is there of subtlety? How might that contribute to a designer's intentions?

Are some design elements used only once in a poster or sign? Why?

What kind of eye movement is created by the organization of the design elements? A straight line? A circle?

How many elements are contributing to the main part of the message? Is the idea bigger, more colorful, or centrally located? Is it smaller and in a corner but obvious because of some other unique characteristic?

Why do some signs include more visual information than others?

Are some designed to appeal to certain people? What evidence is there of that?

Many questions can accompany these posters and signs. Each new design problem offers the potential for unique solutions best suited to the particular endeavor at hand. Again, the purpose is to broaden the range of design possibilities for your students and provide them with tools, not answers. Having a variety of examples for reference will contribute to this goal.

Changing the Design to Change the Message

Select a commercially made poster and display it where all the students can see and

study it. Ask each student to individually redo this poster retaining the same words and images but changing sizes and/or colors to make the poster more effective. The poster you select should be simple enough in design that redoing it will not cause technical problems nor take long to do. Select a message that can be displayed around school when the activity is over.

When their redesigning is completed, display all the posters and compare each one with the original. Look for examples of:

1. Change in what is most important,
2. How the overall visual impact may have changed, and
3. Whether or not the intended meaning is still the same.

Have the students discuss the specific reasons they feel these changes, if any, have occurred.

Changing the Impact of Graphics

Many written and spoken words are highly expressive and offer great visual potential. A word's meaning may suggest its visual design and may influence the design or use of other words and images that accompany it.

A hiccup comes quick, hard, and unexpected, causing a noise and a jerk. Anticipation of the next one accompanies the lull that follows the last one. What can be done with the word *hiccup* so it visually does what it says and means?

Have your students each select a word that expresses an action or a feeling. Ask them to write one sentence describing that feeling or action and then design that word to not only be read but also to visually express what it conveys. This design problem was simply but effectively done by a twelve-year-old who cut the word *tiger* from colored

construction paper. The letters formed the shape of a tiger and were completed with claws, stripes, and a tail. A college art student stitched a tubular casing of muslin to form the word *soft*. She then filled the form with white plaster. The result, when sanded, was the word *soft* that looked very soft until you touched its hard, cool, smooth surface.

The potentials are here for a short exercise in paint or paper, or for an extended two- or three-dimensional design problem of small to enormous physical size using whatever materials are desired and appropriate to the design plan.

Designing with a message can be effectively done in three dimensions as well as on a sign or a wall. The goals in the following activities are to begin to understand the complexities and potential values of designing a message that can be walked around or seen from more than one side.

Have your students discuss the possible advantages of a multisided message:

When would it be more effective than a billboard or poster?

Where should this form of message be exhibited to be most effective?

How does it have to be like its surroundings to fit?

How does it have to be different to be seen?

What would be appealing or appropriate for the audience chosen in terms of color, size, and shape as well as what the message is about?

How are cereal boxes and other containers examples of multisided messages?

Ask your students to select *one* of the two following activities to explore and to list all their major intentions on paper. These intentions will be affected by the nature of the message being conveyed and to whom. The students' goals should be to construct a three-dimensional form which is well designed structurally and visually and which

conveys a message. The message is a determining factor in how the total structure is to be organized, and this total structure is to be organized by considering (1) all the elements of design they have studied previously, (2) the audience, and (3) where it will be displayed when complete.

As students are working, offer some reminders:

Repetition can sometimes be effective and appropriate, while other times more variety is needed.

Complexity of design causes visual confusion if some order is not planned.

For some purposes, strong visual impact may be desired; for others, subtlety.

Class review and evaluation of the ''structures with a message'' should necessarily include their designers' goals and the factors that determined their design decisions. Supplement their written intentions with discussion, if students desire it.

The words and images on cardboard boxes were undesirable in Level 2. However, the words and images were placed on these boxes to identify the contents, and some design considerations were made as to how this might be done effectively.

Ask your students to each bring two or three boxes to class. Select a few to discuss with the class. Review how similarities and differences in color, shape, size, texture, space, and line are used in planning the design and message of the boxes and how these relate to the contents.

Critiquing the Design of Manufactured Objects

This activity helps students integrate what they have learned about design into one activity. Design considerations include tactile, visual, and manipulation factors. Select a specific object of interest for students

to analyze in detail. Perhaps a small transister radio would be suitable. Ask:

How many kinds of ways is it used?

How well does its form, its size, and its color fit with each use?

How well does its form communicate what it is?

How well does its degree of order and variety fit its use, its function in someone's life, and the way it communicates what it is?

Is there enough order in the dial design to clearly see where it is tuned?

Can the knobs be easily seen and taken hold of?

Will the material it is made of hold up under the kind of use it gets?

Does it feel like the way it looks?

Does the way it looks help tell you how to use it?

If possible, get two quite different small radios and ask students to decide which are the best design features of each. If another object is of more interest to them, don't use the radio, but ask the same kinds of questions. If the students write their answers to your questions, more responses can be considered and compared in discussions. Their judgments may vary widely and give clues to how differently people respond to what they see.

This kind of analysis will be useful to your students in understanding the quality and purpose of design of objects they find around them and will assist them in their own designing as well as make them more thoughtful consumers.

Redesigning Poorly Designed Objects

Ask students to select and bring to class a manufactured object they feel is visually unappealing. Give them time to write down what they feel is acceptable about the object's appearance and what is not. Give spe-

cific attention to the relationship of the look of the object to its use.

Then ask them to redesign this object to their satisfaction without altering its use. If they only need to change its color or other surface quality, this change might be applied directly on the object. If more elements must be changed, a model can be made with cardboard and tape or papier-mâché. It can be drawn on paper as it would appear from various angles. The redesigning should be accompanied by a written or oral explanation of how these changes have improved the object's appearance.

The follow-up discussion should include what the changes are, how the changes improved the quality of the design, and what, if any, limitations the redesigning may present when using the object as it was intended to be used.

Designing for Recycling

Everyone should develop design problem-solving skills to reuse things that have been designed for one use and function, so that they can be used in other ways without always having to reprocess the materials. To succeed, careful analysis of all the possible potentials an object has must be compared with some real needs for other objects.

Students may have to spend considerable time analyzing the potentials and alternatives of both the old object and the new need. They should consider:

The uses, such as fastening, containing, supporting, transporting, separating.

The ways the objects function in people's lives.

The ways their visual order and variety makes things look and how well they show how they are to be used.

The appropriateness of the materials, the strength, and the surface qualities of the old object in terms of the new situation.

One example that is often poorly done is cutting the tops off of old bottles with a hot copper wire or glass-cutting tool without carefully analyzing what some real container needs are. The search should be for old bottles the basic shape, glass thickness, and color of which are most appropriate for other uses, and one should be aware of the ways these objects will function socially in people's lives.

Too often people cut bottles and *then* find uses for them. The result is often more discarded glass and wasted time, space, and energy. But with careful, thoughtful planning and sensitive, selective designing, useful and handsome glass objects can be made that will enhance people's lives.

Plants, foods, and beverages are used in many different social ways. The form, color, and quality of an object should tell us what kind of social and environmental situation for which it is designed.

Designing Personal Objects

Ask your students to think about why people wear the clothes they do. Why do forms, sizes, colors, textures, and patterns of designs vary?

What uses do the clothes appear to serve besides keeping people covered and warm or cool.

What do the clothes tell us about who and what the wearer is and does?

How does the amount of order and variety help communicate what the clothing says about the wearer.

What are the particular contributions of the form, the lines, the colors, the textures, and the qualities of fabrics?

What different kinds of clothing design can you identify?

Discuss how styles are sometimes a result of moral, social, or political changes or come about because of newly developed fabrics. These all contribute to the new or

fresh design ideas that continue to emerge from creative people experimenting and discovering the potentials that can be derived through the manipulation of the design elements into new forms.

Think of as many design-related questions as you can. Your students should gain an active awareness of the relationship between intention and product, design use and social function. Once you have explored some questions and possible reasons why clothes may have particular design characteristics, give your students the opportunity to design a garment. Before drawing or constructing a garment, ask them all to individually write a description of the garment's intended uses and function(s), including the following:

For whom are you designing the garment?

How do you identify this person—contemporary, young, conservative, masculine, feminine, independent?

For what kinds of activities will this person wear the garment?

In what kind of weather and terrain will the garment be used: indoors or out?

Have them add anything else they feel is pertinent to an adequate description of the garment's intended uses. Be careful not to limit their imaginations. If a student wants to create an imaginary person who lives in a place with which we are not familiar, he or she should be encouraged to do so. But also encourage the students to be creative in a framework, describing the imagined place and person so that their design is functional. Emphasize that these designs should be uniquely theirs—not a dress that was worn to school yesterday or the adornment of a currently popular musician. Have the students draw the person for whom the clothing is to be designed, and then design the garment on that person,

keeping in mind the descriptions they wrote. The drawings should be fairly large so that sufficient detail can be added as desired. If students are not as advanced in drawing as in design, they can draw an outline around another student and work on a life-size image. Different design experiments can be drawn or painted on other paper and attached to the whole figure. Ask them:

What qualities do you want to express through the garment's design?

What skills must you develop to make it?

What materials will look and function best for its purpose and use?

How much order and variety of size, color, texture, shape, and spacing should be part of the garment's design and why?

The materials to be used will depend on what the individual needs are and, of course, what is available. There will be technical questions like how to make fabric appear furry or sheer, lightweight or heavy, shiny or textured. Individual designs will require many kinds of decisions. You and your students are best qualified to attend to these by recalling prior experiences and making the best use of materials and ingenuity at hand.

Students can approach the design in a number of ways: pen and ink with color, a collage with fabrics, buttons, or other materials, etc. Students with different aptitudes can use simpler or more complex media. It is often helpful for students to keep a log of the things they have tried and what has worked best.

Students can make the garment and figure three dimensional out of papier-mâché or the figure out of papier-mâché and wire and the garment of other materials. If your class is small and your funds are large, actually making the garments of the desired materials to fit themselves or a friend would be challenging and satisfying.

Developing Creative Group Solutions

If you are interested in a more extensive group effort, have your students create clothing for a community in which a radical change in some aspect took place. For example, what if hydrogen were developed as an unlimited source of heat and light, or maximum heating had to be 55°, or people lived to be 200? Divide the students into groups and have each group design clothes for the particular functions or roles these people would have within that community in terms of the changes that one thing would make in their life styles.

Ask students to consider clothing design for other circumstances: What would happen if suddenly we had unlimited power and light, or had it reduced very suddenly? How would clothing design be affected by the changed roles people play and the climate in which they would carry out those roles? Another list could be drawn up with the changes in stereotypes of young, adolescent, middle-aged, and retired if most people lived to be 200.

What might new stereotypes be?

How could garments be designed for them?

After students make their descriptions and plans, analyze the basic design processes in terms of use, function, meaning, and visual quality of order and variety:

How well are the practical aspects related to people's roles?

How well do the visual qualities communicate how the garment is to be used?

Does it look like it would function in the new situation?

How well do all the design aspects relate to each other?

LEVEL 4 ADVANCED DESIGN STRATEGIES

This level provides some examples of ways design may be used in solving different kinds of visual-use problems. The methodology of attacking problems can be used in unlimited ways. This section can also be a basis for solving environmental problems in Part Four.

Review of Basic Design Concepts

The structure, the materials, the visual shape or form, the size, the craftsmanship, and the potential user must all be related to the way an object is used.

This activity provides a review of the first three complexity levels. Ask your students to bring to class a small, useful object that they "really" like, or provide a collection of things from which to choose that are related to their interests. Provide them with questions to help them analyze the object they brought or selected. Be sure that each question is clear to them. Discuss their answers and whether they like the object less or more after the analysis and why.

Students' written responses to the following example of a questionnaire will help you assess their understanding of design to see if they are ready for the tasks at this level:

1. What are your reasons for liking it?

2. What ways do you use it?

3. Does the way it is made make it easy to use?

4. How does the way it looks relate to the ways you use it?

5. Look at it as if you had never seen it before— what is its shape or form? What is its color, line, texture?

6. How do the similarities and differences of these create order and variety?

7. Is there enough order to know what it is and how to use it?

8. Is there enough variety to make it interesting to you?

9. How does it function in your life?

10. What does it say about you who selected it?

11. Do you still like it as much as before you asked these questions about it? Why?

The following activities in this section are more advanced analyses of design than are covered in the first three levels. Section Six includes examples of advanced design strategies for individual student differences.

Analyzing the Dynamics of Design Change

When there are two or more design elements in the same art work, each element not only functions on its own, but also affects the other elements and establishes dynamic patterns.

Cut a circle, square, and triangle approximately the same size and of different colors out of paper. Pin them to the wall closely spaced in one group. Move the circle away slightly. Ask if it is still part of the group visually. Keep moving it until the general consensus of the class is that the circle is no longer part of the group.

How can the circle be made part of the group again without moving any shape?

Place a large black dot in the center of each shape.

Do all the shapes appear to belong together now? Why?

Are there two groups now, one because of close spacing and the other because of the black dot?

Add another square the same color as the triangle, placing it near the circle.

How many groups do you see now? Is there some visual confusion or is it merely more complex to sort out? (Discuss.)

How can they be rearranged into less complex groups?

What can you add to all the shapes to make them visually appear as one group?

Where do you see similarities and differences in color, shape, size, and space? (Discuss each separately and how these all contribute to order and variety in designing.)

Relating Subdesigns Within Complex Designs

Using two black squares, place each one on opposite sides of the entire group of shapes. Discuss how visual tension can be created between strong similar things even though there is distance between them. Our eyes seem to move back and forth from one to the other. Explain that these simple exercises can lead to highly complex designing.

Have each student decide on a simple shape the same size and color to cut out of paper several times. They will need enough shapes to cover another large piece of paper when spaced closely together in an orderly arrangement of rows or groups. Once these shapes are cut and arranged (not glued), ask the students to organize one large *complex* design by moving some shapes and adding as many other shapes and colors as they wish, incorporating each of the following criteria:

1. Make variety in similar things such as shape, color, size, and texture.

2. Make *order* in *different* things.

3. Use *spacing* to make order *and* variety.

4. Make four separate and different arrangements grouped by similarity and link all four visually so they seem to be four parts of a large whole.

5. Create visual tension by stretching out the distance between strong similar things.

These criteria will have multiple solu-
tions. Solving one may solve or undo an-
other. Be sure students understand what
each one means. If some students become
frustrated, provide individual help and re-
state the criteria. Students can help each
other or work in groups. The activity can
be done in more sophisticated collage
materials, in paint, stitchery, chalk, or clay,
or a printing process. It can also be adapted
to making a mobile. Degree of craftsmanship
may, in part, determine a student's satis-
faction with a completed design. Therefore,
choice of materials should take that into
consideration. If a variety of media can be
chosen, it will enhance student learning
and the discussions.

Display the completed designs and dis-
cuss with the students the various solutions.
Use criteria 1 to 5 to analyze the designs.
Then explore with students the following
questions:

*Are some designs easier to sort out visually? Others
more complex?*

*Do some designs emphasize subtlety? Boldness?
How are these effects achieved?*

When can a subtle design be more effective?

*Is more light necessary to see a subtle design? Need
we be closer to see the detail? How subtle could a
design be and still be seen as a design?*

*When can a bold design be used effectively? On
what? Where? How do we react to bold designs?
To subtle ones? Does it depend on where they are
and how large? (Discuss.)*

*Do some of your designs remind you of places or
objects?*

*How does the environment affect the boldness or
subtlety of a design?*

Are some designs for textiles, walls, helmets, quilts?

*Would some be better outside and others inside?
Why?*

Have any shapes been used that convey messages?

Do the colors in some create a mood or feeling? Why?

Figure 2.24 *Bridget Riley.* Painting, *1966.* (From:
C. H. Waddington, *Behind Appearance,* Cam-
bridge: M.I.T. Press, 1969.)

Show paintings done by artists such as
Frank Stella, Robert Indiana, or Bridget Riley
and ask students to identify design qualities
in those works that they have experienced
in their own designing. Ask them what else
they see.

The experience can provide your stu-

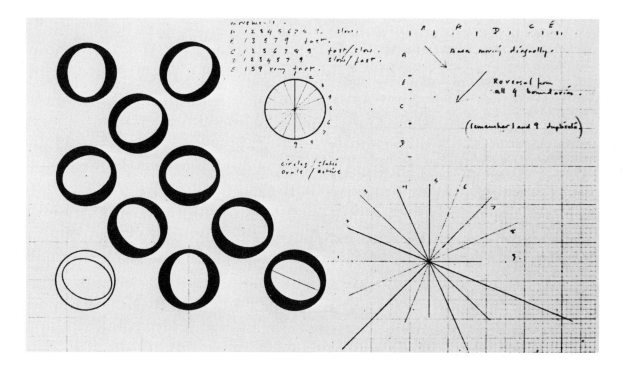

Figure 2.25 *Bridget Riley*. Working Drawings. *The continuous action of axis variations keeps our eyes constantly moving.* (From: C. H. Waddington, *Behind Appearance*, Cambridge: M.I.T. Press, 1969.)

dents with designing tools that may be useful when making art works that contain very personal or social forms of expression. It can also be helpful when dealing with problems in environmental design, as well as when designing for personal pleasure or to enhance functional objects.

Tensions and Dynamics in Design

Designs can stimulate feelings of tension and dynamics in us by strong contrasts, by stretching out the distance between strong, similar elements, and by organizing elements at angles that suggest movement.

What are some ways to show movement and direction with shapes? By increasing or decreasing size and space? By gradual or bold color or texture shifts?

Select some similarly cut paper shapes of various colors, textures, and sizes. Pin to the wall in a line left to right several shapes of the same size that gradually change in color value (i.e., light to dark green, or yellow, yellow green, blue). Discuss how color can move the eye. Cut each one successively smaller to further emphasize movement. Discuss how if the largest shape is dark or intense and the smallest very light, a different direction will likely result than if the largest were light and the smaller were dark. Rearrange the shapes in a curving line and discuss the implied direction. Move one shape slightly out of the line to change the movement. Move the smallest shape far from the others, still following the implied line or direction. Discuss these as examples of suggesting direction:

If the smallest shape is light in value and is replaced by a more intense color, would movement or direction be more emphatic?
Would the opposite also be true? Why?

A single narrow line broken at smaller and smaller intervals may imply distance and direction. A line at a sharp angle or in a wavy wisp can suggest movement and direction. This movement can be further emphasized by changes in shape, size, color, or texture. Circles placed inside one another may imply movement if the colors change in intensity as they decrease in size.

Have students each develop a complex design which (1) emphasizes movement and direction, (2) varies subtly and dynamically, and (3) incorporates visual tension. These should be interrelated to keep the design cohesive and working as one unit.

They can include all or some of the ele-

ments of size, shape, color, line, and texture using various printing processes, paint, inks, colored pencils, collage materials, or pastels or work it out in a three-dimensional form. The design might contain only abstract shapes or express a personal statement using recognizable images.

Emphasize this inquiry by having students view paintings by prominent artists. Select a few slides of paintings that are different in their uses of color, space, and composition. Cassatt, Matisse, Dali, Mondrian, Newman, Stella, and Indiana are but a few painters that vary from each other in the use of design elements. Using various artists' approaches will emphasize that design decisions are part of every artist's work, and that those decisions are an integral part of an artist's intentions and preferences.

These inquiries can be followed by making large, colorful felt or paper banners that use words or images or both to convey a message or feeling to a particular audience through the dynamic and subtle use of tension, contrast, and movement.

Designing Moving Images for Film and Television

Colors, shapes, and forms that move and change in subtle and dynamic ways are present in film and television images. Differences in the use of design to organize images in motion is often the major reason some films and televised programs are visually effective and others are not.

Work with elements of design in motion will extend students' understanding of the application of design and give them a basis for evaluating the quality of movies or television.

Have students experiment with what can be done with shapes and forms, color or color values, textures, and lines used in

motion in space and record their experiments using a movie or portable television camera. Ask them to create simple shapes and forms of various sizes that can be attached to long sticks for manipulating in front of a solid background. Ask some students to manipulate spotlights to change the patterns of shapes and shadows. Other students can film the objects in response to the following questions:

How can these shapes change in apparent size?

What happens as shapes and forms are moved away from the lens? When they are turned slowly? Quickly? When they are overlapped?

How can color or color value change? How do different amounts of light affect color?

What happens to a form when the direction of light is changed?

What happens to a shape if the focus is rolled back and forth?

If shapes are moved away or toward the lens as the focus is rolled, what are the visual effects?

How do different textures appear when moved? When very close to the lens?

Does the direction and amount of light change the appearance of a texture in low relief? High relief? How?

What effects can be achieved with transparent objects or paper using light and motion?

How can deep and shallow space be conveyed?

Along with these experiments, provide an overhead projector and screen and have students use lines and shapes to create motion. These animated designs can be recorded with the television camera right off the screen. As these experiments progress, an important point should be made. The images that they produce fall into a rectangular frame, like a frame around a painting. The organization of the images, colors, and space and where these will move should be planned for within this area. Provide an example: Attach a cardboard circle with a swirling design on it to a stick so that it can be held and spun. Demonstrate responses to the following questions:

As the circle is spun and moved away from the lens, should it begin its movement from a corner or from the center of the rectangle? Where will it move to?

If it begins far away and moves closer, what part of the rectangle is filled? As the circle gets closer, does it center up or not? Will it stop at some point or by-pass the camera? If so, to the left, the right, above, or below?

How can the rectangle be changed to appear a square? Another shape?

The answers will depend on what the intentions were. Students should be able to make these kinds of decisions and know why and how each decision affects and is affected by others. The various options to the questions should be recorded on videotape so they can be replayed and discussed.

Let the students divide into small groups. Supply each group with a super 8mm movie camera, one 3-minute roll of color film, some hand-held lights, and colored cellophane to change lighting. Make all the materials in class available, too. Ask each group to make a film using abstract shapes and forms, various colors, sizes, textures, and lines in space. The film should include:

1. Color that changes because of light.

2. Colors that change as shape and form move in space.

3. Transitional images that go from subtle to dynamic in various ways, using color, size, shape, texture.

4. Movement that suggests and explores deep space, shallow space.

5. Light used to create motion.

6. Variation in movement and pace to effect a mood or elicit tension.

Explain that using color will require different considerations that were not attended to in the experiments using black-and-white television.

Each one of these six areas may be planned separately, using 25–30 seconds of film time each. However, segments that vary in length may be as important to the entire three minute statement as are the variations within a painting. These six criteria and others students may use can be intermingled at long and short intervals. Parts of one will often be present in others. Very short segments can be filmed by squeezing and quickly releasing the trigger, providing an animated effect. Occasionally one or two frames will be lost and cause white flashes on the screen but those can be edited out easily. Editing will probably be necessary anyway, in most instances.

Remind students that visual continuity will, in part, depend on repetition, but also on how each segment is related to what was before it and what is to come after it. Attention to similarities and differences is still important. Suggest that each group choose one design element that will be used repeatedly to provide thematic, visual continuity. The film might even be titled. Perhaps the shapes will do something that suggests a storyline and a beginning, middle, and end. But these aspects are not as necessary at this point as concentrating on designing in motion, creating effects, and making transitions.

The extent to which the assignment is carried depends on available time or by how much follow-up there will be. This might be the first in a series of filming experiences, and each one can be progressively more challenging. The value of having this kind of design experience through motion will increase students' options and degree of sophistication in future designing with movement as well as in their viewing.

Relating Sound to Vision

If students wish, sound can be incorporated since super 8mm movie cameras are now equipped with sound recording devices. Tape recorders can also be used.

View the completed films at least two or three times each and have students discuss what they see:

What were the design intentions?

What design qualities are present but were not planned?

What emotional responses do you have when viewing the different films or segments of films?

What is thematic or visual continuity?

How were visual transitions made?

How do particular colors and forms affect others?

This design activity might be followed by planning a two or three minute message or a one minute "commercial" for film or videotape. Messages or feelings could be effectively transmitted, using their previous experiences in designing in motion. Visual time-space words and symbols could be organized so the impact would move and change to enhance the meaning.

This would be an appropriate time to explore animation. Many super 8mm cameras have devices that allow single-frame shooting. After discussing the number of frames per second the camera uses, how many frames various kinds of motion take, and the materials from paper to clay that can be used to animate, the students will be able to experience a new dimension of designing and movement in space.

A Model for Design Problem Solving

At this level, students should be ready to do complete designing tasks and work through

a complex series of problem solving. Encourage them to start with a real need in their own environment.

The following questions can help them get started:

What is needed?

What kind of object will fill the need?

How will it be used?

How will its social function operate in your life?

What do you want it to mean?

What do you want its visual quality to say about the user?

Where will it be used?

How will its design quality fit with the design qualities of the environment in which it will be used?

What kinds of form or shape most appropriately serve the use, social function, and meaning?

Is it a thing that needs to be easily seen, its parts readily recognized, or is its social use one that suggests excitement or variety? Or subtlety?

At this point many drawings and critical evaluations should be made of how well the ideas fit together.

When drawings seem workable, ask questions about how to make the objects and what materials will be used:

What materials are available that suit its use, social function, and visual quality?

What structural strengths and what surfaces are needed to make it work?

What are the ecological costs of the materials?

What skills are needed to work with those materials?

What colors fit with the form or shape, the use, the social function, and the meaning?

How can texture be used to enhance its use, social function, and meaning?

Your task as a teacher is to help individual students set realistic goals for themselves in terms of their abilities, the time they have, and materials that are available.

Wide varieties of design tasks can be undertaken according to the equipment you have available. Hopefully, labs in other areas of the school can be used as well as the art room. Some projects may be woven; built of cardboard, chipboard, or wood; welded or soldered; cast; tooled; molded and fired; carved; photographed; painted; block-printed; or silk-screened.

When objects are completed, have students evaluate their work in terms of the design processes they have gone through and identify what they might have done differently.

STRATEGIES FOR HANDLING INDIVIDUAL DIFFERENCES*

The examples of activities and concepts in design in the preceding section allow you more flexibility in selecting work for different individuals or small groups in your class. Teachers who use individualized and small group instruction will find this flexibility in teaching at different levels in the same classroom most useful. Students can proceed at their own rate. A review of Level 2 activities will help you see in which areas students need special help. If they are beginners, use Level 1. If they are older students, use the Level 1 activities with media that would interest them. The media can be changed to allow for more complex solving of the same basic problems. Design must be studied more in different aspects at one level than drawing. Design is so integrative that learning usually is more effective if the whole level is covered. Students who excel at some parts of design may advance at their own rate, even across levels. But if you have your students for only one period a day or less per week, you may have to select complexity levels that are more appropriate for your class as a whole.

The activities at Level 2 are the most comprehensive and can be introduced as a review for older or more advanced students. Students' performance at that level will help you to assess their readiness. You may discover that you chose too complex or too

* Parts Six and Seven provide a theoretical and research basis for each of the individual differences discussed in this section.

simple a task for the whole class to begin. When you find an appropriate level, then follow this with a period of individualized assignments to help the more advanced students carry the general assignment into more complexity, and those who need special help build up their understanding.

The problem that will be most difficult for you in assessing growth will be that there are diverse ways to solve design problems. Because a student's solution is different does not necessarily make it better or poorer than another student's. A good solution is one that takes all the elements into consideration. But if a student's design is different because he or she does not understand, cannot see the problem, or cannot handle the medium, that student needs extra help. The range of individual differences in a classroom will probably be as great in design as in any other subject.

DIFFERENCES IN PERCEPTUAL DEVELOPMENT

The specific abilities needed in design include learning to see; to use environmental information as well as words; to see shapes and forms as they change in space, light, and changing viewpoint; and to separate figure from ground. In design, students who look at things only to know what they *are* need more time and help to see the pattern of design. They may have to work longer at the same level of complexity to learn to see adequately. Using different media to learn the

same thing may keep up their interest and reinforce their learning. Students who have trouble seeing apparent size changes as they get nearer or farther from objects or apparent shape changes as they move around objects will need more work in learning to see before they can succeed with three-dimensional design problems.

Some students succeed in two-dimensional design problems but have trouble working in three dimensions because they have not learned to see and think in three dimensions. Students who have trouble separating figure from ground or separating elements from their context may well have trouble seeing how the forms, colors, and textures within shapes and forms are alike or different from the forms, colors, and textures behind shapes.

In activities in which drawing is required, teachers may find upper elementary, middle, or junior high students whose drawing abilities are very undeveloped. In these cases the teacher will either have to select more simple objects for the students to draw or help the students design with things they can draw. Some students can cut out symbols of objects better than they can draw those objects. Therefore, work on drawing is often needed before some students can do much work in design.

Some students do not observe details very much but are very good at organizing abstract shapes into ordered and varied designs. You should cultivate these strengths until the student has a great deal of confidence in his or her ability in design before stressing the use of complex detail in design. But students should also be encouraged to go beyond their strengths. What they have never tried is never a choice for them.

ABSTRACT AND CONCRETE PROBLEM SOLVING

Many young children and a few students at most older ages cannot work with abstract forms at all. Such forms appear to have no meaning for them. They can solve design problems if they work with real objects. Other students who are very successful in solving design problems with abstract forms are overwhelmed when they have to see the abstract qualities in actual objects. They need more experience in observing the visual qualities of familiar objects to see forms, shapes, and the varieties of colors and textures in different views and lights.

INTUITIVE VERSUS ANALYTICAL PROBLEM SOLVERS

You will find some of your students have a strong overall intuitive sense of design. They appear to be able to find ways to make cohesive and varied designs without having to consciously think about what they do. But since most students have not exercised this ability enough to use it, they have to learn by analysis. Intuitive children or young people may resent having to learn to analyze.

Often they can do similar kinds of things without having to use the same processes or answer the teacher's inquiry about *why* they do what they do. It has been our experience, though, that such people, if not forced, can become interested in analyzing the ways the visual elements of design function and eventually some of them become the most analytical of all. But some very gifted students in art never become consciously analytical of their own or other people's work. Apparently the ideas flow too fast to be put into words.

IMPULSIVE AND REFLECTIVE MODES

Some students will try to quickly and impulsively find an answer to design problems. Others may want to think about and mull over the ideas for some time. It is important to encourage the more impulsive ones to think more, to come up with several impulsive answers, and then to compare their effectiveness. Otherwise, their learning experience will be limited to what they do the first time. Highly reflective students may lack the spontaneity of the impulsive students. They may need some tasks in which they record their first possible solutions and then their more reflective one. A comparison of these may show them which is the most creative.

GLOBAL AND ANALYTICAL WAYS TO SEE

Some students will be very global in their perceptions; that is, they tend to see the overall pattern of things and not details. Other students habitually look for small details and rarely pay attention to the overall pattern. Students should be encouraged to change their sets for looking to include both kinds of perception. They can learn to

Figure 2.26 *Paintings of children with highly developed design abilities who are analytical or global.* (© International Collection of Child Art, Ewing Museum of Nations, Illinois State University, Normal, Illinois.)

express their ideas both ways and, in some cases, select parts of both to make a finished work of art.

VARIATIONS IN MANIPULATIVE DEXTERITY

Students will vary widely in their manual dexterity—their ability to control their uses of tools. Often this problem is less one of physical dexterity than one of a lack of analysis of what they want to express and how. If they have learned to use drawing as a searching tool, as a means of clarifying what they want to say, and as a means of sharpening their perceptions, they will often develop the motor skills they need to carry out their ideas. Drawing skills are also a good basis for learning to control other tools. But to carry out designs with tools that require skill, most students need considerable time to explore and experiment with what a tool will do to get it to do what they want.

Some kinds of tasks will enchant some students and frustrate others. Students who dislike the feel and smell of rubber cement in experimenting with shapes and colors of construction paper may better succeed

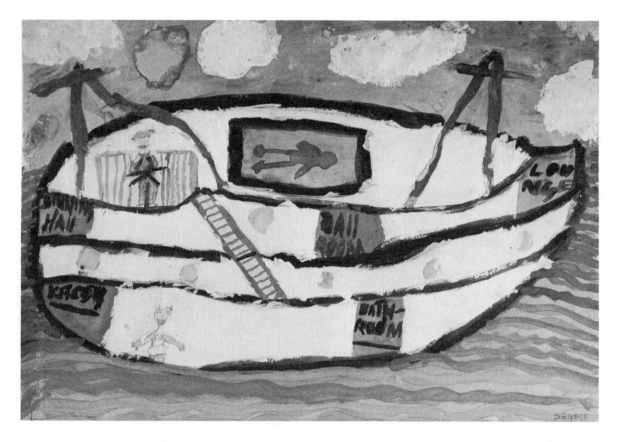

a. *A South African girl has a strong sense of the overall design of the levels of a boat but is quite global in her use of detail, relying on words rather than visual symbols to express ideas. The complexity of the design suggests she is an urban child who depends on stereotypes of things rather than on visual images.*

using paste. Others can use paint; but paint requires more skill. Students who feel insecure with small paint brushes and working in small detail can work with larger brushes or even stiff cardboard rectangles. Students who find all these difficult may succeed in using printmaking media to experiment with design. Printmaking pro-

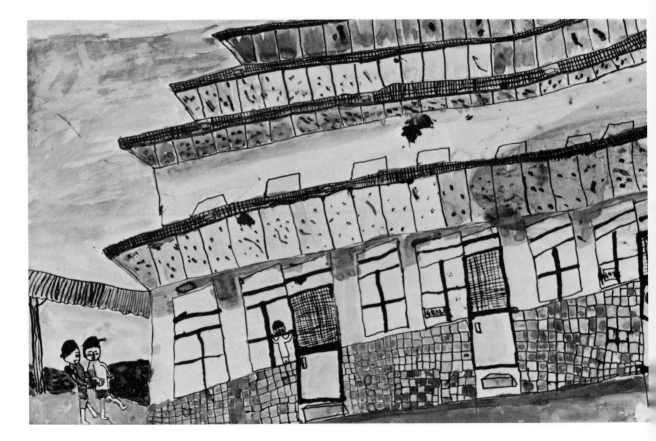

b. *A nine-year-old Japanese boy has a highly developed sense of three dimensions and surface detail. The complexity of the design he saw and his ability to symbolize it indicate that his observations are highly analytical.*

vides for a wide range of manipulative skills, from gluing string designs on cardboard for a printing surface to making silk screens.

One of the stereotypes that has hindered art teachers in working with individual students is that art should be taught in terms of media. Traditionally, more care has been made in selecting what media was consid-

c. *An eight-year-old Korean girl displays an analytical sense of the pattern of design. She calls her painting the* Electric Wire Work.

ered appropriate for what ages, than in what can be learned about design and communication in and through art. When the emphasis is on *learning,* the learning can be designed to fit the readiness of the individual or the group. Then media can be selected for students according to their readiness to use certain media and their tools.

d. *A ten-year-old Korean boy's aerial drawing shows he is very analytical about some details such as tiles and surfaces but draws people quite globally.*

Students may be able to work at Level 2 complexity but may not be able to master the media used. Conversely, students may be facile with media and yet not be able to handle the concepts. In these cases, you will have to adjust the activities and concepts to fit this more unique pattern of development.

Figure 2.27 *These two young people are finishing a group project of turning telephone switch boxes into works of art. The boxes did not fit the environment. The children's creative solution to the problem was to paint natural forms over them. They worked together, with some bickering over territory, to transform the boxes into something more acceptable. Peter and Emily Roske.*

CREATIVE APTITUDES

Students will tend to be more creative in some of these areas than others. A few students will be highly creative in all of them, and a few will be underdeveloped in most of them. But all students can be more creative than they already are.

Some of the most basic differences in creativity are learned. People are rigid or

flexible, depending upon the habits they learned as small children and on the opportunities they have to be rigid or flexible as they grow up. Rigid people tend to want correct answers quickly and are threatened if their habitual patterns of thinking and acting are challenged. Flexible people can adapt easily to new situations, and they are willing to hold the solution to a problem in abeyance until all the information is gathered that is relevant to the problem. They are perceptually open, and they are willing to keep looking at things without coming to quick conclusions about what they are. The more rigid student is probably more afraid of failing. The flexible student has a much more open definition of what is success and what is failure. Flexible students can find things of value in a solution that has been unsuccessful, and they are willing to see limitations in their most successful solutions to problems. Two students representing these two different extremes can sit side by side in an art class and have very different experiences with the same activity. Rigid students need much more help, assurance, and praise of even their smallest successes.

Students will also vary in their fluency in solving design problems. Occasionally, you will find a very slow moving child who may be very creative and flexible, but who rarely has been given enough time in school to carry any of his or her ideas to completion. Other students may be very fluent but not very innovative. They may get many ideas, but none of the ideas break out of the habitual ways they solve problems.

Creativity is often the ability to look at things analytically and then being able to see new patterns of design. It is also the ability to see how disordered things can be made more orderly, and to see how one small change can make the whole thing work. Such activities need to be encouraged and rewarded.

DIFFERENCES IN RESPONSE TO INQUIRY METHOD OF TEACHING

When you use inquiry methods with your students, watch carefully which students are answering what questions. Do not be lulled into thinking an inquiry session is working well because some of your more outgoing, vocal students are answering. Assess your progress by how involved most of your students get. Move around your teaching area, and rephrase questions so more students will respond. Even then, some students will not answer in front of the whole class for lack of confidence, fear of failing publicly, or because they come from a background so different from the majority of the class they do not feel part of it and are too uncomfortable to respond. Sometimes you need to begin with small groups, and when you feel most of the class understands the inquiry, you can work with the class as a whole.

If you set a "climate" of inquiry where students recognize that there is rarely *one* right answer and that everyone's analysis has something to contribute to the class's understanding, a wider range of students can learn in the same classroom with the same activity going on at different complexity levels.

Teachers can hardly deal with all the individual differences in a classroom. But if you are aware of some of the key ones that affect students' work in design, you will be able to make this study more meaningful to more of your students and your teaching will be more rewarding for you. So many of our problems today could be worked out if more people were able to design. With diminishing world resources, space restrictions, and the need for meaningful environments, all people, not just those who appear to be gifted, need design skills.

CREATING ART

PROVIDING A LEARNING ENVIRONMENT FOR CREATING ART

Part Three provides structure for the study of the complex subject of art and its creation. To do this, we must analyze different ways people consider art and its varied manifestations. Considerable effort has been made in the past to separate what artists, designers, and craftspersons do. At some periods the distinction has been clear, at others diffused. Today the same person may be all three or just one. All art is in some degree designed or composed, so all artists are in some degree designers. All designed objects communicate values and feelings, so all designers are in some degree artists. Craftspersons express values and qualities and design the structure of their products, so they are both artists and designers.

Each segment of society has somewhat different ideas about what art is or is not and what contributes quality to it. People are influenced in their choices in art by their culture. They also vary in how much change they will accept. Yet popular arts, fine arts, and crafts all change as people's values change, and these in turn affect styles.

What students do in art classes in schools depends on what the teacher encourages or discourages as art expression, what the students have learned to accept as art, how both teachers and students react to change, and whether they see the class as developing artists, designers, craftspersons, or all of these.

There are two purposes for creating art regardless of whether people consider themselves artists, designers, or craftspersons:

1. *Oneself.* Creating art to express the person's own feelings, ideas, understandings, perceptions, and relationships.

2. *Others.* Creating art to communicate to others, to stress ideas, to clarify issues, to illustrate meanings and relationships, to intensify other people's perceptions of things, and to enhance the quality of their experience.

These two reasons for creating art overlap in several ways. Even personal art must communicate in some degree. Artists who design for themselves may produce objects that have little practical use or function, but may nevertheless have value because they communicate a very subjective interpretation of experience. Every designed object carries a message. The major emphasis on designed objects is on their use, their social function, and their meaning in people's lives. Designers who are very sensitive to other people's needs can produce objects that contribute immensely to the quality of life.

Some people, mainly in the Euro-American tradition, separate crafts from "fine arts" and treat crafts as lesser arts or applied arts. However, the separation is currently breaking down. Pots, weaving, and jewelry are becoming sculpture, and fabric designs are becoming paintings. The emphasis on emotional expression traditionally found in painting, sculpture, drawing, and printmaking is also emerging in the craft media; and painting and sculpture are now being done in nontraditional media, sometimes in those once reserved for the crafts. Many

photographers are considered artists as they use the camera as a medium for creating art rather than recording.

Artists who create mainly for the satisfaction of bringing their own insights and experience into focus produce remarkably revealing and penetrating messages. Artists who communicate mainly to others use more familiar symbols to express their ideas in order to be understood. Occasionally artists do both: their individual insights are so penetrating and the art they create for themselves and the design of their work is so strong that their work is appreciated generation after generation and by more than one culture. Picasso's *Guernica* is a classic example of such art. The message is so strong and his sense of design is so powerful that the images he conceived have reached millions of people.

Some students are engrossed in very personal expression. Others try to master the techniques of communicating in clear, well-known symbols so they can get their ideas across, to contribute socially through their art. Some students design and compose intuitively, some intellectually, some draw on their outer visions, some create from very personal visions from their inner world.

STUDENT NEEDS

Whatever reason students have for creating art, they have some needs in common. First, they need to be motivated to create. They must have, or have searched for, ideas to express and to which they can give form. Second, they need symbols, visual images, and designs or compositions that express these feelings and ideas. Third, they need to find materials that are appropriate for the message. Fourth, they need skills to manipulate the media so their ideas or feelings can be brought out. And fifth, they need skills to criticize what they have done so that they can continue to develop.

These needs and the learning behavior that arises from them may not develop in this order. Students may find an interesting material, and, as they play with it, they become motivated to create an idea that comes from experimenting with the material itself.

Other students may have intense desires to influence people's ideas about some social or environmental issue and be searching for a visual image, a design, and a medium that will bring out the idea. Visual images often require experimentation. Students can borrow symbols, but if they want to create their own visual images, they may have to make many drawings of their ideas to develop one that is acceptable to them.

Still other students may enjoy the patterning of design, filling the margins of their notebooks with doodles and symbols. With some encouragement, such drawings may become complex drawings, paintings, prints, or sculpture, developing the students' obvious love of order and variety into complex art forms. Some students will be much more eclectic and quick to change than others. Some may grow in art expression but stay,

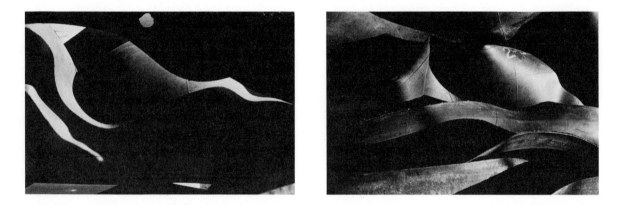

Figure 3.1 3.2 *Rogena Degge. Using the camera for expressing unique perceptions. Inner tubes hanging on a fence.*

as many great artists have done, within one style for a lifetime. For example, if students are using the camera as an art medium, their purposes will vary. Some students see that moment in time when the light, form, contrasts, and relative position of things excite their sensitivity to order and variety. Others search for images to illustrate critical social issues. Others use the camera as a very personal tool for expressing their own unique perceptions of their environment and their experience in it.

Art classes should provide opportunities for students to work for either of the two basic reasons and (1) to increase their abilities to develop ideas, (2) to create symbols and designs of their ideas, (3) to find appropriate materials to use, (4) to develop manipulative skills, and (5) to evaluate their

work. They should gain confidence in their strengths before trying new reasons for making art or using new media. Teacher guidance is essential, especially with students who are insecure in art activities.

Some students can progress the most when they try to express an idea or make something, get stopped by a problem, and then learn the skills in seeing and drawing or designing needed to solve that problem. Other students may need to develop some beginning abilities to see and design before they can get involved in creating art. Generally, students in a given class need to work in all three areas: (1) learning to see more, (2) increasing their designing ability, and (3) developing creative ideas to express themselves, to communicate to others, to create for themselves, or to create for others.

VARIATIONS AMONG
TEACHERS

Teachers of art come from different social backgrounds and identify with different aspects of art. If you are preparing to be an elementary classroom teacher but have limited art background, this chapter can help you recognize the diversity in your children and open up more avenues for creating art in your classroom. You may actually be more flexible in your approach to art teaching than art specialists because you have no highly developed habits and preferences.

If you are an artist yourself, you will need to recognize your own reasons for creating art as well as compare them to the many different reasons your students may have. This should help you overcome a common limitation of art teachers: that is, being so engrossed in their own ways of seeing, drawing, and designing; their own preferences of materials; and their high value on their particular reason for creating, personal or social, that they inhibit students whose development as artists is moving along another track.

In a study of teachers' grading, it was found that teachers tended to give the best grades to students work that was most like their own (Doerter, 1966). Many people who are bound to a certain style and medium learned and succeeded in using that style or medium from an authoritarian teacher. One of the writers was shocked to hear a student telling a new student that "chrome yellow is a dirty word in this class." She recognized her dislike of chrome yellow at that time, but had not realized she had passed the value on to the students.

In the rest of Section Seven, we will discuss motivating, symbolizing and composing, selecting materials, developing skills, and criticizing work in terms of the basic reasons for creating art. Section Eight sug-

gests activities for each area at four levels of complexity, showing ways to help students who have different goals. In Section Nine, we will discuss some of the variations in art behavior to help you modify your handling of each area so that your students can develop in their own way in art.

GUIDING THE MOTIVATION
TO CREATE

Creative motivation is the drive to move in an innovative way toward a goal. Some motivations arise from inner needs. Other motivations arise from outside stimuli. A teacher can arouse students' interests and motivate them to act. But teachers' attempts to motivate and students' potential to be motivated must meet on some kind of common ground for creative solutions to take place.

Art for Oneself

People whose reason for creating art is to express their own feelings, attitudes, and ideas are usually self-motivated, depending very little on others for ideas. The most creative artists are often the least understood by large numbers of the people because their personal visions and symbols break away from the accepted ways of seeing and feeling. The painting by Mark Tobey (Figure 3.3) shows his perception of pattern as more important than people or buildings. It is his subjective view of reality. He dropped the details of images in his later White Writing in which the sheer essence of the patterns of shapes emerged.

Everyone conforms in some degree to accepted cultural values and at the same time everyone does not conform in some degree (Barnett, 1965). Creative artists do more nonconforming than conforming. Although they can never entirely escape their own culture, they often see things about their culture that

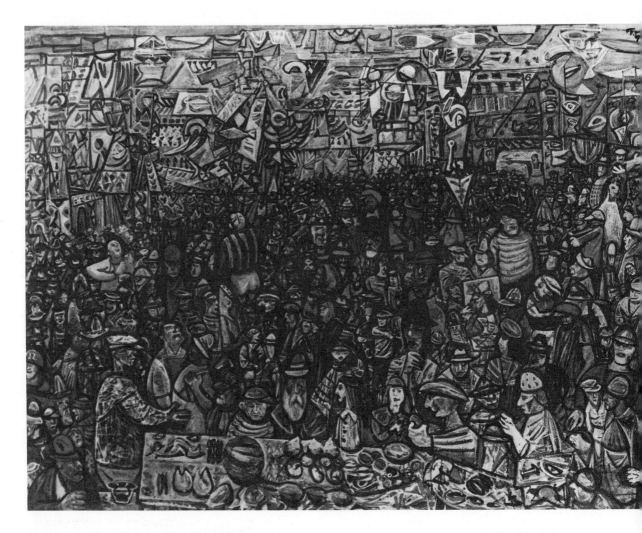

Figure 3.3 *Mark Tobey.* E Pluribus Unum, *1942. Tempera on paper mounted on panel.* (Seattle Art Museum. Gift of Mrs. Thomas D. Stimson.)

other people do not see. Thus, their art is often startling to people who are in the mainstream of their culture and who accept, in large part, the values and beliefs of that culture.

There will be students in your classes who are capable of very personal visions about their society, about the structure of natural things, or who see time and space in different ways. Their visions may vary from pure abstraction to extreme reality, more "real" than photography. The media they choose may not be within the traditions of art media you are used to at all. Their designs may fit within your sense of "good" design or follow a personal system you cannot decipher. Evaluation of such students' work is a delicate and difficult process. In one sense, only they can evaluate. If you can help at all, a communication must develop between you and the students, in which they define and demonstrate the evaluation processes to be used. This is the most difficult kind of evaluation, assessing whether the students are growing and developing in the context of their own expressive mode. Difficult as such evaluation is, it is worth doing, for it provides these very interior people with an outside reference point and stimulus for their art that is ultimately more helpful than the "anything goes if it's mine" approach.

Some students may want to be expressive but lack ideas. They may have been brought up on mass media, on vicarious, stereotyped experiences of other people's lives. They find out when they try to create that they are not in touch with their own experience and that something very dull or "plastic" results. Such students may need a chance to reflect on their experience, to stop and look at what has meaning for them. As a teacher you should provide them with experiences that stimulate thought and arouse emotions.

The still camera can be a good working tool to open up the vision and to suggest creative ideas. Photographing a place as used by many different people, a place in different lights, the same person at different times in a day, and the same place or thing from many viewpoints can help students break out of stereotyped ways of seeing, feeling, and thinking. But they must do more than take pictures. They have to analyze what is going on in the scene they photograph, what values people show by the way they treat each other, or the ways a place is treated by people.

If a camera is not available, students can perceive things better if they simply record what they see in a sketch. The better students can understand emotions and the various situations that result in different emotions, the more they will become aware of their own potentials to be sensitive human beings and sensitive artists.

Art for Others

If students' main purpose in art is to express ideas to others, they need to create visual images that convey the meanings they want to express. There will be some students who have very clear ideas about what they want to express to others through art. But other students need specific motivation. If the teachers know enough about their students' interests, values, and curiosity, they can encourage the motivating forces students already have. If teachers only provide students with art materials and ask them "to create," many student efforts will be mainly manipulative. Their messages will be shallow because they will not have been encouraged enough to clarify and articulate their concerns so those concerns can be communicated through art. Even students who know they want to communicate to others through their art may not realize how

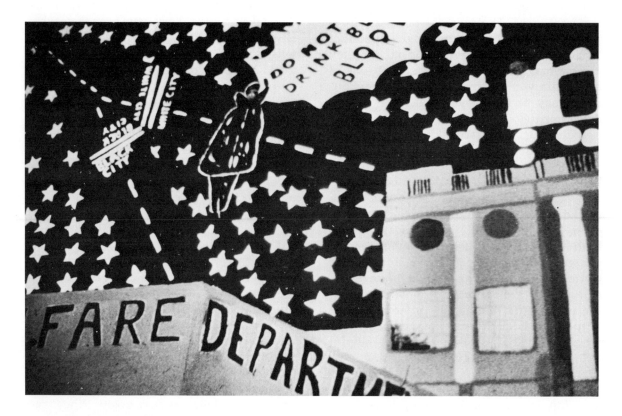

Figure 3.4 *Mural detail, 1969. Mexican-American junior high school students in California expressing their feeling about social conditions.*

much impact they can have. They can be motivated by hearing others' reactions to their works. Such reactions help them clarify their ideas and sharpen the way their symbols and designs carry the message.

If the students are concerned about designing objects for other people to use, have them analyze the uses, functions, and messages that objects can have in people's lives. The emphasis may be either on the ob-

ject as an art message or on the object as a useful thing.

Often students lack ideas or experience with things they can make for others. The teacher can help by asking questions to get students to think about the things other people need and use. Small children often relate most to whoever cares for them; older children to their peers. The right questions can get them to watch what people do to find things they need. Then they can choose which things they can make. The questions need to be geared to the students' own environment.

Is there someone at home who needs a space to put buttons, pencils, needles and thread, nuts and bolts, or letters and bills?

What shape would the space need to be?

What can you make the outside of the space with?

What colors does that special person like?

What colors are in the room it goes in?

Does the person like more variety or more order?

How can you make it look like what it is to be used for?

Then, as they plan, you can ask questions about the need for other art elements like texture and line so the container will look like it is for that special person in the special place they live. Such questioning can lead students to get their own ideas to solve some other person's need if you open up the discussion to other kinds of objects and situations.

Art Itself as Motivation

Students can also be stimulated by exposure to the work of other artists, particularly if you are careful to provide many choices of art and many approaches to it. Some artists' reasons for creating art may appear similar to

Figure 3.5 *Renè S. Pfund.* Soft Sculpture. *The artist is a Portland, Oregon high school student. Exposure to the soft sculptures of Claes Oldenburg or to Duane Hanson's fiberglass, lifelike sculpture of* Woman Eating *may have influenced this student's work. (Teacher, Ann Cowyer.)*

theirs. Subjective, personal paintings, sculptures, or films will stimulate some students, more public works in which the artists and filmmakers use more recognizable symbols will appeal to others. Very personal crafts will appeal to one group. Crafts designed for others will appeal to and motivate others. But if you are working with students of limited background, you need to begin with art that has some meaning for them, whether or not you particularly like that kind of expression.

Art must relate in some way to the students' own experience to get their initial attention. Once they are paying attention, they need encouragement to keep attending to and absorbing detail. Many are limited in their perceptual development, and they will see little even with encouragement. Students who have learned to see and who have drawn to see can absorb more information than those who have not. But by asking the right questions you can get many students involved in responding. Start with questions that are calculated to make them aware of what they are experiencing as they respond:

What do you see when you look at this picture (film, etc.)?

What is your experience like when you look at it?

How does it make you feel?

Then use questions that make them do more thinking about what is there:

How does the design affect the message?

How do the materials the artist selected affect the way you see and feel in looking at it?

Does it look different to you after you have looked a long time?

What do you think the artist thought was important?

Does the work tell you anything about the artist, where or when she or he lived?

What kind of a space or place fits with the work of art?

Later, when they know more about the work, ask them to re-analyze their experience. All such questions can help motivate students to develop their aesthetic experiences in viewing art and in evaluating their own work. Such inquiry needs to go on throughout art education. Each new work observed provides new opportunities to respond.

GUIDING THE DEVELOPMENT OF SYMBOLS AND DESIGNS

Ideas and feelings in art are expressed through symbols. Many students yearn to create in some way but have never tried to create symbols to express their ideas and feelings, and doubt that they can.

Art for Oneself

It is commonly assumed that people who are individualistic in their perceptions and ideas need no motivation, that they have the ideas they need and already want to give expression to them. But there are reflective, introversive children and young adults who have never had the opportunity to express their deep concerns and feelings. Their particular vision may have been rejected or ridiculed by earlier teachers or other adults, or they may have tried and failed and felt frustrated and unartistic. The teacher's difficult task is to keep such students from getting discouraged and to maintain their inspiration as they experiment with symbols and designs to express their feelings.

Such students may find it helpful to make many sketches or models and then choose the ones that most clearly express their feelings or ideas. Sometimes sketches

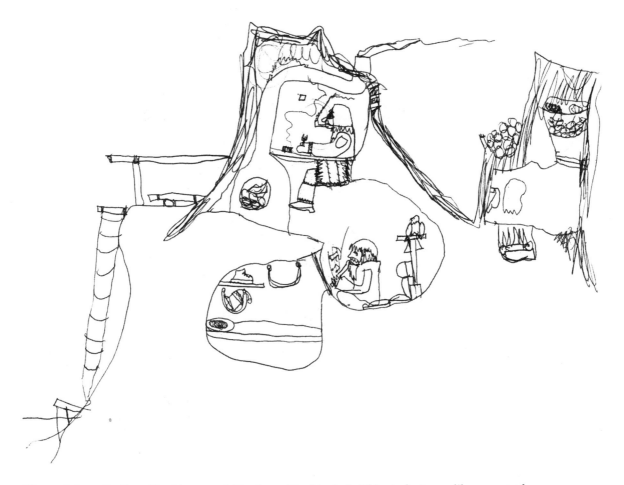

Figure 3.6 a. *Geoffrey Hawkins, age 9 (Spokane, Washington). This student uses likenesses and differences in expressive symbols to order and convey ideas.*

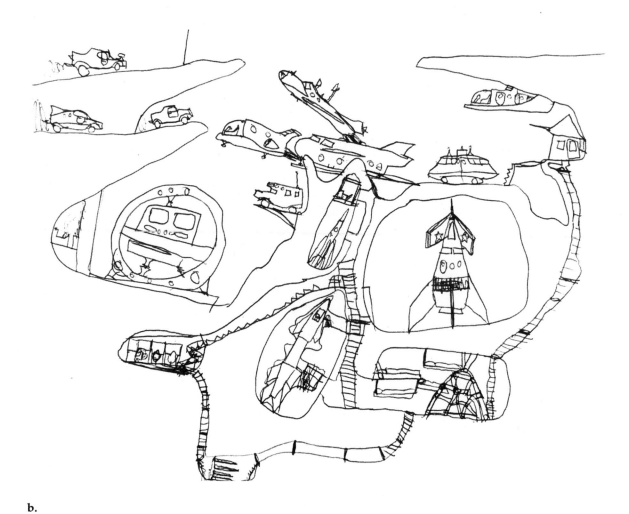

b.

need to be put aside for a while so they can be seen fresh. This fresh look may help students organize their ideas or see them in new and more meaningful combinations. If they try an ambitious project and fail, they will need your help in identifying what parts of the work have succeeded, what they learned from trying it, and what can be salvaged from it.

Many students who can create expressive symbols for things need help in seeing that their whole composition or design is part of the message. You as the teacher can give them technical help: encourage them to analyze the ways they have grouped things, the ways they have used colors, and the ways likenesses and differences are used to bring out their ideas. Students often need encouragement to *really* look at what they have expressed to see if it says what they feel. Since an idea can be ingrained, students must learn to become objective about their art and whether or not it really expresses the idea. If they decide that the idea is not being expressed, they may want to abandon what they have done and try again, or, if the medium allows, modify their work. They can re-evaluate their work after each change.

Introversive students get their main response from the work itself while those who want to communicate to others evaluate their work in terms of how the message is received.

Art for Others

Students whose main concern is to communicate to others may have quite clear ideas about what they want to say, but some may need to do a great deal of thinking and planning and get a great deal of encouragement to get their ideas expressed in a visual art form. Sometimes the most verbal students who have been the most successful in other school work have the most difficulty

expressing their ideas in an unfamiliar, symbolic way. They want to communicate, but think about their message in words and need motivation to make the transfer to visual expression. Such students will need to overcome their fear of failure in trying something new, and they will need plenty of time for trial and error if they are to communicate visually. They should be given time as if they were learning a new language—that is just what they are doing. They have to learn to design, to analyze, and to organize with visual symbols. They may have tried before, but, not succeeding, assumed they just weren't "artistic." Neither they nor their teacher may have realized how much time and effort they needed to get over this hurdle. But such students can learn to be visually expressive and, when they do, often have a great deal to say through art.

Students who have observed things from many views, in many lights, and from different angles and then made abstract drawings of the essence or basic nature of these things usually find it easier to make symbols of their more subtle feelings and ideas than students who have not had this experience, whether they want to create for themselves or for others.

GUIDING THE SELECTION OF MATERIALS

School art budgets obviously vary, and classrooms vary in the range of media and materials that can be used in them at once, but concerned teachers rarely have everyone working in the same medium at the same time. Choices must be available, because an important part of an art object's effect is the way the medium fits the message. Students' messages vary widely. The expressive qualities of the symbols and the design or composition are enhanced by the materials used to express them.

There can, however, be too much emphasis on media. Many art programs have been based primarily on media. Our review of art curricula of the last fifty years shows a preponderance of courses based on media use and not enough on art creation. *Students are presented with a medium and then have to search for ideas that will work in that medium rather than working on the symbolic expression and design of their ideas and feelings and then finding media that fit.* This approach has tended to produce many adults with technical skills but not too much to say through their art. Students do need opportunities to explore media, to develop confidence in using them, and to understand their potentials for enhancing the expression of ideas. But the medium chosen should not become an end in itself.

Art media vary so much in qualities that they add to the expression of ideas. Many woods have textures that are open and organic; plastics by contrast appear sealed and molded. Both can be used in many shapes and forms. But a hand-turned wooden bowl and a similarly shaped, molded plastic one express different qualities. Wood, fabrics, film, paints, metals, clays, and plastics all have distinctive characteristics, but each can be used in many different ways. The tools and equipment used to paint, carve, build, weld, bend, weave, model, or photograph all produce different effects and each tool can also be used in many ways. For example, paint can be laid on with a palette knife in thick layers, used as washes or textures with different soft or bristle brushes, sprayed with pressure, and/or smoothed with brayers or rollers. A welding torch can not only weld, it can be used to burn, melt, smooth, and texture woods and metals. Students need to be able to see how other artists have used these media, but they also need to explore with them themselves in order to evaluate which fit their ideas at a given time.

Students who have succeeded in one medium may want to use that medium over and over again. If you think they should move on, choose a time when they become dissatisfied with their results, for then they will be receptive to evaluating how their ideas fit with the medium. If they find the two do not fit for this project, they can be encouraged to explore the qualities of other media to see what might work more appropriately.

Ideally, all students should be able to analyze the visual qualities of the ideas and feelings they want to express, to analyze the properties of different media, and to select the media that most enhance their expression. Ideally, too, students should not be limited either by their own habits or by the choices of materials available to them. When budgets are limited, you can keep students from wasting materials without inhibiting their creativity. And if students have learned to identify the physical qualities they need in media, they can find these qualities in recycled or recyclable materials as well as new ones.

For example, take your students to a park on a warm day and have them stretch out on their backs on the grass to watch for things that fly by. Flies, bees, butterflies, dandelion seeds, clouds, birds, and jet trails will move across their vision. Many of the students may want to draw their impressions so they can show other people what they saw. A few of them, enthralled with the experience of lying on the ground and seeing the sky from a different viewpoint, may want to capture and express the experience just to savor it themselves.

The media needs of the students who want to share what they saw will be different from those who want to re-create it for themselves. The first group could select drawing or painting materials. The second group might want to make a three-dimensional ob-

ject, which expresses what they saw more concretely. A young child might collect fine straw and dried corn silks, tie and bend the straws, and glue on bits of cotton or corn silk to make a flyaway object that would catch the breeze as the dandelion seeds did, repeating the original experience. An older student might create a wire sculpture that though physically fastened would look lighter than air. A young artist from the first group might create a painting that expresses the feeling of layers of experience: the hard, slightly damp ground, the feeling of lying on it, the sun warming and the wind blowing, and the objects that floated across his or her vision. This would be a difficult problem to solve, probably requiring much time on the student's part and quiet, patient encouragement on the teacher's part.

The teacher's task here is *not* to provide straw, dried corn silks, and wire and show the students how to make dandelions but, rather, to help students identify the visual and expressive properties of the materials they need to express their ideas and to encourage them to find materials that will work. A collection of storable materials as well as art media will provide students more alternatives, but *they* need to seek them out.

Individualized instruction of this sort demands a lot of flexibility from teachers. Not that they need to be able to do everything with all media, but they do need an experimental attitude, humility enough to learn along with their students, and basic experiences with unfamiliar media.

Students can use many different criteria in selecting what materials they want to use to make things for themselves or others. Though they may unavoidably be limited by what is available at a cost they or the school can afford, they may be needlessly limited by the properties they can see in a material. If they are encouraged to experiment with media to see how many ways they can make

them work, they can have more choices with fewer media. If students are very creative and expressive, they may use materials in ways that are inappropriate for use but valuable as expressions of ideas. If the products are to be physically used, then the selection needs to be thought through in terms of the particular use, the social function the object will have, the meaning the material may convey to the user, and the way the material will hold up under use in a given kind of environment.

For example, two students might be making boxes. One wants to express the opulence and overdecoration of modern society and make her box of sheets of styrofoam which she pierces with all kinds of brightly colored sequins, pins, beads, and hair ornaments. The other wants to build a strong box to keep a coin collection in. Certainly the first student's box would not hold up with use as a container, but, as an expression of an idea, it can be very effective. The other, because of its need for strength, would look, as well as be, strong.

DEVELOPING SKILLS TO MANIPULATE TOOLS AND MATERIALS

Students whose motivation in art is expressing their own unique responses often have the most difficult time learning techniques and skills, because they are so much more interested in their own feelings. Many of them will not like to follow set directions for using a specific tool or medium. The teacher should encourage their exploratory efforts with information about the limits or possibilities of tools and materials. Such students will tend to use their sense of feeling in using tools. To experiment till they are satisfied is a form of practice for such individualists. They are getting feedback about what

Figure 3.7 *Carving slate. Ninth-grade student developing skill through a need to control the media.*

does or does not produce the results they want, and from such manipulation they learn skills. These skills go with their need for expression and may not fit a teacher's preconceived idea as to how a tool or material *should* be used. But if it works for the student, it can be accepted and rewarded. Skill is only a means to an end, not an end in itself. For example, many teachers still think of crayons as they do pencils: tools to be slowly worn

with use on one end. They are disturbed if children tear off the paper, use both ends, break them, or use the flat sides to mark with. The child who can use a crayon several ways is developing more kinds of manipulation skills than the one who uses it like a pencil, and has more choices in using it expressively.

Sometimes students stay with a tool or medium for a long time, only because they have developed enough skill with it so it works well for them. Other media might be equally satisfying or even more satisfying if they would try. Your task as a teacher is to get them to try something new, and to succeed in using it. You can introduce a new medium to the whole class by using it yourself in different ways to express different qualities and then by encouraging the students to experiment as well. In such a situation the students can adapt the medium to their own ways of working.

Other students who are also mainly interested in expression for their own sakes may go from one medium to another and never be satisfied with the results. Such students can be helped by encouraging them to analyze what it is about the media or tools they like and what they do not like and then by trying to find which tools or media combine the best potentials for them.

Students whose main desire is to communicate to others may generally be open to working not only with a variety of tools and media but also in more depth until they can get their message across as clearly and with as much emotional and visual impact as they want.

A common characteristic of children who have had a great deal of variety in their lives and who have been entertained by a barrage of media is an expectation of immediate results. They may need encouragement in staying with a tool or medium until they are effective in using it. But forcing such

a. *Tin cans, pliers, vinegar, and abrasive cleanser.*

Figure 3.8 *Jewelry with simple tools and materials.* (Courtesy Marie Rasmussen.)

children or young people to stay with a tool too long can turn them off. Conversely, a constant barrage of new media and new tricks may keep them busy, but they will not

students want a wooden object to express boldness, strength, and stability, they will have to practice using cutting tools so that the strength of the wood shows. If they want the object to be delicate, graceful, and ornate, but still have the natural qualities of wood, they will have to select a wood that is easily carved yet strong enough to hold together in small parts. Such students must develop skills in using fine-carving tools, gouges, and chisels so the delicate effect will show. The medium and the skill must be related to each other in all art. Almost every basic art tool—brushes, crayons, pens, chalks and charcoals, knives, gouges, scissors, and even cameras—can be used in many ways and with different skills to achieve varying effects. The skills needed will differ not only for each tool and medium but for each way they are used to express ideas.

GUIDING STUDENTS' SELF-EVALUATION

The ability to be objective about one's own work—to look at it as if it were someone else's—and to evaluate it as if it were not one's own is critical for continuing development. Teachers must be alert to students who are not learning from their evaluations, but who think that the fact that they created something is all the evaluation they need. One way to deal with this situation is to present such students with a series of their works and ask them to describe their growth. They may see the stagnation of their efforts. Encouraging them to select parts that are more effective will make them think about their own work more objectively. This simple sequence can lead to changes in their creative work.

Students who want to communicate to others will probably vary more widely in the ways they evaluate their work than students who create art for themselves. Some may be

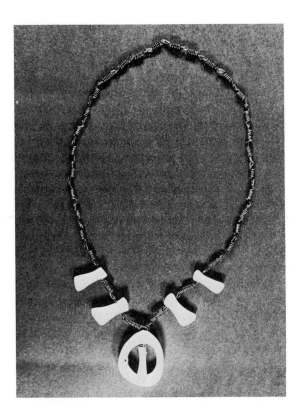

b. *Wire bent around nails and sawed bone.*

grow in communicating effectively.

Students who are going to design and make products for others should develop their skills in using media and materials in relation to the qualities they want to express and the nature of the media. For example, if

as strongly self-evaluative as those who create for themselves; and some may be very open to the evaluation of others if it is supportive, but may be resistive if the evaluation is critical. Still others are very open to evaluation and can learn from it without fear of giving up their own ideas and feelings. Some students may be very objective about their work and sensitively evaluate their progress. The teacher's role is to provide a psychologically supportive environment and to listen to students' evaluations. Students may ask your opinion. This is your opportunity to suggest other options for expressing their ideas. Several kinds of evaluative help may be needed. Different aspects of student work often have to be looked at separately:

What is the key message?

Have you studied the things that motivated you to create this message enough to clearly express their qualities?

Do the symbols you developed carry the message clearly?

Does the nature of the design help convey the message?

What part of the design is strongest: shapes or form, colors, textures, lines, or spaces? Is there enough order and variety to carry your message and stimulate people's interest?

How effective is your selection of materials and your skill in using them?

What have you learned from this evaluation that will help you in your future work?

If the work is for someone to use, then the evaluative criteria in design can be added:

How well does this object fit the life style of the person for whom it is designed?

What will its quality say about the identity of that person?

How well will its structure and its materials work?

The paradox in art education is that the creation of art is private, but its value lies in its being made public. Art should be valued privately, so that students who develop their art more privately do not have to wait for the teacher's or the class's evaluation to evaluate their own art. Those students should be encouraged to reflect on their own work until they want to share it with others. Then their work should be displayed and evaluated.

One great value of art is that it objectifies experience so that artists grow and develop and see their development. Encourage students to display several works—some that were done early in the class and some done later on—to show how they have grown and what important changes have taken place in their work.

The following art activities are suggested for differently motivated students at different levels of art development. Remember that you may find young children who are quite advanced, and young adults who are just beginners.

ART ACTIVITIES

LEVEL 1
INTRODUCING ART TO
BEGINNERS

Becoming Familiar with Art Materials

Art is often taught with an emphasis on materials and lack of emphasis on the *idea* to be developed. These activities stress ideas, feelings, or concepts and make the choice of media or materials dependent upon the expression of ideas.

But students need experiences in various media and may have satisfying experiences manipulating media until an image or idea emerges. For example, a student may construct a form out of a variety of sizes and shapes of wood scraps by analyzing the pieces and how they can be combined. Through this experimentation he or she may arrive at an idea and work toward it. Others may prefer to work more intuitively. In either case, they will make personal choices regarding what they prefer visually, what kind of organization pleases them, and what kind of design works visually and structurally. Experimenting with media helps students learn about new materials and that the choice of materials will affect how the idea will take its final form.

Many students at Level 1 will have had few opportunities to explore various media and may have to spend some time learning about them. Discovering that tempera paint, for example, results in a different visual qual-

ity than watercolor or that clay will result in a very different form than a printing process will allow students to visualize how to formulate an idea more completely by keeping certain media in mind. This information will become increasingly important to students as they move on to Levels 2, 3, and 4.

Primary-grade children can mix dry tempera with water, acrylic base, or liquid detergent. They can use bristle or hair brushes, brayers, sponges, combs, tooth brushes, cardboard strips to make different kinds of marks, on rough and smooth paper. With the detergent they can use fingers, hands, and arms to paint on shiny paper or glass. Have them compare what it feels and looks like to use tempera in all these ways. They may not be satisfied with painting abstractly but may want to use the paint to tell about something they know or see. Older Level 1 students can begin by comparing watercolor and tempera. Have them do any or all of the following: use each paint thick and watered down, overlap two wet colors or a wet color over a dry, mix and paint groups of similar colors and groups of contrasting colors. They can try different kinds and sizes of brushes with each paint on different colors and kinds of papers or on fabrics and cardboard. On glass, plastic, or a waxy surface, they can use their paints as mixed and then add a little soap to the paint and try again to apply it to different surfaces. Students may focus on overlapping paints of various consistency and color. Encourage them to explore all kinds of brushes and

Figure 3.9 *Analyzing pieces of wood to see how they might be combined in order to arrive at an idea. Mark Marxer (l) and Mike Vanderzanden (r).*

various papers and other surfaces. These can be coordinated with painting about a special idea, using their new media discoveries to develop the idea. Another time can be devoted to moods or other expressive words. If you have an independent group of students they may be able to do much of this exploring with minimum direction from you. More dependent students may need encouragement with each new experiment.

Their results can be discussed as a group and individually:

How does each paint change when water is added?

Which paint (watercolor or tempera) seems more powerful? More delicate? When? Why?

Which paint lets the paper show through?

When you paint thick, red tempera over blue, can you see the blue through the red? Can you see the blue under red with watercolor? Does it depend on the amount of water? What happens when you combine other colors?

Is dry watercolor less intense than tempera? Can you get a green watercolor as intense and bright as green tempera when dry? How much paint do you need?

When two wet tempera colors are overlapped, what happens? In watercolor?

What happens when you add a little more white to a color each time you paint a splotch of tempera? More black? How can you lighten watercolor or tempera if there is no white?

Does blue tempera show on black paper? Does blue watercolor? What colors show up a lot on dark paper, on light paper? Which colors are more subtle? Can this help you express a mood?

How much water and paint do you need to make a long thin line? A wide heavy line? A dry brushed line?

What kinds of brushes did you use? How does a stiff bristle brush compare to a soft one when you use thick and thin paint? Can different lines express different moods?

Which paint is more suitable for cardboard, for newsprint, for newspaper if our desire is to cover it completely? What effects will result using watercolor on newspaper?

What happens when you paint on glass or on crayon? Does it bead up? Why? Does adding soap to tempera help? To watercolor?

What colors did you use to express happy, sad, frightened, excited, and dreary?

Why do some people select different colors than others to express happiness? Does happiness mean different things to different people?

Figure 3.10 *Imprints in clay. Choosing a technique to increase the means of expression. (Molly Albert.)*

Give students time to discuss various results to help remember what they have done and to choose techniques that can increase their means of expression.

This kind of exploration can be extended with the various media available in your

classroom. Clay, for instance, can be squeezed or pushed into a form, rolled into coils or into flat slabs, cut, drawn on, or imprinted with designs. Give each student a piece of fabric and one of plastic and discuss the visual and tactile characteristics of each: how they are similar and different, how each material can be changed by draping, melting, or ravelling, or by holding, absorbing, or repelling water. Ask the students what they might do by cutting, folding, stitching, weaving, gluing, shaping, ironing, tearing, or stretching. By experimenting, students will discover many expressive qualities possible with a single media.

Learning about new materials and what they can do should be an on-going process at all levels. What is selected depends on students' abilities to handle and control materials and tools. For example, woodcarving is inappropriate for very young children because of the strength and control necessary to use sharp tools. Knowing the past experience of your students and watching them as they work will help you determine what media to introduce.

Creating One's Own Images

Students who enjoy being by themselves, who look within themselves rather than to others for their concepts and feelings usually need little help from teachers to express ideas through art. But many students who want to express themselves have not had opportunities or encouragement. They may need help in creating symbols, in selecting suitable materials, and in developing skills with media to express their ideas.

If all students in class do not participate in this activity, choose a time of day when the others can work quietly so there will be minimum interference or distraction for the more subjective students. Discuss with your group how we sometimes cover our

eyes and ears when we want to think about something very important. We search for a quiet place and then shut our eyes so our thoughts will not be interrupted by what we may see and hear. We are then able to concentrate more easily. Ask the students to try this. After a while you can ask questions:

When you lie down to rest, do you think briefly about different things?

Are these thoughts about things you've done, want to do, or need to do?

Are some of your thoughts fantastic? About being able to fly without wings? Performing heroic feats? Seeing imaginary creatures? Finding something special?

Discuss their responses to these questions so they will become more open to their fantasy life.

Have a place where students can rest their heads or their entire bodies and ask them to shut their eyes and ears to what is going on around them. Without structuring this into a ritual, provide students with time to be reflective by softly asking questions that stir their imagination:

What is the most wonderful idea you can think of?

Imagine the way your idea looks. Is it a rough, shiny, or smooth kind of an idea?

Think about all the colors your idea has.

Watch the way your idea changes as you think about it.

What kinds of lines (shapes, colors) does it have?

Your task is to help them transfer words and feelings into visual images.

Encourage them to draw their ideas over and over and then select the ones they like the most—that most express their feelings—to develop further. For example, they can draw their ideas in great detail, paint a tempera or watercolor picture, construct them

of clay, wire, or papier-mâché. Some students may want to use all their images.

The emphasis is on allowing students the time to attend to their own private thoughts and feelings, to record and render them visually. Some students may want to keep working on an idea for several days or even weeks. This kind of activity can be repeated many times. The students can do variations of this activity by writing down their images, composing poetry or prose about their images, and then drawing or painting the feelings they have about them. Show a film or bring in an object to class that you think would interest them and then encourage students to paint or sculpt their own reactions to it. When you find a student daydreaming, ask for a drawing to express his or her thoughts rather than force him or her to pay attention to what the rest of the class is doing.

Encourage children to keep a collection of the drawings and paintings they like most. Encourage them to go over their folder often to see how their imaginative ideas and their art are developing. If some feel they are not growing, give them more opportunities to talk about what they think and feel and help them find ways to express those thoughts and feelings. Point out how they have developed in their art and encourage them to go on.

Creating Expressions of Self

People make self-portraits for various reasons—to capture a personal self-impression, to encourage self-awareness, to increase their perceptions of their visual characteristics. In many art classes students lie on butcher paper, outline each other's bodies, and paint in their own features, hair, and clothes. Although this activity allows for some degree of self-expression, teachers often present it for *all* students without considering the possible negative effects. Students who are overweight, who have physical defects, or who differ from their classmates socially, psychologically, ethnically, or economically may find self-portraits accentuate their differences at a time when they most want to be like everyone else.

The following activities will appeal positively to more of your students by pursuing self-portraits that allow for personal expression or what they do with their bodies rather than just their physical images. These activities should be presented as voluntary rather than as required ones. If you have a class of emotionally and physically healthy students, they may all choose to participate with great enthusiam; however, you may see obvious reasons among your students for not introducing the activity at all. Introduce the idea to students by asking them a few questions:

How small a space can you take up?

How far can you stretch? What is the difference in the way you feel when all your joints are folded and when they are all stretched out?

How big an arch can you make by bending backward at your waist? By just bending your head and neck?

What do you hear and feel when you stand absolutely still?

Are these feelings part of you?

Wait for only a few answers to each question before explaining that they can create images of these different movements. They can lie flat or in an action pose on a piece of butcher paper and have someone in class trace around them. After later discussions, they can fill their silhouette with various images, some of which may express the action they are taking in that pose.

Ask them to discuss what kinds of experiences they have with their noses, eyes, ears, mouths, hair, and cheeks:

What do you do with your nose? Does it change its shape when you sniff? Rub it? When you breathe deeply, does it feel the same?

What do you do with your mouth? (Taste? Chew? Whistle? Talk? Yawn? Yell?)

How does your mouth change when you are angry? Happy? Hungry?

What do you do with your eyes? (Blink? See? Cry? Wink? Frown? Show you care? Close out the world? Are surprised?)

What do you do with your ears? (Listen carefully? What can you hear? Can you wiggle them?)

Avoid making your questions too directive. The parenthetical responses above are only to help you supplement students' responses. Allow them time to think. Instead of having them draw their features, let them make small images in the outlines of their heads of what they like to do (e.g., watch butterflies, taste hot chocolate). Emphasize that they are making visual statements about themselves which are clues about what they do and like.

Encourage the students who want to draw large figures to use bold, colorful materials like brightly colored crayons, chalks dipped in water, felt pens, or other tools to draw their images so that they can be seen from across the room. Others may want to work with more detail and subtlety so that their images are viewed only by close, careful examination.

If students use crayon very boldly throughout their self-portrait, they may wish to use watercolor washes over various areas of their self-portraits to increase the visual impact when seen at a distance, and perhaps enhance the crayon-drawn images. If the images are done with water-based felt tip pens or other tools, they may wish to boldly outline their traced silhouettes and cut them out with scissors.

Use the same procedure when students are ready to draw the arms and hands:

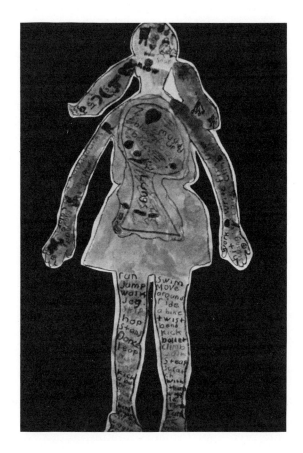

Figure 3.11 *A six-year-old's expression of self.*

What do you do with your hands? Your elbows? The forearm? (Swing a bat? Squeeze a sponge? Sweep? Caress a puppy? Model with clay? Use them for support when resting or to do gymnastics? Swim? Shake things?)

Have them discuss what they do with their arms and hands. In these portions of their traced figure, let them draw images of things they like to do with their hands and arms. Large and small images can fill up these areas. Some students may even want to fill in or trace and fill in their fingers with the tiny images of what they do with their fingers, such as print, give directions, dial a phone, count, and draw. Let them decide on the images to include.

Some children may be interested in drawing their internal systems. Encourage them to imagine what they think is going on as they breathe, as their blood circulates, or as they consume energy running, dancing, stretching. Let them find their own direction. Try to encourage their imagination rather than providing an anatomy lesson.

Have them fill in the legs and feet of their traced body as they did with their arms and hands. Ask questions about what they do and like to do with these parts of their body.

Some students may want to include a few words here and there, and sometimes using a word instead of an image may be appropriate. However, they should be encouraged to increase their abilities to visualize through symbolic imagery rather than to reinforce their verbal skills. Students with visual as well as verbal skills will be more adept at expressing themselves, will respond with more diversity and creativity, and will increase their ability to communicate and interpret the visual communications all around them.

Some students may prefer to work on just the face of their self-portraits rather than the whole body. They are not body-oriented and are unaware of themselves as physical organisms. Your role as teacher is to encourage students to take different approaches. Although the portraits are for themselves and some students may not want to share

their portraits, many will enjoy talking about themselves and learning about their classmates.

Because students vary in interest and attention span, they should determine their own pace for completing their self-portraits. We caution against compressing these experiences into a short time because students may not have ample opportunity to explore each area.

Variations of these experiences can be repeated throughout the school year. For example, they can:

1. Bend and shape wire to express their different bending and stretching actions.

2. Draw with felt pens or paint designs on T-shirts that accentuate how their arms will stretch or bend.

3. Paint a composite body portrait showing all their possible actions drawn one on top of another.

4. Paint what they imagine their body functions are.

See how your students grow in such a series of experiences by comparing a drawing of themselves before and after the activities. If the later portraits show much more detail, movement, and expression, they have learned a great deal about themselves, about expressing their feelings and ideas in symbols, and about seeing themselves in new, less stereotyped ways.

Conveying Ideas and Feelings to Others

Begin by covering the words of single picture cartoons and asking students to tell what they think the pictures are about. Discuss how images can tell stories, how artists talk with images instead of words. Students will interpret the cartoons differently and will discover that images say dif-

ferent things to different people, depending on each person's experiences. Discuss how the selection of images to convey the ideas must be done carefully, depending on the intended audience and its familiarity with the images. Uncover the written caption and show how the artist guided the viewer to a particular idea with words as well as images.

The backgrounds and experiences of your students should determine the pictures you will select. Students of various ages respond to well-designed posters. Older Level 1 students could view a slide of Picasso's *Guernica.* Ask students to interpret the message and then explain how the artist used symbols and art elements to sensitize other people to his view of war. Discuss how this painting tells people about a personal concern through images and encourages them to develop their own ideas and feelings on the subject.

Then let students become personally involved in thinking about messages or feelings they would like to convey:

What is the message?

How can you express it so people seeing it would feel the way you do?

Do you think you can change the way they think (feel or act)?

How can you say it without words? Can it be done with images, symbols, or pictures that form an idea or feeling?

Have students select a person or group as an audience and provide them time to make some sketches of images that express what they would like to convey to this audience. Students without ideas may need questions to get them started:

Who does things that interfere at school?

How can we make them aware of what they do?

What do we all need to do to make school (or neighborhood) a better place to be? What messages would remind us?

Other students may have many ideas but need help visualizing them. Encourage them to think about one idea at a time and draw representations of that idea. As students are rendering their ideas, remind them to think about *who* their message is for. Are they using symbols or images their audience will understand? Discuss how color and line can suggest happy or gay moods or convey sadness, excitement, fear, and how they can use those elements to make their message carry greater impact. Draw a variety of curved, jagged, straight, and broken lines on the board and discuss which lines suggest specific moods. Students can analyze what feelings can be conveyed with one color or groups of colored papers, or they can see how color and designs suggest certain feelings or moods in fabric.

When they have a collection of sketches, let them select one or more to render or combine in the medium of their choice. Discuss with them the possibilities of using different media and how, for example, a detailed pencil drawing conveys a different kind of message than a large, colorful brush painting. If they have had little media experience, allow some time to explore how watercolor, crayon, tempera, clay, or other available materials might affect the development of their message. Some will want to try new, unfamiliar media; others will feel more comfortable with a familiar one. Experimenting with various media will give students a greater range from which to select and the chance to develop their ideas with greater satisfaction.

This activity can be later expanded using magazine pictures and phrases focused on a specific idea and combined in two- or three-dimensional collage forms. Also, se-

lecting one word and developing a visual statement on fabric, posters, or through sculpture will increase students' ability to communicate through art.

As each work is completed, give the class the opportunity to discuss the images, the message, how the person used media, color, and line to help convey ideas to others, and which audience they feel would be most interested in the message conveyed. Help each student personally analyze his or her completed idea by considering what the original plan was, how it developed, and which qualities are the strongest and why.

LEVEL 2
EXPLORING EXPRESSIVE
QUALITIES

Exploring Relationships
Between Media and Ideas

Some students may be at Level 1 in familiarity with various materials and at Level 3 or 4 conceptually, having developed most of their ideas using two or three media. However, most students will have used different materials in many ways but will not have had the opportunity to understand the important relationship between materials and ideas. Level 2 students should become aware of how their choice of media will, in part, determine how their ideas may be expressed. For example, select two or three of the artworks used as examples in the activity *Expressing Moods and Feelings* and have students list what ideas are depicted, discuss how the ideas might be done in another medium, and what changes should be made in the design and the subject matter.

Have students now try an idea in different media, and ask them to compare how the message is changed by the medium. Ask students to develop the same idea through contrasting media. One may be a printing process, the other, clay or paint. Some may wish to use film, videotape, or photography as one approach and woodcarving as another. You can help them see that different aspects of an idea can be emphasized in each medium because of its characteristics.

Expressing Moods and Feelings

In these activities, as with many others throughout the book, you may want to include the entire class in discussions of their experiences, feelings, and perceptions, and then provide opportunities for creating art for interested students. Other students' work may later show the influence of these discussions.

One way to encourage students to create art for themselves is by analyzing common experiences they may all have had:

What does it mean to have moods?

Do people always have the same kinds of feelings or moods?

What different kinds of moods do you think people have?

What does the word mood *mean? (A state of mind in which an emotion prevails?)*

Is it beneficial to express your moods? Is feeling exuberant, joyous, or playful a mood?

Can we be reflective, quiet, curious, concerned? Are these moods?

Are some of your moods more special or noticeable than others?

Can the mood we are in make us feel differently than the other people around us?

Do things on the outside change how we feel inside?

Does going to a different place change our mood?

Do your moods change with the weather? The time of day? Because of things that occur around you? Because of what you do or what others do or say?

How many kinds of moods can you identify?

Can you describe different moods you've experienced?

List the different kinds of moods your students name, and encourage them to discuss why some are more noticeable than others. Discuss how moods are an expression of emotion. Then present some examples of art works that depict different moods such as Seurat: *Le Chahut,* 1889–90; Picasso: *Woman Weeping,* 1937; Ernst: *Les Obscures,* 1957; Shahn: *Liberation,* 1945; Rothko: *Red, White and Brown,* 1957 (Haftmann, 1971); and Kuniyosh: *I'm Tired,* 1938; Bell: *Untitled,* 1971; and O'Keeffe: *New York Night,* 1928–29 (Rose, 1975).*

Discuss with students what they see in each work you can provide:

What kinds of moods are being portrayed?

Which works cause viewers to feel a mood?

Why do artists depict moods?

What kinds of shapes and lines were used in Woman Weeping? *Why do you think she is painted as she is?*

What other symbols can you identify that convey a mood? (Smiles, tears, curves, angles, somber and gay colors, movement, stillness.)

Select one mood from the students' lists and ask them how this mood can be portrayed visually:

What kinds of images can express this mood?

Would people be necessary as images? What other symbols can be used?

How can these images be arranged or formed to clearly express the mood?

What kinds of lines and abstracted or nonobjective shapes can serve to express this mood?

What colors might express this mood? What textures?

* These are suggestions of suitable kinds of art works that can be seen represented in art reviews and histories. We strongly recommend that teachers collect prints and slides of art so they have many resources. Art consultants, libraries, art slide suppliers, art museums, and art sections of news magazines are other resources.

After students have discussed one or two different kinds of moods in the examples of art works, some students can select a mood to express visually that they feel they understand or know a lot about through experience or observations. Several may choose the same mood because of its familiarity.

Those who need more motivation can identify a specific situation in which they have seen certain moods expressed and then develop images from their memories. Let students determine what media and form will best suit what they intend to express: two dimensions, three dimensions, with color, with pencil or ink, boldly, or delicately. Some may use color, line, and texture to make expressive shapes and forms. Others may use people, animals, or other special symbols that will convey their mood through recognizable imagery. Some of their works may contain highly complex visual imagery, others may be simple and direct. Still others may be so abstract that some cannot get their message without the artist's explanation.

Some students will finish in a short time. Others will take hours, days, or even weeks to complete their idea. It is important to recognize that the time it takes to complete a work is not the same for all. Students who finish very quickly may have a thoroughly completed idea, but if a student is unsure about an idea's completeness, he or she may need more encouragement to explore the idea more critically. Students who take a very long time to work on an idea may appear to be without a clear direction. It is important that you distinguish as carefully as possible between students who need help and students who do not, and give help where it is most needed. An effective way is to provide options that students can consider to achieve their goals.

When all students feel they have completed their works, discuss these varying interpretations of mood as a group. Works

that represent the same or similar moods can be studied for varieties of interpretation and similarities and differences of expression. Students who chose a difficult mood to express or a mood different from anyone else's should receive attention for their unique interpretations as well. Some students may not want to enter into group discussion of their work; they may want to talk only to you about it. You can invite them to discuss their work in a group when they are ready.

Creating Expressions of Self

Encourage students to think about things they want that they can make themselves. Get as many ideas from them as you can. If they are slow in responding, stimulate their thinking:

What do you wear that you could make more special for yourself?

How can you change the garment so it expresses who and what you are?

Have students bring to class an old T-shirt, shirt, or old tennis shoes (washed) so they can modify them. Keep in mind the socioeconomic background of your students when you ask them to bring items to school. They can cut block prints from wood, erasers, sponges and do overall prints on fabrics; draw with nonwater-soluble felt pens (provide extensive ventilation for safety); or paint designs or iron patches on tennis shoes.

Because of the high cost of clothing, most families encourage children to take care of their clothing. For children from economically deprived families, taking care of clothing is extremely critical. You can get clean, wearable used clothing from the Salvation Army or Goodwill Industries that can be brought to class for recycling. Have students select something that they can make over for themselves. They can dye it, embroider it, paint it, recut it. It is important that the stu-

Figure 3.12 *Recycling used clothing, making something to wear that conveys an expression of self.* (Lance Garner.)

dents think about what they can use, how they can make it *express themselves to themselves.* What images, colors, and shapes do *they* like and why? They will have to use what they are learning in design to make the message come through—what they are saying to themselves about themselves. It is this expressive quality that makes the object function as an art object as well as just something to wear.

Conveying Messages in Murals

Discuss the word *mural* in class—that it pertains to walls or being on walls, such as a painting on a wall. Present examples of contemporary murals and those from previous centuries: Rivera and Sequieros (Reed, 1960); Titian, Michelangelo, and Raphael (Meiss, 1970); Delacroix (Spector, 1967); and the murals during the W.P.A. support of artists during the Great Depression as well as more recent American murals.

Why do you think artists paint on walls?

Why are many murals found in churches and other large public buildings?

Why do these artists wish to have their work seen by others?

What kinds of messages do these murals express? Do they tell stories? Express opinions?

Select two different examples of murals and provide students with some background about the artists, their possible reasons for doing these murals, and the social impact the murals have had or may have for viewers. Re-emphasize that murals are planned for *others*—to convey a message or give pleasure.

Secure interest and permission to paint or mount a mural on a wall of your school either indoors or out. Present this opportunity to your students. In a brainstorming session with interested students, explore potential messages that would be appropriate for the place and the viewers. List all the ideas, review their potential, and combine or expand some and eliminate others.

Murals last a long time, so students will have to consider future viewers as well as people today. Ask them:

Is the topic timeless or will it be meaningless later?

Does the message have meaning for many people or only a few? Are we asking the most important questions about the subject of the message?

What kinds of visual images or symbols, what design qualities, and what expression of mood would best carry the message?

Students can draw individually or in small groups single or multiple images that they feel express the message. Display and discuss these plans to determine how they should be organized. Discuss areas of emphasis and subtlety. Size variation and repetition of line and form, and visual movement as well as texture and color are all elements they must consider. Detail as well as larger shapes will provide interest when viewed from a distance and close up. If the mural plan contains several small messages, their planned images can be combined and organized as a collage. Planning must also include site and medium:

Does the site have a variety of lines, textures, and colors?

Will the message have to be highly ordered to be seen?

What colors, textures, and lines will contrast with the surrounding area?

Is the site so ordered that a complex design will show up clearly?

Which colors and textures will contrast with the surroundings? Which ones will blend with it?

Then students must consider their media experiences and which medium will best convey their message.

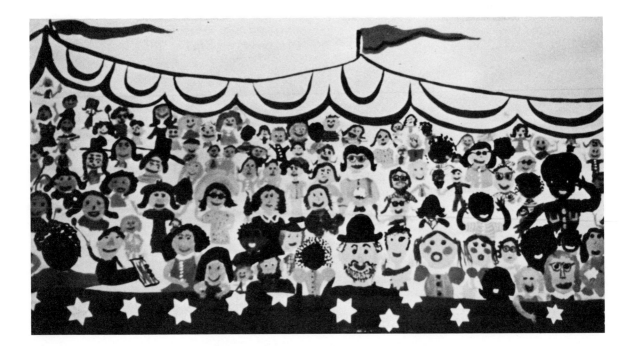

Figure 3.13 *Diverse people sharing an experience joyfully. Made by students in the Community School Summer Program, Woodmere School, Portland, Oregon.* (Teacher, Anne Begenich.)

If the students are going to use paint, they can draw their plan directly on the wall with chalk. It might be desirable to paint the mural on a large piece of masonite that can be fastened to the selected wall. This approach may be especially suitable if the message is a current social theme that may not have as much meaning to future viewers. Acrylic paints are best because of their permanence. If the mural is to be a clay relief, it must be carved in small sections, fired, glazed or painted with acrylic, and then glued to a plywood board for mounting or set in a wet, plastered wall and filled in with grout. Should the students choose to use wood for a relief mural, they can use wood scraps or cut out images with a jigsaw and layer them to achieve variation in depth.

Figure 3.14 *Layout of mural drawn on a junior high classroom wall.*

The pieces can be secured with white glue and painted or coated with a plastic or lacquer sealer.

As the mural is being drawn in its final size, re-evaluations of design and color selections may be necessary because the increase in scale may produce a different visual effect. While the mural is being planned, and upon its completion, students should inform the school of their procedures and intentions.

After the mural is completed and has been viewed for some time, have students evaluate what they have done:

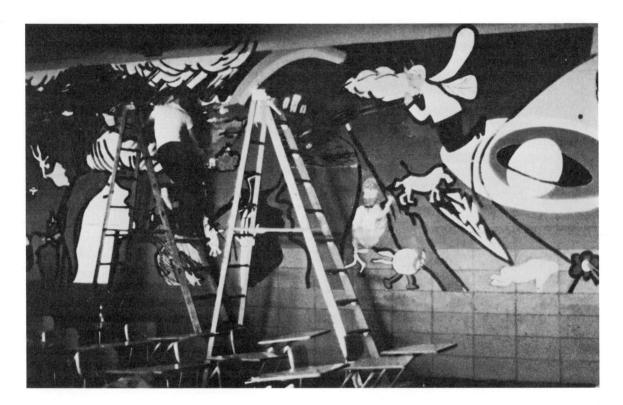

Figure 3.15 *Final touches of the mural pictured in Figure 3.14. The mural contains several messages about a larger message: interaction of the forces of humanity and the universe.*

How well did you get your message across?

How do others respond to it?

Do others understand the intended message?

Do they perceive the message differently than you intended?

Do you see more or less than was planned?

How can viewers be helped to understand your mural?

How successful were you in making "art for others"? Why?

What images, colors, or other design elements might be changed to make the mural even more effective?

Have them review what they had considered important in making ''art for others'' and discuss what they would do differently or the same if they were to do another mural. Ask them what they feel is important about making art for others.

LEVEL 3
EXPRESSING DEEPER
MEANINGS

Exploring Unique Materials

Students need to develop flexible attitudes toward media in order to have more freedom to carry out their ideas. Traditional concepts of how media should be used are fast disappearing. Some weavers create sculptures, sculptors wrap nature in plastic to create forms, and the only evidence of video artists' work is fleetingly seen on the screen. When students are forming ideas and making choices of media they should consider how materials can be combined effectively or what new potentials they can offer. They should study artists who are using media in unusual ways to develop their own sense of adventure in media.

Robert Indiana made a sculpture combining an old wooden beam, iron-rimmed wheels, and white paint. He called it *Moon* (see Figure 3.16). Show a slide or print of it to the class and ask the following questions:

What kinds of message do you get from looking at the worn texture of the wood contrasted with the hard, cast-iron wheels? What kind of message do you get from the paint that lets the grain of the wood show through?

Is this just a stick of wood with wheels tacked on the sides and some white dots that repeat the pattern of the wheels?

Is it a profound selection of universal elements to symbolize the search for new frontiers?

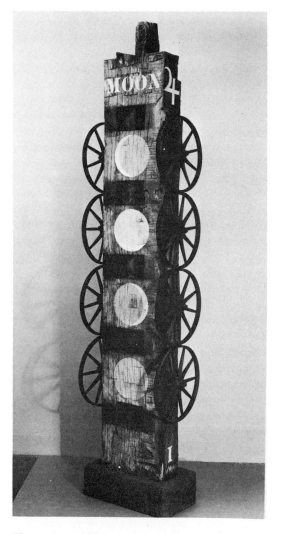

Figure 3.16 *Robert Indiana.* Moon, *1960. Assemblage.* (Collection, the Museum of Modern Art, New York. Philip Johnson Fund.)

Does it suggest the heat of the sun to make trees grow combined with human ingenuity to use wood and to create machinery, to symbolize our drive to go through space?

What is the significance of one going up to four? Of packing case letters? Why is the shape thrusting up against gravity? Is it going somewhere?

Would it have as much meaning if it were all chrome or stainless steel? Does the familiar, worn wood help us go along on the trip?

How do all the aspects of design, line, shape, form, and texture help communicate the meaning?

Marisol (Marisol Eshobar) used wood, paint, and even some metal for a three part painting—structure called *The Family* (Figure 3.17). She used the same materials as Indiana, but the meaning is very different.

Ask your students to contrast the meaning in the two art works:

How does the use of materials change the meaning?

What is going on that is different in the way parts are organized? In the kinds of symbols used? In the use of round forms?

What effect does the use of semirealist drawing with untraditional surfaces such as old doors and boards say about the family?

Students should think about their own stereotyped ideas of materials and try to change them:

What various uses of wood have you seen or can you think of that you would be curious to try?

What do we usually print on? Print with? What surfaces or objects can be used in a printing process? What particular qualities or effects does printing suggest (e.g., repetition, degrees of complexity in design)? What visual effect that you have not tried might be possible in printing?

Have you ever combined printing and drawing, printing and painting, drawing and stitchery, clay and fabric, wood and plastic, photography and painting, or weaving and sculpture? What other possibilities are there?

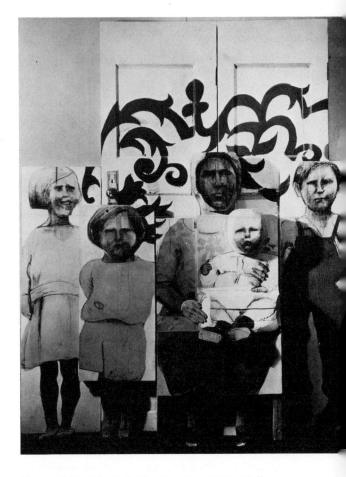

Figure 3.17 *Marisol.* The Family, *1962.* (Collection, the Museum of Modern Art, New York. Advisory Committee Fund.)

Students may want to consider what idea can emerge when the media is predetermined. What image or concept, for instance, particularly lends itself to the combining of photography and painting? These inquiries may also help those who are searching for a unique way to express a well-known idea. Students may find that combining media or using them in new ways is a satisfying and effective way to represent an idea.

Searching for Meaning in One's Environment

For this activity you must understand the kinds of environments in which your students live. You should get firsthand experience with these environments yourself. Many children grow up with only rare excursions from their neighborhood. Other children may not leave the city often but have considerable mobility within it and are aware of the different kinds of areas. Some urban children spend summers or vacations in recreation areas and have exposure to varying kinds of natural environments. Rural children's experience varies with the parts of the country in which they have lived.

Experience with weather patterns varies. Some children learn to watch for and enjoy changing weather patterns, others learn to fear them. Some students see weather and environment as elements to control, others as elements to which they must adapt.

Some are very aware of their natural or manufactured environment, others have learned to see it or experience it only marginally and, therefore, have no background of emotional involvement with it. It is these degrees and kinds of experience students have that teachers can draw upon to stimulate student responses to nature to create art.

This activity is an approach to making

students more aware of their own personal reactions to their environment. Discuss how many of us pass through our environment every day without giving specific notice to the many things around us that affect our experience. We often are too busy to be aware of their impact on us. We ignore how things are made, how they grow, and how the forms that are created move and change in space and light. Most of us do notice certain things that catch our eye but may not take the opportunity to explore their special nature or why we like or dislike them. Have students name some of the natural life that is around the school or in the community:

What kinds of plants can you name?

What geological structures are familiar to you?

What animal life is natural to this area?

Can you describe them in words? Could you sketch some of them?

Are there some you especially notice? Why or why not?

Are some abundant and others rare?

Discuss how artists have been interested in the natural world for centuries and how they enjoy painting, drawing, and using other media to make a personal, visual response to what they see. Some artists have recorded nature very *realistically*, attending to great detail and accuracy. Others have chosen to give their *impressions* of what they see, often attending to shapes, patterns, and colors less for the photographic realism and more for the visual qualities that give them certain impressions. Some artists are more *expressive* in their response to nature and may use line, movement, and color, for example, to express the feelings they get from their environment. There are also artists who see a humanlike or bizarre quality in nature and create plants, land, and animals in fantastic images. They exaggerate and

give a sometimes humorous, sometimes frightening quality to natural things. Escher provides some examples to discuss (Escher, 1973):

M. C. Escher: *Dew Drop*, 1948; *Puddle*, 1952; *Rippled Surface*, 1950; *Three Worlds*, 1955.

Other examples (Haftmann, 1971) that reflect various responses by artists to the environment are:

Paul Klee: *Subtropical Landscape*, 1918; *Garden with Birds*, 1924; *Ocean Landscape*, 1929.

André Masson: *Wounded Animal*, 1929.

Max Ernst: *Phases of the Night*, 1946; *Petrified City*, 1936.

Marc Chagall: *The Blue Circus*, 1950–52.

Henri Matisse: *River Bank*, 1907.

Georges Braque: *Melon*, 1925.

Carlo Carra: *Pine Tree by the Sea*, 1921.

Seraphine de Senlis: *Tree*, 1930; *Tree of Life*, 1928; *Tree of Paradise*, 1928.

Henri Rousseau: *Primeval Forest Landscape with Setting Sun*, 1909.

Piet Mondrian: *Grey Tree*, 1912; *Red Tree*, 1908; *Apple Tree in Blossom*, 1912.

Wassily Kandinsky: *Landscape with Church*, 1913.

Still more examples (Rose, 1975) are:

Helen Frankenthaler: *Mountains and Sea*, 1952.

Nancy Graves: *Indian Ocean Floors*, 1972.

Andrew Wyeth: *Christina's World*, 1948.

Grant Wood: *Stone City, Iowa*, 1930.

Which appear to be impressions or expressions rather than a realistic reproduction?

What do some artists notice that seems special or unusual in nature?

Are some works more realistic than photographic? Why?

What do the artists seem to be conveying?

How are shape, form, line, movement, space, color and texture treated that seems unusual or special?

What evidence of exaggeration is there? What evidence of subtlety or obscurity do you find? Why do you think these approaches were chosen by the artists?

Why do you think artists see their natural environment differently? Do we each have a different way of seeing?

Students who want to study nature through art forms may begin by making some sketches. Have them spend some time on the schoolground, in their yards, in a park, or have them look at botanical illustrations, photographs, and some natural objects under a microscope. As they become more familiar with natural aspects of their environment, ask them questions that will help them form some impressions about what they see:

Do you find natural forms delicate, bold, quiet, active, beautiful, ugly, grotesque, bizarre, humorous, humanlike?

What patterns of repetition, movement, line quality, and special textures do you see?

Do certain colors impress you? Why?

How do these natural elements exist in the space around them—is the space crowded or spacious?

Are the elements controlled by humans or do they exist, grow, and move about unattended?

Do you associate certain moods or feelings with certain natural life? What feelings? Why?

After these questions are answered and discussed, let students make their own decisions about how they would like to visually respond to their natural environment from a personal point of view. Some may want to do a very detailed drawing, others may paint expressively or impressionistically. Some may find sculpture, printmaking, or photography suitable to what they want to create,

while filmmaking or videotaping may appeal to others.

Since different media and responses will take varying lengths of time, each work should be discussed as it is completed. Students can talk about what was important to them in what they did and why they did certain things. Some may want to give their impressions of other students' work. Some may want to write a paragraph or poem to accompany their art.

Expressing Experiences Through Abstraction or Distortion

Distortion emphasizes certain ideas. Abstraction emphasizes shapes and forms. Abstractionists use less detail; their work is a representation of a whole class of things. Some artists are concerned with the pattern created by the forms, shapes, textures, colors, and not with any subject matter.

Charles Zerner's fine-line, detailed drawing of children's play on a city street has all kinds of distortions that suggest the whimsy and imagination of children's play. Students should study the picture to see all that is going on and to understand how the artist has distorted shapes, forms, and perspectives to create the fantasy world of space ships, trains, helicopters, trains mixed with toys and children (Figure 3.18).

Would you get the same feeling if the artist had drawn it as he actually saw it, instead of the way he felt about it?

Do you think this artist has retained his ability to see imaginatively?

Some artists who use abstraction to express the more universal qualities of things often start out drawing real things in detail and then abstract the key forms. The two drawings by Morris Graves show this technique clearly (Figures 3.19 and 3.20). The first

Figure 3.18 *Charles Zerner.* Asphalt Circus Dance. (Courtesy of the artist.)

shows detailed studies of birds that Graves
spent years observing. The second is an ab-
stract showing the beauty of a bird's form.
A third drawing of Graves', a wash, is a pure
abstraction showing what line can do to
make us feel the bird's presence (Figure
3.21).

The painting by Joan Miró presents
familiar patterns. It is somewhat like the
Zerner drawing in organization of shapes,
lines, and light and dark backgrounds.
Miró's objects, on the other hand, are pure
fantasy (Figure 3.22). We cannot try to cate-
gorize them but, rather, let our eyes and
mind respond to the flow of the pattern of
things in relation to each other.

The following are suggestions of paint-
ings (Haftmann, 1971) to study with your
students:

Paul Klee: *Fool in Trance*, 1929; *Garden with
Birds*, 1924.

Oskar Schlemmer: *Dancer*, 1922–3.

Ernst Kirchner: *Portrait of Graf*, 1924.

Max Beckmann: *Trapeze*, 1923.

Pablo Picasso: *Sylvette*, 1954.

Joan Miró: *Peasant Woman*, 1922–3.

Amedeo Modigliani: *Portrait of Zborowsky*,
1917–8.

Marc Chagall: The *Cellist*, 1939.

Georges Rouault: *Pedro*, 1939.

Fernand Leger: *Large Breakfast*, 1921.

More suggestions of paintings (Rose,
1975) follow:

Claes Oldenburg: *Giant Soft Drum Set*, 1967;
Giant Iceberg, 1969.

Eva Hesse: *Repetition*, 1968.

George Sugarman: *The Shape of Change*, 1967.

Discuss the examples; ask students to
make judgments about why they think the
shapes and forms are made as they are:

Figure 3.19 *Morris Graves. Pheasants and Birds.
Pencil sketches done on the back of sheet music.*
(Museum of Art, University of Oregon. Morris
Graves Archival Collection.)

Figure 3.20 *Morris Graves.* Drawing of Bird with Long Beak. (Museum of Art, University of Oregon. Morris Graves Archival Collection.)

Is the artist using distortion or abstraction?

What does the work seem to be about?

How do the abstractions or distortions of images help portray an idea or feeling about an idea?

What kinds of repetition and variety of size, shapes, lines, texture, color, and space is there? Does orderliness create a mood? Does variety?

Is movement or direction suggested by use of lines and shapes? Does the amount and intensity of line create a mood?

Are colors exaggerated or unusual to the subject matter portrayed?

How are spatial relationships changed and abstracted? What kinds of feelings can be expressed with different kinds of space?

Why do you think abstraction is important to expression?

Are the entire paintings, prints, or sculptures abstracted to some degree? Why is that important? Would it help them work well as whole images? Would abstraction always be desirable? Why or why not?

Ask students to discuss different kinds of physical activity. Encourage them to come up with a *range* of suggestions: riding a roller coaster, making tiny stitches in needlework, getting the snarls out of their hair, dodging a speeding car, jumping into a pile of leaves, walking alone on a dark street at night. List the situations they name and then select one from the list and ask them how it can be emphasized by exaggeration or distortion in order to express what they feel is most important:

Is it the action itself?

Would it be the people involved—their facial expressions or a certain part or all of their bodies that could be changed?

Would it be the way people are placed in relationship to one another and to what they are doing? (Refer to Beckmann's Trapeze; *Haftmann, 1971.)*

If someone were using a tool, would the tool be emphasized, or would the tool's use be emphasized?

Have students discuss how they could emphasize a basketball game by exaggeration or distortion. How is the confrontation between players in protecting the basket affected by:

The different sizes of the players?

Their expressions?

The fast pace of the game?

The sweat?

The coach's reactions?

The look of players on the bench?

The expressions of the crowd?

The noise?

Discuss how some elements might be omitted or made less important than other things in order to have even greater emphasis on those ideas or single idea of importance to them, the artists. Ask them to suggest uses of lines, shapes, colors, textures

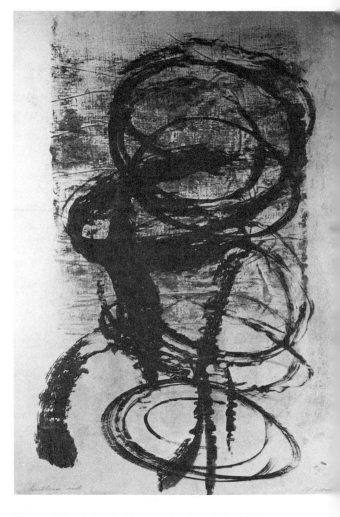

Figure 3.21 *Morris Graves.* Restless Ink, *1943.* (Museum of Art, University of Oregon. Morris Graves Archival Collection.)

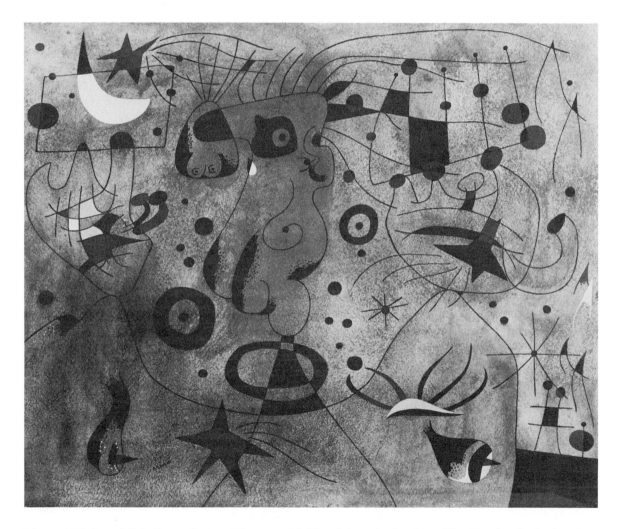

Figure 3.22 *Joan Miró*. Constellation: Woman with Blond Armpit Combing Her Hair by the Light of the Stars, *1940*. (Contemporary Collection of The Cleveland Museum of Art.)

and treatment of space that would add to or define a particular expression.

Then give all those interested in abstracting the opportunity to select an activity from their lists or choose an event or feeling they have about something. They can plan their abstraction by listing all the ideas related to it and select what they feel are most important. Some students may not need to go through this step, but may move directly to a medium.

Discuss the various media they might consider. If their subject is delicate, they would use a different medium than if the subject were aggressive or bold in nature. Encourage them to explore possibilities freely. They can paint objects not usually painted, or they can use traditional drawing and painting techniques.

When they are finished, discuss how they achieved their goal and how they expressed the idea that might not have been expressed through a more realistic approach. This kind of activity can be repeated many times by varying the messages and the media.

As students continue to work, they should be able to see how they have progressed in creating images and understand why they have progressed. Their criteria for evaluating their own work should be articulated. They should be able to describe differences in content, organization, degree of abstraction or distortion, and use of media as well as tell which alternatives best fit the message.

Promoting a Social Concern

The various publishing and broadcasting media present and emphasize issues and ideas of concern. Newspaper columns, editorials, letters, and cartoons keep us up to date on many of these concerns and affect our opinions as well. Radio and television transmit news and documentary programs on current issues; some filmmakers and TV producers put their concerns into a story context to make a point; and photographs capture and expose situations we may otherwise overlook. Posters not only announce specific events but express opinions about current social issues.

Discuss various media presentations in your community and their possible effectiveness. Ask students to bring in posters advertising past events in which the message is designed to change people's ideas. Note that some artists also use their skills and insights to present personal and social concerns to those who will view their artworks. Some examples are:

Duane Hanson: *Race Riot,* 1968.

George Tooker: *Subway,* 1950.

Joseph Hirsch: *Triptych,* 1967–69.

Edward Kienholz: *The Wait,* 1964–65.

Clayton Pinkerton: *American Hero,* 1968.

Select some examples of works to discuss with students:

What do these works seem to be about?

Do they reflect issues that were relevant only to a particular time and event, or are the ideas portrayed still concerns today?

Which concerns are still important now? Which are not? Why?

Why do most of these works contain people or seem to be about people?

What are some concerns people have today that are not represented in the works just studied?

Do some things concern only certain ages of people and others become important for all people regardless of age?

Let students discuss various concerns they can think of—local, national, and world. Give them time to review newspapers from

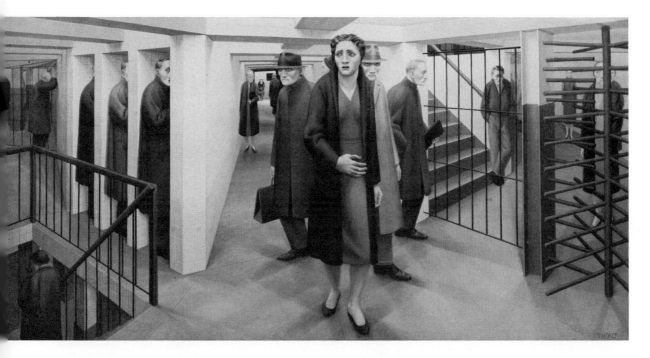

Figure 3.23 *George Tooker.* The Subway, *1950.* (Collection of the Whitney Museum of American Art, New York. Juliana Force Purchase.)

various places, to listen to radio stations from other parts of the country or world, to watch TV as well as listen to their families talk about social issues, and to ask people questions.

Then have them name the concerns that seem to be important. Begin with international issues and eventually narrow the discussion down to their community and school. They will discover that there are varying points of view on some issues, which will help them understand why social and political problems often take so much time and effort to resolve and why some issues cannot be resolved to meet everyone's needs.

Students who want to create an art work that will bring other people's attention to a

Figure 3.24 *Edward Kienholz.* The Wait, *1964–65.* (Collection of the Whitney Museum of American Art, New York. Gift of the Howard and Jean Lipman Foundation, Inc.)

topic of immediate concern in their school or community may choose to work in small groups or individually. For others unsure of how to proceed, suggest they list ways to make their point or sketch images that express those points. Remind them that the medium they choose should suit what they are trying to convey as well as where it will be seen:

Will the idea be expressed as a poster, a painting, a photographic essay, a film, videotape?

How large should their images be? How long should a movie or television production be?

Who will your audience be? How will the audience affect your choice of images and subject matter?

What shapes, forms, colors, and visual movement might be effective in getting viewers' attention?

Encourage them to keep their focuses narrow in scope so their points can be made in depth. If they use special, recognizable symbols to enhance their point, they should be careful that these not distract the viewers or limit their ability to respond to the intended idea. For example, if students want to encourage energy conservation, they should focus on a key point that influences the viewers' lives. With few words and familiar symbols, they should be able to design a clear message.

This activity can be open-ended or directed, depending on your students' degree of independence or enthusiasm. The media and scope of students' intentions will influence the amount of time the endeavors take to complete. As each one is completed, discuss what the visual and verbal elements are that promote the intended idea.

Students may search out places to exhibit or present their works and solicit attitudes and opinions of their work and of the issue to evaluate how effective their works are. They may follow up community or school efforts to deal with their concerns.

They may even do subsequent art and can keep the class informed as work, if any, progresses in their area of concern. Students who choose not to participate in this activity may find something later in the school year that will compel them to create socially meaningful art work.

LEVEL 4
DEVELOPING INDEPENDENCE AS AN ARTIST

Students at this level are proficient in many areas. They express more significant ideas. They put familiar things in new contexts, gain new insights in familiar situations, see problems in new relationships, draw together remote but related ideas, and distort things to emphasize a particular meaning or mood. Students will have their own ideas and a broad range of symbols from which to create and amplify these ideas. They are flexible and try different compositions or design alternatives for expressing ideas. They can select appropriate media to communicate ideas and develop the skills to use them innovatively.

The quality of their work will depend in large part on the quality of their own reflective experience. The teacher's role is more passive—providing encouragement when needed, listening to students' own self-evaluation of their work. Teachers may provide examples of other work, fiction, poetry, music that they think students will find stimulating. The range of media can be as varied as your classroom situation and economics will allow—fabric, metal, plastic, paint, ceramics, wood, ink, and film.

Even though students will often work independently by the time they reach this level, there will be some instances when the teacher's role will be to suggest ways for students to extend previous experiences and to offer new areas or ideas. The teacher's

role may also be that of a museum director selecting work from a body of student art. One-person shows are usually not encouraged until graduate study and are rarely done in high school. But for complete development in art education, young people need opportunities to exhibit their work. Exhibits give young artists a chance to reflect on their work, to see their progress, and to be stimulated to develop in new ways.

Unusual Media to Convey Ideas

Students at this level should be encouraged to look at unusual media and materials from new technology. In the recent past, artists have used materials that were originally designed for other purposes: steel beams, neon lights, maps, aluminum foil, vinyls, fiber glass, polyester resins, plexiglas, polyurethane forms, machinery parts. Show examples of how technology has made it possible for artists such as Javochef Christo to wrap a coastline in one million square feet of plastic (Christo, 1970); Claes Oldenburg to make gigantic vinyl or wooden objects like a vinyl ice cream bar, a giant wooden saw, a three-way wall plug, and a suede baked potato with vinyl butter (Haskell, 1971); Eva Hesse to make clothed and painted hangings of fiber glass, (Lippard, 1971); Jean Tinguely to create kinetic sculptures with moving mechanical parts (Callas, 1970); and John Chamberlain to form sculptures of mineral-coated, melted plexiglas or aluminum foil (Baker, 1972). Students who are now faced with the high cost of such materials and the need to conserve resources may not be able to understand the feeling of opulence of past decades. But other artists more involved with the environment worked with common objects in uncommon ways. The total environmental works by Edward Kienholz such as *The Beanery, The Wait,* or

The State Hospital incorporate furniture, forms made by the artist, and actual smells that represent what the place is about (*Art in America*, 1969). Students may find it intriguing to make assumptions about why Robert Rauschenberg chose to make a 100 gallon tank of boiling mud for an art and technology show (Burnam, 1971) and to consider why David Lowery Burgess' blocks of ice containing crocus bulbs arranged on the frozen Charles River (Burgess, 1971) and the tank of mud are considered art works.

As students look at slides or pictures of such art, ask the following questions:

What ideas or conditions do you think might have stirred the artists to produce such works?

What were the artists saying about society at that time?

Why do you think they chose certain materials over others?

Why would an artist want to make a sculpture out of plexiglas rather than clay or bronze?

What materials can we use today?

What differences are there between food made of vinyl by Oldenburg and food painted on canvas by Thiebaud? Do you see a different message in each kind of work?

Could Kienholz have conveyed to us the same message or idea in a painting? How would you feel standing in one of his environmental sculptures? How important would the smells be? How would the sculpture compare to a painting of the images he assembled?

How do you think you would feel sitting at a table with Duane Hanson's Woman Eating *or being in the midst of his* Race Riot? *Could he have achieved the same effects with clay?*

Student opinions will vary, and through discussion they should begin to recognize that the creative process includes selecting particular materials with potential for artistic expression, that selecting materials that are

available and appropriate for an idea is valid, and that more ideas have potential because of additional materials.

These artworks may influence your students to try some of the same materials but because of special costly or inaccessible equipment, they may not have the opportunity. However, you can help them find ways around some of the barriers. One way is to find more readily available materials. For example, students can bring to class items they consider unusual or less common as art materials and explore several ways to form visual statements with these materials: painter's drop cloth, old shower curtains or table cloths, remnants of canvas items, sturdy or flimsy cardboard, used glass and plastic articles, garden hose, screen, wire, hosiery, old T-shirts, paper bags, foil, plastic wrap, ice, rope, plumbing pipe, machinery parts.

Or *you* bring something to class—a mousetrap, for example—and let students consider its potentials as a vehicle for visual expression.

What does a mousetrap imply?

What is its function? Why does it exist? What meaning or importance may it have for different people?

What symbolic meanings could it be given?

How could its shape be altered to express an idea?

What other media should be incorporated with it?

What capacities does it have for becoming mobile or for creating motion?

Another experiment is to have students choose descriptive or image-provoking words and think of materials or objects that express their meanings. For example, *warmth* suggests wool, furs, heat, light, fire, bed, steam, gloves, tea, socks, insulators, flowers, old lace. *Growing* could be represented by seeds, balloons, tools, building toys, a population sign, a height gauge, a

textbook, a child's old and new shoes, photos of urban sprawl, stretchable fabrics, wheel cogs, a "one-size-fits-all" clothing tag.

These experiments with media should provide students with an understanding that the nature of a material may, itself, be the motivating force that leads an artist to a new idea. Familiarity with a greater range of media will give students the opportunity to develop more ideas into visual statements or to rework previous ideas into new forms.

Most importantly, students should see how uses of materials change with time. What is expressive in one five-year period may not be ten years later. Materials are closely related to people's values, the state of the economy, and the supply of resources. Ask students to assess their environment to determine what materials would be the most compelling to make people aware of their society. Then the selection of the material becomes part of the message.

Responding to People and Places as Affective Forces

Level 3 emphasized the various personal impressions we may have in analyzing nature. Some students who have experience at Level 3 may be ready to consider how their lives are personally effected by the natural elements of their environment. Some students may be so engrossed in interpersonal relationships that they may be unconcerned about the natural environment. For other students, the most important concern may be cities—the conditions of cities and their affects on people's lives. For still others, finding a personal identity in a changing culture may be their primary concern. These concerns are the motivation to create art. However, finding visual images and symbols, the most powerful design and media to express the meaning, can be most difficult

and frustrating. This kind of work can take place in school if students are free from pressure to produce within a given time. To provide the needed environment teachers must be sensitive artists who can respond to students' attempts to create. The following questions can be modified depending upon individual student needs:

What experiences have you had in hearing, seeing, smelling, being jostled by crowds?

Do people seem real or are they just a mass of "others"? Does this feeling depend on where you are going? The weather?

What inside-outside feelings do you have about yourself when you are in a crowded place? Does this change from when you are bundled up against the cold or when you are wearing something cool in the summer heat?

If you have always lived in the city how would you imagine a rural person feels?

Could you stand to be all alone in a deserted place for several days? How do you imagine you would feel? What kinds of things would you want to take with you?

If you've recently come from another place, what are the things you most remember and care about from that place? What kinds of images do you have of that place? Are they images of actions of people? Of people in places? Or the place itself?

Some students will have many more experiences with nature than others. City dwellers may feel they have little contact with nature. But if they realize that reflected sun intensifies the summer heat, that buildings cut off natural breezes, they will see that nature affects them in spite of their steel and concrete surroundings. What media they choose to express their ideas will depend on what they feel suits the idea they want to develop. Evaluating their work should include asking if what they are visualizing expresses their ideas, how certain design elements and principles may improve their work, and how well the completed work expresses the intended idea. Some students value the opinion of others and may ask you or classmates for suggestions.

Students can ask the same kinds of questions about structures, clothing, or attitudes that may be transmitted through television or other media. This activity will help students analyze how elements affect their lives.

Creating Body Adornment

Students who have developed understanding of their personal design preferences will be able to make things to wear or use that reflect a knowledge of their own identity and those aspects of self they want to make public.

At this level students have had many experiences in designing and drawing, have developed skills in various media and should be able to combine these skills in new and interesting ways to design and construct wearing apparel. Two references, *Creating Body Covering* (Laury and Aiken, 1974) and *Native Funk and Flash: Emerging Folk Art* (Jocopetti, 1974), illustrate a vast potential but should not determine or limit students' own ideas. Students interested in making personal adornment should ask these questions:

What are the characteristics of my identity I want others to know about?

What visual qualities express these identity characteristics?

What mood or feeling do I want to express?

What materials do I like, want to work with, feel suits the use of the item to be made?

Will I be very active or quiet when I wear it? How will this determine materials selected and the construction?

What simple basic patterns will I start with?

Is there a special occasion for which I want special body adornment?

Some students will need advice on basic garment construction, or on the use, cost, and characteristics of particular materials. As students plan, they may find it helpful to draw how the garment will appear, using color and materials to achieve an accurate representation. Then they should evaluate the feasibility and organization of their design, how will it communicate what they want to say, and determine how to proceed with the final work.

Students' evaluation of what they have done will show in their personal satisfaction with the garment and how long they consider it important to wear.

Communicating Symbolically to Others

Students may learn informally from each other and they may critique each others' work. The major evaluation of art for others is how well it communicates to the people being "spoken" to. Students can devise ways to see how people are responding to their work in order to sharpen their message. They can observe people viewing their work, recording their reactions. They can formulate questions to ask the viewers that will tell them what they want to know about how special audiences respond to their art, or they can use more than one media and, by gathering viewer response, learn which is more effective.

At this level students should be evaluating art of the past and present in order to understand the works in relationship to the period in which they were created and in order to think about their own works in this context as well. Present Robert Indiana's *Love*. Ask the following questions:

Figure 3.25 *Personal body adornment created by Barbara Kensler. A greatcoat worn by Jean Ellen Jones.*

What major historical events were occurring in the U.S. in the 1960s?

In what ways might this painting be a reflection of those times?

Why is it an example of art for others? Why do you think so many people identified with it?

You might point out in the discussion that the red, white, and blue image became a national symbol reproduced on postage stamps and as posters. There was a large response to the work in these forms. People asked for this stamp at the post office, feeling they were sending an extra message through the mail.

Discuss how artists generally select familiar, more common visual symbols when they are making art for others because they want to touch other people's lives in some way. Ask students to analyze artists' choices of symbols, media, color and style or design as it may reflect the 1960s and 1970s:

Does the painting suggest a timelessness in some ways?

Will its impact diminish (or has it?) as social issues take on different concerns?

Interested students can analyze what symbols they feel are currently a fad, as well as those symbols that seem to be timeless. They can look at art works of the past for symbols that are used over and over and try to determine why. They can plan art for others that would have special meaning for the present, reaching large numbers and kinds of people, or they can plan a work that they feel would be timeless as well as currently important. In either case, the choice of symbols will have to be considered carefully. The choice of media will require careful consideration as well. Film, videotape, sculpture, garments or jewelry, painting, pottery, weaving, photography, or printing are all possibilities.

INDIVIDUAL DIFFERENCES*

Students' individual ways of seeing and designing will affect their creative artwork. Those who have learned to see in terms of what they *know* about categories of things from past experience will create differently than those who have learned to *see* the sizes, shapes, and colors of particular things as they actually appear. These two groups of students will not receive the same information from what is around them. They will have had different experiences even though they are in the classroom, have the same cultural background, and live in the same neighborhood.

REFLECTIVENESS

Some students are reflective about their experience, that is, are willing to look at things a long time and think about their qualities, whereas other students come to judgments quickly about the things they see. Some respond in terms of how they feel emotionally about things, others in analytical terms. These differences will affect the kind of creative work a student produces. Some students will be more fluent, have many ideas quickly. Some of these fluent students will also have more original ideas. But some less fluent students may also have important original ideas although they take longer to arrive at them. Highly creative people are usually more flexible than less creative people. A creative person will use a common pencil in uncommon ways: develop many kinds of textures, lines, shadings, dull or sharp points, and use the eraser as well as the point. Creative people can easily change tools and media to fit their messages. Less creative students, those who lack self-confidence, or those who are afraid of failure, may want to keep on working in the same medium.

Some students will develop favorite symbols to express ideas with little modification over and over again. More creative students will change and develop their symbols when they have satisfied their desire to explore with any one set of them. At the undesirable extreme of flexibility are highly fluent students who change ideas, symbols, and design styles so often that they rarely bring any artwork to completion. The activity most profitable to the creative growth of these students is to choose a partially finished work that pleases them most and to finish it, using self-discipline to harness their ideas. This type of activity is different from the creative activities needed by the children who have few ideas and are content to continue in the same, unthreatening ways of expressing themselves. Such students need exciting experiences to get them started thinking and seeing in new ways, and rewards for getting as many responses as they can in a short period of time so they can discover that they are capable of more than they think.

* The abilities, aptitudes, and cultural differences discussed here are analyzed and documented in Part Six. Use the subject index to find the specific pages.

If you want to extend your students' creativity, you must realize that no one method of teaching or increasing creativity will work for all your students. The most creative students usually need only time to work, a supportive environment, a choice of media, encouragement in evaluating their own progress, and opportunities to review with you. Other creative students often need help with one or more aspects of art—thinking out design alternatives, developing the skills to do what they want.

Students whose creativity is relatively undeveloped may need assurance that they will not be punished for failure. You can usually find some aspect of their work that is successful. Others may only need enough time to get an idea developed or carried out. Very rigid children are often fearful children; they need your encouragement to gain confidence. Children who are rigid and judgmental need encouragement in looking longer and seeing more possibilities in the objects they are studying and the tools and materials they use.

Highly success-oriented students have learned in other subject areas that there is one right answer to every problem. Helping them discover that answers are relative is very difficult—a design solution may work very well in one context, but not another; a failure in one situation may be a good working solution in another.

There are also differences in how independent children are encouraged to be. In all cultures, some children have parents who are more restricting than others. But some cultures have extended, closely knit families, where cooperation rather than individual initiative is stressed. Children who were raised in communes, children from traditional Mexican-American families, and some from American Indian families may do creative work better in groups than alone.

Sometimes art programs actually inhibit creativity. When we give students a constantly changing array of materials, we deprive many of them an opportunity to take a medium and work with it long enough to become facile or innovative with it. Ideas and the symbols used to express and organize them are more important than the medium through which they are communicated.

SOCIAL INFLUENCES

Societal changes and issues as well as the recent increase in drug and alcohol use by students present teachers with difficult challenges. The art teacher, in particular, faces not only the physical and psychological effects on students, but also the pervasive and persistent symbols used to identify issues. It requires a great deal of compassion and understanding to reach our students. Creating art can be a means for students to reflect on and evaluate their experience. It can be a way to help them evaluate the effects of the choices they have made. But students must go beyond borrowing symbols. They need encouragement to find ways to symbolize meanings for themselves and to ob-

jectify experience, so they have more alternatives for making choices for enriching their lives.

A ten-week study of twenty 14- to 16-year-old lower-middle-class junior high school students in an art class showed that students' experience ranged from no experience with to active drug use, from cohesive to almost undefinable family structures, from pre-adolescent to adult physical development (Degge, 1975). Students were in varying stages of sex-role identification, attitudes, and participation with their peers, adults, and with changing social mores. The social interaction patterns of the class included scapegoating, imitating, and social clustering with power roles within clusters such as the most successful with wit or with the opposite sex. Some students found nothing in school with which they could identify. Others felt school was an integral part of their growing up. The reward system of school meant nothing to some and was very important to others.

Most of the art work was stereotyped with rare occasions of students with special interests creating something more individual. Serious study of drawing, design, and the development of a personal imagery based on encounters with ideas or individual reflections was not in evidence.

To enable students to find viable avenues for developing critical awareness and reflective expression, teachers must understand the diverse influences on different members of their classes so they can design different learning experiences and interfaces with art that can reach different students.

ENVIRONMENTAL EXPERIENCES

The environment can make a difference in students' art work, as in every other aspect of life. There are many deterrents to creative work. City people are exposed to many different kinds of visual stimuli, much of which they ignore. Country people are exposed to fewer *different things* but those who grow up in rural areas tend to see more because they do not have to ignore so much.

Fear of failure is probably the strongest deterrent to creative work. Since some children and young people are much more fearful than others, this factor obviously varies from student to student. Many students are afraid of art because it is unfamiliar. We can overcome this by making it familiar, by helping students find out art is not so different and strange.

Students who are creative may be afraid of being analytical because they think it may ruin their intuitive mode of working. But highly intuitive designers use analysis to evaluate what they have done and it gives them a springboard for more creative work.

Students who are afraid of experimenting with media because of strict training in keeping clean, and who cannot face what they perceive as a mess, may need help in seeing that "messes" are often the origins for new ideas and new design solutions.

Learning that failure is a useful tool in finding out how things work or do not work is invaluable in areas where right and wrong answers are not clear cut. Failure is also a matter of labels. If students can learn to relabel unsatisfactory works as *unresolved potentials for change* or more as *possibilities*, they will not stop their explorations. To take this approach, they may have to change their ideas about work and play. Creativity is a playful activity. It is playing with ideas, designs, tools, and media to see what kinds of messages and objects one can make.

ART AND ENVIRONMENTAL DESIGN

PEOPLE, ART, AND ENVIRONMENT

People constantly interact with their environments. What they create there gives them feedback about who and what they are. We can find out what people value, their life styles, who does what, through the design and conditions of buildings, streets, homes, parks. In this way the city becomes a collective art form created by all the people who build and live in it.

The main purpose of Part Four is to help you and your students make more thoughtful judgments about the quality of the built environment as this affects people's experience. The design of objects and structures, the layout of cities and towns, people's varied life styles, the natural landscape, and the weather all affect each other (Lynch, 1960). When we neglect one, all aspects of our experience in our environment suffer in some degree.

Section Ten sets the stage for understanding the relationships among people, art, and the environment. Section Eleven suggests activities that deal with children's and young people's own use of space, the ways they share space and use networks to get from one space to another, and the study clusters of spaces, which become parts of communities of spaces. In Section Twelve the growth of towns and cities is studied in terms of people's needs, the lay of the land, and the values that affect how cities are built. Section Thirteen discusses differences among students that should be considered in adapting the activities to fit their readiness to study the environment.

GOALS FOR ART EDUCATORS

As art educators, we want to help people become as concerned about visual quality as they are about social, political, and economic concerns in the decision-making process. As resources become scarcer, ingenuity, recycling, and creativity will be needed to keep our environment livable. It is particularly critical that materials not be wasted by using them without concern for their full visual, social, and economic impact.

NEED FOR MANY-FACETED PROBLEM SOLVING

We tend to separate urban development and government into separate activities with separate departments in charge of each. Some are concerned with providing shelter, some with transporting foods, services, and people, some with safety, some with zoning (what goes into neighborhoods), some with the social needs of people, and some (usually small and weak) with how a city looks and what the way it looks means in terms of past and present values (Ewald, Jr., 1967). Few of the people in charge of these separate departments are concerned with their effect on each other. But to solve even the smallest environmental problem, all these factors must be considered. As we saw in our study of design, most things in our environment have a physical use in people's lives: they support some kind of

biological, social, or psychological need; they communicate meaning; they illustrate some kinds of values; give us information about the technology of the people who made them; and contribute some kind of visual input into the environment. The way any one of these functions is handled influences the ways all the others function (Ittelson et al., 1974).

To make this clearer, let's take a common thing in our environment. A city street provides a physical place for people and vehicles to go from one place to another. It supports biological, social, and psychological needs of people to get from one place to another for food, care, work, social interaction, and to support their psychological needs for doing and being. The way the street is designed influences how well the street functions for people. The design of all the things in and along the street influences the kind of experience people will have.

To make a street work well for pedestrians and drivers, *all* people concerned with the different aspects of it must work together. Safety engineers should be sure there is adequate space for the people who use the street to get to where they are going safely without getting in each other's way. At the same time, they should be concerned with the visual and social effect of their work on the landscape and all the ways people use the street. Police and lighting engineers must ensure the street's safety at all times of the day or night and control the use of space at corners. But they need designers' help

to determine the visual effects of the light on the street on people walking, pedaling, or riding along it.

The engineers and designers should consider people's spatial needs as well as their life styles. There must be room for people who walk vigorously, for people who move slowly, for people of different sizes, for people who carry different-shaped objects, for people with canes or perambulators, and for people in wheelchairs. Some people consider the street a place to meet friends and visit; the street is their main contact with other human beings. Others use the street only to get somewhere else.

Designers and architects must design all the buildings, signs, and street furniture so each clearly identifies what it is without interfering with the identity of the other signs or buildings or with the movement of people and traffic. Property owners should be aware of their contributions to the street through the design and maintenance of their buildings. They must consider how the designs of their entrances affects street traffic flow.

Landscape architects can design plantings and street furniture that separate people from cars and trucks, that designate places to rest or visit. Plantings must be designed so that shade is provided for people resting or walking without cutting driver visibility or covering up traffic lights (Figure 4.1). Plantings should relate to buildings to complement their forms, to create variety or order, and protect people from the wind be-

a. *East 6th St.; Austin, Texas.* (Courtesy of Robert S. Harris.)

Figure 4.1 *How are plantings used to modify the street? Compare the original street and the plan.*

tween buildings and the heat reflected off of them.

For any one group's decisions to work well, its members must consider how every other group's decisions are being made so that safety, uniqueness of buildings and signs, and people's individual needs will all work together. If not, a street could be safe, but people may not enjoy using it because of its barrenness. The same street could be very pleasant because tree plantings soften the lines of buildings and divide walking

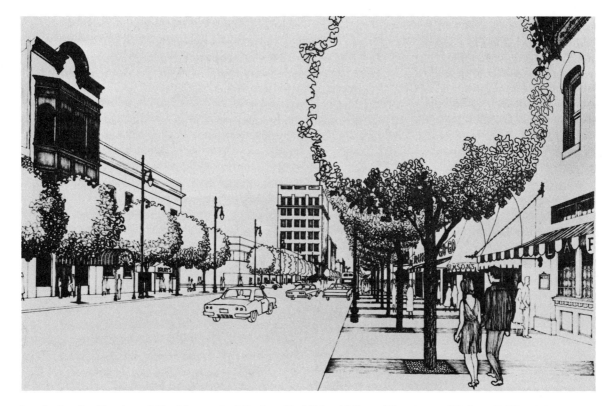

b. *A plan by Harris and Shefelman, Architects with Michael Utsey.* (Courtesy of Robert S. Harris.)

from driving areas but could cause accidents because the plantings obscure drivers' vision.

No one person or programmed computer can analyze all the elements that influence a city (Forrester, 1969). Often some neglected element inhibits the work of others. For example, a place may be very well engineered; it may look very beautiful to the designers. But if the forms, shapes, and colors of the place are foreign to the people who use it, it can be a strange, even

People

Differences Between People

reason for being there
what they expect to do there
how long they expect to be there
where they are going next
attitudes towards self and others
ages, sex, ethnic background
past experience
understanding of the place
ability to perceive space and visual detail

Their Relationships to Each Other

known-unknown
similar-different socioeconomic status
similar-different cultural background
likenesses-differences age/sex

*The Images They Present of Themselves
and the Impact on Others*

expression
dress
ornaments
hairstyles and body painting
objects carried
style of body movement

Places

Physical Condition of the Place

Size and form in relation to:
number of people
time spent there
activities

Surfaces:
combination of colors,
materials, textures

Sound:
kind
inside-outside
absorbancy of surfaces

Maintenance:
degree of repair
order-disorder
sanitation

Air:
temperature
oxygen content
pollution
odors

Light:
amount
source
color

Openings:
number
size
vistas

Figure 4.2 *Things that can influence the experience
of any given individual or group of people in a
given place at a given time.*

Arts and Designed Forms

cultural meaning
design
relation to uses
quality
amount
organization
placement

**Relationship of Nature of the Place
to Other Places in the Network**

a linking place between central places (public)
a central interaction place (social)
a space for individuals (personal)
a place to be alone (private)

Dynamics of the Place

How well does the quality of the place provide for the range of activities and quality of the experience of the people who use it?

How can any of these factors be modified to create a more effective, personal, physical, and qualitative environment?

How does the nature of individual parts affect the nature of the other parts?

The Experience of People in Places = What People × What Places × What Arts and Designed Forms × What Relationships with Other Networks × Total Dynamics of the Place

lonely, place for them. Also, a place with rich cultural meaning and that makes people feel comfortable can limit their safety.

City planning is a very complex matter. But if all the decision-makers and users pool their special knowledge and consider all the complexities, they will solve problems creatively and build livable, workable environments.

DYNAMICS OF CHANGE

At the same time, solutions are always temporary. *People, places, art, cultures, societies, and economies are always in some dynamics of change, and the relationships of all the things that influence a place change over time and need continuing review.* If we did this reviewing, our cities would not have deteriorating areas. As our resources diminish, neighborhoods as well as resources have to be recycled.

As we recycle, care has to be taken to preserve our heritage from the past. *What we are today has evolved from our past.* Cities that re-use their significant old buildings not only re-use space but preserve symbols of what has made us (Sommer, 1972).

In a book designed for teachers of art, we cannot cover so vast a subject in detail, but we can point out the relationship between art and the design of cities, art and the cultures of people. Everything considered in this book relates to our environment: how we see it, how we design it, how we express our feelings in relation to our experience in it, and how our culture, our values, attitudes, and beliefs affect how we will respond to our environment (Figure 4.2).

THINGS THAT AFFECT
OUR EXPERIENCE

The organization and design of a physical place can provide people with choices and

enhance their experience in it. But people come to a place with predeveloped attitudes and abilities to see, think, and feel, which influence what their experience will be in relation to that place at that particular time (Gutman, 1972). In Figure 4.2 you will see what some of the different variables are that influence people in space. Assume that there are eight people in a small space. You can almost play a game imagining how different their experience might be if you change any of the variables. If the people are highly developed in terms of what they see, are sensitive to design, and are aware of differences in people's cultures, they will experience much more than other people in such an environment and will be better prepared to make changes in the environment to make the place more workable for more people. The figure can be a checklist for you to help you see what you may be ignoring. It will help you see the interrelatedness of things. Imagine how the people would react if they were all friends, enemies, strangers, different ages, or different cultures; if the walls were solid or glass (and if glass, whether the outside were devastated or pleasant); if the temperature were hot, or hot and humid; or if the air were stale or fresh, or freezing and there were no hope of a change.

Imagine that the people are in an elevator for half a minute, or that they do not know how long they will be there. Imagine that the room is all red or blue or green, that the room is all patterned or perfectly plain, that the room is a familiar place, or that the people have all been there before or that the room is completely strange. Innumerable combinations of situations can be made by changing the different social, physical, and visual situations.

How do we help children and young people deal with such complexity? In Section Eleven activities we approach this problem in three ways. First, we start with individuals and their uses of space and work toward the use of communities. Second, we will help you help students look at some of the ways cities evolve and grow, and at the relationships between human needs and the things humans build to meet these needs. Third, we help students synthesize more aesthetic social and physical concerns into single problems.

HOW PEOPLE USE SPACE

The following activities are designed to help students recognize how they use their environment and to become more thoughtful designers of their own spaces and those they share with others. The activities are divided into four areas of inquiry: I-spaces, shared spaces, cluster spaces, and the networks between spaces. It starts with the individual's own use of I-space and builds logically to the larger framework, just as social studies start with the family and extend to neighborhoods, communities, towns, and cities.

AREA A
I-SPACES

People use spaces in everything they do. We call these territories "I-spaces." A person's I-space is called a portable territory because it goes along wherever the person goes (Sommer, 1972).* The size and shape of I-spaces change, depending on what people are doing or where they are going: running to catch a bus, eating dinner, driving a car, or watching television. An I-space is also something we feel. When we are in a crowd, we psychologically pull our sense of space close to us. Conversely, alone on a beach on a foggy day our I-space may stretch as far as our eyes can see.

People's I-spaces include not only those spaces they regularly occupy and consider their areas, but things they wear and carry. For instance, the student's desk in the schoolroom is his or her place during a given time; and the things arranged on the desk are part of what identifies the individual's space. Most children have some kind of place at home that is their space, that is an extension of themselves, an I-space. Children's clothing and the ornaments they wear, such as ties, pins, and jewelry, contribute to their space and identity as people. Their coats, sweaters, rain gear, and boots are further extensions of their I-space. We symbolize who and what we are and the space we need through the things as well as the containers we need for things to carry on our activities (school book bags, purses, briefcases, tool boxes, lunch boxes). All these are designed and decorated to symbolize who we are and the space we need to be what we are.

Our I-space does not always stay the same, but changes according to the way we feel. When we are sad, our space may feel small, but when we are joyous, our space may feel huge. It is not like the space in an empty box or in the classroom, marked off permanently by its sides or walls. I-spaces change as we move to different environments, change the kinds of things we are doing or the way we feel. I-spaces depend on body movements to do different things, on the kinds of dress people wear to symbolize how much space they need, and on the feelings we have about ourselves in relationship to the things around us.

* This is an adaptation of Sommer's concept of personal space with emphasis on the uses of space rather than the psychological meaning.

Level 1
Understanding I-Spaces

This concept that everyone uses space is not hard for small children to understand on a feeling level—cared-for children have learned there are safe, warm spaces in a parent's arms, where they sleep, or where they keep their things. Even rejected children usually have some place to which they can retreat. But children may not have thought about how many different kinds of spaces they use, the bigger and smaller space they need at various times, and whether they feel safe or not. Older students and adults also use an I-space all the time, but probably have not thought about it as a continuous bubble of shifting shape and size.

To get students to think about I-spaces, you can begin by having them role-play the different things they do in some familiar situation such as is found in the classroom. Or, you can use games to get them involved in analyzing their spaces. Since some people learn more through feeling and others through analyzing and most of us through both, we need to provide experiences that allow all kinds of learning. The amount of space one's own body can stretch, extend, reach, and bend to, is as large a volume of three-dimensional space as one can use standing in one place. Running, hopping, and dancing help one see how much space one can use through time. Older students can watch track meets to see how athletes run not only against time, but see how much space they can cover by running and jumping or throwing objects. They extend their use of space by hurling themselves and other objects through space. The winner claims the biggest I-space of all.

In each kind of activity, ask students to think about how it feels, what it looks like, and how space is used. It isn't necessary to follow the athlete's value that more is better. Many times we should use less space, and less energy to control our actions, and then enjoy the aesthetic balance between our need to express and our need to control. Ask students:

How much space do you need to put on your coat and hat, tie your shoes, paint a picture, clean up your brushes at the sink, climb on the bus, eat your lunch?

Do you feel differently in your space when you come into school after being out on the playground, go out the door after school, walk down the crowded hall?

Send your students out searching their libraries and homes for books, magazines, and newspapers that show pictures of people in different roles. See what film and slide resources your school district has of people actively engrossed in different roles at different kinds of events and places such as busy city streets, courts, carnivals, construction areas, hospitals, and police stations. Ask your students to analyze what they find and to consider the different I-spaces people use in these different roles:

Do you think this person takes up a big space or a small one? What makes you think so?

What would happen to a clown's I-space if he or she were taken to a police station?

What would happen to a police officer's I-space if she or he had to go out on patrol wearing a clown's suit? Would people do what he or she asked them to?

Would a person's I-space be different in this situation if he or she were lonely, frightened, happy? Does the way other people see us affect how we feel?

Do you think that all of you feel the same about the spaces around you? How could we find out?

Sufficient discussion should take place to ensure that the students have a basic concept of their own and others' I-spaces; how they change, and how differently designed environments and costumes and different activities affect our own personal sense of space.

The activities listed below may provide experiences that will help children understand the concept of people's individual spaces and how they change. They can be repeated in changed forms so the students can see how their I-spaces function in many different situations. Ask students to think about the spaces they use as they go from their seats to under their tables; are crowded into a corner, closet, small room, or between two tables; crawl through a large box, under a table that has the sides covered, or through some other "tunnel" arrangement; or leave their classmates and walk out alone to the center of a gymnasium, cafeteria, or stage. Ask the students to recall a place, situation, or activity that made their I-spaces seem smaller (or larger). Have students draw (or paint) a picture of someone that will communicate the size of their I-space. A follow-up discussion may be held to see whether others in the class felt the picture communicated what the student recalled.

Have small groups of students design spaces that allow for small (or large) I-spaces that fit different activities, using tables, chairs, or cardboard boxes:

How does the color around you affect your I-space?

If you have to be in a space by yourself and you like the color, do you feel that all the space is your I-space?

If you don't like the color, do you "pull in" and limit your sense of I-space to yourself and your clothing?

Encourage children to experiment painting the insides of large cartons different colors, to see which colors they like to be in. Cut holes in the cartons so that light shows through. A portable covered light can be used to help children see how more light changes how they feel about being in the carton. Ask them to sit in the carton and write or draw how they feel. This helps them learn to express feelings directly in relation to an experience.

Students can experiment with textures and details to see if they can make the carton so "busy" inside they cannot stay there very long. By eliminating variety, they can seek a degree of order that they like. They can compare differences among them in the amount of order and variety they each like.

Level 2
Using Art to Create I-Spaces

Help the students understand the roles of clothing, jewelry, facial expressions, and body movements in defining and communicating I-spaces. The clothing that we wear helps shape and maintain our individual space. Clothing, along with facial expression and body movements are visual indices that communicate to others about the size of space we use.

Ask your students to imagine that they are wearing raincoats and walking in the rain:

Figure 4.3 *People communicating roles through dress.*

What are the boundaries of your I-space?

What happens when it stops raining and the sun comes out?

Does your I-space change when you take the coat off?

Are the I-spaces of people wearing raincoats and walking in the rain different from those of people who are also using an umbrella?

How do you feel and what happens to your I-space when you go outside on the first warm day of spring without a coat or jacket?

What happens to your I-space when you change clothes from jeans to shorts, from regular clothes to a swimsuit, from wearing a coat to not wearing a coat?

What are some other examples of how clothing affects your sense of I-space?

Conduct an I-space change party so the students can assume another identity and I-space. Obtain old clothing the children may alter by cutting, painting, gluing, sewing (Laury and Aiken, 1973). Outgrown clothing can be used by smaller children. This kind of activity could fit within the framework of a costume party. Encourage the children to use their imagination on the design of their outfits. You might suggest that the children work out some theme they can act out in their costume. They should also consider the use of the space they would need to act out who they think they are:

What kind of role do you want to play?

Whom do you want to pretend to be?

What kinds of action and space does that kind of person need to fill his other role?

Can you design a costume that will let other people know who you are and what kind of space you need?

You may be able to fit this activity in with your social studies program. For example, in the study of a particular culture, you could ask the students to identify the different roles people play in that culture, the kinds of clothes they wear to identify the roles, the kinds of space they need to act out the roles, and the amount of order or variety needed to portray who they are.

Level 3
The Functions of Dress Design, Gesture, and Movement in Creating I-Spaces

Costume is an art form used not only to protect us from weather but to symbolize who and what we are and the kinds of space we need. Gesture and body movement are used to make the message more alive and real.

Figure 4.4 *I-spaces in public places. How has the mall designer provided I-spaces for people?*

With your students, develop slides depicting varying kinds of dress design, facial expressions, gestures or body movements, and jewelry. If costumes are available, students can act out appropriate roles while

examples of people in action. Get the students to answer questions about the nature of the I-spaces they see in the photographs on the basis of the visual cues available. Figure 4.4 shows some relevant visual cues. You can ask the students about:

How can we tell from looking at people and the things they include in their I-spaces, who and what they are and how much space we should give them?

How do clothes—work clothes, play clothes, formal and informal clothes for various occupations and occasions—indicate how much space is needed to perform the role?

How does the way the clothes are designed communicate the nature of a person's role and how much it is valued?

What do facial expressions—happy, sad, angry—tell us? Body gestures?

How are people's statuses, ages, ethnic or regional origins, occupations, and self-concepts expressed through the ways their clothes are designed, ordered, or varied?

Are people always like the way they look?

Students can collect photographs of people in various daily activities (at home, work, or play) from trade journals, theatre magazines, news magazines, and newspapers. These pictures can be used to depict the varieties of dress and kinds of changes in the spaces people have around them that we see every day. Have students develop a montage of I-spaces under a specific heading with a written analysis of the things that describe the I-spaces needed for the activity: people at play (skiing, swimming) and people at work (logging, mining, lumbering, truck driving).

Have an I-space-change party centered around the changes people need in I-spaces. Let the students use only masks and headgear. Provide media for experimenting: theatrical make-up, papier-mâché, paint for

Figure 4.5 *Finding an I-space where none was planned.*

others photograph them. Slides can be made from photographing people on busy streets as they come from and go to work. Photographing news events on television screens using fast black-and-white film provides

masks, sewing and stitching for headgear, assorted materials, decorated old felt hats:

What do different kinds of headgear tell us about what people do and the space they need to do it?

Why do people wear masks?

How many kinds of masks and face painting do you know about?

What kinds of masks do people in our society use?

How do masks change how you and other people feel about your space?

What kind of mask could you make so people would not know who you are?

After creating the masks and/or headgear, ask students to act out the kind of person the mask says they are:

How does the mask change the kind of space you need?

Does it change the amount of space others give you?

Create a game situation after a student has made a mask, a headgear, or painted face. Ask the class to write a description of what they think the student is saying and what others will think he or she is saying through art, then see how closely they match.

If a student's description does not match the class', compare the cues they got that were different:

How could we change the mask or the face painting or the hair design to make the message clearer?

Do we always want everyone to get the same message?

Level 4
Defining I-Spaces with Objects

Shift the emphasis from clothing to objects we use to identify and establish spaces for ourselves:

How do we maintain our territory with the arrangement of things—in the classroom, at home, on the way to and from school, in the cafeteria, gym?

To get students thinking about it, ask them such questions as:

How would you reserve a whole seat in a bus if you really didn't want anyone to sit by you?

How would you keep a whole work table to yourself?

How would you define your space in the library?

How would you provide space for your work in sculpture or ceramics?

How would you keep your lunch from being mixed with others in the cafeteria?

How would you eat a hotdog at a stand-up lunch counter?

Many of these things we learn to do without much conscious analysis, so often we do not realize how much our definitions of spaces affect the qualities of our lives. Students will become more aware of the ways schoolbooks, purses, shoulder bags, backpacks, lunch trays, and umbrellas are not only objects that serve us but also definers of personal space.

Then students can begin to analyze the design qualities of things provided to give them their own individual spaces—chairs, desks, tables, lockers, cubicles—to see how well they really serve.

After analyzing the space-definers at school, they can look for spaces provided in homes, theatres, parks, cars and buses, drive-in restaurants, and stations. They can use the criteria for designed objects in Part Three (use, social function, meaning, aesthetic quality, and information) to see how well objects serve people in providing and communicating I-spaces:

How well does the object communicate how it is to be used?

Does it provide enough room for the person's I-space in doing her or his tasks?

Does its aesthetic quality enhance people's feeling in using the I-space provided?

How could people change the way they use the object to make it function better?

How could they change it visually to make it look more like what it is used for?

Students may enjoy developing charts or diagrams that show how much space different actors use to perform their roles in dance and theatre as well as on TV and in film. Take into consideration the performers' I-spaces, including their manners, as well as dress. Then the students can compare the charts to their ideas of the social positions, values, and personalities of the people portrayed. In addition, students can look at art works showing people and make some assumptions about what is being transmitted to the viewer regarding social positions values, and even personalities through the people portrayed:

What kinds of people use grand gestures and what kinds are reserved in their actions?

Who are the aggressive, the timid, the secure, and the insecure? How does their appearance support this?

How do hair styles identify character roles?

Which ones are given the appearance of being acceptable by the majority of an audience? Why? Which are not?

After critically viewing several television programs, they will be able to recognize patterns and stereotypes in characterizations and begin to make some assumptions about the degree of creative thought invested in the development of these characters and how that relates to the quality of the programs.

Those students interested in transferring these experiences into their art works might select the following activities among several approaches.

A small group could select (or write) a short play totally defining the characters by appearance and manner, instruct their actors in how they will act out their roles, and then actually produce the play. The play itself, in dialogue, as well as visually, could relate to the students' observations on I-spaces and social and cultural values, and the performance could be videotaped for playback and analysis.

Individual drawings, paintings, prints, sculptures, or murals can become a means for students to make a social statement about their observations of feelings toward and responses to I-spaces and social and cultural values.

Whatever the art form, when students represent people in their works, they should be aware that they must get the I-spaces right as well as the figures of the people. Otherwise, they will not have expressed what they intended, and will not be satisfied with their work.

AREA B
SHARED SPACES

We all live in the environment and, at the same time, make up a part of that environment. Many of our environmental problems stem from looking after our I-space and not considering the I-space needs of others. But, as population increases, we must share space with more people. Much of the quality of our lives depends on the quality of the space we share with others.

We have learned that people's I-spaces depend on what they are doing, how they feel, and what they look like. But another important dimension is the relationship of one person's I-space to the I-spaces of others. We must design spaces so that all people have a place to *be* what they are, carrying on their own activities without interfering with the things other people do and the ways they

Figure 4.6 *Charles Zerner.* The Night of the Babylonian Astronomers. *An artist's projection of children's meanings for the spaces they create in leftover urban space.* (Courtesy of the artist.)

Figure 4.7 *Spaces designed for sharing become I-spaces when one person uses them.*

feel. This affects how I-spaces can develop as people share spaces.

A person living all alone in a large space has more freedom for using space than people who have to live, work, and play in close proximity to others.

Level 1
Learning About Shared Spaces

Start with a game that most of the students are familiar with. They may need to actually play the game to analyze how they use space in playing it. For primary children, games like musical chairs, hopscotch, squares, or "Squirrel in the Tree"—all space-sharing games—can be played and then repeated to see how they change spaces, how what one child does in a space affects how the others use a space. Older children or teenagers can play baseball. This is a group activity that depends on both individual and shared spaces. When a team is up to bat, that team's batter gets to use the homeplate. The homeplate is an I-space that players take turns using, as are first, second, and third bases. Baseball is not only a game of pitching and hitting the ball and running, but of who gets to claim a certain space in a given amount of time—the time the ball can be caught and sent to the player who is trying to defend that I-space for her or his team. See what information you can get from your class about the shared spaces in baseball, hopscotch, jump rope, and checkers. All these games involve playing with spaces—who gets to claim a space at a given time. You can stimulate their inquiry by asking:

Does everyone use the same space?

What decides who can use a space at a given time?

How does winning the game relate to the use of certain spaces?

What objects do players carry? Who does what?

Does the costume of players tell anything about what space is theirs?

How are the costumes designed to help people play the game?

What would happen if the large spaces (those that have smaller spaces within) were changed in shape?

Could you play football on a baseball diamond?

Have the children make flat models on large sheets of butcher paper of the games they play. Use black crayons to show the routes the players take. Shared use of space occurs where many lines cross. Ask them:

What kinds of spaces are needed to play the game (homeplate, bases, whole field, or pitcher's mound)?

What kinds of symbols are used by players to tell what they do?

What kinds of symbols are used to designate different places in the game?

How do you tell when you can use the space?

How are different spaces of the game separated from each other?

Which are the most important activity spaces the players share?

Which are the most important spaces that link one activity space with another activity space?

Level 2
Designing and Symbolizing Spaces

This activity will probably come up as a problem from the prior activity: "Where can we put everything when we are not using it?" The problem is to design and construct an individual storage space that will fit into a shared storage for all the class. Each school will vary in the amount of adequate storage space. Most will be deficient in some ways. You and the children can determine the areas which need development.

The various spaces can be small or large, group or individual storage spaces, depend-

ing upon the need. Some consideration for stacking of the units would be advisable (modular concept). The storage space might be very small: designed to fit in or on an individual's desk. It might be larger: designed to accommodate student artwork or papers. Wooden boxes and/or cardboard boxes reinforced with paper strips dipped in wallpaper paste would be suitable basic materials for the designs. Students can develop a color code and symbols to label storage areas instead of traditional word signs.

The key problem is designing the shape, form, and color of the three-dimensional forms so that they can be used together and we can clearly see who owns each space:

What questions do we need to ask ourselves about our storage space?

Does the way it looks work well with the way we use it?

How does the whole storage space relate to the way we use the whole classroom?

Does it set up any traffic problems going to and from the storage area?

If so, what can we do to solve them?

Is it easy to get things in and out?

Did we solve all our storage problems?

A symbol for the outside of the classroom door can be designed to tell people who is inside and what they do. Inquire into government use of seals on money to symbolize what is important about the government and into the ways in which trademarks are developed and designed to symbolize the nature and quality of the products. Ask:

How can we make a symbol that tells who and what we are?

What is our message about ourselves? What do we value?

What can we draw that means what we think?

How can we all participate in making the symbol?

The students should identify their values and find out which values most of them agree on. When they have the information they need about their message, they can review concepts of design to see how to express it most effectively. You can help them review with the following questions:

How are you going to symbolize what is important about the class?

How can you design the symbol with enough order and variety so people can understand what you are saying?

What else is already going on in the hall? What colors would relate to other colors in the hall yet be different enough to show up? What shapes or sizes would be related yet be different enough? Would the symbol make it too busy?

What materials should the symbol be made from? What is available? What would last? What are we skilled enough to use?

Level 3
Analyzing the Look and Use of Space

Not only in games, but in our everyday lives, we must share spaces, and sometimes even compete for spaces. In a well-designed place, people have choices of the kinds of I-spaces that will fit. In a well-designed place, one person's I-space will not interfere with another's in terms of the physical space, the way it looks, or the way it makes people feel. Groups of people crowded on a beach or in a waiting room identify their shared spaces by the ways they group themselves, and the ways they build barriers with the edges of beach robes or stacks of luggage. In a well-designed place there are spaces for groups so one group will not interfere with another.

The kind of space we live in and share with others depends, in part, on where we live. In large cities, our home might be an apartment. If we live on the edge of a large city or in a small town, our home might be a

house or a duplex. In the country, our home might be a farm house. Not only do these homes protect us from weather, but they identify different kinds of shared spaces— spaces for families, spaces for individuals, spaces for children, spaces for adults. Sometimes these are separate rooms; sometimes these are designated spaces within one or two rooms.

Besides the home, many people have other living or working spaces where they spend part of their time. Some of these spaces are outside and some are inside; some are natural spaces and some are manufactured.

When we are designing, we try to think about how the spaces will look together, how they will be used, and how they will make people feel. The way spaces *look* is important because it tells us what activities can be done there, how important the place is, and how much people care about it. The way spaces look affects the way we feel about a place and, in part, how we enjoy or dislike being there.

This discussion activity is designed to help the students do a critical analysis of how their own classroom looks and how it is used. Students can probably solve some design problems from this analysis, such as better rearrangement of furniture for better individual and group work, improvement of the look of the room, and combinations of the two. The analysis is done primarily through the inquiry method of eliciting ideas from the students, but may involve the changing of some furniture to "try out an idea." The practical design problems may be best solved by small groups rather than the entire class, but the whole class should analyze suggestions and accept, modify, or reject them. Begin by asking:

In what ways is our room similar and different from other classrooms in the school?

How can we make it work better for everyone in the class?

Does our room limit what we can do in it? Is it so ordered that it is uninteresting?

If we could do anything we wanted to do to make the room more "interesting to the eye," what should we do?

Why do we need to change it?

How can we make our room different from other rooms in the school so it will really be "our" room?

Would different colors make us feel differently about the kinds of activities we do? How much do we care about our room?

Lead the students toward making suggestions of possible changes or rearrangements that *can* be accomplished. Try to get enough different "projects" so the whole class can be working in smaller groups. When the projects have been completed, allow several days of "usage" before having students evaluate the success of their redesigning:

What different arrangements of tables and chairs do we need for the different things we do?

What do individuals need?

What spaces do groups need?

How can we use time to share space?

How do the arrangements make spaces so we can get things from storage, and use the sink or blackboards?

How can furniture be arranged between activities with the least confusion, noise, and time consumption?

Have students decide on furniture arrangements for different activities. Keep track of how their arrangements work so the class as a whole can evaluate how well their decisions work for everyone. Use a chart and a check sheet to make sure each detail is considered.

When they have an arrangement that they think works, ask them to evaluate how it looks in relation to how it works:

Does the room look confused in some places?

Could we adjust the arrangements so there is more similarity in sizes of furniture, color, or shape?

If the arrangement does not work, could we relate things along a line? Would grouping objects help? Do any of these visual design decisions inhibit people's use of them?

Are there places in our room that look empty? Do we need some variety in those places?

When we design spaces for people, should we leave the people out?

Try various suggestions for solving the visual problems:

What have you learned about design?

How does the way it works relate to how it looks?

Can you think of ways this happens in other places?

Level 4
Analyzing How
Sharing Spaces Makes Us Feel

A small group or an individual might elect to enter a public building in which they have never been before and assess their/his or her own reactions:

How large is your personal space? Why? Does that get larger or smaller the longer you remain and move around there?

Are you sharing space with others? Who? How does sharing feel? How large is that space?

Are you sharing a small space with a few and a larger space with many? Which do you identify with?

Students can, as a class or in small groups, do a study of an area in their community or school. In the school cafeteria students can secure a vantage point that will

allow them to identify and record the various ways space is shared and by whom. For example, over a five-day period they can assess which spaces are used by most, by some, by a few, or by no one. To help them get started, you can ask:

Do some students repeatedly use the same space to eat or talk?

Which spaces do all students use? Which are shared by teachers or other school personnel?

Which spaces appear to be "off limits" to students or other persons? Why? How does this suggest social roles within the school?

What is the traffic pattern? How is it determined?

What evidence is there that personal space is being interrupted or changed? Why would this occur? Between whom?

Have a small group of students analyze how a variety store or food market is organized to accommodate people sharing space:

Which spaces are organized to control and which to accommodate people?

Are some spaces larger than others? Why?

How can customers determine which is their space and which is the store personnel's?

Are some spaces only for one person? Why?

How do the doors and windows tell us it is a public place? What other visual cues tell us it is a public place?

Is the store large enough to accommodate the number of customers?

Charts, diagrams, or drawings can be useful in describing what is observed. Photographs, film, or videotape can be used to record the patterns and variations of shared space for later class analysis.

If there are malls, parks, shopping centers, or other public open spaces where people gather in or near your community, students can make studies of these shared

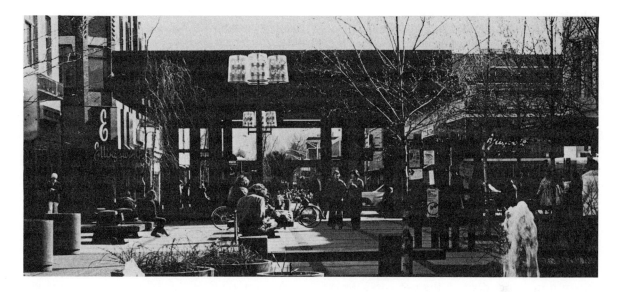

Figure 4.8 *Shared spaces in a cluster. How many kinds of things are going on in this place? Which ones require shared spaces? How well do they appear to work?*

spaces and decide how well (or not) they seem to accommodate the uses people make of them. Students can become directly involved in their community by doing a careful study of a space, determining improvements or alternatives that would make better use of it, making a detailed scale model of the change, and presenting these all to their city officials for consideration.

Students can attend a play and analyze the way the characters are placed and move in a shared space (the stage), how their personal spaces change, and how these all contribute to the message, mood, or feeling of the performance. To some degree this kind of analysis would be possible with TV and film as well. Discussion and analysis of art works can include the elements of shared space as they affect or determine what the work expresses to the viewer.

Studying and reacting to the *effects* of shared space in its many forms should provide your students with a more acute response to their surroundings which, in turn, will offer them yet another avenue to pursue in their art.

AREA C
NETWORK SPACES
OF SCHOOLS

Schools, like larger communities, have many different kinds of networks that serve the people in them. For example, transportation networks include the halls and stairways, which are like the streets and sidewalks in the community. They are the pathways people use to get where they want to go. Sidewalks and streets around the school and those used by students and other school personnel to get to and from the school building are all networks used by the people who use the school. Each network needs room for all the people's I-spaces, and sometimes groups of people sharing activity spaces. The effectiveness of a network depends on how well the space allows for all the kinds of movement necessary. Sometimes the network works very well in some places and not well in others. As students study the activity and network spaces in their school, they need to evaluate how well they work. If students can deal with the complexity of the idea, show them how dependent all the networks are on each other. Without the hidden networks and the fuel supplies to make the networks work (which are also networks of supply), they would feel cold and be in the dark.

Level 1
Networks in Classrooms

Make several maps of the classroom on large sheets of thin paper as much in proportion as you can. Ask the students to work together to identify all the paths they take in coming into and leaving the class. Ask them to identify all the usual paths they take with all the different activities they do in a single day in the class. They may have to act out the activities to be more aware of their routes to get to doors, book shelves, storage areas,

sinks, coat racks, different activity centers, to talk to teachers and other students. Use two or three activities that usually would not be done at the same time to draw on each of your maps. The students may see why some activities cannot go on at the same time as others. Time is a way of dividing the use of space in a classroom as well as a baseball game. Ask:

Where are our congested points in our networks?

What spaces are not used very much? Why?

Are there ways you could rearrange things so crowded points in your networks could become less crowded?

Do some of us need to change our I-spaces or our shared spaces so our community spaces will work better?

How can we make the community work better without individuals having to give up too much time or space?

Level 2
Network Spaces Within
and Around the School

A floor plan of the school and a schematic drawing of the surrounding grounds will be most useful for these activities. If a floor plan is not available, making one could be one of the activities. A map of the community is also needed. Enlargements can be made using an overhead projector and tracing the details on sheets of paper hung on the wall.

Using the floor plan of the school, locate and mark places in the school that are used by all the students, e.g., cafeteria, gym, and library. Using felt-tipped pens, mark the traffic patterns used by the students in the class to move around the school. A marking code will be helpful in distinguishing paths used by the class as a whole from paths that are used by individuals or small groups. Students should then make tours following different pathways, paying particular attention

to what they see during the trip. Groups of students can study the halls, lobbies, and corners when they are empty and when they are used. They can look for the kinds of activities students carry on in the halls, at what times, and how these activities change depending on how many people are in the space at a time.

Then they can study the routes people use in the school, going to and from the classrooms, auditoriums, rest rooms, offices, and recreation areas. Each member of the class can draw on a single layout of the school their usual route each day or through the week. Then they can look for areas where they need to study in more detail. Ask:

Where do traffic jams appear?

Do they happen all day or just at certain times?

What kinds of activities go on in the halls besides going from one place to another? Why do they happen where they do? Which happen in the heaviest traffic area?

Do people act differently at different times of the day?

Is there enough light?

How does the color affect the way people act in the halls?

Are there enough places to stop and talk to other people?

How do you feel about different parts of the halls of the school?

What happens to your I-space when you go down the hall? How does it change from one place to another?

What would changing the times people use spaces, the ways people behave, and the amount of light and colors do to make the halls more pleasant places for getting from one place to another and for meeting other people?

Level 3
Creating Symbols
to Help Networks Work

Develop an awareness of how symbol systems are used to inform people where dif-

ferent parts of a building or places are located, what the places are used for, and to make it easier to share the network spaces with other people.

The inquiry will be more meaningful if slides, photographs, or drawings of different kinds of symbols used in our society are available. Maps that use symbols can also be helpful. Ask:

What are some of the signs or symbols that are used to tell people what road they are on and where it is going?

What are some of the different kinds of symbols that are along roads that tell us there is a railroad, a park, danger on or near the road ahead of us?

What kinds of symbols are used (besides words) on local store signs that tell us what the store sells?

How are different rooms in our school marked to tell others what is going on inside? The library? The office? The gym? The different classrooms?

If they are marked with "word" signs, how do the small children in the school who cannot read know what the signs mean?

How do you think most visitors to our school find their way around?

Could you find your way the first day of school?

Does our school need some symbols to help us use the halls more effectively?

Students can then study how traffic lights direct where people can go and share the time a space is used at cross sections. Study the traffic of the halls at school by reviewing what they learned at Level 2.

What are the basic shapes that make up the school? How well do these shapes serve the network functions that go on in them?

Are there parts of the school that were added after the original building was completed? Do they fit in with the networks of the rest of the building?

What shapes, sizes, colors, and textures are used in the building to show how the networks work to keep people moving during class changes?

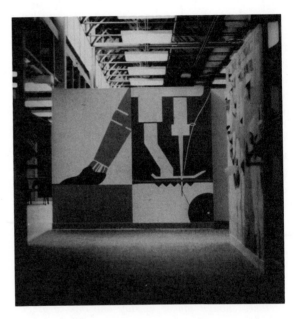

Figure 4.9 a. *Signs and symbols are separators in cities.*

b. *Graphics in a school direct traffic, Branford Intermediate School, Branford, Connecticut. Carlin, Pozzi & Associates, Michael S. Shellenbarger, Project Architect.* (Photo courtesy M. Shellenbarger.)

If there is no way to change the building, how could the timing and numbers of students make the networks work better? How could this be made clear with symbols?

Then they can design symbols that fit the place, are easy to understand, and that help people use the halls more effectively and pleasantly.

The symbol system can identify different parts or areas of the school so that students and visitors will be able to find places easily. These can become large graphic designs that serve to add variety and interest

as well as information. Students will need to ask such questions as:

How can we make the symbols readable at a distance so that people can anticipate which way to turn to get to the place they want to go?

Where can they be seen when the spaces are full of people?

What shapes, colors, textures will best communicate the message? How can they help change the mood effects of the environment?

Students will have to study the school from different directions so they can see more of how the whole network system works in order to design their symbols to work in the whole place:

How can students change their behavior so that it is more pleasant for everyone to use the halls?

How can networks be divided by use of symbols so traffic will be less congested?

Would music make networks more ordered, quiet places or active, fast-moving places?

Level 4
Networks of Pedestrians, Cyclists, and Drivers

Level 4 students can study network spaces that lead to and from the school. People in cars, on bicycles, and walking often get in each other's way when they share the same space. Compare the kinds of cars, cyclists, and pedestrians in different kinds of streets or parking lots around the school. Later, residential and business streets can be studied for cars stopping, starting, parking, turning, passing; for people getting in and out of cars; and for bicycle riding, stopping, and parking. The students should answer such questions as:

How are spaces divided for different directions, speeds, parking spaces, drivers, and riders coming and going, turning and passing?

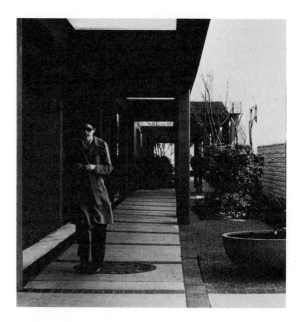

Figure 4.10 *A network between city streets. What kinds of light, weather protection, variety and order are provided people?*

How are spaces for people, cars, and cyclists separated when people are getting in and out of vehicles and drivers are parking?

How are timing and spacing used to create order in traffic flows?

What spatial allowances are made for emergencies and emergency vehicles?

How does the visual environment contribute to or hinder drivers' awareness of where and how to turn or stop? How readable are traffic signs? What is the background of signs? Does it help or hinder reading the signs?

How does the environment of highways or parking lots affect drivers and passengers?

Are there items that could be introduced along residential streets, business streets, or freeways that would make driving both safer and more pleasant? Are there items that could be removed?

The selection of questions depends on the area studied. Some schools are in much more congested areas than others. Your students may have to go farther away from school to study streets if the area is all suburban residential.

AREA D
CLUSTER AND COMMUNITY SPACES

Cluster spaces are areas where groups of related but somewhat different activities go on in the same space. For cluster spaces to work well, all the I-spaces and shared spaces within them have to work well together.

These spaces are often the most difficult to analyze, but they are also the most critical if the cluster space is to work well for all the people who use it. Students will need to: (1) identify the different activities that go on in a place, (2) identify the space requirements of people to carry on these activities, (3) identify what is physically in the space that may or may not have to be changed, (4) identify what the time dimensions are that control how the space can be shared and (5) identify what smaller *networks* go on within the cluster.

The reason for looking at different kinds of spaces is not so much to put them in categories as to help students become more aware of how differently they use space.

Figure 4.11 *A landmark where networks meet in the center of a community. The children create a shared space in a central square—a cluster space of a community.*

Sometimes it is hard to categorize a space. When five thousand people are all sitting listening to a concert, each has his or her own I-space, but they all share the larger space with the musicians and ushers, who do different things. We could call the space they occupy, whether a lecture hall or a meadow, a cluster space.

In the more common type of cluster space, multiple individual and group activities go on. A department store is a good example of a place where many small groups share spaces and do somewhat different things. There are networks to allow for the I-spaces of people going from area to area carrying packages and hanging on to children. There are shared spaces for salespeople and customers to talk and try out or on the goods for sale. The amount of space depends on the kinds of goods sold. There are cluster spaces made up of departments in the store. Each cluster is somewhat different, depending on the kinds of goods sold and the kinds of space required to display, sell, package, and remove them. It takes more room to buy and sell furniture than perfume, for example.

A small town or community is made up of many cluster spaces: homes, schools, churches, libraries, stores, factories, and government service centers, and all the networks needed to make the trips between them and to enter and leave the community.

A community is identified by the kinds of things that go on in it that hold the community together and are somewhat different from the surrounding area. Usually, the design of buildings or cluster spaces and networks are related to the activities. That is why a business community looks different from a suburban community or an academic community. Residential communities ideally are somewhat self-contained, clustered around basic services: schools, stores, banks, and professional centers. Planned communi-

ties provide for both homes and services at the same time. But sometimes a community space is formed by outside forces, such as freeways through a city. Old communities that may have been formed by groups of people who shared some common goals may be divided. What remains is a community formed because it is surrounded or cut off. Sometimes a new social community develops there as people find common goals for renewing the space.

Level 1
Creating Cluster Spaces

Level 1 students can create cluster spaces in their classroom by making areas for individuals and small groups to work or play away from the rest of the class. You can get them involved by asking:

Do you already have cluster spaces in your room? Where are these places for groups to do things? What is there that tells you what the space is for?

What other kinds of spaces do you need?

What do you want to do in the space?

What kinds of spaces do you need to do them?

How much space will each group member need?

What kind of space do you need for tools, materials, storage, and display?

How can you use the objects you have (tables, chairs, portable bookcases, and/or screens) to create the space you need?

How can you take care of the space so it will always work?

How can you use colors, shapes, textures, and drawings to let students know what the space is for?

They can begin by "playing house," with different children playing different roles as individuals and members of groups. You may want to let them freely play roles and then ask if their spaces were right to play these roles. You can watch primary chil-

dren's unorganized play to see what kinds of spaces they use on the playground. This can be repeated in the classroom so they can think about the spaces they use.

Level 2
Evaluating Cluster Spaces

Students can study the whole classroom to see how well all the subspaces work for the kinds of activities going on in them and how well the subspaces work together:

Where does one student's use of I-space interfere with other students' I-spaces?

Is it the physical arrangement at an art table or a science experiment area? How can the arrangement be changed so more students can work in the space?

Is it the ways some people work? Could they change the ways they use space and still accomplish what they want without interfering with others?

Is it the ways people take care of spaces that makes them not work for others?

Do the messages they get from the things in the space let them know how the space may be used? Does it look more crowded than it would if there were more order in the area?

How does changing activities in the same space require rearranging the space into another kind of activity space?

How easily can a space be changed for use from one activity to another? What are the easiest ways to change spaces with the least noise and disruption of the other shared spaces?

Each classroom varies, but most classrooms can have places to study alone or read quietly, to study together in groups, to work together on projects, to listen to what students in the whole class have to say, to listen to what the teacher is saying, to create alone or in small groups. Play areas vary depending on what kinds of games or free play are going on. Music has different space needs for singing, playing instruments in groups,

and listening. Dramatic play and dance have special spatial needs in a classroom. The key question is: *How do all the spaces for all these activities work together or interfere with each other?*

Level 3
Cluster Spaces in Communities

Students can use their Levels 1 and 2 learning to study their communities. Parks, playgrounds, community centers, informal play areas in alleys, dead-end streets, and empty lots can be studied to see how well they serve the people who use them. A good deal of time should be spent watching what goes on, to identify the activities and shared uses of spaces in any one place. A team of students is needed to study a particular area, as each of them will see different things. Each team can use several techniques:

1. Identify all the different kinds of activities going on.

2. What kind and amount of space does each activity need?

3. What other kinds of activities could go on in the cluster space if there were enough I-spaces and shared spaces?

4. How well do the networks work between activities?

5. Does the way the place looks tell people what is possible there?

6. How does the way it looks affect how you feel about being there?

7. What could be moved, painted, changed, cared for, ordered or varied to make the cluster place work for the people who use it?

Before they make decisions about what can be done, ask students how well this place fits into the larger community:

What kinds of spaces surround the cluster space? How do these spaces affect the cluster space?

How does the cluster space affect the other spaces? How much noise is there?

What are the effects of networks (people coming and going, freeways, and roads) on the cluster space? On the surrounding spaces? On people's physical safety? On the visual quality?

When all the information about the place is gathered, the students can identify what element needs work. Then they will have to find out what government agency or private owner controls the area. To learn how concerned citizens can make changes, students should be encouraged to write letters to appropriate agencies and newspapers and include copies of their study. City planning commissions sometimes send representatives to talk to students about ways to get changes going. Students can contact adults in the area who are trying to make changes and who might welcome help. When they have contacted the governmental agencies, they can find out from different agencies what would be possible for them to do as volunteers. Then they could try to get other volunteers to help. In this way they become participants in solving problems and not only more informed critics.

Level 4
Analyzing the School's
Cluster Spaces as a Community

This activity should be based on developed skills in all prior levels. Advanced students should begin with more detailed studies of all the kinds of I-spaces in the school. When they know the kinds of spaces needed, they can assess how many and how adequate the I-spaces are. Then shared spaces for a whole class, group work, laboratory or studio work, social interchange, teacher-student conferences, and teacher and administrative

meetings can be identified. Students can then evaluate these spaces as to how well they meet the needs of groups.

In schools where the same classrooms are used by different teachers and for different subject matter, the design problems need particular attention. The key question is: *How can the space be flexibly used so it will work for the different kinds of activities that go on in it, with their different needs for storage, use of work spaces, display, light, resource materials, blackboards?*

Teams of students could assess the needs as seen by each teacher and students for each kind of class using the room. These needs can include what the teachers would like to do but cannot because of space limitations. Then the teams can combine all the needs to see which are the most critical areas of conflict and can find ways to change things so all the classes can work better without destroying the work situation of the other classes.

As the students develop design solutions, they will have to devise ways to communicate their ideas clearly to everyone using the spaces, get feedback from the users about their ideas, refine the ideas according to the feedback, and then try to get all the users involved in carrying out the plans.

Advanced students can also look at the whole interaction of cluster spaces or classrooms and the networks between them to see how well the whole school works, or does not work. They can identify new curriculum developments, which the building does not support or seriously limits. They will have to include assessments of how well the school communicates visually what it is and the diversity going on within it, and how well the visual quality reflects the differences in spatial needs of individuals and groups in networks and activity spaces. Some students can study how well all the peripheral areas—playgrounds, plantings,

Figure 4.12 *Open schools let people know what is there. Branford Intermediate School, Branford, Connecticut. Carlin, Pozzi & Associates, Michael S. Shellenbarger, Project Architect.* (Photo courtesy M. Shellenbarger.)

open spaces, parking—support the school and relate it to the neighborhood. They will have at this point the basis for a school remodeling that an architect could use, or a basis for plans for a new school.

The same process and concerns can be applied directly to a community, but there are some differences. Students will need experience relating the ideas and concepts they have learned to their larger community as they go on to study their town or city. The clusters in a community are more varied than in a school. Each cluster creates a traffic flow to and from itself that affects the whole community. One of the best ways to identify the dynamics of a town is to see how the clusters affect each other in terms of use, social meaning, and visual quality.

Students can identify all the kinds of things they can about what draws people together. They can start by listing the cluster spaces in their community. The yellow pages of the phone book will help identify all the kinds of cultural, social, religious, and economic clusters in the town—institutions, businesses, indoor and outdoor arts and sports clusters, schools, churches, governmental agencies, and multiunit housing. Ask students to draw a large map of the town or community and locate all the cluster areas. Then teams of students can study the different clusters within a given area of the city to see how they affect each other:

Does one cluster's use hinder the uses of other clusters? All the time? Some times? By sound, by numbers of people, by space, by the ways they look?

Does the way one space looks keep people from seeing how another cluster looks?

Does a given cluster space add more order or more variety to an area? Does the area need more variety or more order?

Does this help or hinder the overall quality of the area?

How do they relate to the land?

What is the overall effect of the cluster space in the area?

What do the different clusters mean in the lives of the people around them?

Do they conflict in many ways? Does each have its unique place which does not conflict with others visually or socially?

How do the networks around and between cluster spaces affect the clusters?

To answer these questions, students will have to talk to the people who use the places, to find out what the places mean to them and how the places appear to them.

Communities exist at several levels— the physical level, the condition of which can be counted and evaluated; and the social-visual level in the minds of the people who live there and of government agents who police, zone, and maintain the area. Information from all these sources is needed to understand a place.

HOW CITIES AND TOWNS EVOLVE

This section deals with *concepts and related activities concerning cities* that will help children and young people understand more about the look and use of their urban environment (McFee, 1971). We change our focus from I-spaces and cluster spaces in Section Eleven to how towns and cities grow, what forces affect the ways they grow, and the quality of their growth.

The section is divided into key concept areas with questions and answers that will help students understand their city or town. The descriptions of the key concepts are written at a level a majority of fourth-grade children can understand and use. They will learn how the history of a town has created its present form and that the decisions made today will affect how the place will continue to develop. The most important concept, which influences all learning about cities, is that they evolve; they are not static.

QUESTION A
WHAT MAKES A CITY WORK?

People *make a city. For many years many people have been building cities and town into what they are today. You may think of cities as physical buildings, streets, freeways, stores, factories, homes, and schools; but cities are much more than that. They are the symbols and images of what people needed, what they valued, and their particular style of living and working. Every part is there because people needed it, valued it, and built it to express what was important to say about them, their families, their work, their institutions, as well as to be useful in providing* the kind of space and shelter for a particular part of their life.

When you look at your city, you can see its history. Even the city itself was built where it is because of these needs and values. Sometimes cities started because there were places to trade with the people who were already there. In the North American plains, the original people ranged over large areas seeking animals for food and wild crops to harvest, so their villages were moved in relation to where they could find what they needed. Indians in the Southwest and South grew crops and had settled villages and trading centers much earlier. Later settlers who went to grow food or raise sheep or cattle also needed a place to trade their goods with the Indians and each other. Towns were settled where farmers could go and return by horse and wagon in one day. Towns were built on rivers and sea coasts so that goods from the land could be exchanged for goods from up or down river or across the sea. People first needed places to live in the new towns. Then they built places to sell and exchange goods, as well as churches, schools, court houses, and public places.

Towns grew into big cities as more trading went on and more people came to live. This required more people to build schools, houses, city halls, more kinds of stores. As faster and better ways to get in and out of the city developed, more people and goods came. So the city grew and grew to where it is now, with you and all the other people who need to work, go to school, and live there.

People in cities today still have the same basic need the early settlers had. Many kinds of places to live are needed for families, for elderly people, for single people, for visitors to the city, and people who need special care. People still need places to sleep, to cook, and places to be together that are separated from other groups of people.

Many kinds of places to work are needed be-

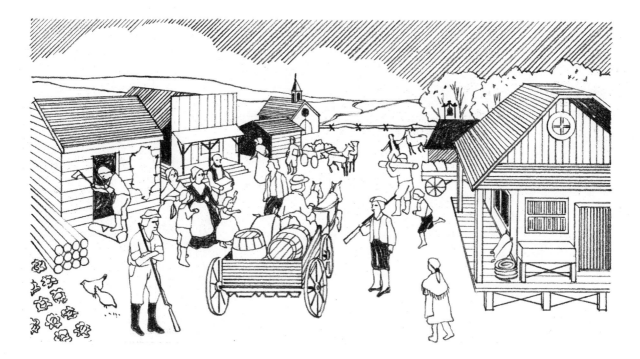

Figure 4.13 *Cities begin because of people's needs. What needs are provided in this early settlement?*

cause, when thousands of people live close together, no one can do as many things for himself or herself. In little towns, people could have a garden to grow their vegetables, and even have a cow for milk, but now we must buy most of the things we use. This means that many kinds of vehicles are needed to bring things into the city or transport them from where they are made to where they are sold. Many more places are needed to process and sell the things people need.

One of the big differences between the way your city was when it was very small and the way it is now is that much *of what a city is reflects the amount of space needed to transfer all the goods and services all the people in a big city need.*

A city is not just things, it is also the transporting of goods in and out of the city, from one part to another. Not only does a big city have to have more goods transported but more people must go from many places to many other places—from where they live to where they work or go to school, to where

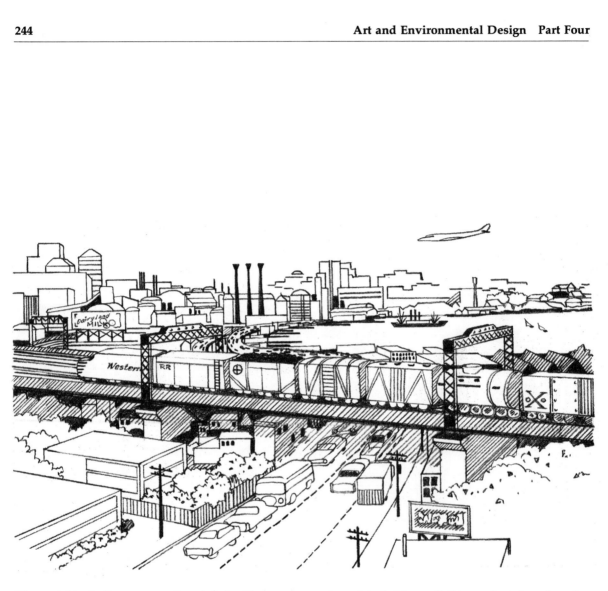

Figure 4.14 *A city moves on its networks. Have you ever stopped to feel how all the people and goods and services are coming and going in your city?*

they buy most of the things they eat, wear and use, to see a show, watch a parade, or visit a park, to visit friends and relatives, to go uptown, downtown, across town, to get things fixed, to pay their bills and taxes, to get where they need to go. As people change where they work, live, or go to school, their patterns of coming and going change. So you see that a city today is a very big, very complex, changing thing.

Level 1
How Do You Use Networks?

Begin by discussing where students live and where they go to school:

You are one of the hundreds or thousands of people who use your city so you can begin to understand

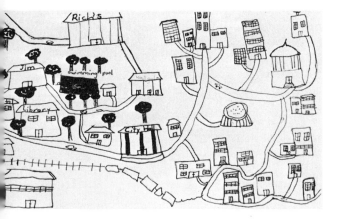

Figure 4.15 *A child's view of his or her city's networks.*

Figure 4.16 *A child's view of his or her city's traffic.*

how well your city works by seeing how you use it. Ask yourself these questions:

Where do you live?

How do you usually go to school?

What route and form of transportation do you take?

Have the students draw maps of their routes to school, to the store, to where they go after school. Discuss the networks they have created.

Level 2
How Do People Use Networks?

Discuss with the students that although they go to the same places—school, store,

playground—the networks will be different. Help them see that:

Cities are made of hundreds and hundreds of places people live connected to many places to go to school and hundreds of places to go to work. This makes the city a big network of the lines created between all the places. The biggest lines in the network are those used by the most people— these become stop streets and freeways. Look at maps of your city—see how some lines are thicker or redder to show they are used by many people.

Ask each student to draw a continuous line that represents his or her route between home and school on sheets of tracing paper laid over maps of the area around the school. Tape the drawings up on the window so the light shines through. Add each drawing directly over the one before, so that the stu-

dents can see how all their drawings together make a map of the class's use of the neighborhood.

Where do the networks overlap the most? Where do they overlap the least?

What does this tell you about your part of the city?

Can cars and buses use the same routes you do? All of them?

What are the routes like where only people can go?

Are these people-routes shown on the city map?

In what ways is your map like the city map?

What would happen if you all drew maps that showed the routes of everyone in your family? If we put all these together would it show new networks of how people use the city?

If all the maps of a city were destroyed, how could you help develop new maps?

Level 3
What Are the Networks
Built into Your City?

Help your students use these concepts:

Let's see how established streets got that way and how they affect our networks. When people move into places where other people have lived before, they get more *than a place to live—they get a whole network of ways to come and go. From these, they choose the ways they like to go and create their own networks—some people always go the same ways, other people like to go many different ways.*

Streets are networks that grew as the city grew. Sometimes streets were built on old paths and wagon trails, or they followed a stream or river or around a hill. Some cities were planned when they were little towns and have grown along the plan. In other cities, each new person added what he or she wanted. Other times, streets were built around rectangles, making city blocks. These created different kinds of street networks. Some cities were ordered like spider webs, some like spokes on a wheel with the part of the city used by everyone in the center.

Have your students get maps of their neighborhoods. If none are available, they can make them. This requires that they study the neighborhood on foot to see how it is laid out. Ask students to study the lay of the land, hills, rivers, and the patterns of established streets to see if they can find out why their city has developed as it has. Collect old maps and photographs to identify how the city grew. Send teams of students to find out whether some parts of their city were planned and others not. Ask for their opinions as to how well these old decisions serve us today. If they find a pleasant, old street that is becoming crowded with traffic, ask them to find a way to relieve traffic congestion and maintain the older atmosphere:

How could traffic patterns be changed and still retain the street?

Could old trees be preserved and still make the street workable?

What are the most important elements to consider in street planning?

What do you need to know to solve such a problem?

How do old networks fit in with the new ones?

Level 4
Is the City Part of
a Bigger Network?

Level 4 students can study the networks of people coming into a town or city to see how their use changes the look of the places and life quality of the people who live near the access routes:

What areas are cut up or off by freeways and highways?

How can the noise be reduced? Can signs be changed to let newcomers know how to enter, leave, and find what they need without visual litter?

How can the city or town change its image where people enter so they will know what kind of place it really is?

Students can paint examples of what could be done with buildings or places that do not communicate what the town is about to show owners alternatives. You will have to check your school's liability insurance if students are going to work off school grounds.

Advanced students can also study how the cost of land affects the development of areas of the city.

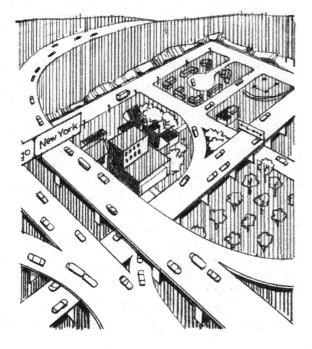

Figure 4.17 *Streets are parts of bigger networks.*

When a place to live is built, it has to fit onto the ground available. This changes the way it is built. If ground is scarce and expensive, places to live are narrower and closer together. If there is lots of ground and it is not so expensive, places to live often are a different shape and leave open ground around. Sometimes very tall places are built with apartments for many people stacked one on top of the other and ground is left so people can share the open space. Some parts of a city look very *busy. The buildings are taller, the streets are more crowded and more kinds of things are going on because this is where more people are gathered. This also means that many people are sharing more parts of the same networks.*

People who live closest to the busiest part of a city live closer together because there is less land, but more things are going on. Other parts of a city are shared by fewer people, there is less traffic, and there may be more space between places to live.

The way a city is built depends upon the place the city is in. Some cities have lots of land to grow on and the city spreads out for miles and miles. Some cities are surrounded by water or mountains and places to live have to be closer together. Other cities are divided by rivers and have to be tied together with bridges. Freeways and bridges are the big networks that tie the whole city together so you can get from one part of the city to another. They tie big cities to little cities and to other big cities. In fact, if you live on a street, and you probably do, your street ties to every other street so you could get to anywhere in the country from where you live!

Ask students to map out the dense areas of the city and to consider how the density affects how the city feels to them:

What different kinds of moods do you get in the different environments?

Students at this level can create plans for changing access areas, including plantings, signs modifying buildings, clean-up. In some cases they may have permission to make actual changes in small communities' entrances. Students can remove litter, weed original plantings, change plantings, design and create new signs, and photograph eyesores and encourage the owner to look at what they contribute to the public view.

What are the visual effects of density?

What kinds of visual order and variety are found in dense places?

Is there enough order to see where you are going?

They can study how individual and shared spaces are or need to be developed in high-density places—how space can be arranged so that individuals have enough space on crowded sidewalks, in entrances, and getting off and on public transportation:

How does the land affect how the spaces are divided up in a high-density area?

Do rivers break up or divide your city?

Do hills separate neighborhoods?

Are streets straight or do they follow the contour of the ground? Does this make variety or order?

What difference does it make for people inside buildings if streets are straight or winding?

How does living on one side or another of a hill affect the kind of light one gets in one's rooms?

QUESTION B
WHAT THINGS
DIVIDE CITIES?

A city isn't all networks that tie things together. It is also full of things that are separated by networks that help many people live closely together and use the same networks without getting in each other's way. People who are walking are given space to walk that is different from places where people drive cars or ride buses—the curbs separate sidewalks from streets.

Traffic lights separate the time people use the space where streets cross. People walking or driving in one direction don't get in the way of other people walking or driving from another direction. Freeway cloverleaves separate traffic going in different directions without having to divide the time. School bells help many children share the playground or lunchroom by separating the time different classes use them.

Fences are lines that separate activities. They keep children safe from cars on busy streets and cars

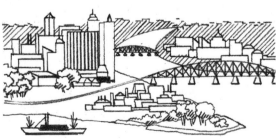

Figure 4.18 *The way a city is built depends on the form of the land.*

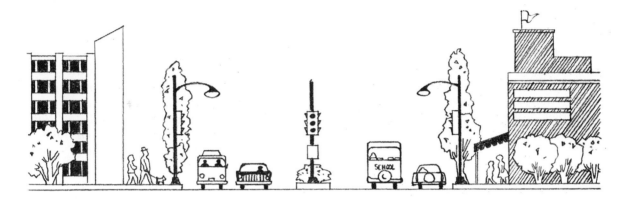

Figure 4.19 *Trees and plantings separate places to walk from places to ride.*

safe from children playing games. Floors in buildings, walls between families, and partitions in houses, apartments, and schools also separate one kind of activity from another.

Level 1
How Do Dividers Work?

Students can explore things that divide and separate around their schools to see how well the way they look communicates what they do.

Ask your students to identify all the different kinds of places in the school grounds: places to play games, to park cars, to walk from the street to the doors, to deliver supplies and fuel, to show where the main door is. Ask them to identify what separates moving cars from people, pedestrians from grass growing, athletes from spectators. Some things will

only be symbols, such as a baseball diamond that lets us know what is to be played there and separates playing baseball from an area with a basketball hoop. Sometimes plants or lines of trees separate parked cars from sidewalks. Sometimes wire-mesh fences with barbed-wire tops keep outsiders from a particular area. All these have different effects on our experience.

Ask the students to describe how they think different dividers make them feel:

How well do different dividers divide?

How do we feel when we are inside a fenced area? Outside?

What do people say about themselves by the kinds of fences they use?

Do you feel differently about chain-link fences than dividers made with trees and bushes?

Level 2
How Do Signs and
Symbols Divide Cities?

Students can explore the symbols that communicate messages that divide people into different directions. Some are clear and obvious with words incorporated into the signs, but others communicate meaning through the design.

Send your students out to look for word signs whose meaning is made more clear through the design. They can use cameras or sketch pads to record their findings. Students can develop notebooks on their study of the neighborhood or city with sketched examples of what they discover. Exhibits of their photographs or drawings can help other students understand the city more.

Level 3
How Do Dividers Help
or Hinder Neighborhoods?

Students can go out into the neighborhood gathering examples of dividers. With cameras or sketch pads, they can record dividers and write descriptions of how well they separate and what they mean to the students. They can make a booklet display of their findings that could communicate to others in the school or neighborhood the nature of the things that divide. They can list the positive and negative qualities of dividers to show which ones need changing: how and why. They can look for ways different kinds of traffic are separated — pedestrian, cycle, motor — by trees, curbs, shrubs, grass, light posts. They can look for ways factories and service stations are separated from places people live. They may find places where there is not enough separation: noise and car pollution may be close to where they live; they may only have the street on which to play or socialize.

They can develop reports with pictures to illustrate the need for better dividers that would enable people to do more activities in an area. Their reports could be sent to the city government, the newspaper, or displayed in the school for parents to see.

Level 4
How Natural and
Built Dividers Affect Cities

At this level students should be aware of the ways cities are divided into spaces by human-made symbols, fences, routes, and pathways, and different kinds of housing, density of buildings, and amounts of open space. They can combine a study of these dividers with a study of natural dividers — rivers, lakes, hills, gulleys, streams, woodlands, harbors, and bays.

By using tracing paper and colored inks, each system can be worked out separately. When they are hung one over another in front of a window or strong light, the pattern will be made clear. Hills can be shaded one color, water another.

When students have gathered this information, they will understand what exists, and they will be ready to ask questions about what might be changed. Every time a change is suggested, you should encourage them to ask if this change will interfere with another division or open an area that should remain open, or if traffic is let in, what kind of traffic can use the place without needing new dividers.

QUESTION C
WHAT DO CITIES TELL US
ABOUT PEOPLE?

Even if all these networks work very well for the uses of the people in the city, it is not enough. Cities are mirrors for the people who live there. They tell us a great deal about what people care about, about

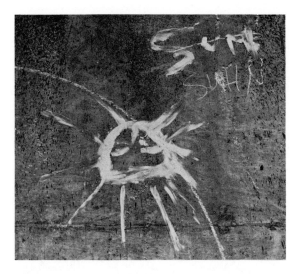

Figure 4.20 *Sun graffito.*

Figure 4.21 *Which part of the shop appears most important?*

what is important to them. Cities are full of symbols that tell us what is going on. Cities can be read like we read a book, if we understand what the symbols mean.

You all can read the symbol SUN. These are the letters we have developed over many years to represent the sun. Most of you know when you see the symbol that it means the same sun. Just as you read symbols like that for the sun, you get information about what people think about things now or in the past by the things they surround themselves with. People tell who and what they are by how they dress, so families and neighborhoods, businesses and organizations tell who and what they are and what they value by the things they build in their communities.

People whose front doors are well kept and neat, but whose back doors are not, think differently about the front and back of their house. Fences that are falling down are no longer useful; no one cares whether the things they divided before are divided now. Old places that are restored, the broken glass replaced, the fences straightened, the doorknob polished, the insides painted and repaired, the yard replanted, tell use that someone cares about this place again and that it fills someone's need.

Old houses tell us something of what the city was in the past—if they can be maintained, if they can still serve a human need and provide comfortable shelter for some activity, then it probably is important to save them. One of our needs as people is to know

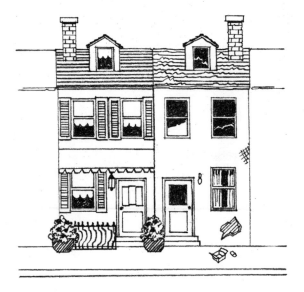

Figure 4.22 *What are the differences in the message of the two houses?*

Figure 4.23 *What qualities can trees provide streets?*

who we are. Part of what we are is what went on before we got here; old homes and old public buildings often symbolize the important ideas that came before us.

Sometimes the same thing can have different meanings. Trees can serve different purposes and convey very different messages:

1. Provide shade for pedestrians.
2. Provide variety as the seasons change.
3. Provide an atmosphere that slows traffic.
4. Provide a divider between pedestrians and motor vehicles.
5. Provide variety of light and shade.
6. Provide contrast to manufactured things.
7. Provide all these things.

Landmarks tell us a lot about a city or town, and they take many forms. They can be manufactured, such as particular streets, large buildings, monuments, business establishments; or they can be natural elements such as a river, hill, a bay. Often they are combinations such as parks and other planned open spaces. Landmarks are places that quickly tell you where you are. They are outstanding marks on the land made by nature or by people.

If a city has a river, we talk about the east river part of town or the west river district. If the city has a hill, we tell the people we live north of the hill, or south, east, or west of it. These are natural landmarks.

Landmarks are often large buildings that house government buildings. They often are bigger than other buildings because so many people use them. They are designed so they look important. Often there is a lot of space around them so they can be clearly seen.

Sometimes landmarks are open spaces, parks, playgrounds, or wide streets with parked areas along them. Many people consider them very important in a city. They give room for natural things to grow among manufactured things. They let in the light and give everyone a view of the sky. They cut down traffic noise and separate heavy-industrial areas from where people live.

If your students have recently worked on the design tasks in Part Three, encourage them to relate the city to the similarities and differences of order and variety in design. If it has been a period of months, you may want to review the concepts.

Street signs are the subjects of many arguments—whether they make cities disorderly or interesting. They are a good place to apply what has been studied about visual design to the city. It could be applied to any part of the city as well. Some people say that all the signs do in some places is make a visual argument, every store owner trying to outdo the others to capture your attention, with bigger signs, more flashing lights, or moving parts.

Some people argue that in some places all the mixture of signs makes the street an exciting place to be—it tells people there are lots of things to trade, places to eat, choices to make.

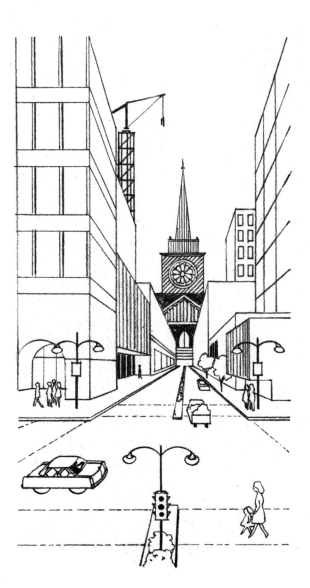

Figure 4.24 *Landmarks tell us where we are.*

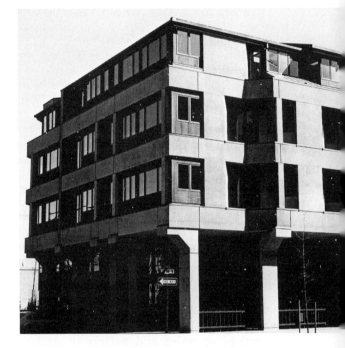

Figure 4.25 a. *Citizens Bank Building, Eugene, Oregon. An example of corporate image.*

b. *South Parks Building, Eugene, Oregon. An energy saving, people-oriented office building. Daniel M. Herbert, Architect.*

Still other people argue that every merchant has the right to put up a sign, but needs to consider how the sign looks in relation to the others, not only to create a balance of order and variety on the street, but to make the sign readable. Then the place can be exciting and still all the signs can be read.

If signs are to meet people's needs, they have to let people know what is going on there, what they can buy, what they can do. People also need some places that are interesting and exciting. If every place were too orderly, a city would be boring.

Students' drawings of their city will tell you how familiar they are with it and whether or not they are ready for this area of study. Ask your students to draw from

memory all those items in their town or city that help them tell where they are, the landmarks they use to get around the city, and the way the main streets lie in relation to these landmarks. Then ask them to draw in all the things they can about the city.

Level 1 students may draw a landmark but have little idea how it relates to streets. Level 2 students will know a couple of key items and some street patterns. Level 3 students will have some grasp of the relationships between landmarks and the streets that connect them. Level 4 students will have a clear picture of the landmarks and connecting networks.

What you do in this area depends on whether you can get students out into the city to look. You may be restricted to your neighborhoods. Some of you may be teaching in high-risk neighborhoods. Others may be teaching in suburban areas in which students have little idea of what the rest of the city looks like. Many schools are restricting the use of tours. If you can, use school buses or city transportation to get your students out looking. To make the best use of the travel time, get them ready before the tour. Get as many slides and movies of the city as you can and fill in with your own slides so students will be alerted to some of the things to see. If they cannot go out, the visuals may be their sole basis for study.

Level 1
How Is Nature Helping Your City?

Ask younger students to build a model of a part of their city they know with blocks or painted cardboard boxes. It is not so important that the model be accurate, but that streets, sidewalks, back yards or a park be included. These can be painted on butcher paper as a base for the buildings.

If possible, take the group to the area to look for the trees, shrubs, and grass growing. If it is spring or early fall, they can look for the ways the leaves shade people on the street, keep the heat off of buildings, and the way trees divide the sidewalk from the street. Then they can go back to the classroom and, using small plants they have grown in the classroom, put plants where the houses and people need shade, where streets need dividing, or where parks need more shade, separate spaces, and a more natural environment.

If students cannot get out, you can use a strong flashlight as if it were the sun and shine it on their model at positions indicating high noon and afternoon. Ask them to find which places need shade and protection from heat. By using model cars to simulate traffic, they can see where trees may protect people walking.

Trees and shrubs also provide a variety of forms and textures where buildings are stark and hard. Trees evenly placed along busy streets can provide order to a busy, varied place.

As students make decisions about where shade is needed, they will also have to ask themselves whether more or less order is needed. If more order is needed, plants can be planted in even-spaced rows. If more variety is needed, spacing can be varied or the plants or trees can be of different varieties, sizes and shapes.

Level 2
How Do Landmarks Help Us Find Our Way?

Even if students cannot go out as a group, they can pool their knowledge and yours to draw a big map of the city from a city street map. Then ask as many students as can to draw or paint a picture of a landmark they

can remember—rivers, parks, major buildings, hills—that helps them know where they are.

Take pictures of the key places in the city and show the slides to see if students can recognize where they are in relation to the map.

If students can go out on a tour, they can collect information to draw a landmark map of their town or city without relying on others' selections.

Level 3
Can You Read the
Past in Your City?

This study helps students relate history to visual images. They will have to collect historical materials about their city from different periods—how it got started and key points in its change. Trips to the newspaper and calling on older people with their own collections of photos will give them a basis for understanding what people valued, what was important, and the ways they built things to fit those values. Sometimes records can be found of a single building's many uses.

In all these cases, students can relate what they think the buildings and places communicated about the quality of life at a given time. Then if possible they can survey the town or city to see what is still there, what condition the buildings are in and what they tell about their past.

Level 4
Do People's Values
Show in Cities?

This question will need to be developed in terms of the students' backgrounds. The objective is not to teach your values of what objects, buildings, and places mean, but to help students be more aware of the informa-

a.

Figure 4.26 *Cities are full of mobile homes. What does this say that is different? Handcrafted home from an old school bus has superb spatial design with recycled materials. It expresses concern for a nomadic life with functional elegance.*

b.

tion they are getting all the time from their city (Figure 4.26a and b). All of us need to sharpen our perceptions of cities as mirrors of people's values.

Students can search the city for places they like and dislike and then analyze the values the place expresses and why they value or devalue those places. To get them ready for this evaluation, you may want to show slides of various parts of other cities and through discussion, get them to identify values expressed:

What does open space say about the people who keep it?

What do littered waterways, maintained older buildings, busy neon-lighted areas, quiet streets, industrial areas, say about the people who built them or live and work there now?

What do huge, formidable buildings say about what goes on inside?

What do whole neighborhoods say about themselves?

QUESTION D
HOW CAN WE MAKE BETTER DECISIONS ABOUT CITIES?

There are many reasons for liking some places and not others. But often we do not know why we like what we do—sometimes we like a place because it looks like something we have seen on television or because it looks like it cost a lot of money or it is a place we have been in before when we were very happy. But these reasons are not enough when we make decisions for our city. Everyone who lives in a city contributes something to the way it looks. You can contribute disorder by adding litter or order by picking it up; that is a beginning. When people are old enough to vote, they have to make decisions like whether a new freeway should be built and where it should be built, whether an old house should be saved or not, where playgrounds should be built, or what part of town most needs help in restoring itself to serve the people's needs.

You and your students will have to think about how your decisions will meet people's needs. You will have to find out how all the people use an area and what networks they have developed. How will the new freeway or rebuilt homes or park change the networks? You will want to ask questions about how the new elements or the old elements make more things alike or different.

Some people feel that planting enough trees would solve cities' problems. You can ask:

How do trees make a particular place more useful?

Do they safely divide moving traffic from pedestrians?

Will they work for some purpose in winter as well as in summer?

What kind and shape of tree most fits this place and serves the most purposes?

Living in a city is a big responsibility. Much of the city belongs to all of us. Each of us can contribute to making its networks work better and be a pleasant, ordered, yet interesting place to be.

To understand your city, you and your students can: (1) discover your own networks, (2) discover other people's networks, (3) see why the city was started there, (4) see what the natural landmarks did to make it grow as it did, (5) see how basic human needs for shelter, privacy, transportation, and order and variety are met, (6) see how your city is changing, (7) see how the visual design of a place, the degree of order and variety, makes each function of the city work better, and (8) see what you can do to help it grow into a better place to live.

Level 1
How Can We Relate Social, Spatial, and Visual Elements?

In many classrooms there is a sink used at various times of the day for various purposes. Students can identify all their uses of it, such as to wash clay off hands, mix glue for papier-mâché, clean up paint boxes, fill a vase, get a drink, rinse photograms, rocks, or plant specimens. As students consider all the various uses they make of the sink, ask them to consider how well the sink serves their needs:

Is the height of the sink comfortable for all to reach?

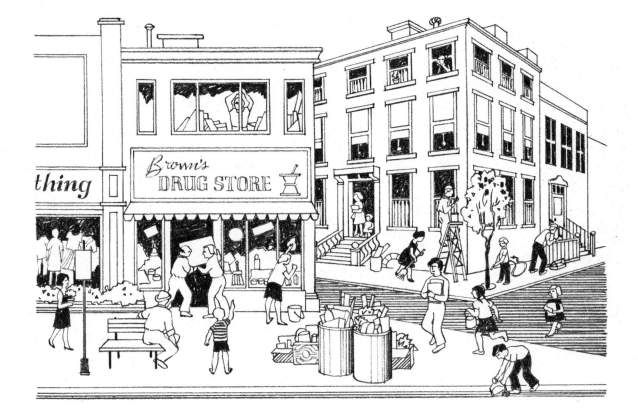

Figure 4.27 *What could individuals do to make the place work better for everyone?*

Do the faucet handles work easily; fit your hands well?

Is the water temperature easy to regulate?

Is the sink deep enough to allow you to fill a big container? Is it wide enough to hold a tray? Is it too high for small people to use? Too shallow, thus causing a lot of splatter?

How many people can use the sink at one time? Do more people need to use the sink at one time than others?

Are there times when the sink is used that it disturbs others? Is it a noisy place?

Is there a traffic pattern to and from the sink that may interfere with students working?

Is there an area convenient to dispose of things not to be dumped in the sink?

Is it easy for each person to clean up after his or her use of it? Are cleaning materials conveniently available?

What does the condition of the area around the sink tell about the habits and values of people in the class?

If the sink could be replaced with another, what considerations would influence your choice of size, color, shape, and materials and its location and position?

What things could you change to make your sink more suited to the needs of all who use it?

Students might suggest providing a small stool for shorter persons; decide who they would ask to adjust their faucets, or, if they could, do it themselves; plan routes to and from the sink and test them for given periods of time, or rearrange the room to allow easier access with minimum disturbance to all; organize themselves so there is less crowding and perhaps less chance of accidents; find ways to do the best job of cleaning up with the least amount of effort; search for containers and trays that would be more convenient to use at the sink; set up special holders to have cleansers, sponges, and towels handy but not in the way; and enhance the area to make it special to those who use it as well as visually complementary to the rest of the room.

As the students' plans change, ask them whether the change will get in the way of other uses of the sink. For example:

If you add a stool, would it get in the way of those who do not need it?

Where could it be stored?

Could it be easily moved or should it be permanent?

These questions and examples of how students can synthesize the social, spatial, and visual aspects of something into analysis and action are only examples.

If your students are primary students, you may find role playing helpful. A child goes to the sink to wash something and other children watch to see what is wrong: if the sink is too high, the soap out of reach, the towels too far away. When a solution is found for that child, then a taller child could use that solution and find the stool gets in the way. The class can try to solve the problem in different ways so the sink works better for everyone. This makes the problem solving more concrete.

Level 2
How Can We Create Spaces for Things People Do?

Designers of public spaces often must make many judgments based on estimations of how they anticipate the spaces will actually be used by people. Most often the spaces are completed and quite permanent before anyone actually uses them. Then the designers discover to what extent they met the needs of the people they planned the area for, sometimes discovering the spaces are used quite differently than planned for.

Students could be given the opportunity to set up a hypothetical arrangement of space and make estimations and analyses of its use based on their own past experiences, personal insights, and on the multiple variables they feel would enter into a given situation. For example, you could have all the classroom furniture moved to a far corner of the room and ask students to consider how the room could be organized if the entire class were involved in planning the production of a play. Have students consider a short, familiar play so they will know what major elements are involved and what the

different spatial needs are in the practicing and production stages of the play:

What activities will go on?

When and what space do you need?

Does the play require a stage set or not?

Is costuming a major undertaking requiring many persons, or can it be solved by one or two people?

With the limitations of the classroom, they should consider where people will have to rehearse lines, construct sets and costumes, and plan publicity. As they arrange the room according to anticipated spatial needs, have them also attend to how the arrangement might affect how people function in the areas:

Is there a need to move, to speak loudly or softly?

How close together can people within a given group work?

Do they need to be nearer one group more than another?

Does the arrangement allow for ease of movement from group to group for interaction?

How does the arrangement affect communication within as well as between groups?

Together with these considerations, students would consider the visual elements of the arrangement:

Does the way the arrangement is organized reflect what will be going on?

Is the overall arrangement visually pleasing to you?

Would this affect how you feel when you enter the class to engage in your planning of the production?

What considerations should there be to allow one group to alter your set-up without disrupting another group or the overall estimated workability of the plan?

Ideally, students could spend an afternoon planning and arranging the space, and

the following few days put their plan to test—actually planning the short play using their space arrangement. During their production plans, they could assess how groups were actually using space:

What is working well?

What doesn't work?

What didn't you consider that affects your ability to function as you feel you should?

How are you adapting your spaces to accommodate considerations you did not anticipate?

How can you make changes that will make the whole system work better?

Level 3
How Can We Reuse
Old Buildings?

Students could study old buildings that could be saved if workable use of their space could be made to defray the cost of restoring them. Set one group of students to work studying kinds of spaces and relations between spaces. Another group of students can study the space needs of groups or organizations that need space, to see which groups might be interested in using and restoring the old building. One group could make contacts with the town or city planning office to see what the neighborhood's future is. Another group could search the records for the history of the building to see if it has historical significance. Still another group could study its architectural style in terms of other buildings built at the time to see how well it represents a period. They can also analyze how the style of the building fits with all the other buildings in the area today.

Still another study should be made of the whole street or neighborhood to see what effects different uses of the building would have on the areas around it. Help each group

develop its own questions about what it needs to know and how to find the information.

When all the groups' information is gathered, it should be pooled to see which alternatives are workable and what compromises need to be made. All these experiences are needed by people who want to make neighborhoods more workable and satisfying — physically and aesthetically.

Level 4
How Can We Work
Together to Solve
Environmental Problems?

There are hundreds of ways in which an integrative study of the social, physical, and visual design qualities of a place can be analyzed and plans made for changing and modifying it to make it work better. You, as teacher, can help your students explore possible areas for study.

Your students may be working on ecological problems in other classes. In your class, you may find they can study how the effects of functional and visual design can serve ecological needs. They could study the water systems that flow through a city to see how the water is affected by poorly designed environments as it moves from its source through the city. Water pollution is often accompanied by visual pollution. The impact on cities of murky, congested, foul-smelling canals contrasted with clear, clean, fresh waterways can be very dramatic. To clean up a dirty system, a great deal of study of all the ecological, social, and political values of people must be recognized as well as the visual design of places to make a change work. Such study gives students real experience in integrating the different kinds of information in making complex decisions.

Some students may want to study other ways to improve our adaptation to nature:

How can natural functions, the growth of plants, the contours of land and soil be preserved and still allow people to live there?

What designs will help keep people from destroying nature?

How can what is natural in the city be made more recognizable — adapting nature to the built environment?

The students could make an analysis of a neighborhood of all the trees, shrubs, grassy areas, streams, contours, hills, gulleys, rain water flows, wind directions, and animals, even in highly dense urban areas. After this analysis, they would know which areas were very barren of natural elements and which areas were well provided for. They could identify problem areas — where water stands in pools, where summer sun reflected against concrete makes streets too hot, where high buildings make wind tunnels between them.

They could study ways that plantings could divide areas of public places so some would be semiprivate. They would have to consider what the users of the place may want to do, what the different weather conditions are in different seasons, what city regulations are concerning public places, and to whom they might submit a suggested plan to get it implemented.

Several groups of students might decide to focus on a block of the main street to study how people use the place, to see how many more choices they can develop. One group could study the space of streets, crossings, vehicular and pedestrian traffic. One group could study the needs people have while shopping or visiting professional offices in buildings along the street, such as protection from rain and snow, places to store purchases, telephones, mail boxes, places for children to play, places to rest, places to get in and out of cars, to be safe

from cars. To identify them all, students would have to spend many hours watching how the block is used and keeping notes of what they see. They would have to ask people what would make the street more convenient for them.

Another group could analyze how congested signs are and make plans for redesigning them so all of them could be seen clearly.

Another group could study street furniture and plantings to see how they provide places for people who meet to stop and talk, for people to sit and rest or wait for buses, for ample space for people carrying packages or pushing baby strollers, and for people in wheelchairs.

Another group of students could visit city hall, the planning commission, the Chamber of Commerce, and community development groups or urban renewal offices to find out what is being planned for the area.

When each group has gathered their information, they should pool their findings to see how they relate or conflict. Conflicts will have to be resolved so the whole system provides more workable choices for more people in more pleasant and convenient surroundings.

PSYCHOSOCIAL DIFFERENCES IN RESPONSES TO THE ENVIRONMENT*

DIFFERENCES IN ART APTITUDE

Many student differences have been covered as we studied the different aspects of art behavior. Some students may have a highly developed sense of design and react to the city in terms of its visual qualities, but they may be unaware of the social meanings of places for other people. Other students who are highly creative in developing art for themselves may see the city as a resource for studying their own reactions but be quite unaware of it as design. Students who create art to communicate to others may see the city as a design message of the values and attitudes of people. Those students who create objects for themselves tend to concentrate on their own environment, ignoring the rest of the city, while those who design for others may be deeply troubled by the city in which so many elements do not appear to fill the needs of people using them.

DIFFERENCES IN CULTURAL AND PHYSICAL BACKGROUNDS

People from different cultural and physical backgrounds also see cities differently. Children who are raised in structured, finished environments will probably not interact with places in the same way as children who have had opportunities to improvise,

* See Parts Six and Seven for the theoretical and research basis on individual differences.

take apart, and put together things. Children who grew up in "don't touch" situations develop different readinesses for learning about their environment than children who are allowed and encouraged to open and shut, crawl through, handle and feel the surfaces of the things around them.

Opportunities to Experiment

Some children are encouraged to use tools to modify their surroundings; others are never allowed to. In some poverty situations, children are highly creative with found objects. Others with no tools interact mainly socially. The latter would probably be passive observers, rather than be motivated by their abilities to change their environment. A third-grade teacher tried to find out how much her students would adapt to a problem situation and how they would try to solve it by pushing all the furniture in the center of the room before the first class in the fall. She was appalled to find the children squeezing themselves into uncomfortable places rather than either moving or asking if the furniture could be rearranged. Apparently, they were willing to use the furniture this way because the teacher had not disapproved of it.

Responses to Structured and Unstructured Environments

By watching children of any age use playgrounds, you can observe differences in be-

havior in different kinds of play areas. If your school has formal and mainly individual play equipment, you could set up a play area of the "junk" or "adventure" type with assorted cartons, wood, open ground, nails, hammers, and saws and see which children choose which area to play in and what they do while they play. This will give you some idea of how they have learned to interact with their environment.

Interpersonal Relations

A child who grows up in crowded situations, sharing a bed with other siblings, playing in crowded streets, learns to relate to space and other people quite differently from a child who sleeps alone in a bedroom and plays alone in a large yard. We cannot expect children raised so differently to have the same sense of themselves in relation to the spaces around them. Children who come from subcultures in which they must be close to other people to communicate will react differently from children who feel threatened if anyone gets too close to them.

Charles Zerner is an architect, artist, and poet who is concerned with the involvement of people with places (Figures 3.18, 4.6, and 4.28). Following is his description of this kind of urban art:

They are the Blacks, Chicanos, Nicaraguans and Samoans, the Puerto Ricans, and the Guatemalans who gather the scrap, the junk, the flotsom and jetsam, the hulks and shards, residues and things of the city to forge their creations, their foster-children creations which in their very funkiness, their assemblage, their improvised character, resemble their creators.

They have rough edges; a kind of roughness which we do not speak of in the same context as high art. It is not high art; it is bad ass art. It is low down art—the art of the street, the corner, the back alley and backyard art, the art of get-down-with-it and boogie and its spell is the mumbo jumbo of the waste-land, waste-lot magic. They forage within the labyrinth for their parts and pieces . . . [in] the landscape of the waste-land, the tin can, the rag-a-muffin stuffed sports car seat leaking polymer fiber-fill out of its seams like a vinyl scare-crow leaking straw. It is the art and rhythm of the rink-a-dink, clang-along, lang-a-long music of tin cans' metallic tunes bonking along the street.*

Anxiety Levels

Students who see their environment as a source of threat to their safety will be more concerned about social problems than children who are physically secure. The latter tend to be more aware of physical ugliness in their environment than the social problems that may have produced the visual decay.

Students will vary widely in how much they use concepts or visual images in re-

* Charles Zerner, from "The Astro-Turf Phoenix." Used by permission of the author.

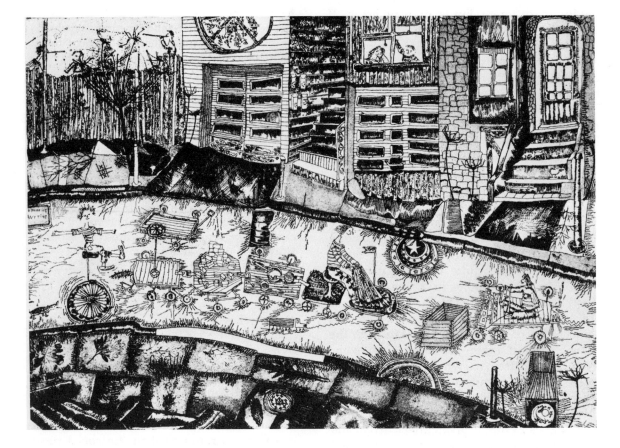

Figure 4.28 *Charles Zerner.* Zigzag through Jerusalem. (Courtesy of the artist.)

membering what they see. Children who come from rural areas and whose visual development occurred in more open areas may see more details in the city. Students reared in the city may rely more on labels for what things are. Some students will remember mainly through visual images, others mainly through words, and most students through some combination of both.

ORIENTATION TO SPACE

Students will vary widely in how they relate themselves to three-dimensional space. Some will depend largely on kinaesthetic or body-feeling responses and think of themselves as very separate from their environment. Others, often younger or more dependent, will rely on information outside themselves to relate themselves to space. They tend to see themselves as part of their environment. Girls who have been taught to stay dependent longer tend to follow this pattern. We can assume that as more women learn more independent roles, this sex difference will decrease. The dependent child or adult tends to rely more on authority figures. The independent person, male or female, sees the world from a much more separate perspective.

In helping students understand their I-spaces and shared spaces, you are apt to find the task more difficult for dependent children. You may find that having them close their eyes and stretch their arms, mov-

ing, dancing, and "feeling" the space they take up, may help them reflect upon and become more aware of their use of space. It may take a great deal of work to help some very field-dependent children (those who rely on cues outside themselves) gain freedom from outside authority and the influence of what they see around themselves and become aware of their own separateness. At the other extreme, there are some children and more teenagers and adults who are so aware of themselves as three-dimensional beings in space and so self-reliant that they ignore others and the effects of their own actions on other people and other things.

DEVELOPMENT OF COGNITIVE MAPS

Environmental psychologists are exploring the ways people develop cognitive maps of a city: how they relate to landmarks, divide up the parts, acquire mental images in developing their maps, find symbolic meaning in the city. These scientists find that each individual experiences the city somewhat differently due to differences in cultural background and opportunities to see the city, but that people attempt to develop overall maps on the basis of what they have experienced in their neighborhoods, especially in the degree of crowding.

In the study of children's drawing of the city, cognitive maps reflected whether

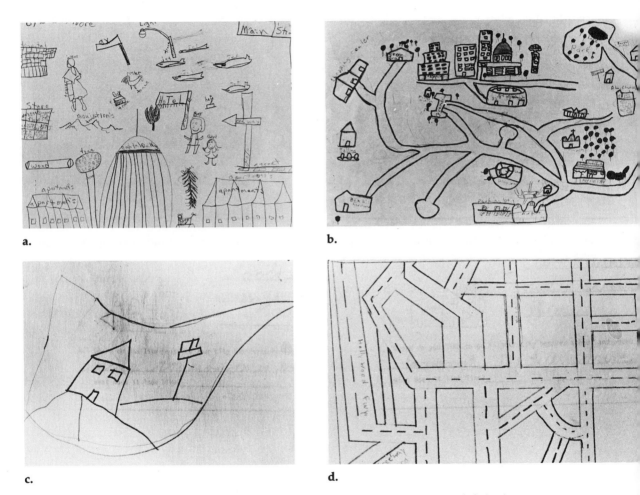

a.

b.

c.

d.

Figure 4.29 *Four fourth graders whose drawings suggest different cognitive maps of their city.*

Figure 4.30 *Children model a town.*

children had had overviewing experiences, traveled around the city a great deal, or were limited to their own street and neighborhood. Your students' drawings of their city will help you find out how they know the city. You will find out what images are clearest for them.

THE TEACHER'S ROLE

Your role is to recognize where children may be and encourage them to try tasks that will help them develop broader ways of seeing and using their environment, to be more aware of self and others. The activities

Figure 4.31 *Children study an urban place.*

of this chapter are designed to do this but many students will need special help, more time working at one level than others, and more encouragement for looking outward or inward.

As our environment and our resources decrease and our numbers increase, we may not be able to afford the luxury of either isolation or absorption into the city. We all will need to understand our own needs, those of other individuals, and all groups to make our lives together workable and yet preserve the amounts of I-space and shared space needed.

EXPLORING
THE CULTURAL
MEANING OF ART

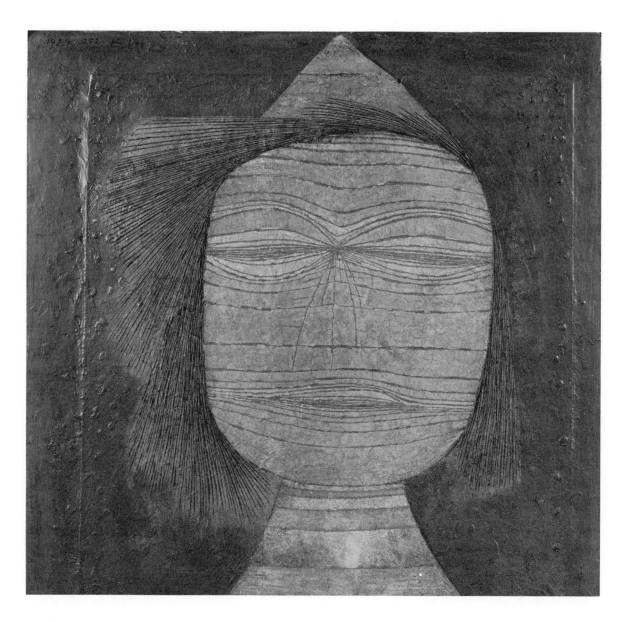

EXPLORING THE RELATIONSHIPS BETWEEN ART AND CULTURE

In this section we analyze the diverse meanings of art and explore the ways these meanings function in the lives of people from different cultural groups. Culture is a pattern of behaviors, ideas, and values shared by a group. The visual arts are a means of communicating, teaching, and transmitting these cultural ideas and values, thus maintaining the behavior, ideas, and values. First, we will look at art as communication, relate it to culture and cultural change. Second, we will provide a method of inquiring about art to help students deal with change in art. Third, we will provide a method to help teachers be more open to the diversity and change of art expression among their students.

Activities in Section Fifteen will enable you to get your students involved in inquiry about works of art in terms of the role art plays in people's lives and the many kinds of information and aesthetic understanding to be gained from studying art. Finally, in Section Sixteen we will look at the cultural diversity among students and ways this may affect students' responses to art.

The traditional study of art has been to identify the characteristics of art within each period of social and political history. Classification of art by periods and by peoples, such as Ancient Greek Art, Colonial Mexican Art, Contemporary Black Art, gives us only part of the knowledge we need. It keeps us from recognizing the dynamics of change in either art or society. It solidifies our stereotypes of what periods of history and art were

like. Although stereotypes make categorizing and organizing bodies of knowledge easier, we must be aware of the ways our stereotypes limit our view of a subject. When societies change as rapidly as ours is now, categorical thinking is more restrictive than ever. We must learn to think of art and people in processes of change. Change is not necessarily sequential; it may be circular. But it does go on continually at some rate and in some direction. It does not stop within periods. Some aspects of society and art may change at different degrees and directions from other aspects of society and art.

Just as we can learn to see more in design by recognizing similarities and differences, so we can better understand the dynamics of art in human lives by seeing both similarities and differences in art and life among various periods and peoples.

ART AS COMMUNICATION

Art is a principal means of communicating ideas and emotional meanings from one person to another, from one group to another, from one generation to another. When people have experiences, they symbolize the experiences in an art form; they observe their art and then obtain new insights about their experiences. How is this different from just thinking about experience? It enables people to express what they might not be able to with words. When people say that they are at a "loss for words," they may mean that they have had an experience that is so rich

in detail, in meaning, or in emotional quality that they cannot describe it. If people have learned to use art expressively, the essence of their response can be expressed graphically. They can refer back to their art many times to analyze the ideas and emotions they expressed, thus gaining insights into their own development.

When we observe art, we not only get information about situations, conditions, and events, but we can be stirred emotionally by the meaning the information has for us and by the qualities of the design: its intensity, excitement, tranquility, order, boldness, refinement, vividness, variety, roughness, crudeness.

Ideas are communicated through art as well as through words. Poets often "paint pictures" with words to stimulate our visual imagery; to force us to go beyond the ideas to the images they convey. But visual artists can provide us with both images and ideas. We usually have words to describe the artists' images, whereas we may not have images the poet describes. Some artists are concerned with the communication of ideas, some with communicating feelings and emotions, some with the aesthetics or beauty or form, some with the effects of manipulating materials, and others are concerned with some synthesis of all of these communications.

A painting may be abstracted from the form or shape of familiar objects, or it may be a pure arrangement of visual elements, forms, lines, textures, and shapes that stir in

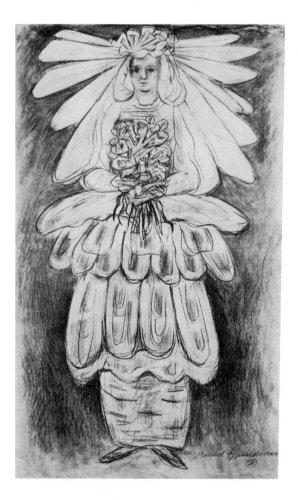

Figure 5.1 *Manuel Izquierdo.* Bride #1, *1967. Izquierdo clearly communicates the ideas and images of "brideness."* (Collection, Museum of Art, University of Oregon.)

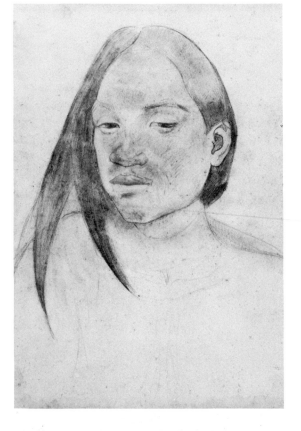

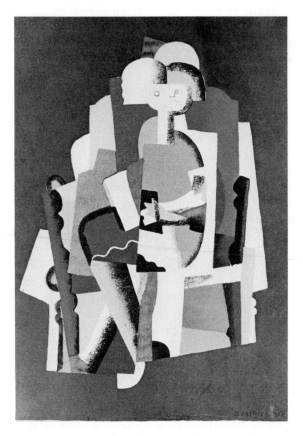

Figure 5.2 *Paul Gauguin.* Head of a Tahitian Woman (*French*). (The Cleveland Museum of Art. Mr. and Mrs. Lewis B. Williams Collection.)

Figure 5.3 *C. Valmier.* Watercolor, *1926. The artist's main emphasis is on the beauty of form and the design relations of shapes.* (From: Guillaume Janneau. *L'Art Cubiste,* Paris Editioris d'Art: Charles Moreau, 1929. Reproduced by J. Jacomet. Courtesy G. Janneau.)

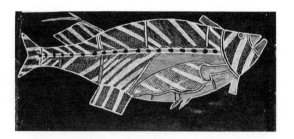

Figure 5.5 Nguleingulei. *Contemporary Australian aboriginal bark painting. Art that reflects identity with nature.* (Kensler collection.)

Figure 5.4 *Barbara Kensler.* In My Grandmother's Garden, 1974. *While the artist is concerned with design, the manipulation of rich, textured materials to achieve the results seems the most absorbing.* (Courtesy of the artist.)

us feelings of order, variety, intensity, excitement, and so on.

The degree the message comes from the artist, through the work, to the viewer, depends upon the nature of the message, how well the design carries the content and effect of the message, and how receptive the viewer is to the message. Some people may respond to some parts of the message and not to others; many people only to the subject matter; some mainly to the emotional impact; and others to the beauty of the or-

ganization. Some people get all these messages, a few almost none of them.

Some people look to nature and its order for their sense of identity. Their art tends to be about nature. They attempt to repeat nature or abstract from it. When people are isolated from nature as is often the case in urban areas, or when relations between peoples become strained, artists' subjects become people, urban environments, and social issues. When the stress of human experience becomes acute, many artists retreat from social concerns and express in their art subjective impressions and self-reflective analyses. Some introversive artists work this way in periods of relative social rest because they are so far removed from the mainstream of the life of the people in their culture.

forcing us to see more minute details than we would pay attention to in ordinary lights and views. They force us to find the "reality" of experience in relation to the thing portrayed.

Some societies have art forms whose main purpose is to communicate—painting and sculpture in Western and Oriental Art. Other societies mainly use art in relation to some useful object—masks, ceremonial body coverings, tools, vessels. But these all communicate qualities, ideas, and emotions as well. Every human-made object that we can see, touch, or smell communicates; it tells us something about its use, its function, and its social meaning.

Defining and Evaluating Art

By art we mean all those human-made things that are done *purposefully* with some attempt to enrich the message, or enhance the object or the structure; to affect a qualitative and content awareness in the viewer. A painting, a sculpture, and a photograph are art, so are a building, a body covering, and a designed tool. To develop criteria for judging the quality of the art, we need to know what its main function is. All forms of art communicate qualities and ideas, but they differ in their functions. Paintings, sculptures, drawings, prints, photographs, and craft media communicate ideas and feelings. If the artist is commissioned by a political, religious, or philanthropic group, the group may determine the message and to whom the message should be directed. In each case the communication is between the artist and the art and the art and the viewers.

Art varies widely in quality. Criteria for judging art include:

The nature of the message,
The design and organization of images that carry the message,

Figure 5.6 *August Herkin.* Watercolor. *Purist, unmarred by human symbols or events.* (From: Guillaume Janneau, *L'Art Cubiste, Paris Editioris d'Art: Charles Moreau, 1929.* Reproduced by J. Jacomet. Courtesy G. Janneau.)

Some artists use their own subjective experience as scientists use nature. They search for truths that underlie the visual order of the universe. Some purists search for unmarred beauty. Weller (1963) calls this the most humanist art of all, coming from no object but from the artist alone. Other artists paint more "realistically" than nature itself,

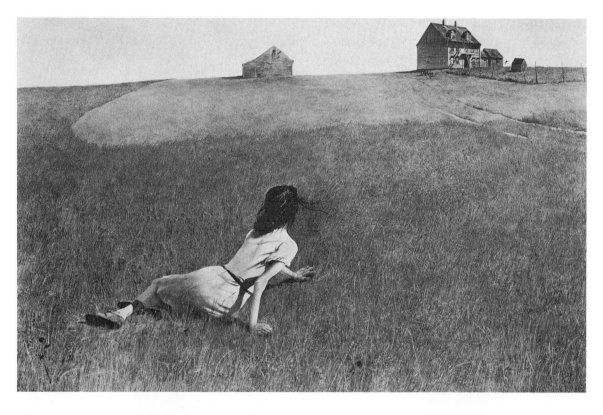

Figure 5.7 *Andrew Wyeth.* Christina's World, 1948. *Painting "more realistically" than nature itself.* (Collection, The Museum of Modern Art, New York.)

The effect of the media on the message,

The way the media is used,

The creative quality of the message, design and use of media,

The total impact of all these criteria.

Paintings, sculptures, prints, and photographs that have trite, overused images usually have shallow messages. The designs do not stir us to become involved with the message. The media may be poorly handled

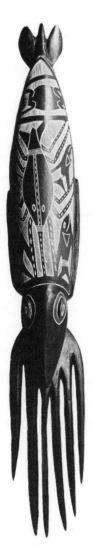

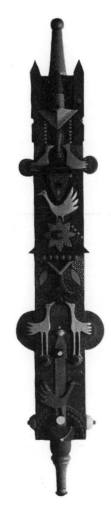

Figure 5.9 *Stanley Day (Canada). A bird totem of wood construction. Both artists in Figures 5.8 and 5.9 work in three dimensions, and both abstract from nature, but the traditions they come from lead them to use different kinds of shapes and lines.*

Figure 5.8 *Contemporary Australian aboriginal carving.*

and not very appropriate for the message. If we are concerned about quality in art we usually judge such works as low in quality.

Designed objects, ceramics, fabrics, metal-work, jewelry, leather work, and wood work can be judged not only by their message, *how they are to be used,* but on how well the design fits their use. The selection of materials has to serve not only the visual message but the practical use. The skill in making an object not only communicates the concern and care of the crafter but also how well it will serve its users. Structures, buildings, and spaces between them, can be judged by the same criteria as art objects. But they also must serve varied kinds of activities by different kinds of people as well as their needs for air, light, protection, and private and public spaces. Structures also carry social meanings and the design carries the message of what it is. In the degree that each of these art objects and structures is well done, it will be effective in changing our experience with it and the structures around it.

When we look at the art of any one group of people in a certain period, we usually find that they have selected some visual qualities to use and not others, that they value some emotions and neglect others. They use some kinds of lines, shapes, colors, textures more than others. In this way, we identify the period or style. We can judge the art as to how well it fits with that culture. We can also judge its form and impact on people worldwide. Either judgment is useful; neither is more correct than the other. But we need to be aware of how we are judging.

When we look at all the art of a cultural group, we find most artists using the visual qualities selected by the group and expressing the most valued emotions. But we will also find artists in the same group who are breaking away from the usual mode of expression. When we observe the art of a cultural group over a time we find transitions and changes in the most common ways of expression, but we can often still recognize from what group it has come.

At some periods of a group's development, there may be more cohesion, more agreement, among artists of what is acceptable as "art" and what is not. At other times the degree of agreement among artists may be minimal. Then it is sometimes quite difficult to look at a work of art from such a group and tell where and when it was done.

Sometimes the art forms of a group of people will be recognizable over hundreds of years. Sometimes the changes are so rapid that a year makes a radical change. Some individual artists stay with the same style and subject matter for years, and others shift styles and content from one focus to another as they change and develop as people (Meyers, 1967).

We often hear the statement that art is a universal language. It may be true in that the ordering processes of human beings, used as a basis for design as discussed in Part Two, appears to be found in art forms everywhere in the world. Some kind of ordering of the art elements of shape or form, line, color, texture, and space is used by grouping in similar and varied ways. Art also requires some concerned, caring effort to produce it. There are common human experiences in the processes of living that are expressed, but the interpretation of the *meaning* of time, space, human relations, the structure of social life depend on the cultural group. To some degree we can respond to any people's art even though their language may be incomprehensible to us. But we can only understand their art in the degree we can learn their culture. When we remember that a culture is learned through the values and beliefs expressed through the day to day actions of people, their language, the sym-

bols in their visual environment, their art, myths, and music, we should not be surprised that a latecomer can rarely learn it as a child learned it growing up in it. But each child learns his or her own culture somewhat uniquely, learning some aspects and ignoring others. For these reasons art is not wholly a universal language. In observing a given work of art, we are limited by our understandings of the culture and the degree to which the artist is central or peripheral to the culture.

UNDERSTANDING CULTURE

People both create and react to the culture that maintains and sustains their way of life. Changes in styles are visual time charts of when things occurred. All these are communicated through art as well as through language. Material culture and art continuously educate the members of a cultural group into the behavior patterns of a given society.

The definition of what the word *culture* means is under continuous and serious debate (Bohannon, 1973). Social scientists study it from different perspectives, and the differences in definition may only be due to differences in looking at it. Some people find that culture is stable and continuous over time. Others find that culture is always changing and that different cultures are affected by different degrees and rates of change.

Some people spend their lives in the cultural environment in which they were born. Others spend their lives trying to break out of the habits and attitudes they learned as children. Most people probably operate between the two extremes; they are adhering and breaking away at the same time. Most people are also multicultural. Their dress, appearance, language, relationships with others, status and roles change

whether they are at work, at home, at play, or in church. A woman may be a teacher at school, a mother at home, an outstanding member of a profession, and sing first soprano in a church choir. Each role calls for different relations with others, sometimes different dress, and often varied speech patterns.

Each individual is a culture carrier. The individual's expression of the culture depends upon the continuing opportunities the person has had to learn culture, what he or she selected to accept or reject. People who have shared the same cultural experiences are more alike than people from other cultural clusters.

While there is adaptation to culture, there is also stability and sameness of culture. When ideas such as human equality and civil rights become strong in a complex society such as the United States, pressure to change and resistance to change can be seen throughout the whole culture. People communicate where they stand on issues by their language, dress, and the art forms with which they surround themselves.

LEARNING CULTURE

Culture is also design. Each individual is exposed to cultural elements: language, visual symbols, values, and beliefs, the status and roles of people at different ages, and the ways these are symbolized in dress and behavior. Each child learns to talk from what he or she hears. Each child learns to see and discriminate from particular environments. Choices are influenced by what others think is important. Thus, a child builds up a sense of design based on opportunities, choices, and the influence of others. The learned design tends to persist, but it can also be modified and changed by new experience. People try to maintain cohesion in their sense of reality not only as individuals but

Figure 5.10 *Terry Barrett.* Jesse. *Learning to see and discriminate.*

as members of groups as they cope with changing physical and social conditions. Groups of people who grow up selecting from the same cultural pool tend to value similar attitudes, ways of seeing, material culture, and sense of reality. But groups are continually facing new situations in which reorganization of their cultural design takes place.

The family is a cultural group, and family culture is the composite of cultural elements the members of the family have selected from the pool to which they have been ex-

posed. Each family member will be somewhat different because of individual selections, and the family pattern will be different in some respects from other families. Each of you represents a different composite of culture that you have learned from parents and peers. Families are usually part of other cultural groups; they are more like some families than others because they share similar values and life styles. There are similarities imposed by poverty or affluence no matter what the ethnic group.

In small cohesive societies parents often have very similar values. In large complex societies such as the United States, where there are many different regional, ethnic, and religious cultures, one's parents may be of very different cultures and one learns parts of both depending on how values are taught and who makes decisions. Families are also in the process of change. As children grow older, roles and relationships change, and spatial needs and activities change the life style of the family. A family's culture depends on the pool of cultural elements the members have opportunities to select from, the ongoing selections they make from the pool, and the way they adapt to change (Bohannon, 1973, pp. 262, 263).

The elements of culture, belief systems, values, roles of people, language, and art are like form, line, color, and texture in visual design. You change any one part and the system of relationships among the parts are modified. At the same time, strong relationships are harder to break down or modify. The search for order and predictability in culture goes on much as our need for order in our visual environment. But we also need change to keep a culture vital and adjusting to new needs. The history of humankind appears to be a history of changing systems of interactions, a continuing reordering as things within and without the system cause disruptions.

CULTURE CHANGE

Change in culture is caused mainly by the innovations of people. Inventors, religious leaders, artists, scientists, architects, planners, and politicians may be working within the value system of a society and improving and refining social organizations, improving tools and technology, creating within an established school or style of art. But any one of these people may step outside what is established and create a new relationship, a new invention, a new art form that substantially changes all those who are in the same cultural network, those with whom they share and communicate ideas.

On the other hand, there are self-contained cultural groups who intermarry within the group and resist change from outside. Often these cultures center around a religious or ethnic value system. Resistance is strong against being influenced by life styles, technologies, and art forms that do not fit in with the established values. New communal groups try to establish value systems in contrast to the cultures the members have come from, to set up their own patterns of culture and art. But these are usually borrowed and selected from patterns developed previously.

By contrast, there is an increasing international culture shared by people from all nations involved in international trade, travel, science, and art. What happens in one world city is soon seen in Buenos Aires, Tokyo, New York, London, Paris, Los Angeles, Singapore, Melbourne. The speed of interchange of ideas, the impact of change in politics and resources in one part of the world has immediate influences on the rest of the world.

Inventions and fundamental changes in ideas have long-range effects on cultures. Short-term changes—fads—are more fleeting. Most of us are affected in some degree by fads—such as fashions—as people are attracted to things that are currently popular. Just how fashions emerge or kinds of thinking evolve is not fully understood, but part of the power of trends is the desire of people to be part of the larger society. Trend setters try to create new fashions to stimulate new purchases and quick obsolescence so people who want to be "with it" must buy and reject with great rapidity.

One fundamental change in thinking has been caused by the impact of shortages on a world wide scale in relation to accelerating population and the realization that the consumption of world resources is concentrated in the industrialized nations. Recycling is a fundamental new idea and will have lasting effects on culture and art. Restoring, renewing, reusing may be considered more creative than innovation and change.

ART CULTURES

Cultures develop among artists who value similar styles or attitudes toward art. Some are geared to resisting change, others to keeping up with or developing change. For one group, the art is "good" if it conforms, for the other, the art is not really great unless it is in some degree a new insight, a new organization, a new inventive use of media. For example, two contrasting art cultures are those of recreation artists and professional artists. They have different ideas about what art is for and different values about the processes of art.

One can visit county fairs all over the United States, even year after year, and see artists doing similar things. One can visit contemporary art galleries and art departments in colleges and universities, and while one sees wide varieties in quality, the pervasive trends are amazingly similar. This suggests that there are aspects of culture

that are not regional, local, or socioethnic, but are shared by people doing similar things for similar reasons, and having similarities in values about art and ideas of how art is changing.

Without extensive research on differences in purpose between these two groups, we can only look at the most obvious differences in the art works to describe the differences in the people who produce them. One difference is that the professional artist sees art more as a life work with a stronger commitment to analyze and express new insights. Those insights may be subjective or objective, individual feelings and responses, or responses to events and situations outside oneself. The artist who uses art for recreation does it in contrast to his or her main life work or often after the life work is over. Making pictures, objects, or crafts appears more important than the message. There appears to be more conformity among recreation artists. The push appears to be able to make acceptable art within that group of artists rather than breaking new ground with new ideas and techniques (Jones, 1975).

Among professional artists there are many different "schools." As a new idea develops, such as op, pop, or minimal art, a school develops and artists set up a culture of values and attitudes and ways of expressing the new art. The culture may spread around the country and the world and persist for a long time. Sometimes when a new form becomes old, it reappears with a new vitality.

During periods of extreme social upheaval some artists revive art styles from past periods. A revival may mean nostalgia or it may mean that the old form expresses values and beliefs that are still part of the present culture, but have been neglected or not popular for a while.

To the uninitiated viewer art that is not realism is modern art. Yet in actuality, what is being shown and done at a given time, including many aspects of contemporary art, have come and gone and come again. For example, during this present century photo realism, hard edge abstraction, minimal art, conceptual art, abstract expressionism, op and pop art have been coming and going in varied forms with the tides of art expression over many years. The surrealism, cubism, and impressionism of the earlier part of the century are still alive and still currently influencing artists and the art viewing public.

COMMUNICATING STATUS AND ROLE

All people are walking information centers. The clothes they wear, the way they wear them, their grooming state, their use of body painting, their body movement, and their choices of jewelry or ornamentation tell other people a great deal about who and what they are, the culture they come from, their values, their degree of acceptance of change, as well as their economic status, which, of course, influences their pool of choices. Styles and symbols are used to identify different ages, social roles, sex roles, occupations, and, in some cases, ethnic or regional origins. In art, as in culture, change happens when groups intermingle, when new ideas, inventions, or catastrophies change people's ways of life. The messages change over time with ongoing fluctuations of style. Fundamental changes in values make markedly different changes in the art forms that express them.

In most societies there are ways to identify children, youths, or adults. This is not only communicated by changes in size but by differences in the symbols used in clothing. Children's toys are kinds of art forms, symbols of roles children are taught to play to enter into adult roles. The clothes one

Figure 5.11 *Peter Purdue.*

Figure 5.12 *Eugene Lockwood. What do the men's clothes in Figures 5.11 and 5.12 say to you?*

wears and the toys one plays with communicate whether one is an infant, a preschooler, a young child, or an adolescent.

How sexes dress in given situations communicates how they relate to each other. When they dress alike, their roles are more alike. When sex roles are very different, they look very different. Clothes worn for marriage ceremonies are clear examples. The clothes symbolize what part of society the bride and groom identify with and how important the ceremony is in their life.

We can usually recognize different occupations, different economic levels, and different ages by what people wear, and how far behind, how current, how conservative, or how extreme they are. We would be dismayed to see a well groomed and manicured person beating another over the head with an umbrella. Their behavior would be out of character with the stereotypes their clothes suggest. Another indication of personal care is body movement and stance, whether casual or dignified, and how close people are to each other when talking, walking, and sitting (Hall, 1966). All these subtle forms of body movement and dress are cultural art forms—they communicate and enhance experience.

But symbols change their meaning over time, and often radically so. During periods when roles are stable and clearly defined, we can more easily read what a person's status and role is through dress. When societies are in periods of rapid cultural change, the communications are not nearly as clear.

Someone entering the area of another culture group must learn to read the symbols. This often means embarrassing trials and errors before the meanings are recognized. It is easier when culture change is slow. When it is rapid the problem is magnified. You not only have to learn the meanings of symbols but how they are changing. A person may learn the symbols at one time, but

Figure 5.13 *Women in Singapore.*

on returning to a culture find much to relearn. The women in modern Singapore shown in Figure 5.13 tell whether they are of old Chinese culture in a servant role, modern Chinese matrons, or modern young women.

The design and style of jewelry and the situations in which it is worn all communicate subtle messages about culturally defined status and roles and the social situation these roles are being played in. Jewelry is often symbolic of critical changes in people's lives that are culturally determined. In some cultures, married and unmarried women wear different dress as well as different

Figure 5.14 *Plains Indian beadwork medicine pouch.*

jewelry. When young people become adults or graduate with new degrees, jewelry is used to denote the change. Achieving membership in organizations, years of service, and ranks of chiefs and nobles are all symbolized by jewelry. People with more traditional values tend to wear traditional jewelry. People who value rare and antique things wear antique jewelry—it communicates they are people who care and are knowledgable about the past or who have ancestors who could own such jewelry, by reason of their status in the tribe or society.

People from industrialized societies often prefer jewelry of nonindustrialized people because of the values they attach to cultures less affected by mass production. Part of the appeal of the jewelry may be its beauty of design, but a large part may be that the people who made it lived closer to the earth, had long-established roots, and had directness in their use of materials that people living in more industrialized societies lose. It makes an urban person feel more real, more natural when he or she wears it. The Navaho wearing his or her own silver is reinforcing his or her identity as a Navaho. The urban white who wears it may enjoy it solely as a handsome art form, or as a search for identity through borrowed symbols of another culture.

VISUAL COMMUNICATION AND PREDICTABILITY

The art of dress, the symbols used to communicate how the individual views himself or herself, the roles he or she expects to carry out, and arts in the environment provide predictability. Art communicates much more quickly than if we had to go around asking everyone who they were or what they do. With just a glance we get much more information; even subtle cues people could not tell us. If we could not predict behavior,

our judgments would be slowed considerably. Each of us every hour of the day would be trying to figure out what the others were going to do.

ART AS ENHANCEMENT

We feel differently when we wear different types of things. Sometimes people dress to lose their identity, to get lost in the crowd and look like everyone else; other times they want to be seen as close to their own self-image as possible. People use clothing and jewelry to help them become acceptable as a part of another group or for specific events, such as celebrating the New Year, the naming of a child, a marriage, or a religious feast day.

Status and role are communicated through the design of structures and arrangement of places. When we look at a building, its form, color, kind of ornamentation tell us something about its role in the social organization of the community: how important or how valued it is to the people who live there. A large building with imposing multiple entrances, made of long-lasting and costly materials, and meticulously cared for communicates that it is important in people's lives. The same building in deteriorating condition would communicate that it once was important, but that its social function is no longer valued by people today—at least not enough to pay for the effort to maintain its original condition. It might also mean that the people in the society no longer consider maintenance important, and value the used, worn characteristics of the place. Or the building may have been taken over by another group of people who are using it for a different purpose from the original one. Its changed condition communicates both a change in function and how we would expect to feel being in it.

Forms tell us whether buildings are post offices or churches, shopping centers or schools. The style often tells us *when* structures were built. As culture changes and values are modified, buildings are modified—churches of a given denomination tend to change form as the church changes from more formal to more informal services. Schools that stress student-centered education are usually built differently than schools that stress discipline and formal education. Informal schools provide more choices of spaces, formal schools are rigidly laid out and clearly identify how students should behave. Furniture in formal schools is rigidly organized and hard to change, while informal and open schools can be easily modified to change with the times. When we see these buildings, we get the message of how we should behave and what to expect there. This does not mean that innovative teaching does not go on in rigidly designed schools and that rigid teaching never occurs in open schools. It does mean that the environmental influence is towards one or the other kind of teaching.

People's attitudes towards where they live and the housing they choose to live in reflect their values, attitudes, and in what part of the culture they belong (Gould, 1973). All these are related to their sense of identity. Within their cultural value system, the qualities they create in their environment give them feedback about who and what they are in relation to the other people in their group. As land and building costs increase throughout the world, the freedom of people to choose and modify their housing according to their culture decreases. Multiple housing tends to be even more standardized than tract housing because the outside and yard of tract housing gives people more area to modify their environment. This may be a factor in people's apparent sense of identity loss. It is harder to create and maintain one's

own culture and see it expressed in one's environment in standardized housing. This is particularly so when one's background culture is different from the dominant culture that does the standardizing.

Where people can create their own housing from materials available to them, the housing and their life style are closely related. The nomadic Plains Indians' tepee fit their life style, and their life style was developed in terms of the limitations of their use of the materials that were available. Housing was portable, easily assembled, adjusted to heat and cold and wind direction for eliminating smoke, and was big enough to allow for a variety of sleeping, eating, and socializing activities. The modern migrants who make homes out of school buses and other vehicles are also adapting their life style and their housing to each other.

Standardized housing often lacks this flexibility and divides the sleeping, eating, and socializing functions of people in stereotyped ways. It structures people's life styles more than they realize. It limits how much they can communicate their own status and role through their housing. It limits how much other people can learn about them.

The efforts to modify or custom build motor cars and the painting and decorating of standard cars are efforts to express identity or cultural values different from the mass produced. Standard cars themselves are sold with varying degrees of status symbols so that one can buy status depending on how much one is interested in spending. Sizes and shapes fluctuate with fuel supplies and economic conditions. Styles change to stimulate turnover. The success depends on how many people find it necessary to communicate through the car they drive that they are current and up-to-date. Cars are homes away from home and are part of contemporary people's identity structure. As power

demands and resources change, people's identification with automobiles may change. Other modes of transportation will probably take on more meaning.

Social position and group image are also communicated by the drawings, painting, sculptures, and crafts with which people surround themselves. Corporations use art to communicate their stability and prestige. The nature of the art they select tells whether they are appealing to people with popular tastes or to people of educated aesthetic tastes. Some businesses make their customers feel at home with calendar art.

The ways people dress, behave, and talk to each other usually fits the nature of the building and the art forms that are selected to communicate what kind of place it is. Sometimes there are value conflicts. For example, a corporation gave a sizeable sum to purchase a contemporary sculpture for a town's park. The townspeople suddenly discovered a "modern" sculpture was going to be placed in their pioneer park. The values of revering the past and celebrating the present were in conflict. An issue arose, the gift was withdrawn and another community with a new park welcomed the sculpture.

People in business, communities, and families surround themselves with art and artifacts that have meaning to them. The arts include such popular arts as dime store prints, "hand-painted" work by number kits, trophies, travel momentos, plastic-mold sculptures and painted plaster casts, posters, calendars, crafts made from kits, copies of well-known paintings, carvings, religious symbols, hand-knit and crocheted covers, ash trays, vases, picture frames, and more creative arts and crafts which range from the most amateur to the very professional, from the traditional to the most advanced. People make their selection from whatever pool of things they can make choices from and their own judgments. Sometimes the judgments

Figure 5.15 *Hugh Townley*. Concrete Sculpture, *1974*. (Alton Baker Park, Eugene, Oregon.)

are unqualified likes and dislikes. Other times they are careful, thoughtful decisions about life style and how the art enhances it.

Many times decisions on what art to buy, collect, or create is made on the basis of what art other people in the same culture group have. People share the same values and share the desire to have similar environments that enhance those values. When you enter someone's home, you can quickly read their values and the kinds of people they identify with culturally.

Figure 5.16 **a.** *New Hebrides totem.* **b.** *Raymond Pell. A ninth-grade American black student's totem. Eva Thomas School, Fulton County, Georgia. Roosevelt Harris, teacher.*

MAKING CULTURAL "REALITY" MORE REAL

Most cohesive groups have some system of accounting for values and beliefs that relates the world as they experience it with the ordering system they develop to explain it. Languages and art are used to describe how the system works. Myths, folk tales, drawings, carvings, and paintings objectify a cultural group's concepts of reality. Forces that are not explainable appear concrete and often are thought of as the force itself. Ceremonies, rituals, and artifacts explain weather, hunting and gathering successes, and crops growing or failing.

The structure of our beliefs is made apparent, that is, more real, through art. Art expresses what we believe, what we value, what we feel about the relationships we make between things, the kinds of diversity we will or will not tolerate, and how much we revere the past, the present, or the future (Geertz, 1973, p. 82).

Art is used to make symbols of things appear more real whether in a remote tribal society or a complex urban one. A symbol of a tribal deity or revered person or animal is not the original idea people have in their minds, but by symbolizing it, it becomes more tangible, more real. As they observe it, the symbol and idea can be more inseparable. The quality of the design communicates the nature of the idea. The symbols in Figures 5.16–5.19 are by contemporary artists, three of whom are in somewhat remote areas that are carrying on old cultural traditions. The New Hebrides totem is repeated in many sizes and varied in carving from island to island, but the message remains much the same. An Australian aborigine's bark painting and carvings of precious animals makes the ideas of the animals more tangible, more real. The Eskimo carver whose ivory supply is gone now carves in

Figure 5.17 *Bob Bilinyarra. Australian aborigine bark painting of turtles.* (Wulaki Tribe from Gadje.)

bone the bear which was for so many years a keystone to Eskimo survival and is much revered. Now it is a symbol of past Eskimo culture, something that makes that culture still real. The New Guinea mask-maker per-

petuates the values that existed before his land was overrun by foreigners.

Raymond Pell, a young American black, studied art with Roosevelt Harris while in high school in Fulton County, Georgia. Harris encourages his students to become involved with African art, searching it for essences that can give meaning to their own contemporary individual expression today. This search has particular meaning for those black people whose cultural continuity was cut off by their enslavers.

In our own society we would probably be disturbed if our coins and currency had all symbols removed and we exchanged blank coins and papers with only the numbers of the amounts on them. Our money seems more real and valuable because the symbols of our values as a national sovereignty are embellished on it. Flags, emblems, medals, trophies, diplomas all communicate a quality of something very real to us. Without the symbol it is hard to prove the reality of the act, event, achievement, or deed the symbol represents.

Traditions are maintained and communicated and thus made more real by the art forms associated with them. Country and western, folk, rock, jazz, and classical musicians symbolize their traditions with varied types of clothes appropriate to their traditions. To make the music more real, all the accompanying symbols need to be present to give the audience the full impact. Musicians in white ties and tails, sitting in symphonic orchestra form, and playing country and western music with appropriate facial and body gestures would make most of us laugh.

Many major art museums are housed in buildings built when museums were considered elite institutions, to be used mainly by the upper classes. Now many of them are trying to change their image and appeal to more kinds of people. The problem

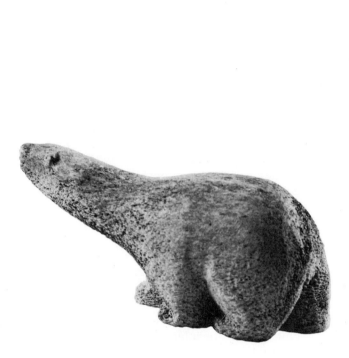

Figure 5.18 *Eskimo bone bear.*

is that the design of the buildings makes them look exclusive, formidable, and formal, which frightens many people away. New entrances, new attitudes of staff, friendly guards, and public advertising try to communicate an egalitarian institution.

Theatre is an attempt to create a total reality through all the arts: body movements, costume, dance, sets, and music as well as language. Through this re-creation of culture patterns we can be quickly moved to another time, place, or culture. The success of the play depends upon how well it is written, acted, and produced. People who know the culture well are rewarded by the play's authenticity and people who do not are rewarded by its cohesive reality.

Ethnic, regional, and religious festivals are cultural celebrations when people dress, act, and play to celebrate values that may be neglected in their day-to-day existence. Historical roots and cultural traditions are made more "real," are taught to children, and reassert the cultural identity of groups. They provide a sense of belonging by giving people an opportunity to participate and by showing outsiders who the insiders are.

ASSESSING THE CULTURAL IMPACT OF ART ON OUR OWN LIVES

An awareness of the impact of design on our lives comes with understanding what art is communicating about qualities, values, and beliefs. You may find that your own cultural values do not fit with the environment of art in which you find yourself. This could mean that you are living in situations you did not create or that you have not paid much attention to what you selected to have around you. Perhaps you are satisfied with your immediate environment, the art forms in your own living environment, but abhor the environment in your neighborhood or school. Few people in the world live in a homogeneous culture where the values, beliefs, and qualities of a people are directly expressed and interwoven with all the things with which they surround themselves. Their concept of "reality" is directly made real in their environment.

If you wonder how much your life is influenced by art and the design of things in your environment, imagine what it would be like if you were standing naked and alone in a vast area where nothing made by humans existed. You would probably desperately search for something recognizable, something to relate your sense of self to, something to be real. If you suddenly went to live with a cultural group quite different

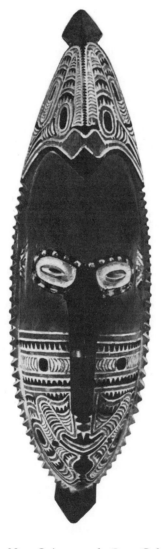

Figure 5.19 *New Guinea mask.* (Jane Gehring collection.)

from your own, you would find that the people's speech, dress, relations with each other, and their environmental feedback systems that reinforce their sense of reality would be strange, and that you would feel alienated and out of place. If someone were to walk in, dressed as you are dressed, speaking in language and dialect like your own, with familiar gestures, you probably would be much relieved. A part of your "reality system" would be there to relate to. A person need not be present though. You could feel at home if suddenly in a strange place you were to enter a room and find a composite of designs that were very familiar.

Although art in our environment communicates and affects us strongly, being culture bound is not necessarily right and good. Part of art education is to help children and young people understand other people through art—that is, to go beyond just appreciating their art as art and to see how it is an expression of their sense of reality.

MAKING CULTURALLY RELEVANT ART JUDGMENTS

The question of cultural relevance of art is important to the art teacher. "If my students are creating art that fits with their cultural group's values and attitudes, if it expresses qualities that gives them a sense of identity, should I try to teach them to change it?" Each teacher and each school district must ask this question and answer it for themselves and others in their group.

Many people are so immersed in their culture and their culture's art that they are not aware of its effect on them. They accept both the culture and its art without question. But in a complex society which has many cultures, students should learn to understand cultures other than their own. People who are culture bound, that is, live entirely within one cultural framework, are less able to understand the impact of their own culture as compared to others. In order to make decisions about the cultural life style and art that is appropriate for them, they need a broad basis of understanding of both art and culture.

As teachers, we must help people become more thoughtful about their judgments rather than tell them what their judgments should be. We can help people think about what makes beauty in their lives. Then they will be better able to apply their own criteria rather than our ideas of what is "good" art. We can expose them to other choices, but respect them and their culture. The results may be that they will become dissatisfied with their own standards, respond to new ideas about art and beauty and extend their life-style to be more encompassing. Or they may choose to stay within the context of their own cultural patterns of what art is, yet refine and improve their work.

CURRENT RANGES OF KINDS OF ART

A wide range of kinds of art is evident within and between cultural groups. The resurgence of folk art and interest in people who know the basic skills of quilting, spinning and weaving, woodworking, metalsmithing, and glassblowing comes from an increase in the number of people who want their life style to express simplicity of function, rather than the machine manipulation of materials. This is a resurgence of what they think is a culture pattern. People are turning to objects that stimulate an atmosphere they feel is missing in the fast pace of automated, mechanistic, plastic society.

The arts of the 1960s counterculture changed in the 1970s as forces within and without the movement emerged. At first, the counterculture arts appeared as a blatant rejection of the affluent society. They

Figure 5.20 *A contemporary folk artist, Goldie Casady, and her quilt work.*

were hastily made, often by people with little crafts experience. Then those arts became popularized and machine-made while the counterculture force was somewhat dis-

sipated. By the mid-1970s, the counterculture was less a reaction and more a way of life for young people than their predecessors of the 1960s. The artists of the 1970s

b. *Detail of the quilt in Figure 5.20a.*
(Photos courtesy of Robert Dean.)

symbolize their values and life styles with a much more refined craftsmanship that has emerged from the initial counterreaction.

Efforts have been made by ethnic crafts groups and tribes in many parts of the world to upgrade and protect the authenticity of their crafts, not only to preserve the art, but to protect the public from imitation work brought in to compete in the market. They have also wanted to sell their crafts as a means of educating people about their culture. But, as traditions in a group change, the art may not be changed, because in the

public view only the crafts of a given period are considered "true" Navaho, Eskimo, or Plains Indian art.

The "art world"—the fine arts of the professional exhibiting artist—is difficult to describe culturally. Artists tend to be more socially isolated than most people and come from many different cultural backgrounds. They are more spread out around the country than in previous years. The museums, galleries, and art school centers attract artists as places to exhibit and teach or study. Every major city and many towns have some loosely knit groups of artists and craftspersons. College and university art departments germinate much of the vitality in the arts today and function as art centers in their regions.

A great deal of communication goes on among art centers. But regional characteristics, effects of climate and topography, the degree of urbanization, and regional cultural values can be seen in art from different areas. Changes in inventions in art and resurgences of past styles go on constantly, and affect the work of people all over the country. These same effects can be seen on an international scale. National characteristics continue, but international trends are found in much of the free world. But these international centers have less sway than they did because of the growth of art in other regions throughout the world. What appears to tie them together is the concern for the human experience, which changes as social, cultural and political forces change.

SUMMARY

We have looked briefly at some regional, ethnic, national, and international art. In thinking about them, remember that they are all in process of change, that any one artist may be moving away from or more centrally into any group. When we look at any

one group's art we find their style has always been subject to slow change. There is no period which is absolutely true and authentic. But when we ask about cultural meaning and craftsmanship, we see some artisans producing much more significant work than others.

Each art form can be evaluated in terms of the cultural influences on the artist, or it can be judged in terms of art generally. But the latter keeps us from seeing the value the work may have in the life style of a group. To judge a county fair exhibit by the same criteria as an international art show tells us how different the cultures are of the two groups of artists but tells us little about the meaning the art has in either culture.

In schools where diversity in expression in art is encouraged because of the diversity of cultures represented by the students, their work must be evaluated in terms of their cultural background. Conflicts arise with individuals whose perceptual development, culturally learned sense of space, and values are different. They are evaluated in terms of the dominant culture's art. Such students may want to accept the dominant values, perceptions, and symbols but lack the background experience to do so. As teachers, we must try to understand what their experiences have been and what they value in order to understand their readiness for art.

If teachers help students become more aware of culture diversity in art and help students evaluate the qualities of art in different contexts, they may be better able to understand themselves in terms of their own cultural background—why they like what they do and see as they see. And they may be more critically aware of the impact of their own and other people's art.

ACTIVITIES: LEARNING ABOUT ART IN CULTURE

Each time we look at other people's art in terms of their culture, we can get fresh insights into our own. As we understand art in our own society, we are better prepared to understand the functions of art among other groups. As we compare our own with others we extend our understanding of both.

You should consider the cultural diversity in your class. If your class is made up of young people from quite different backgrounds you should begin their study with a cultural group very different from any of their own. This will help them recognize differences in culture and art and thus be more tolerant of the diversity of attitudes among their classmates. When they study art in American society, they will see how diverse both American society and art are. Even in small towns or neighborhoods cultural differences can be found.

You and your class can do research in school and public libraries, art museums if they are close by, through films and slides. Books and films do not have to be on art. Art can be found wherever people are found.

DISCOVERING THE CULTURAL MEANING OF DESIGNED OBJECTS

Level 1
Comparing the Meaning of Objects

To begin to understand that there are such things as different cultures may be very difficult for some young children. They see the

world and other people entirely from their own ideas of what is "real," "right," "beautiful," and "ugly." You can begin with familiar art forms from different cultures that are somewhat alike. For example, you can start with cooking pots, something everyone is directly or indirectly involved with (see Figure 2.23).

You should understand your students' backgrounds to select a range of pots that will be familiar to them. If your students are just entering school, you could collect some toy pots and pans. Hardware, dime, and department stores and crafts shops in your school's neighborhood will give you some idea of what people are buying. Also collect some pots from other countries. Ask the students to compare the pots:

What kinds of materials are the pots made of?

What kinds of heat does it look like could be used to cook with them?

How is the shape and the material related to the heat?

What kinds of things do you think could be cooked in them?

How are the pots designed and/or decorated?

What does the design tell us about how a pot is to be used? For special events, every day, for cooking special foods?

Do the pots tell us anything about the people who use them?

You may have an assortment of pots to use as references. There may be sources of cooking and serving ware from your own group of students that they could bring to

share with the class to illustrate how differently people in this country cook for different occasions and the different pots needed to do it. Students from different backgrounds can be encouraged to talk to people at home to get more information and examples. You can get your students thinking about these differences by asking:

Do we use the same pots for serving dinner every day, dinner for families, dinner for company, barbecues, picnics, weddings, Thanksgiving, religious holidays?

Do the pots used tell us something about the ceremonies, kinds of celebrations, or everyday meals?

Do we use some kinds of heat and pots to give a cultural quality to an event?

At what kinds of events do we use charcoal, wood, alcohol lamps, candles to heat food, even when electric or gas stoves are in the kitchen?

How are cooking pots or methods of cooking different for these kinds of heats and the events where they are used?

Older students can also use books, encyclopedias, films for examples of the pots used in a particular group such as early pioneers, American Indians, or Mexican villages before they could buy metal pots. What they used depended on the materials available to make containers for cooking. The pot did not just have to go over the fire or onto a plate heated by gas, wood, or electricity as we use them today. It had to hold the food, water, and hot rocks to make it boil. California Indians wove watertight baskets,

Northwest Coast Indians carved wooden bowls, Plains Indians made containers of animal hides. Some people fried directly on hot rocks. For special occasions and to identify family groups, baskets and carved bowls were designed to communicate whether these were everyday containers or for special celebration events.

When you get through, you and your students will have some ideas of how culture today and other cultures in the past are both alike and different. It gives you information about special events, about materials and foods that are available, what kinds of decorations are important, and how food is prepared and eaten.

The children or older people beginning this study can also reflect on the quality of their own life styles in relation to the cooking and serving of food. Educationally, you are not teaching taste or what is "good design," but you are extending the range of students' awareness, providing them with criteria for looking at some basic cultural processes which in time may lead them to more thoughtful concerns about their own life styles.

This same kind of activity could be done with different kinds of simple tools such as knives, hammers, choppers.

Level 2
Reading the Messages in Objects

Learning to "read" what objects say to us requires that we spend enough time looking

Figure 5.21 *Cutting and serving tools from Japan, Germany, Italy, Holland, and United States, antique and contemporary.*

at them to get the messages. Our environment is full of information, much of which we get without being too aware of how the message is affecting us.

Students who have learned to see the meanings and art qualities of simple forms can extend their inquiry to get more information from all kinds of objects. All kinds of tools—eating, drawing, cutting, marking, opening; containers for storing, transporting, moving; clothing to keep you warm, to tell who you are, to give you privacy; body ornaments to decorate, to show your status; magazines, books, toys, badges, drawings, photographs, fences, and doorways are all ex-

amples. The range of objects will depend on where the students live and the opportunities available in their environment.

You might gather a collection of items found close by and get the students to write as many things as they can about the messages they get from looking at the objects. If children are not proficient at writing or reading, you can ask them questions and get them to describe their ideas to the group. Each item could be written on the board. Some students will see details (colors, shapes, textures), some materials (wood, aluminum, paper), some will see cultural meanings and values (nice, clean, pretty, ugly), some will just give word names for things (chairs, rings, bicycles, lamps). As different ideas come up, you can help each student see all the ways of looking at objects that contribute to the object's cultural message.

There are many ways you can get students involved. You can ask students to draw pictures of some things made by people that they most value or that they think are most beautiful. Then ask them to answer such questions as:

Why are they important to you?

Does the way it looks affect the way it is important?

What is it about the way it looks that shows it is important, or valuable, or beautiful?

Does the material it is made of help you see its value?

What does its design say about it?

How did you learn it was beautiful? Did someone else tell you? Or does the thing itself contain a message? What is the message?

Clocks are an excellent example of objects to study because time is so central to many different people that clocks come in all kinds of designs and sizes. Clocks range in degrees and kinds of ornamentation from kitchen clocks to London's Big Ben, from

Mickey Mouse wristwatches to some of the most ornately jewelled bracelets. Each clock or watch tells us something about the values of the person who uses it. Clocks are different even in the same house. Though they all have the same use—to tell us what time of day it is—they can have a different social function. A well-oiled, preserved old clock with ornately carved wood usually belongs to someone who cares about old things, likes their sound, and likes the look and feel of the wood. Living room clocks usually do not look like most kitchen clocks. You can start an inquiry with this idea:

Why are clocks in living rooms different from alarm clocks, school clocks, or kitchen clocks?

Why don't nurses wear fancy little watches?

There are use functions of watches, but there are also cultural ones. We read people's roles by the watches they wear. Women with big, efficient watches do different things than women with small, ornate watches. When women change their watches, it often means they are changing what they are going to do. We also understand what is acceptable behavior in going into a room by the kinds of clocks people have put there. We particularly learn how they expect us to respond to time in that place—from the slow, solid tick of a Grandfather clock which symbolizes a long, steady period of time, to the quick click of a wind-up alarm. The advent of electric clocks with their low hum eliminated some of the communication of clocks. But clocks are still designed to show that they are to be used in different kinds of places. The design of clocks changes over time, but many old styles have been revived as cultural qualities and values in the past are given new emphasis.

As students study more and more things, they will become increasingly aware of how much cultural meaning is communicated to them through art forms. As with any other object, you will want to get your students to relate the design of the thing to its cultural meaning, its social use and meaning, as well as to its physical function.

Level 3
Studying the Meaning
of Placement and Arrangement

More advanced students can study how the placing of things communicates cultural meaning. They can look for the values and attitudes expressed by the people who selected and arranged the objects. Children's playgrounds are a good example of places where things are designed and arranged according to values:

How does the design of equipment tell how children can play?

Does the equipment encourage them to play imaginatively or routinely?

What kinds and how many choices are provided?

Are adults and children's activities separated?

What does this say about the culture?

Is the play equipment attractive, are the colors playful or drab?

What does the design of the equipment say about cultural attitudes toward play?

What does it say about how adults feel about children?

Places people gather can be studied to see how the things in the place communicate whether people are welcome to come and stay awhile or only walk through. One way to do this is to involve your students in designing a place where they can meet and talk in large and small groups:

What do people meeting and talking need in their environment?

How could you make it look like they were welcome to do so?

How could you let people know that privacy was valuable, so small groups or couples could talk without being disturbed?

What kinds of people would be welcome?

If all ages are to be included, what do different age groups need for shelter, space?

How could you design it so people would feel welcome?

After designing such a place and making it, if possible, they will be in a position to evaluate other public places. They can photograph different places and analyze what is valued. Some public places are actually designed to keep people from gathering—or what is negatively called loitering.

Some places exclude people in wheelchairs and also children: there is nothing that fits the way they get around or their size. A place that has ways for many kinds of people to get around, sit, and rest, singly and in groups, has all kinds of signs in the design of furniture and in the shape of divided and open spaces so there are many kinds of choices for people to make.

The ways trees and shrubs are planted tell whether a park is a place to play or whether it is a formal garden. If plants are trimmed and controlled, it indicates people value order over the design of nature. Formal English gardens show a distinct difference in attitudes toward nature compared to Japanese gardens. The British tradition of controlling nature, trimming plants into balanced, symmetrical forms, is related to a long tradition of believing that nature was important to be preserved but controlled. The Japanese tradition of living in balance with nature, using the asymmetry of natural forms in garden design with arrangements made as much like nature as possible, is based on their high value of nature as it is rather than how humans may control it. The

feeling, mood, and meaning of both types of gardens are not the same. In one the emphasis is on human skill and gives people a feeling of power, in the other people are invited into tranquility with nature.

Room interiors are composites of people's values about how to live. This is a delicate subject to handle as it is so related to economic factors. One way is to select magazine article pictures of interiors and analyze the values expressed. Advertising of all kinds of products surround the object with all kinds of symbols that are selected to communicate what it will be like to use this product. Students can write descriptions of what they think the values are that are being appealed to to make people buy things. For example, linoleum and carpet advertisements fill rooms with all kinds of objects—lamps, tables, trophies, art objects— that tell what kinds of people would like such floor coverings. They sell self-images that people can buy along with their rugs.

Shampoo and cosmetics ads show environments that appeal to people's desire for opulence. Beautiful young women are made up so that women who are not so young or beautiful will want to look like them in those kinds of settings.

Often sex roles that the advertiser feels will appeal to buyers of particular kinds of objects are stressed. Women cooking or serving sell foods, young and beautiful women sell cars. In science magazines young and beautiful women who wear white coats and glasses are shown in rooms full of computers and testing equipment. Handsome, robust men are used to sell soaps and cleaners in already spotless kitchens and houses. This use of art to express values will appeal to people who have these values —almost without their realizing it. Helping students become aware of this helps them see how they can be influenced unknowingly.

Level 4
Designing Meaning
Through Organization
and Placement

Advanced students can study the designed objects in relation to their own cultural values and beliefs and make plans to modify and redesign their environment so it fits their values. If such students have developed skills in drawing and seeing, have an understanding of the ordering systems of design, and have an awareness of their own cultural values, they will need little help from teachers except to try out their ideas, to get feedback about their progress. This is particularly true when their values are being redefined or when the cultural context in which they are working is changing rapidly.

They may need more help when they try to design things for people with values and cultural life style patterns different from their own. When they are designing for spaces they share with people of quite different cultures, they will have to assess the values they share with others.

For example, if an art room in a community-oriented school is going to be used by rock-polishing students during the days and a collecting hobby group in the evenings, each group's storage needs, work space needs, and effect on table tops and display space would need to be designed for. But the values of the two groups would need to be assessed even more. If some students were working on long-range, large projects, with all kinds of materials, and the rock collectors were very neat, disciplined, and conservative, the environment created by one group could create conflict with the other. The rock people might "clean up" what they considered to be a "mess" which was some student's highly innovative development.

An easy solution would be for the rock people to change to rooms where the cultural

Figure 5.22 *Personalized small group space in Branford Intermediate School, Branford, Connecticut. Carlin, Pozzi & Associates, Michael S. Shellenbarger, Project Architect. (Photo courtesy M. Shellenbarger.)*

values were more alike. But if the art students were at Level 4, they might tackle this problem and see what questions they could raise and then solve.

THE ART OF COSTUME AND CULTURAL ROLES

Level 1
Dressing Up and Playing Roles

Pretending to be something other than what you are is a beginning to understanding the culture of other people. Children who "dress up" in older people's clothes are learning to be adults. They use things that symbolize certain roles as well as make themselves feel big. Imaginative and observant children can take on body movements, stances, and copy speech patterns of the adults they mimic. But the play acting becomes much more real to them if they have art forms to help create the illusion.

At this level a teacher can begin by helping children recognize the diversity of roles of people in their own culture. A big box of things collected from various agencies and second-hand clothing stores can provide a range of badges, headgear, clothes, and tools used by different kinds of people. Children can select things to try on and react to each other in terms of the clothes or badges they wear, or the objects they carry. After a play activity you can hold up each object and ask the children to identify what it was about the object that told them how to act as they did:

What was there about the (_____) that let you know how to act?

Was it the way it looks?

The material it is made of?

The designs on it?

How did wearing it make you feel?

What would happen if everyone dressed alike?

Figure 5.23 *American Indian students redesigning their environment to fit what they value.* (Photo courtesy of Leona Zastrow.)

You will want to be sure the range of things are from the background experience of many of your students so they will have had prior learning experience. What you are doing is extending their prior learning. They

have learned what a police officer's badge is. But they have not learned that the shape, color, and materials communicate a whole range of ideas about what police officers do. They will become more aware of how much they are "reading" in their environment as they analyze several objects.

After some experience with symbols in their own environment, the beginning students can read about, see films, and hear stories about other groups of people and then create objects of papier-mâché, paper sculpture, and/or cloth that they could use to help them play roles of people in the culture about which they are learning. Again, you can help students analyze the things they have made to see how the art qualities helped make the ideas and role playing more real.

Level 2
Comparing Apparel Cross Culturally

Costume can be studied cross culturally. Begin at this level with some item that is easy to analyze, such as hats and headgear. You may limit this study to two clearly identifiable cultures; but later get your students to look for many kinds of headgear they can find in this society and in others. In either case, in order to make comparisons, they will want to find answers to such questions as:

What uses does the headgear have?

What does it tell us about who the wearer is?

How do you think it makes the wearer feel?

What does it tell us about where the person is going?

What kinds of things will the person do?

What does its design tell us about the status of the person?

What influence will it have on how others behave?

How much space will someone wearing the hat require?

If your class is flexible enough, you can encourage their trying on different hats and improvising what the hat makes them feel like doing. This will help them see how much effect these visual arts symbols have on them.

Masks can be studied in the same way as hats. Facial painting, false eyelashes, beards, and lipstick are kinds of masks as well as those carved in wood. They can be included to show how mask wearing operates in our society.

Masks, like hats, can change our image—what we communicate to others about who and what we are, do, and how valued our status is in the society. Students can analyze the art qualities of masks to see how the design works—the ways colors, lines, textures, forms are used to create qualities that make people react differently to a person with a mask than they would to someone without the mask:

Does the design show how important the mask wearer is?

What kinds of feelings do we get when we see someone wearing it?

How does the design create this feeling?

What part of the design is the strongest: the shape, form, or the colors?

Does a person become something else when he or she wears a mask?

After they have collected hats or masks from two or more cultures and analyzed each one, they can begin to see some things about the different groups' cultures—what roles people have, what kinds of forms and designs they like, what people do. They can look for things that are similar and different between the cultures by the kinds of headgear used.

At this level, students can begin to make comparisons of craft items from different societies, such as handweaving, ceramics,

fabric coloring such as tie-dyeing and batik, printing, and painting. They can compare the social uses the objects have, the ways forms relate to the physical use, the selections of media, the techniques, and who is encouraged to make different crafts, men, women, young or old:

What kinds of ceremonies are the objects used for?

How does the form, design, selection of media influence the way the object is used and valued?

What are the differences in the crafts between cultures?

How can we identify which crafts in another culture serve those people better?

What values in our society affect how we use crafts?

What is the difference between machine-made and hand-made crafts?

Level 3
Studying Values and Roles
in Costume Design

The study of costume in various cultures can be as extensive as your students are ready to make it. Not only varieties in a culture's patterns and life styles arise, but many diverse and interesting kinds of design and use of media can be explored as well. Students can individually or in groups make in-depth studies of the values, status, and roles of people in a given culture to see how their values are expressed in design. They can experiment with weaving, stitchery, printing of fabrics, tooling and carving of leathers, dress design. Drawings of the different types can be made to help analyze likenesses and differences between them. Encyclopedias, histories of costume design, social histories, and ethnographies can be used to identify types of costumes.

Students can study travel, authentic fictional, historical, anthropological, and documentary films of cross sections of people. Different members of the class can watch for different types of costume that illustrate specific roles and values, as well as for the spatial distances between people wearing different costumes. Students can make studies of people at different kinds of functions in metropolitan areas, county fairs, festivals, weddings, on holidays, to identify and study costuming in different aspects of our society.

After the different reports are readied, comparisons between present culture or cultures changing can be made:

How are sex roles defined through dress?

How does each culture group identify through costumes of religious, political, or social leaders?

How does the design communicate the role?

How can costumes be described—humorous, dignified, powerful, submissive, designed, disordered, ornate, simple, colorful, drab, vulgar, refined, meticulous, careless, formal, casual?

When all the different costumes of a cultural group are analyzed students can ask:

Which kinds of costumes are prevalent in each culture?

What cultures have many diverse roles and statuses and which ones few?

How does the nature of costuming within a cultural group help describe through visual design the nature of the culture?

After students have developed some awareness of the art of costume to communicate cultural values, they can analyze how costume is related to cultural values in their own society:

How many different cultures are there in the United States that can be identified through the clothes people wear?

What military, judicial, medical, religious, law-enforcement costumes are prevalent in the United States?

What historical traditions are preserved through these costumes?

What regional differences?

Would you expect a county sheriff in New Mexico to be dressed the same as one in Massachusetts?

Are different traditions influencing this difference in what it means to be a county sheriff?

For historical changes, students can go to libraries; for regional differences, film and print media.

Our society also uses costume to identify subtle differences in political persuasion and sex roles. Social identification such as "refined middle-class matrons," "the backbone of America" blue- and white-collar workers, "sophisticated urbanite," "upperclass casual elegance," "executive," and "counterculture" are all examples. Such differences are found regardless of skin color or regional area.

Teachers will have to handle this subject carefully and differently depending upon their classes. Although the ideal of a classless society is valued in this country, people do cluster themselves into "identifiable" groups and people enhance their self-image through dress to identify with the group to which they belong or aspire. By starting with questions about dress in their neighborhood, how people there tell others who and what they are through dress design, you may avoid some conflicts for individuals. The objective is to help students see how much social information they are getting from their environment through costume design. Some of them may become more consciously aware of what they may be saying about themselves. Teachers should not question a child's or adolescent's taste or background culture, but their role is to help students become more aware of

their culture and its art and see if their values and what they are expressing fit.

Level 4
Studying Taste, Images, and Values in Dress

The advanced study of status and role as expressed through art can include studying variations within cultures as well as differences and likenesses between them. For example, students could be interested in finding out what influences a given group's tastes in clothes and how much alike and how much different people are in responding to these influences. First, they should identify who the tastemakers are—who people look to to set trends. Then they should identify what it is about such people that is valued by other people.

Then they should see what trends are influencing their own high school or neighborhood in costume design. This activity could lead to more independence from outside trends because under more careful scrutiny they may become more aware of how their own values are different from those expressed when they are superficially carried along by fads.

As they study the variations and similarities in other cultures, they will probably find out that much more freedom is tolerated in some societies than others, and that some people are more influenced by outside forces than others. They will recognize that as new roles or changed roles appear during culture change, new designs and new communications are needed to express what people are and do.

Finally, such study will help students see that in such social communication as costume design, we can have enough similarities so that we can "read" what others are, yet have enough variety so that people can express their individuality.

UNDERSTANDING CULTURAL INFLUENCES ON ART

Drawing and painting, sculpture, and murals can usually be identified by period and culture. Some of their elements, such as the concepts of space, the kinds of realism portrayed, the range of kinds of symbols used, give us clues. A key objective of the study of cultural likenesses and differences is to help students achieve more openness and understanding of art different from that of their own culture. It is probably as difficult for young people whose families prefer landscape realism to understand the work of a subjective expressionist as it would be for them to understand the work of an artist from another part of the world with a very different cultural background.

Levels 1 and 2 Comparing Art from Different Cultures

Smaller children and beginning students can look at art to see what it says to them in terms of how it makes them feel, what it tells them about some event, situation, or place, and whether the work is mainly about feelings, dreams, imagined things, or about things they can see in their everyday world. They can analyze the ways colors, shapes, forms, textures, and space are used to communicate ideas and feelings.

By comparing clearly different examples of similar kinds of objects—Mexican, African, European, and American, or Oriental art, or two periods in history of the same people's art—Level 1 and 2 students can see some differences between them as well as see some likenesses. You will have to select examples of prints or slides that are all painting or sculpture or fabric design so they will not be confounded by the differences in art form.

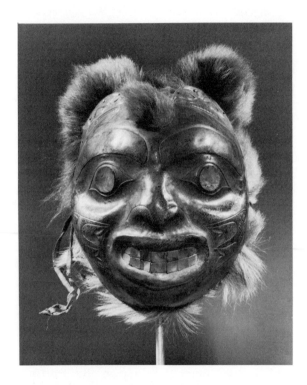

Figure 5.24 Mask: Sea Bear. *British Columbia or Alaska, Haida or Tlingit. Copper, fur, shell.* (The Museum of Primitive Art, New York.)

Using two examples at a time from different cultures, ask students to identify how the works are alike and different in feelings, in kinds of symbols used, in colors, in kinds of shapes used. Then you can ask them what they think the people who made them were like. Ask them what they think the people in

Some students will say categorically that one is an animal, one is a woman. Some will say one is a drawing of a mask, the other is a picture of a mask. Some will think one is scary, the other not. If you ask how the lines make them feel about each object, they can see how different the impact of the works are. You can make lists of feelings different students have about each mask and then compare the lists. With young children, you can ask what kinds of stories the lines tell. They may want to draw lines that tell the story of the Haida mask or the Klee mask. Ask them whether they think the people where these objects came from were alike or different and how different.

Then you can switch to ways the two objects are alike. When you ask about likenesses, you will probably get responses such as: they both use lines to tell their story; they both have hair around the face; both are strange, that is, different from our common ideas of bears or women.

To focus on the design, ask questions about how the two sides of the masks are alike and different:

What parts of the lines, shapes, textures are the same?

What are different?

How did the artist make variety and order in each mask?

Finally, ask if the feelings they get from looking at the masks are similar. After students have made such comparisons they will have many more avenues open to responding to the art. You may be able to relate what they are learning in social studies about Indians, for example. If your students are studying a specific group of people, look for examples of that group's art to compare with art they are familiar with.

Remember that an abstract painting by a contemporary American artist may be as

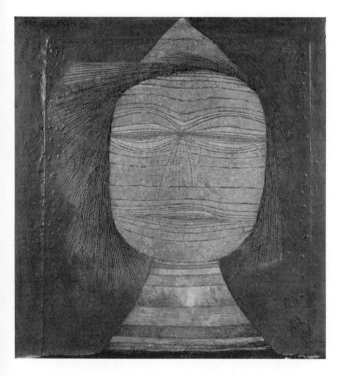

Figure 5.25 *Paul Klee. Actor's Mask, 1924. Oil on canvas mounted on board.* (Museum of Modern Art, New York. The Sidney and Harriet Janis Collection.)

the society (or country) thought was important to express. For example, a photograph of a Haida Indian sea bear mask made of copper with shell inlays, fur, and rawhide has similarities to a photograph of Paul Klee's drawing of an actor's mask (see Figures 5.24 and 5.25).

culturally foreign to an American child of any racial or socioeconomic background who has not been exposed to such art as would be an African fetish or a Northwest Coast mask.

Level 3
Studying the Values and Beliefs of Artists

Students at this level should be able to move on to a higher level inquiry. They can study reports on a culture, the recorded history and contemporary culture of a place, and look at the way art developed in that society. The level of complexity of the study will depend on aptitude for study and observation of the students. It can be quite simple with most of the research done by you. You can start with one culture and its art, selecting periods to show transitions.

For more curious students, you can have them research and compare two cultures. There is very little material for this kind of activity. This relationship between culture and art has been largely neglected by both art historians and anthropologists. But to understand art, we must understand the values and beliefs of the people who create it.

After students have developed skills in recognizing cultural effects on art in societies, they can begin to study the differences in the art of the different cultures within their own society. There are many approaches. One is to select two currently active art styles, such as op and pop. Both have reached peaks of popularity so they are well defined, but people are still working in them. Students can select the writing by or about artists from those styles and analyze these materials for expressions of values and beliefs. An artist interested in pop art values the outside stream of events of everyday life.

The need to show society to itself is important. An artist who values op art, art that plays on the workings of the eye-brain response to things, tends to value how things work, and likes precise, detailed, controlled art. Rarely does a pop artist do op art or vice versa. Their values are different, and they have probably had different cultural experiences in growing up.

Your students who study artists within a given style can compare and synthesize their findings about the art and culture of that style with the art and culture of artists of another style. In this way the underlying meaning of the art style will be brought out.

If your students are involved with people of the popular or mass culture art, that is, if they like art that is literal, quickly seen, easily understood, they may have difficulty understanding the art of the more reflective, subjective, and personal nature that has been so extensively developed in so many different ways since the beginning of this century. By first getting them to look at remote cultures and their art and seeing how values and beliefs relate to art in those cultures, they may be more open to looking at the more subjective arts. Hopefully they will achieve more insight into the art and culture of both groups.

Conversely, students who are sensitive to and well versed about many forms of modern art may write off as trite and unimportant the work of so-called Sunday painters. But if they see how art functions in the lives and culture of many people, they may become much more understanding of it in context. Sunday painters report that their art makes beauty in their lives. It helps them make personal records of places they have seen or been that were important to them. It makes them feel that they are doing important things, that they are artists, and this makes them feel worthwhile (Jones, 1975).

Level 4
Studying Diversity in Art
Within Cultural Groups

This level of student can work to understand diversity within culture groups and diversity in art among artists who share similar values. While variations in cultures should be made clear to students at earlier levels, too much concerted study of diversity would probably be confusing before they reach this level of understanding of how culture and art are related.

One way to begin such study is with questions students are interested in, such as "Is there a recognizable style among black artists?" "When is Navaho silversmithing 'authentic'?" "What are the differences between men and women artists' work?" Questions such as these, if pursued with an open mind, usually result in all kinds of diverse answers. There are all kinds of black artists more or less affected by ethnic traditions and more or less in the mainstream of American art. Navaho silversmiths have varying traditions in various villages, are influenced by the market demands for their goods, and have learned their art from traditional jewelers. What might have been seen as differences in male and female art is changing as the traditional roles and attitudes are changing. But if students find these answers out by exploring art, they will also learn and become sensitive to the myriad forms of diversity in creative art.

Also, at this level, students can review and analyze from their more sophisticated perspectives the work they have studied previously and see the tremendous orchestration of world art. Then they will be able to see the relationships between culture and art.

STUDENTS' DIFFERENT CULTURAL BACKGROUNDS

Within a complex nation there are many cultures. Usually they agree on some aspects of their culture—enough so that they get along within a single system of government. But at the same time they have wide differences in values, attitudes, beliefs, and child rearing.

You may have a class of students who look quite similar, but after careful observation, you may find they are culturally quite different. Often we assume differences because of obvious things such as skin color. But this too can be very misleading. A teacher may have a student of Mexican, Chinese, Japanese, Scandinavian, black, English, and Italian ethnic backgrounds. It is possible that these students could have been reared in the same religion and be from the same socioeconomic class, the same region of the country, and be culturally quite alike, that is, have very similar values, beliefs, and lifestyle aspirations.

Conversely, a teacher may have a class from one ethnic background and assume they were all quite culturally the same and also be quite wrong. A black child raised in a rural low-economic community will be very different from a black child in a poor urban neighborhood. Both these children or young people will be different from a middle-class black child from either a rural or urban area. They will all be different from an upper-class black child used to affluence and extensive travel and opportunities to learn.

A Mexican-American youth who immigrated to Arizona will have difficulty understanding his or her cousins who immigrated from the same Mexican village to Texas or California. They will have some deep-rooted similarities, but the ways they have had to cope with the different dominant white cultures of those three states will have made them different culturally.

In this section we will look at some cultures in American society to see the differences among them. But we will also caution you to recognize that any one person may or may not be typical of his or her group and that physical, racial characteristics may be most misleading in identifying culture.

SOCIAL CLASS AND CULTURE

There is widespread belief that the United States is classless, yet sociological findings show that social stratifications persist. Economic and occupational success or failure combined with the degree of racial and sexual acceptance into upper occupations sets people into social groups. The higher socioeconomic groups have more independence, power, and sense of belonging to the society than the lower socioeconomic groups, who are often dependent, submissive, powerless and separated from power.

Milton Gordon's concept of *ethclass* continues to be useful. He shows that people of different ethnic backgrounds should be recognized in terms of their socioeconomic standings because they share common

life styles with members of their class—black, white, or yellow (Gordon, 1964). Being poor cuts the range of opportunities, being middle class increases them. All poor people are hardly alike culturally, although the experience of poverty makes them all share similar problems and affects their life styles in similar ways.

Following are a few descriptions of different segments of American society and the cultural life styles people who live in them tend to share. Many more could have been included. They illustrate the diversity in what appears to be similar groups of people.

Urban Working-Class Culture

The urban working class are people who work in typically blue-collar jobs in large urban centers. They make up a large segment of American society, but have had little study as a class or culture. The following information about them comes from an in-depth study of a white working-class neighborhood in Boston (Fried, 1973, pp. 62–95). The people develop close ties in their community and have a sense of neighborhood that is much stronger than the outside appearance of their homes would imply. They identify with the territory and the people in it. They value friendliness and participation in the cultural group. Their interdependence gives them social stability. Family ties are strong but also extend to the neighborhood. There is a tendency to seek simple answers to prob-

lems because they have had fewer opportunities to see and understand complex issues. Their dependence on their group and their lack of exposure to other alternatives may be why they are considered conforming.

People live in close proximity in similar housing units, whether new or old, and usually rent rather than own property. Housing usually fills all the property, so alleys, streets, and sidewalks are the only outside leisure spaces. Streets are narrow, and children, young people, and adults compete for the space with parked and moving cars. Stores and shops are intermixed with housing. The dominant feature of the environment is the number of people.

Apartments have natural light coming in from only the front and back, so they are quite dark. Although the basic housing units are poor, many people improve their life style by cleaning and painting their apartments. However, some apartments are in cluttered, unkempt condition. Generally, they are overcrowded and have inadequate heating. The study reported that the exterior uniformity is not found in the building interiors. Apartments generally are well kept but there is more variety among them than the monotonous outside would suggest. The visual contrast between interiors and exteriors is very strong. Many inside walls are washed and painted at least once a year, floors are scrubbed regularly, furniture is repaired. What the tenants can control is in excellent condition; while the parts of the building they cannot, are not. Halls, en-

trances, and the outsides of buildings are uniformly poorly kept. Descriptions of interiors range from decorated to drab, but most apartments are described as "reasonably livable" with much effort shown in making inadequate housing satisfactory. Kitchens are clean, and living areas "sturdy" but "drab-looking." Some have handwork and decorations.

If your students come from such an area, you cannot assume all their experiences of living in these apartments are similar. Some students come from places where neatness is valued, others do not know what neatness means. In an art class, some will have developed organizational skills and others not. For many, cleanliness and order is the main art form. These values are their basis for comparing their cultural values with another. You have to find out what kinds of pictures and religious symbols are used by the people to give them a sense of identity. You can help them look at religious symbols as art forms as well as sacred images. Studies often do not describe the material culture, but the descriptions of other conditions will give you some understanding of the life style involved.

The following case studies do provide some visual descriptions of environments. They were made in a similar socioeconomic neighborhood though the background was Appalachian rather than European and the city was Washington, D.C. (Howell, 1973).

A husband and wife team lived in this blue-collar neighborhood for a year studying the life styles of what they called "hard living" and "settled living" families in the same white working-class community. In reading Howell's reports, one is impressed with how the values, the life style, and the physical environment interact. In the "hard living" families, heavy drinking was a dominant condition of living, marriages were unstable, behavior was often rough and sometimes violent. They moved frequently and appeared rootless. They lived in the present with little concern for the future, and the males of the family were loners with no desire to be part of any community groups and were apolitical (Howell, 1973, pp. 263–264). By contrast, the settled families rarely drank, if at all, had stable marriage relationships, were moderate in language and behavior, often owned their homes and had lived there a long time, saved for the future, were concerned about the future and their community, and considered themselves politically conservative. The street is in an older, but not run down, suburb of Washington, D.C. Housing consists of brick garden apartments, two-story frame houses with asbestos siding built in the 1920s and 1930s, in need of some repair and paint. There are front porches and small patches of grass. Houses are separated by driveways and fences. There are many dogs and beware-of-dog signs. Some houses are in very run down condition and have junk in the front. Cars needing repair are jacked up on cinder blocks along the street. In spring and summer, people sit on porches; trees shade the street.

Two descriptions of interiors show how the life styles and environments interact. First a description of a "hard living" family housewife:

Bobbi Jean tries to do a little cleaning up in the kitchen. For Bobbi Jean, house cleaning is a monumental task. Seven people packed into three rooms means there is not enough room to put things. The children never seem to pick up their toys or their clothes; and Barry insists on leaving his paint cans, battery recharger, fishing gear, and tools strewn about. Bobbi Jean says she could pick up after all of them, but she doesn't have the energy, and besides, there is no place to put things as it is.

Bobbi Jean looks over the three rooms. As for their belongings, they don't have a great deal: a kitchen table and three chairs, two double beds (one in each of the other rooms), a roll-away, one old easy

chair with the stuffing coming out, three chests of drawers, and two end tables. Three old TV sets are stacked in one corner, with only the top one barely working. The walls are bare except for two mirrors and a beat-up photograph of a basset hound which looks just like Barry's dog. In one corner are several old cardboard boxes that contain the children's clothes and toys. In another corner are Barry's most prized possessions: three shotguns and a .22 rifle. Bobbi Jean looks around at toys, clothes, and Barry's junk on the floor. "It's just not worth it," she sighs as she scrapes the remains of Walt's food into the open garbage can in the kitchen. "I ain't going to try to clean this shit up today" (Howell, 1973, pp. 17–18).

Description of a thirty-eight-year-old construction worker from a "settled" family:

Well, my wife gets home about five-thirty and I get home about six. And let me tell you, that house is always clean. There's nothing we have to do. And then we have a big family dinner. A family dinner. All of us eat together every evening. And after dinner I work on the house, play with the kids; sometimes we play horseshoes.

On weekends I usually work on the house. See, the house that we bought five years ago wasn't in all that good a shape, so I've been working on it, bit by bit. I've redone the basement, the living room, and the bedrooms. I've practically done everything. You should see the living room. I've got a brick wall, fireplace here, a speaker here and a speaker here, artificial flowers here. And I've got a swirling ceiling and I've got parquet floors. And all these materials I use, I haven't paid a cent for them. I get them from my job, see, like the parquet floors. And so we got the floors and we got the wall material, and I've expanded the living room, and I've worked on the basement. And it's taken pretty much of five years, working most of the time, to get the house into the shape it's in now. My wife helps me and the kids help me and we try to do things as a family as much as we can . . . (Howell, 1973, pp. 259–260).*

* Excerpts from *Hard Living on Clay Street*, copyright 1972, 1973 by Joseph T. Howell, reprinted by permission of Doubleday & Company, Inc.

The stability and instability of families is not limited to blue-collar or working-class families. It is found in very poor, middle-, upper-middle, and upper-class families as well. It is usually less public when there is more money to cover up the disorganization. One of the authors has observed similar differences between families on an American Indian reservation among the poorest people who lacked a water supply and sanitation. In one home a mother and grandmother cared for several teenage and younger children from the larger family. They lived in a three room, unpainted wooden house probably built around 1910. The lean-to entrance built to protect the only door from bitter winter winds also housed a neat rack of water buckets to carry water from a well three blocks away. The living room and kitchen walls were full of family momentos, newspaper clippings, pictures, religious symbols, and pictures from magazines. Window sills had Christmas-foil-wrapped coffee cans filled with geranium plants. A small table was used for beadwork. Furniture was simple and wooden—a dining table and straight chairs, a cooking stove, and storage shelves for dishes and pots. Everything was clean and in ordered arrangements. Clothes hung on nails on some walls.

The two small bedrooms were filled with patchwork-quilt-covered beds. The house was full of people wearing clean, repaired clothing.

Another house a few blocks away had no protecting entrance; the front door opened on the unpaved street. From the street one could see a small wood table with a weak leg, one broken wooden chair, an iron bed, no curtains. Clothes and pots hung on the wall, and there were no decorations, mementos, or pictures. One got the impression that the poverty was so great there wasn't even much to throw away or clutter. An alcoholic husband and wife and assorted chil-

dren lived there. Both these families lived in the same neighborhood, belonged to the same tribe, had similar opportunities, but one was "hard living" and the other "stable." This difference strongly affected how they responded to their culture and how they transmitted culture to their children. The family with the husband and wife was the least stable, the one with women as heads of the household was the most stable.

The comparison of these two families and the effect of their environment on them raises a complex question: How much can environments change people's behavior? To answer this question we must ask more questions: What kinds of environments would change people's behavior? How? People whose lives are highly disorganized would probably make any environment into which they moved more disorganized. People who have set patterns could probably move into environments that fit their pattern generally even though the design and materials were different.

People with highly developed design sensitivity and awareness of their own life style would have to modify most of the environments into which they moved. In each case the interaction of values, life style, and ability to change elements and environment are made to fit the new environment.

Mexican-American Traditions and Change

Another group of people who have been subjected to considerable stereotyping are the Mexican-Americans. Recent comprehensive studies show that they are a widely diverse group of people, even though as a whole they earn less money than average, tend to live in crowded conditions, and maintain their native tongue more than other minority groups (Grebler, Moore, Guzman,

1970, pp. 350–379). Isolated rural and older Mexican-Americans tend to be more traditional than urban people. Those living in Texas tend to be more traditional than those living in California. The traditional values are: *familism,* an attachment to one's family, a given place, and things. The family is more important than the individuals, so individuals are less apt to accept new ideas. They tend to interact with themselves more than others for protection of the group. *Machismo,* the sexual superiority of males who dominate the family decision making and the activity of females, which is restricted to homemaking. *Disciplina,* the importance of discipline in bringing up children. Girls are taught not to be competitive or excellent in school, both sexes are taught to be decorous and to stay within their expected roles, which does not prepare them for roles in the competitive dominant culture.

But more Mexican-American families are now professional people, middle-class Americans in their values and life styles, have more education, and many are less tied to family and locality. Women's roles are changing but probably not as much as in other parts of American society. Males are not as dominant in families, but the value on discipline of children continues.

The high value on being Mexican-American and the new freedom of minority groups to be self-assertive may lead to resurgences of art forms that identify being of Mexican descent. When asked what of the Mexican way of life was most important to keep, over half the Mexican-Americans from Los Angeles and 32 percent from San Antonio thought keeping the language was most important. Thirty-three and thirty-eight percent, respectively, thought customs and manners were the second most important, but only a small percent thought keeping food, music, and art important (Grebler, Moore, Guzman, 1970, p. 384). But customs

and manners do affect living styles and en-
vironments, which neither the Mexican-
Americans nor the poll takers thought of as
art.

If your students are Mexican-Americans,
you will have to find out what their values
are and what their life styles are like. You
will have to visit neighborhoods, get de-
scriptions of art in homes, get children and
other students to feel free to compare their
culture's art with others. Some middle-class
Mexican-American children may have little
tradition in their family life. Others may try
to reject their background and may resent
being identified with it.

The Diversity of Black People

Perhaps the most overly stereotyped people
in American society are black Americans.
They are included in all levels of the socio-
economic society. They have taken the lead-
ership in the civil rights movement and
have made more progress for more black
people than ever before. More blacks are
college graduates, in the professions, in the
arts, in government, in business, in adminis-
tration than ever before. Many are upper- and
lower-middle-class people; some are wealthy
upper-class people. Working-class blacks,
like whites, have "settled" families and
"hard living" families.

During the recession and the post-
Vietnam economic adjustment, the unem-
ployment rates among blacks has been higher
than among any other group. This has led
to a greater disparity between middle- and
low-income blacks than ever. As the prob-
lems of central cities accelerate, the services
for the unemployed decrease. This increases
crowding, with more people living in even
poorer conditions. This range among black
students' backgrounds must be recognized
by teachers.

CHANGING FAMILIES
AND LIFE STYLES

Families are changing in all aspects of so-
ciety as sex roles change. There are more
women heads of families than ever before,
more of them are black, and more are poor.
At all economic levels, there are women
heads of households on relief or working
who maintain a stable environment for them-
selves and their children. Others do not. In
stable families, more effort is made to create
and maintain a home environment that re-
flects the values and culture of the family. In
"hard living" families, the environment does
express the values, but it is not consciously
made to be what it is but is an effect of the
life style.

MIDDLE-CLASS
WHITE SOCIETY

Unfortunately, much of the study of sub-
groups in American society has focused on
ethnic groups or people with low incomes.
Little study has been made of white middle
and upper classes. Since these people are
affluent, we can determine their tastes and
values from their buying habits. Magazines
show upper- and middle-class white values
through articles and advertising. Women's
magazines and decorating and gardening
magazines appeal to somewhat different
groups. The costs of advertised items tell us
something of the markets to which the ads
are appealing. Knowing the magazines to
which families subscribe gives you some
idea of the aspired to life styles in your stu-
dents' homes. For example, *Good House-
keeping* and *Better Homes and Gardens* gen-
erally appeal to middle-income families,
House Beautiful and *Sunset Magazine* to the
more affluent upper middle class. *Vogue* and
Women's Wear Daily appeal to upper-middle-

Liberal	Conservative	Counterculture
The universe is ordered, patterned, and knowable.	*The universe* is incomprehensible, mysterious and unpredictable.	*The universe* is.
Pursuit of intellect and knowledge is highly valued.	*Pursuit of intellect and knowledge* is lowly valued and held in suspicion.	*Pursuit of intellect and knowledge* is of questionable value as one finds one's self in one's own experience.
People are capable of improving the world and discovering truth.	*People* are powerless, the subject of fate, luck, chance, and originally evil.	*People* have all the resources needed within themselves for being.
People should take responsibility for others, strive for a better future for society.	*People should* enjoy within one's own family and kin what is available now.	*People should* experience the world and nature directly.
People are equal racially and sexually, peaceful.	*People* are unequal, males dominant and aggressive.	*People* are more important than things.
The society should be changed for the better.	*The society should* be maintained, and the past romanticized.	*The society should* be saved from the scientific-industrial forces that separate people from their experience.
The most important time is the immediate foreseeable future—this life.	*The most important time* is the present and the next life.	*The most important time* is the present—what we have.
Probable attitudes toward art are creative, explainable, socially useful.	*Probable attitudes toward art* are familiar, unthreatening, decorative.	*Probable attitudes toward art* are immediate, individually expressive, creative.

Figure 5.26

class women, in terms of dress and life style. *Ebony* magazine appeals to middle- and upper-class blacks. By analyzing the values described in these popular publications, you can get some ideas of what is important in life styles, and you can keep up in some degree with changes in cultures.

Middle-class people do not hold similar views, assumptions, or values. They are divided about the nature of reality, of humanity, and society. Figure 5.26 is derived from one of the rare studies of middle-class people. It shows the values upheld by the institutions that trained more-productive and less-productive scientists in 1960 (Hardy, 1974) and a review of values held by people who reject the dominant culture (Roszak, 1969).

People who are highly productive in the sciences and academics are among those people who hold to the values in column 1 in Figure 5.26. The values in column 3 are held by those people influenced by the counterculture. The values in column 2 appear to be held most often by people with fundamentalist convictions. Most people are somewhere in between this triad of values, espousing values in more than one column, or not extreme on any of them.

The values people have influence the ways they will view art. People in column 1 probably want art to be creative, and to have useful social functions; those in column 2 want art to be unthreatening and familiar; and those in column 3 want art to reveal what is happening now, an immediate expression of present being.

As a teacher, you will have to be aware of your own basic assumptions in order to be aware of how yours may differ from your students. The above statements are extremely simplified, but they point to basic cultural differences you may find in a middle-class school.

Although there are clearly different subgroups in American society, culture and life style depends upon the culture one learns as a child, economics, social opportunity to learn, acceptance by race and sex, family stability, and the degree of culture change accepted. As sex roles change and new patterns emerge, extensive cultural life-style patterns may change at all socioeconomic levels. As society becomes more or less liberal or conservative, old values will be revived or new ones developed. Art forms are carriers of all these changes and express all these values. For these reasons it is important that students have many and continuous opportunities to see how art functions in their lives, as a means of understanding their own culture, and that of others.

THEORY AND
RESEARCH

RATIONALE

The purpose of Part Six is to provide you with the foundation upon which the preceding parts of this book were built. It draws upon research in psychology, anthropology, and sociology as a basis for understanding students' unique development in seeing, thinking, creating, and designing. It provides a model of the research ideas for use in your work with students. The model shows differences in students' readiness for art, the effects of the social and physical classroom environment, student responses to art class experiences, and the ways these experiences influence their creative work and criticism of art.

A key goal for art education is to increase students' range of experiences to give them a more comprehensive basis for evaluating and creating art and to give them an environment for living. But new experiences must be appropriate to *students'* readiness to learn.

We live in an acutely age-based society, grouping people by age with little concern for the amount and kind of experience they have had. We look for ways people are alike at each age rather than ways they are different. As the population has increased we have stereotyped even more. Yet we give lip service to individualized instruction. Art education, perhaps more than any other field, is most focused upon what the individual does rather than imposing a body of content.

Art and classroom teachers are not psychologists or social scientists. But they work with students in very direct, personal ways; therefore, they must extend the range of their understanding of individuals as well as of groups. We cannot know all there is to know about individuals, particularly as we work with classes of students. But this material can provide you with a model for working with students' diversity within the time, space, and energy dimensions of your class. It should help you become more open to diversity and more flexible in helping diverse students.

USES OF RESEARCH IN ART EDUCATION

The long-standing division between science and art is one of attitude. We learn to identify with one more than the other, know more about one than the other, be more comfortable with one than the other. The knowledge, associations, and comfort we find with what is familiar tend to make us uncomfortable, alienated, and often distrustful of the other. Both science and art are attempts to understand humanity and environment, and both give us valuable, useful information. In art education they have to be used together. We can best understand a human being's learning about, thinking about, seeing, and creating art by knowing the qualities of art experiences and the psychosocial behaviors in having these experiences.

The word *behavior* usually produces an emotional reaction against one aspect of behavioral study—behavior modification. But a study of art behaviors can help you

understand what students experience and help you extend students' aptitudes and abilities. If you are teaching in school districts where behavioral objectives are required, you can write these objectives in terms of the differences among your students, or you can write general performance objectives and devise different ways for diverse students to reach them. The latter is the premise of the curriculum of this book, and the performance objectives in Section Twenty are derived from the activities in this curriculum.

SELECTION OF RESEARCH

Studies were selected that help identify what goes on in art experiences and ways in which individuals differ in their readiness to have these experiences. Particular emphasis is given to early experiences that affect how children, adolescents, and even adults continue to respond. Of necessity, a wide range of research materials had to be considered briefly. Graduate students are encouraged to go to the original sources for in-depth analysis.

Psychology has many specialized areas. Different theorists make different assumptions about learning or focus on different periods in people's lives. For this book we focus on the findings of some of those psychologists who deal with how people learn from their environment as it relates to art. We are concerned with how differences in past experience affect how differently people learn to see, to think about and organize what they see to solve problems creatively, and to express ideas. On this basis then, we can more intelligently provide experiences that will broaden and intensify students' abilities to respond. Although art is strongly affected by cultures and social groups, its creation is most often the work of one unique individual. Each artist learns about culture somewhat differently. As we learned in Part Five, people vary widely in the ways they learn their own culture.

ASSUMPTIONS ABOUT ART EDUCATION

The key purpose of education is the growth and development of individuals from wherever they may be to wherever their aptitudes for creating and comprehending may lead. This is countered with the second assumption that individuals can only survive in viable humane societies. For people to develop their own unique life patterns as well as humane, interdependent, shared environments, they all need to understand the impact of their design decisions on each other.

THE BASIS OF THE P.D. III THEORETICAL MODEL

The theoretical model is a current extension of prior studies of the Perception-Delineation theory. P.D. III is simplified and updated for use in this more operational approach to teaching art (McFee, 1970). The theory's

structure is basically the same, but its application to teaching is more direct.

The model is based on psychological and biological findings that every individual has a somewhat unique potential to learn, but that any given child or adolescent's ability to perform at any given time depends upon his or her past and present opportunities to use their potential. This means that ability or readiness is not solely a function of potential or experience but the result of the amount, kind, and degree of opportunity and motivation to see, think, know, and manipulate the person has had (Golen & Moody, 1973, p. 37; Dobzansky, 1962). *Performance* at any given time is in terms of individual readiness and the present art learning situation.

Some psychologists have been most concerned with the effects of early deprivation on children's long-range development. At present, there is evidence that early deprivation continues as an effect only so long as children stay in that deprived situation, and that when they are put in more stimulating environments, their rate of growth increases (Kagan & Klein, 1973). Children raised in visually and conceptually limited situations may appear to be slow learners. But it has been demonstrated that a change to a more stimulating environment can change their rate of growth, and they can catch up with children raised in more stimulating environments. Since we cannot isolate people from their experiences, we can only identify people's performances in terms of the experience they have had. This does not tell us what they are capable of performing provided appropriate opportunities to learn are given.

What we know about a given child should be considered as a resource of useful information to help us try to find appropriate experiences for him or her, not as a category of what he or she is and always will be.

In order to make complex ideas workable, we need a theory of their relationships. Like a visual design, we should see the underlying pattern of orderly relationships to deal with the variety. The theory is the *pattern* that helps the teacher deal with variety — in this case diversity among students. The model is based on the learning of diverse people in a classroom. It includes students, teachers, learning materials, and the environment. It could be applied to other learning situations, but we have based it on learning related to art. The basis is similar to that being used in environmental psychology where the transactions between people and their environment (other people being part of one person's environment) are the action points where learning, creating, expressing, and evaluating take place. Even the very subjective artist reflects on his or her experience to express ideas.

Every student has a readiness to create and know art. Your task is finding that readiness, which may be culturally and psychologically very different from your own. But understanding differences can make us all more tolerant and able to work with diverse students in our classrooms.

The following diagram of the P.D. III theoretical model illustrates points in the system whether students are learning about art and the environment or creating art and designing environments. Key questions about students' differences are asked at each point. Review of the research that will help you understand these differences follows. Then we provide ways to assess how students are learning as a basis for providing the help they need before going on to more complex work.

Point I, *students' readiness*, at a given time is the result of their prior opportunities to use their potential to learn as it has been encouraged through interaction with their psychocultural-physical environment. Since

the values, attitudes, and beliefs of a group of people are the basis for developing the built environment, children learn from their physical environment as well as from the culture of the people in it. People's readiness to know, to see, to relate to others acts as a screen through which they process information from the environment, paying attention to some details and ignoring others.

Point II, *the psychocultural classroom environment,* is made up of the transactions among the individual students and the teacher. Its character depends on how well each individual transacts with the others. The more teachers and students are alike, the more they will relate to and understand each other. The more they are different, the more teachers will have to encourage understanding among themselves and students. The way each student responds in class depends on how she or he understands the situation as a hostile or supportive place to learn.

Point III, *the visual-physical environment,* includes those things in the physical environment that provide the context for the students' learning—the room itself, the nature of its design, the art and natural forms used to motivate, the teaching materials, the familiarity or novelty of things, the way the room appears to students in terms of their own needs for order and/or variety. You operate as a teacher by changing the context of your classroom to fit students' readiness to learn.

Point IV, *information handling,* depends on the students' original readiness, how they respond in the psychocultural environment, and new experiences which change their readiness at point IV. The amount of new information students handle and how they handle it changes their readiness. Your role is to help them see the relationships between new and past experiences. If you understand their readiness to learn and if you create an

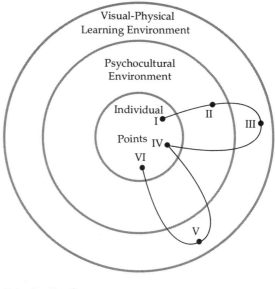

Point I Readiness
Point II Psychocultural Environment
Point III Visual-Physical Learning Environment
Point IV Information Handling
Point V Delineating and Responding to Art
Point VI Feedback

Figure 6.1 *Perception-Delineation III: a double feedback interaction system.*

environment that is socially reassuring and meaningfully stimulating, your work in helping them handle the new information will be much easier.

At point V, *delineating and responding to art,* an art work is *not* a direct expression of personality but of the students' readiness. Motor skills, familiarity with materials, flexibility in using tools and materials in

creative ways, and selectivity of media most appropriate to express ideas or design objects take place at this point.

A student's analysis or criticism of art is based on his or her readiness, the learning environment, the familiarity with the form, and the teacher's ability to help him or her relate to the art form or environment.

Point VI, *feedback*, is the end of the double feedback loop in this system. By observing what happens at points IV and V, we can see how a student's readiness for new work has changed. It gives us information about how we must modify points II, III, IV, and V.

QUESTIONS FOR TEACHERS

In this section we identify key questions for each point in the theory. Some questions must be asked at more than one point. In reviewing the research that follows in Section Eighteen, background on the importance and meaning of the questions is provided so you can better see the relationship of research to practice.

Point I
Readiness

What are the areas of readiness of this class and what are the differences among students in them?

Development How developed are the students in each of the following *three* modes of learning, remembering, and communicating ideas and relationships?

Manipulating: Using sensorimotor skills to analyze present and past situations.

Perceptualizing: Categorizing what they see and hear into mental images with visual qualities and relationships, expressing and remembering using icons, signs, and symbols.

Conceptualizing: Categorizing what they see and hear into mental concepts with labels of qualities and relationships, expressing and remembering using words.

Cognitive Style What kinds of cognitive styles have they developed in learning? Are they more *global* or more *analytical*, i.e., do they work for overall pattern or outlines or for careful detail of parts? Are they *impulsive*, making quick responses, or are they *reflective*, taking time to see and feel what is there?

Cultural Experience How has their background influenced their attitudes toward art, their concepts of what is included in art, what is important to see? Was their cultural background rich in visual symbols and art visually or was it meager and undetailed? How has their experience in their culture affected how and what they have learned to see?

Orientation to Space How do they relate themselves to space? Are they more dependent on their visual field or their inner bodily feelings of separateness from the field? Which of these modes do they tend to use in learning about their environment? What kind of interaction in space have they learned—close use of space shared with others or more independent use of space? What kinds of personal I-space do they habitually use?

Creative Development What response sets or stereotypes have they learned that may inhibit their development? How flexible and innovative are they? Have they been encouraged and rewarded for thinking and doing creative things or for thinking "correctly," and being more conforming?

Art Readiness What mode do students use in drawing? Do they draw mainly from:

(1) observation of things in light and space, (2) from what they have learned from other people's drawings of things, or (3) from what they have learned about things through the use of the word symbols, or (4) mainly from their feeling response to things? What is their mode for designing? Is it mainly intuitive or by analysis and learning? How developed is their designing ability?

Responding to Art Do they attend to the design, the associated meaning, the emotional meaning, or the techniques and processes of art? Do they attend to art by perceptualizing or conceptualizing? What has meaning as art in their background? Are they unresponsive to visual organization? Do they prefer highly ordered "symmetrical design"? Will they tolerate some asymmetry? Are they very sensitive to complex balances between order and variety? Do they use their intuition or their intellect to make design decisions?

Point II
Psychocultural Climate
of the Classroom

What kind of psychocultural environment do the students and I create in my classroom? What are the key values and attitudes we agree or disagree on? What constitutes a good working environment and teacher-pupil relationship? What is success or failure? Which students may feel alienated in this environment? What can I do to reduce their alienation? How can I increase the cultural understanding among the students? What kind of psychosocial impact does my own personality and cultural background— the way I talk, dress, interact with individuals, affect the cultural "climate" of the classroom? How does my influence on the classroom organization affect students' reac-

tions? How do their particular background cultures, values, and beliefs contrast with my assumptions about art? How do my students differ in terms of what they expect an art classroom to be? How can I change the classroom climate by modifying my own behavior and/or by helping different students understand what is going on in the classroom environment? How can we all redesign the classroom to help all use it more effectively? Are there individual students who are so culturally and/or psychologically different that they disrupt the work of the rest of the class? What can I do to help them relate to the class and the class to them?

Point III
Visual-Physical Learning
Environment

The physical environment is not only the design of the work spaces and storage spaces of the classroom, it is also the art forms, the natural and human-made objects that are brought into the room to stimulate students' aesthetic inquiry and creative responses. It includes all environmental field experiences your students use to study environmental qualities and characteristics.

Your questions must relate readiness to the environment to see how appropriate the things you and the students bring into the classroom are to their readiness. If the students are quite similar, the task is easier. If the students are very diverse culturally, psychologically, and artistically, you may have to create mini-environments for different groups of students to work in.

Which students are used to living in close proximity, sharing spaces as much as possible? Which students live in close quarters but require as much I-space as possible? Which students live in small, sparsely populated areas or live in varying

degrees of suburban openness? How many students work easily in groups with much conversation; how many require isolation and quiet?

Their ability to analyze environments will depend on their experience in living. If the students come from the same cultural background, you can begin with valued, familiar objects from that background to see how much their culture means to them. If they can bring objects to class, you may see how diverse the groups are through the range of objects they bring.

If the students come from quite different cultural backgrounds, you will need to either select objects that are common to all groups or provide a good collection of objects from which students can choose. This is most effective in schools where cultures are changing or students are breaking away from their culture. You need to find out what kinds of art these different students relate to already. Some students may relate to the art of painting race cars or vans, others to counterculture crafts, some to traditional, conservative, decorative art, some to contemporary arts and crafts, some to almost no art that they recognize. To get them involved in art, these differences must be considered. You will also have to consider key psychological differences among students in selecting things to motivate them.

Which students need elements that allow them to respond either globally or analytically? What objects would appeal to students who are dependent more on bodily (inside feeling cues) or visual (outside) clues to relate themselves to things? Which students analyze their environment through words (conceptualizing), through looking (perceptualizing), or through activity (manipulating) to learn what is going on around them? Have I provided activities that can be approached in each of these three ways?

Point IV
Information Handling

How can I help my students relate new experiences and new things in their environment to what they already know?

This point is very critical if you want to help students extend the ways they can respond to their environment and to art. Generally speaking, we need to get students initially involved by relating new things as closely as possible to things with which they are already familiar and which fit their development in seeing and their cognitive style. But to grow in art, they need to be able to see more, design more flexibly, and extend their ways of handling information. Usually, growth is in small steps. If the steps are too big, the student may experience failure, feel cut off and turned off. If there are no new challenges, many students will become bored with the process. Helping students become more aware at a rate that keeps growth stimulated is your most challenging task.

It is at this point—helping students understand new material—that you make decisions about how appropriate the new tasks are to readiness and the rate of change a student can assimilate. The key questions in this area are: What evidence of readiness does this student show in terms of responding to this particular art task? How can I help the students understand what is new but appropriate to their way of handling information? Can I design my class in relation to how students process information, so I can work with several at a time?

Students from each cultural group represented in your classroom may be more global or analytical, more impulsive or reflective. Impulsive students need help in handling information so they stay with it long enough to get something out of it. Reflective students may occasionally need

experience that encourages them to be impulsive, to make quick responses because so much is happening there is no time to be reflective. Highly creative students may be those who can shift modes flexibly.

You can group students according to their mode of learning: by manipulating, perceptualizing, conceptualizing. Then you can find stimulating experiences for their ability levels that fit with the cultural composite of each group. Children use all of these modes to some degree, but they learn them in sequences, and some children stay with one mode more than others.

There are three common problems found among art teachers. One is that many of them learned about art by doing it and have trouble communicating with students who learn best by talking about it. The second problem is that art teachers with highly developed perceptual skills assume that their students see things the same way they do, so cannot help students at the students' level of perceptual readiness. The third problem is among those art teachers who are highly conceptual in their response to art and in their creation of it, who have students who are either very perceptual or very manipulative. When students and teachers have different ways of handling information, then both teaching and learning are impaired if these differences are not considered.

Point V
Delineating and
Responding to Art

The functions at point V depend upon whether an activity is to create art or environments through *manipulation*—exploring with media and materials to express images through visual analysis, or to find significant forms to express through *conceptual*

analysis, and then seeking visual forms to express these ideas.

Ideally, an artist or designer can use all these modes, but a beginner can learn to fail if he or she cannot use a familiar way of responding. As a teacher, you can assume you have some students of all three groups in most classrooms. You will need to provide materials and media each group could use.

The manipulative students are most highly developed in responding to things by working with them. They redesign a room by first moving things around, they express by "finding" forms as they manipulate media and materials. The most highly developed perceptually are constantly searching their environments for new visions. They design *visually*. In their mind's eye, they can see relations and patterns and can manipulate images into new designs before they put them on paper or photograph them. The third type of student deals with their environment and their feeling experiences with the environment in terms of the *concepts* they have about them. The concepts are abstractions from what they see. If they are urban, they tend to learn to "see" their concepts and their art is about their concepts.

Some students will need materials that involve lots of manipulation and three-dimensional involvement. Some will want materials that allow them to represent and analyze what they see. This can range from very traditional representation to very unique creative and analytical perceptions. Other students, who are more abstract, who express visual images of words, may want tools that allow them to be very precise.

Art classes that are based on single media, such as watercolor painting or metal sculpture, do not allow such diverse students to work. Choices in materials must be made available. In helping students work through the different complexity levels in

drawing, design, creative art, and environmental design, you must watch for situations in which different media might make a task easier for some students.

If the activity calls for a response or critique, the content of the art and the nature of the environment should be familiar to the students. If another culture's art is studied at point III, its relationship to what is already known should be made at point IV. The students' own response to the work of art or criticism of a work operates at point V when they communicate to others what they see and feel. In this way, their experience can be objectified enough so that they can see what they are learning. This task can be very difficult for less verbal or less responsive people, and you may decide that for some students it is better to keep on exposing them to art if they show interest, even though you are unable to obtain much evidence of what they are learning at point V.

Point VI
Feedback and Evaluating

Point VI is a review of all the other points. It is a means for you to evaluate how well you are fitting the activities to the students' readiness, how effective the classroom environment is for the students' learning, and how well you have helped them relate what is new to what they already know. It is also a means of measuring changes in student readiness so that you can change your teaching to fit their new readiness. Most important, it is a point at which you can recognize and reward growth through praise, recognition, and encouragement.

For example, a very global student may show signs of some penetrating analysis. Up to this time you have encouraged him or her to look for the overall pattern of things, to work in large blocks of space. He or she may not be ready for a lot of analysis, but you can introduce a few more complex details that relate to background and personal interests. As the student responds, you are in a position to reward this progress with more complexity.

A very impulsive student may start working longer at drawing. This may indicate growth in reflection. Your praise of this work in comparison with previous work can help increase the child's recognition of the value of reflectiveness.

If an urban student who usually draws abstractions is encouraged to observe more visual details, which show up in her or his drawings, you have a sensitive decision to make. You could increase your questions about details, encouraging the student to see more and develop more ways of expressing what he or she sees, or the student could be encouraged to compare the abstract or realist parts of a drawing to see which most clearly expresses what she or he wants.

Another student who is analytical may be missing the overall global qualities of the forms and patterns of the city. Encourage that student to look for large areas of colors, planes, lights, darks. If he or she responds, you can encourage using either details or global effects.

If the students still do not respond, you will have to ask yourself whether it is because they are anxious and afraid to try new ways, or if a global viewpoint does not interest them or is not familiar to them. Perhaps they have such developed sets about looking that they have difficulty seeing familiar things in new ways.

You may have to help them with such devices as colored or lightly ground glass that shows only overall effects or with cards with holes cut out that show only parts of areas. If neither of these devices work, you may decide that particular children are so predominantly analytical or global that you should not push their development at a

particular time. Later, you may find another kind of task or another environmental situation that will furnish the avenue for developing both ways of attending.

Students will vary in the amount of time they need to carry on different activities. You should know which students must stay at one level for a longer time than others, which students should change media or subject matter but explore the same ideas. You should also know which students may have proceeded to a more complex level but need to go back to a simpler level to clarify their understanding of basic design ideas.

After long vacations, students also should review simpler activities and information to bring themselves back to where they were before the time away.

By breaking this process into points for analysis, we obscure the continuing feedback cycles of learning. As you work at point VI, you are getting information about changes at point I that need to be dealt with in the social and physical environment. Actually, activity selection involves all six points. As you become more and more familiar with the parts, they will become part of the way you operate in the classroom, and you will not have to analyze them every time you use them.

To summarize, think about people as being in process of change, who are continuously processing information to identify things, to see the relationship among things, and to interpret their meanings. All individuals develop an "inner" synthesis of ongoing experience based on their interactions with the physical and social realities they experience in their environment over time—the changing textures, shapes, sizes, forms, colors, symbols, signs, icons, people, places, spaces which express values, attitudes, and beliefs.

RESEARCH FOUNDATIONS

CONCEPTION-PERCEPTION AND DRAWING AND DESIGN

In these six points we have dealt with selected areas of human behaviors that are used in the field of art. Section Eighteen reviews areas of research on these behaviors and indicates how they function at each of the points.

Much more study has been made of how children express what they are learning through language than through drawing. Current studies of children's linguistic learning indicate that up to the first year and half to two years, children all around the world are quite alike (Slobin, 1971). But after two-word sentences are learned, children begin to learn the structure of their own language. Tremendous learning of language occurs between ages one and a half or two and age three and a half. During that time, variations in culture affect how children learn to structure language.

LEARNING TO DRAW AND LEARNING TO SPEAK

There are similarities and differences between learning language and learning to draw. They are alike because both processes depend in large part on *seeing*. But most study of children's drawing has been in relation to age and not how children learn to organize, identify, and develop visual images for expressing ideas in different cultural environments.

There are several key differences between learning to communicate with language symbols and learning to communicate with visual ones. A child is surrounded by people who use words — the words, grammar, and syntax are provided. But how much systematic drawing of symbols occurs depends on the society. The symbols a child learns depend upon how the family and community identify with change and to what aspects of society they relate. For example, in our society, individual elementary-level children in one classroom may have had different backgrounds of experience with art because of their families' education and exposure to different kinds of art and their openness or resistance to change. Some students may only experience art in comics, on television, in magazines and graffiti; others with popular art posters. Some students may experience art through traditional prints of fine arts or recreational painters. A few may have been exposed to avant-garde artists. Almost all children are exposed to drawing in advertising. Book illustrations affect them depending upon how much experience they have with books.

CULTURAL EFFECT ON DRAWING

Dennis (1966) found that American children who are often read to and have more books did better on the Draw-a-Man Test on the average than children who have few books and are seldom read to. His cross-

cultural analysis of children's drawings show that children raised in environments with rich imagery and many drawings of people excel much more in the Draw-A-Man Test than children who grow up with limited visual imagery around them. All children see people, but not necessarily *drawings* of people. When the activities of a group require that a great deal of observation take place, their drawings of real objects excel.

The Orotchen children of northern Siberia have to observe reindeer against similar colored backgrounds to survive. In a study in which their early drawings were collected, the children had not drawn before — in fact, there were no drawings of reindeer nor any thing else in their nomadic environment. But the children's drawings were amazingly realistic with foreshortened drawings of reindeer in action. Their drawings of people, whom they did not have to observe carefully, were static stick figures. This result indicates that without symbols or drawings but with a strong drive to observe things, children will be able to draw from what they see. The continued, careful perception of reindeer provided them with rich visual imagery which they could recall when asked to draw. Things they had not observed carefully had not provided them with detailed images to recall (Schubert, 1930).

If you collect drawings of people by older children, teenagers, or adults, you can quickly sort them in terms of which ones (1) drew symbols they had learned and often traced the source of symbols, (2) drew from

much observation of visual qualities of people and not as stereotypes of ideal types, and (3) those who floundered because they had learned neither way.

We do not know how much taking photographs of things or watching noncartoon television helps children either to observe nature carefully or to develop symbols for drawing things. If the teacher stresses looking for textures and changes in shapes and encourages students to use the camera as a tool for analyzing changing visual qualities, then they will probably learn to observe more. But if they are taking pictures of objects as things rather than visual images, they may not develop much perceptually. How children will depend on their perceptions as a basis for solving problems also depends on their experience. In cross-cultural studies of rural and urban children, Bruner and others (1966) found that children exposed or unexposed to verbal learning processes vary widely in whether they depend on concepts or visual information to solve problems. Urban children and children from rural areas who go to concept-oriented schools develop cognitive styles (ways to handle information) more through the use of words than with direct visual experience. The Japanese children in Dennis' study (1966) who were so highly skilled in the Draw-a-Man Test apparently were learning from the rich visual imagery in their environment as well as from language.

Two predominant theorists in child development, Piaget and Bruner, do deal with

the environment as part of the learning process, but because they are part of a cultural system where words are valued more than percepts or images, their theories reflect this value system. The theories postulate ages at which children move from sensorimotor, to perceptual, to more verbal information handling. But what is not stressed is that the sensorimotor and perceptual skills, if continually used, also can develop to very high levels. Since our media and visual worlds influence our behavior, we need to develop all three modes of learning.

Einstein reported that his methods of thought were highly dependent on clear visual images which he could bring into thought at will and that he could combine images to produce complex relationships, but he had to translate them into words or signs to communicate with others (Hadamard, 1949). Yet Aldous Huxley, whose use of language certainly is imaginative, reports that he only had rich visual imagery when fevered. Here are two superb mentalities with very different cognitive styles—one highly visual, one highly verbal (Neisser, 1967). If a cross-cultural study of Piagetan theories were as systematically carried out as his studies with middle-class, European children, we might better identify what human cognitive learning is. But one might find out that since all learning takes place in some kind of cultural setting, it depends in some degree on the situation and cannot be studied in isolation. For this reason, cognitive development and perceptual and conceptual learning must be considered in terms of the opportunities a child has had to learn.

Kagan and Klein (1973) studied isolated Guatemalan Indian children whose mothers believe children do not talk until they are three or walk until they are eighteen months. They raise their infants and young children in semidarkness, interact with them mainly by nursing whenever they are fussing or hungry, but do not stimulate them to look and identify things. But when this deprived environment is changed, these children change and by eleven are vivacious, lively, and intelligent.

Kagan and Klein suggest that some human abilities such as abilities to analyze perceptually, to imitate, to symbolize and to use language, to reason and memorize are inherent and will eventually appear in most environments, but specific abilities that develop in terms of specific languages and cultural environments are very dependent on the opportunities to learn in those environments. They fail to recognize that the ability to analyze perceptually is also strongly affected by experience. But we agree with their conclusion that a child can only be regarded as retarded or precocious when compared to other children in that cultural environment. We would stress that this includes what there is to be learned through the characteristics of the physical as well as the social aspects of culture.

On the basis of their research and other cross-cultural studies of development, they caution us to be aware that low scores on aptitude tests of economically impoverished, minority group, first-grade children may be evidence of a limited opportunity to learn school-related aptitudes rather than permanent retardation. Such children need to be viewed and educated in terms of their background experience and given time to catch up in more stimulating environments.

Children's art development will depend on the visual stimulation they receive, the presence or lack of drawings and symbols, and the kind of drawings or symbols. A child whose culture has stylistic drawings will tend to learn in that style. If the child is a male and drawing is a means of achieving male status, male children will draw better than females or vice versa (Havighurst and Neugarten, 1955, p. 171). Dennis (1960)

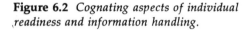

Figure 6.2 *Cognating aspects of individual readiness and information handling.*

found that children's I. Q. scores on the Draw-A-Man Test went down with age if they lived in a society that devalued symbolizing the human figure.

DIFFERENT PATTERNS OF COGNITIVE DEVELOPMENT

Cognitive development is, in part, learned. People develop different patterns of cognition. It influences their readiness at point I of the P. D. III theory (Figure 6.1). We can think of people's pattern of cognating as a screen through which they attend to things in their psychosocial and visual-physical environments, using more perceptual or conceptual modes of knowing. The model in

Figure 6.3 *Individual cognating patterns.*

Figure 6.2 identifies the range of possible patterns of cognition. Figure 6.3 illustrates individual patterns.

On one hand, people learn to interact with their environment mainly by conceptualizing. They communicate through words. They use the right-hand side of the screen—only perceptualizing enough to label what things are. They affect or are affected by the conceptual qualities of what they are dealing with. They operate by transacting between points, that is, by using mental processes. But they process the information through concepts. On the other hand, people analyze experience by perceptualizing—creating mental visual images of what they see. Only when forced do they conceptualize and communicate what they see in visual images or constructs of things. Some of these people perceptualize by looking and processing information mentally. Then they manipulate what they see through drawing, or they verbalize what they see through writing or talking. Others have to manipulate things in order to perceptualize what is there, then they create images to communicate what they see. All of these people are *affected* by visual qualities.

If people are cognating but not communicating, they spend their time thinking in visual images, in concepts, or both. When they do both, each process enriches the other.

Traditionally, the cognitive and affective domains were seen as separate parts of human experience. We see them both as involved in every human behavior in some degree. Perhaps Leonardo da Vinci was highly developed in all aspects. The rural Guatemalan children are probably cognitive-manipulative till age three. Japanese children are encouraged to develop in all these ways—transacting, manipulating, perceptualizing, conceptualizing, image making, verbalizing, and affecting. They learn both through words and through visual images, including art.

Each of the points in the diagram contrasts with the other points across the diagram to some degree. Some children may depend more on concepts than percepts to think, others may be highly developed both conceptually and perceptually, a third group may be more developed perceptually than conceptually. But some perceptual children may have learned by observing things in space and light—like the Orotchen children —and some may have learned to observe cultural art forms like some Japanese children. The cultural art forms children can observe include storytelling, illustrations, religious artifacts, symbols of status and role in clothing and jewelry, comics, graffiti, monuments, buildings. If we find children who are highly developed in perceptualizing visual images, we should know what art forms they have learned from.

As teachers, we have to help children use the learning aptitudes they have already developed, but we can also help conceptual children become more perceptual and perceptual children become more conceptual.

In extensive study in different parts of the world where Western civilization values of education have been introduced, Bruner and his associates found that in such a short time as six months, a rural, visual child could be taught to use words to solve problems (Bruner et al., 1966). There is little evidence that learning one decreases the other, but if a child is rewarded for doing one, he or she tends not to do the other.

ORIENTATION TO SPACE AND DRAWING

Another area of research that gives us insight into the problem of child development and perception comes from the work of

Witkin and Dawson who were concerned with the relationships of child-rearing practice and the kinds of cues children learn to use in relating themselves to three-dimensional space.

Witkin's early research was to see what cues people use to right themselves when they are put in a tilted position rather than an upright one—body cues or cues in their environment that tell them they are out of line with the position of walls and objects in their space (Witkin, 1954; Witkin et al., 1959). He built complex chair-room equipment in which blindfolded subjects seated on a chair with controls to right themselves had to right themselves when the blindfold was removed. The chair and room were tilted off the true vertical at varying degrees in the same direction or the opposite direction. Some people righted the chair to the true upright, regardless of the angle of the room. They were using body cues to relate themselves to space. Other people ignored body cues and used visual uprightness to right themselves. Some people whose original position was to one side of true upright would maneuver themselves through the true upright position, ignoring body cues of uprightness, and tilt themselves to the other side to match the room. They were using cues in the environment.

Witkin's later study with ten-year-old boys shows this tendency to be related to a pattern of cognitive style (Witkin et al., 1962, pp. 103–113). Children who are independent of their environment and authority figures in it, tend to be more analytical, better able to separate figures from ground (background), clearer in describing their personal experiences, and better able to draw a picture of a man using more integration of body parts, proportions, and details of dress and social role (Witkin et al., 1962, pp. 119–120). Conversely, children who depend more on their field to right themselves tend to be more global in their descriptions of their experience and in their drawings. They are less able to separate figures from ground. Interviews with mothers of these boys showed that the independent boys had mothers who encouraged independence, freedom of movement, and opportunities to try out new things, while the mothers of the more dependent boys allowed much less freedom and opportunity to learn to be independent.

In some of their studies, researchers found that males tended, as a whole, to be more independent, females dependent, which in turn are culturally learned traits. But, as in mean differences between large groups, many females are more independent than many males. But when the whole population was sampled, the average male, at the time the study was made, was more independent than the average female. One might guess that male mean scores would still be higher than female in independence, but the difference between means of the two groups is becoming less because of the increased independence of women.

Dawson (1967) studied children in tribes in Sierra Leone, where conformity and group reliance is emphasized and individual competitiveness discouraged—children who are too independent are considered bewitched in some tribes. He wanted to see if children growing up in such environments would behave like Witkin's field-dependent children and to see if he could train them to use visual cues like more independent children.

He found that young adult males were not only more field dependent than subjects in more permissive societies, but that those who came from the Temne tribe, in which mothers particularly dominate their children, were more field dependent than males of the same educational experience, intelligence, and visual deficiency from the Mende tribe.

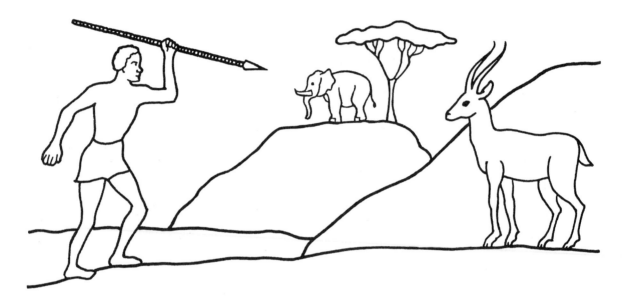

Figure 6.4 *A test of pictorial depth perception from W. Hudson, "Pictorial Depth Perception in Subcultural Groups in Africa," Part I,* The Journal of Social Psychology *52 (1960): 182–208.* (Used by permission of The Journal Press.)

To find out if children reared in this social environment who tended to be global, field dependent, and responsive to two dimensions could be trained to be more responsive to three dimensions, he matched a control and experimental group. Each group consisted of 12 males, 18 to 19 years old, who had completed secondary education and who were in the same occupation; each group had identical means on scores for the perceptual tests of field dependency-independency. The experimental group had eight one-hour (once a week) training sessions in which the members sighted through a small square in a cardboard held close to their eyes and through a window farther away and then drew on the glass of the window the dominant lines of the landscape outside. This exercise produced a three-dimensional image of the scene outside on the flat glass. They learned depth cues by continuing the same process—looking outside, drawing the dominant lines of the ways things looked, and then looking at their drawings to see

how they had made signs that symbolize depth. Then the experimental group drew the outside scenes directly on paper and compared them with the outside scene. Finally, they studied photographs of the area to see how the camera records three-dimensional perspective.

The results were clear. In the pretest there was no significant difference between the two groups on the Kohs Block Test and Hudson's three-dimensional perception tests. But after the training, the experimental group was significantly better able to use the three-dimensional pictures correctly. For example, the drawing in Figure 6.4 is from Hudson's test (Hudson, 1960). People who see in two dimensions see the spear being thrown at the elephant, those who see in three see it being thrown at the antelope. The antelope is closer in three-dimensional space because of the overlapping planes and larger size. People who see the picture in two dimensions see the spear pointed at the elephant, which on a flat plane is closer.

Those of us who live among photographs and pictures all the time forget that we had to learn to read them and that many people have not learned to see perspective in them. From this research we can surmise that some children grow up reading drawings very well, but use words to respond to things if they live in complex environments.

Dependent children need help in learning to see in three dimensions. Specific perceptual help is needed by children who have grown up in situations where their freedom to separate themselves from authority hinders their ability to see and draw objects in three-dimensional space. Global field-dependent children will be getting different information from their experience in their environment than independent, analytical children. Children and adults of both cognitive styles can learn to see as the others see. These differences in readiness must be

considered as experiences are developed in the art classroom so both can learn.

When children's drawings are studied for the variations among them, these differences in experience become clear. Some are global, some analytical, some show wide visual experiences of heights and overviews, some do not. The systems they use to organize space are learned in different contexts. Some have to use words because they have so few visual images, others are rich in remembered images. The drawings of fourth-grade children asked to tell how their city is put together show these differences (see Figure 4.29).

PERSONALITY FACTORS IN COGNITIVE DEVELOPMENT

In art activities we have long assumed that children have likes and dislikes about media and about organizations of art forms, but we have not explored different ways in which children process the information they are getting in different kinds of art-related tasks.

Kagan and his associates (1964) have done extensive study of children's cognitive styles. First, they gave children their Conceptual Style Test. They showed children three black-and-white drawings of familiar objects and asked them to identify two of the three pictures that were "alike or go together in some way." Each child was then asked why he or she grouped as he or she did.

An *analytic response* was made when the child responded to parts of the objects that were related. In the drawings of a watch, a man, and a ruler, an analytic response would refer to numbers on the watch and on the ruler. In more impulsive responses, the child would notice that the man wore the watch or some things were wood and others live.

In further tests, analytic children re-

sponded to ink blots with detailed descriptions ("butterfly with wings and feet"). Impulsive children responded with more single concepts like "mud, cloud, or paint." The analytic children made more new verbal responses to geometric designs rather than just describing the more obvious features.

A mean trend toward more analysis comes with age, but individual differences are extensive at all ages tested. Individual children were found to be about the same over a year's period.

To extend the understanding of these relationships, elementary-school children were tested in tasks of separating figures from ground, analyzing subtle differences in pictures, recalling abstract design configurations, matching familiar pictures, and matching tactile and visual images. Impulsive responses were made quickly, without evidence of reflection or analysis. If children were analytical in one kind of task, they were generally analytical in others. If they were impulsive in one, they tended to be more impulsive in others.

Kagan's tests were given at different times. The Conceptual Style Test, the Design Recall Test, and the Embedded Figure Test were given to two groups of second-grade children. The first group was encouraged to work quickly, but the second was encouraged to work slowly and think about the answers. The slow-working children were more analytical in their selection of related pictures and made fewer errors on the Design Recall Test, in which they see a design and then have to pick it out from a series of related designs.

Fourth-grade boys were compared on their ability to analyze conceptually and to analyze geometric forms into distinct figure and ground. Boys who scored high conceptually tended to be high in separating figure from ground.

Kagan suggests that the accumulated information shows that the abilities to reflect on (take time to think about) alternative solution possibilities and to analyze visually are fundamental to cognitive processes and perceptual recognition.

Students who were strong in this analytic style could sustain concentration on intellectual tasks, showed little irrelevant gross motor action, and inhibited impulsive solutions to problems. A tendency to reflect *before* completing the various perception tasks was one of the most consistent and stable behaviors found. Children who took time to reflect did so more consistently in the different activities when many alternatives were open to them. By contrast, an impulsive child faced with many alternatives would quickly choose one and be incorrect more often.

There was a tendency for children who had high verbal skills to make errors in recognition, mistakes in seeing the pattern and finding its match in the Design Recall Test and the Familiar Figures. This suggests that success in verbal interaction might decrease the child's *need* for developing perceptual skills. Since verbal skills are more rewarded in education, these children have little need or opportunity to develop the analytical mode of perceptual information handling. But boys with high verbal skills were found to be high in ability to separate figure and ground, which is developed in reading. This suggests the ability to work well with the pattern and design materials. Boys who evidence gross motor behavior and who are easily distracted are less able to make analytic responses.

Ability to analyze visually and the tendency to be more reflective or more impulsive influence how people classify information, how they respond to it, and how they solve problems. People establish their own strategies for solving problems. Kagan illustrates with the impulsive child who quickly chooses a wrong cue, fails in the solution,

becomes anxious on recognizing the failure and is handicapped by anxiety when he or she must make the next choice. This maladaptive behavior can lead the child to reject problem situations and become either apathetic or openly hostile when in problem-solving situations. Another child whose success in art has always been through impulsive expression may not have learned to be reflective. Helping such a child to reflect and to think about his or her work could help him or her develop reflective habits as well.

We do not know how much the characteristics of being impulsive and being more global relate. An impulsive response would tend to be more global because less time would be taken to respond in more detail. Both Witkin and Kagan have identified what seems to be one consistent, cognitive style—analytical, reflective, and differentiating.

The researchers indicate that they do not want to give the impression that one style of behavior is "better" than the others; they believe analysis and reflection are needed in the sciences but that a very strong, reflective orientation could be a hindrance in the arts and the humanities. By contrast, impulsive expression in art education has sometimes been stressed at the expense of analytic expression. Since the time of the strong reaction to classic realism and disciplined drawing and the emergence of the child-centered curriculum, teachers have focused on "self-expression" at the expense of much reflective problem-solving.

Reflective behavior and visual analysis are needed more in some phases of art, impulsiveness more needed in others. This research would indicate that some children will succeed more readily in one mode than in another, so teachers should make provisions for both kinds of interaction. That these are, in large part, learned behaviors

suggests that more children could develop both kinds of response.

The art teacher will have to provide a wide range of complexity in the tasks for children because they will have a wide range of differences in ability to separate figure and ground, analyze pattern and detail, and respond to art as a whole.

Highly verbal children may be so lacking in perceptual skills that they need particular help in learning to discriminate before they can become interested in symbolizing through drawing or in responding to art.

INDIVIDUAL DIFFERENCES IN INFORMATION HANDLING

There are three areas of psychology that help us understand people's differences in how they handle information, which in turn affects how they draw or respond to their environment. These are: the *perceptual constancies*—seeing what things *are* rather than what they look like at a given viewpoint or distance; *conservation*—recognizing that the volume, substance, and amount of liquids and solids are the same even though presented in different shapes or forms; and *visual imagery*. These three functions have mainly been studied separately, but they all are related to behavior in making and responding to art and to the social and physical environment from which much of the motivation for creating art comes.

The Perceptual Constancies

One of the main reasons people cannot draw is because they have not learned to see adequately. They have learned that, even though objects look smaller when farther away, or seem to have different shapes when viewed from different angles, or different values and hues in different lights, they are

actually the same size and shape and color. In learning these constancies, we tend to "see" what we know about things and do not pay attention to what they look like. In Part One on seeing and drawing we explored ways to overcome the tendency to learn to see only what is known and to see what is reflected on the retina of our eyes in three-dimensional space. This does not mean we have to unlearn the constancies. We need them to deal intelligently with elements in our environment.

For example, Pygmies see things only at close range when they first leave the forest (Turnbull, 1962, pp. 260–265). They learned to see and identify things from within only a small radius as they moved closer or farther from them. If they moved away from objects, the objects became smaller and disappeared into the dense forest background. They learned in that environment that things are relatively the same size. When first entering a vast plain where they could see for several miles, they thought elephants in the distance were insects. They had not developed the constancy of size. Because they had not learned this constancy, they were interpreting visual information incorrectly. But if we had asked them to observe and draw those things three miles away, the visual image would be correct, at least in size. Conversely, those of us who see people, things, and places from a great variety of distances tend to average out the visual differences in size and see them as we know them to be. Only when we observe carefully and compare differences are we able to draw them in terms of their visual reality.

The same things happen with shapes and forms. Our viewpoint changes our vision of things, but we tend to see our stereotypes of their shape or form. Adults who have not learned to see visually have to learn it as well as younger people. Figures 1.12 and 1.14 are drawings of third-grade children who were taught to observe how objects change in space. By painting them and cutting them out and pasting so they changed sizes, they created the illusion of three-dimensional space. The child who drew the same figure three different sizes had looked at it from three different distances through a six-inch cardboard tube.

During the years children learn to discriminate more and see more visual detail so they can draw visual appearances, they are also learning the constancies—seeing things as they know them to be, categorizing them with words. Most of their education reinforces the naming of things and not the observing of things, so most people do not grow up learning to draw very well because they do not observe well. In societies in which people are seen as part of the environment or societies in which seeing is necessary for survival, people develop the perceptual basis for drawing even if they are not actively involved in drawing. If they learn there are two ways of seeing (as we know things to be, and as they appear in distance and light), then their perceptual and drawing ability can continue to develop even though they recognize things as unchanging in structure. People who depend on the constancies tend not to see in perspective. Teaching perspective systems to students who do not see in perspective is very difficult.

There is little agreement in research as to what ages the constancies appear. The reason for this is that it is learned behavior and not necessarily based on age. Learning to increase differentiation, that is, see more and more detail, comes with experience, but how early children can learn specifics is hard to determine because they have been learning from infancy. Their ability depends so much on what opportunities they have had to see and how they have been encouraged to use what they see.

It is well not to require younger children to see in certain ways but to encourage them to compare sizes, shapes, and colors at different distances and in different lights. They should be encouraged to recognize things as the same in different lights and distances, but should not be judged wrong if they do not identify things as you do. Keep the opportunities to learn to see available in the environment and when they are ready, they will use the information.

In terms of our model of conceptual-perceptual cognition, learning the constancies operates to make people more dependent on concepts than on percepts. If we want to help them learn to use both, then we must keep both avenues of learning open to them. Learning can be encouraged through observing art, nature, and the built environment as well as through written and spoken language.

Conservation of Elements

Bruner and his associates (1966), in extensive cross-cultural studies of children's conservation problem-solving abilities, found that, generally, children raised in urban areas tended to solve problems more in terms of concepts about things than children raised in rural areas. When urban children see an amount of water in a glass beaker that is one shape, they know it is the same amount of water when poured into differently shaped, smaller beakers. Rural children of the same age (years of experience) who depend more on vision are fooled by the differences in real appearance. The water looks different in different size beakers, so it must be different. They reasoned that urban children have so much detail to see that they have to block out much detail and respond to stereotypes in order to manipulate all the information they receive. Rural children moving at a slower pace in a more ordered environment

tend to see and remember more visual details. In the Bruner studies rural children did not do as well in solving a conservation task as urban children because solving the problem required that they ignore what they saw of the shape of things and respond to what they knew was happening. They had not been forced by experience to ignore what is there to see. Both groups of children could learn that visual and structural reality are different and both kinds of information are useful.

A comparison was made of children's ability to see that a solid substance is the same, regardless of its shape. Mexican children from family-based pottery-making groups, who manipulated the same amounts of clay into different shapes, learned the conservation of volume much more rapidly than children who did not work in clay (Price-Williams et al., 1969).

But the children were not any better in weight or liquid conservations. This research suggests that the ability to separate appearances from the ways things are, the conservation of the essential characteristics of things, depends on direct experience. From this, we can generalize that the direct manipulation of media can contribute to children's ability to understand that things are not always what they look like. If, at the same time, we help them observe the differences between *how things work* and *how they look* and how they can change visually without changing volume, substance, or amount, we can encourage all three avenues of cognition development.

Visual Imagery

Study of individual differences in people's ability to have and retain or think with visual images is in a state of flux. Some psychologists feel that people who use words have more flexibility of thought than those who

use images because they feel people who use images are limited by those images. Yet, some scientists and artists report they can manipulate images most creatively. People can be limited by strongly held concepts as well as percepts. People whose imagery is highly developed may see things highly conceptual people do not recognize. There seems to be evidence that people differ widely in ability to have these images. Some people code information using visual elements, some through language.

In a test with five-, seven-, and nine-year-old children, some children responded better to visual information, some to verbal (Kuhlman, 1960). The children high in visual imagery at all three ages were best in reproducing geometric designs from memory, but they were poorer than the more verbal children at ages five and seven in abstract reasoning with words. But the nine-year-olds who were highly visual apparently could use both visual and verbal modes. This suggests that children who develop visual imagery are not hindered from conceptual reasoning though they may develop it more slowly. If they are categorized as slower conceptually and treated this way, they may have more trouble catching up.

One of the questions that has not been studied extensively is how much does opportunity to visualize, encouragement to see, affect whether children develop visual imagery to a great extent and how much is it an inherent capacity, such as absolute pitch. When we see the kind of environment people live in, their living pace, the art forms available to them, the kind of schooling they have, how they develop the perceptual constancies and the conservation of elements, we can surmise that experience plays a role in the capacity to develop visual imagery.

A critical time comes when teachers who have visual imagery assume that their students have this resource and ask their

students to create or express from memory. Some students have resources, others do not. Some may need immediate visual stimuli to get them started, others may have so much imagery going on inside their heads they need little stimulation or motivation from the outside. In other cases, students stuck with some images need encouragement to develop more flexible images.

Although there is no research to substantiate it, people may have highly developed capacities for visual imagery, but their imagery may be stereotyped. Learning to see visually rather than through recognition could help them develop more detailed images.

The children or adults who grow up dealing with abstract concepts of things miss much of the beauty of changing sizes, shapes, and colors in their environment and can more easily ignore them when they are offensive. Rural children who see so much visually may become disoriented when faced with the complexity of urban life until they learn to block out some of the detail. Urban children moving to the country may miss much of what is there to be enjoyed because they have not developed their capacities to enjoy visually.

Both urban and rural children can learn to see both ways. Students with rich visual imagery can extend the range and kinds of images they have. Those who do not have visual images may only need opportunities and rewards for seeing in detail, for learning to see with the constancies and without them. Most of us have learned some kinds of behavioral blinders, but probably many of us can learn to see and enjoy much more.

DESIGN AND PERCEPTION

The organizing processes of design appear to be closely related to the ways people sort and organize visual information. Theories

and research on visual perception processes in psychology and anthropology contribute to our understanding of design. We have taught design both before and after studying perceptual research. We find that the studies help clarify problems students have in designing. They help intuitive designers understand their own processes, and they help people who believe they cannot design by analyzing how designing is related to their own processes of seeing. They do this by learning to understand how they sort information when they see and how this sorting process, creating similarities and differences, can be used to create order and variety in their environment. In Part Two we explored these basic processes. Here we provide an underlying theoretical framework for it. As new research and new theories develop, we assume we will understand these processes more than we do at the present time.

Several different levels of operations affect how we perceive, the things our cultural experience has trained us to pay attention to, and our cognitive style for handling information. Designers sort and organize visual information through similarity, proximity, continuity and closure, figure and ground. But the kind of forms, shapes, colors, and textures used will depend either on their background culture or the people for whom they are designing. Even the ways figure-ground is symbolized depend on whether the cultural experiences of the designers encourage two-dimensional or three-dimensional organization of things in space; whether ideas are organized linearly or organically, or in terms of physical perspective. These tendencies are closely related to the designers' concepts about the nature of reality. They may think of people as part of the environment or separate from and looking at it.

In this section we are concerned with visual perception information handling that appears to underly all human art—the processing that orders the information regardless of what the cultural messages are. Just as grammar, syntax, and linguistic processes can carry myriad messages, so visual design is the vehicle for carrying messages. Whether the designer and the viewer have the same information depends on how well the cultures and personalities of designer and viewers match.

This psychocultural approach to perception is eclectic, as no one theory of perception focuses on the breadth of behaviors needed to explore what goes on in drawing and design. Kennedy's analysis (1974) of the different theories supports our view that each theory helps us understand part of the system, so they may not be as contradictory as many assume. We have relied heavily on the Gestalt theories on the organizing processes. But we have seen them as underlying and necessary but not the only factors in perception.

We are also concerned with prior experience as are the constructionist theorists. People use mental images and knowledge they have learned in the past to help see things they look at in the present. As Neisser (1967) has pointed out, we do not respond simply to the organization that we see, but we use what is there, our organization of it and our prior experience. We continually create a workable visual environment for ourselves, attending to some things and ignoring others, depending on the situation and our prior experience in such situations.

Gibson (1950) has been concerned with what is called the ecological or natural view. He believes it is the nature of textures that tells us what surfaces are and the depth of surfaces on three-dimensional planes. As people have more experience, they are able to discriminate more and get more information from their environment.

We have also included in our theories of perception the effects of learning different cognitive styles which, in turn, affect how we will handle information. Further, we have stressed the effects of child-rearing practices derived from cultural values and belief systems and the effects of living in specific environments as important variables in the kind of visual learning children will have.

SOCIAL-PHYSICAL DIFFERENCES IN USE OF SPACE

In a reassessment of his studies of personal space, Sommer (1974) decided it was too restrictive to try and identify what a given person's personal space was and then build that space so it could be used by others. He found, for example, that there is no ideal library reading situation that fits all people: some like to be with other readers, some want isolation, some more space at tables than others. He feels that more research needs to be done with design problems to understand the diversity of ways space is used. Sommer feels that the main value of his personal-space studies is that they identify the different needs of individuals. We have used his ideas in education and extended them to mean the changing space used by individuals and groups as their behaviors or the situations change.

Cultural Traditions for Using Space

One of the most interesting studies done of how differently people from different cultural backgrounds learn to use space was undertaken by Scheflen (1971). He shows how we learn our habits for using space from our social and material culture, much as we

learn a language from the people with whom we grow up. The whole ecology in which we learn to be human is highly structured and organized before we arrive. When we move to other environments, we carry our social organizations and as much of the physical culture that supports it with us. He studied diverse people in one area of the Bronx to see how they used the spaces provided. Extensive video taping of people in visible areas of their homes was undertaken. His findings give us important data about the variables in the uses of space. There was one serious problem with this research; it was an invasion of privacy and the author has since stopped. For this reason, we are not identifying the ethnic groups but only the diversity of groups' responses. The problem is compounded by the fact that we have little or no such research on middle-class people. But we can become aware of the diversity of backgrounds possible and gain understanding of why different students respond differently to the uses of space prescribed in schools and to environmental design activities.

Each person is an individual user of space, but his or her use of space depends on how it is shared with others, how the space is originally divided, how many people share it, where the individual stands in the hierarchy of the group, and what the values of the group are toward sharing space with which members of the group. It is in these contexts that individual children learn how to use space.

Illustrations of how differently children learn to use space can be drawn from Scheflen's samples of space usage. The most crowded family observed included two parents and five teenage sons living in a one-bedroom apartment. Both living room and kitchen had beds in them.

Scheflen found that the different groups have different attitudes toward space re-

lations between people. This affects how workable the space is. In one group the families sit close together on the sofa, arms around each other, talking and watching television. When there is no company, there is room for everyone to sit. Children and adolescents are not allowed out of the apartment much, so apartments are used heavily. Parents and children in another ethnic group do not sit as close to each other. Some families keep children out of both kitchens and living rooms; teenagers have more freedom to be away. But the researchers found two types of families in this ethnic group at this socioeconomic level: those who used the street extensively as a place to be and those who did not. These groups did not mix and were not welcome in each other's territory, though they lived in the same neighborhood and had the same ethnic background. Teenagers and adult males from the street-oriented group use the family living space much less than those in the other group.

In crowded conditions, more people have to stand, as there is no place to sit, but there is more freedom to use gestures when standing than sitting. But gestures also take up space. Scheflen's observations of body gestures show that some people take up much more space than others. He cites some ethnic groups as needing a foot or more on each side for gesturing. Sometimes they will not talk in a group until they have enough space to gesture adequately to communicate. Others keep their elbows close to their sides using about six inches on each side for gesturing.

Still other people gesture very little, and what gesturing they do is in front of the body. Each of these groups of people need and use different kinds of space in talking and communicating with each other. Studies of Ekistics (the amount of space people use in social interaction with each other) with populations around the world show

that different cultural groups vary in the amount of distance they will tolerate between friends, family, strangers.

When women from the different ethnic groups were asked what they did when they wanted to be alone, the question seemed meaningless to many mothers from the ethnic group with closely knit family ties. Other women from this same group indicated being alone meant being with their families. Women from other ethnic groups responded they went wherever was less crowded or vacant at the moment.

In some households certain spaces are considered as belonging to the mother, particularly the kitchen and living room. What one does in those spaces is under her control. This is often the case where she is sole parent. The territorial control members have over sites influences how people relate to each other and use space.

Who has the right to certain places depends on a given situation at a given time—how many people are present, how many are guests, what the status is of the people. The different ethnic groups have different patterns for structuring the flow of events. Each member seems to know the "rules of the game" even though he or she may overstep the rules at times. When a person has to take over another person's role, he or she tends to take over that person's use of space.

Scheflen stresses that no one body gesture or cultural pattern of space between people can be understood by studying it alone. The things people do cannot be understood just by assessing culture, but personality, culture, and the restraints of the physical environment all contribute. Scheflen observed many places where the flow of people through limited spaces required that people change their normal behavior. Some people pace while talking in order to have the space they need to use their learned way of communicating and relating. The limits

of space affect territory. All these variables, ethnic family group relations, body language, distance between people, numbers of people, sizes and conditions of spaces, interact to create the on-going flow of patterned relationships. In Part Four we described some organized and disorganized homes in which the ways the places were ordered also affected the quality of experience. Scheflen did not attend to these qualities but he did observe the artifacts of a place and their condition in relation to the individual values of order and confusion and the ways the space was interpreted and subsequent behavior in it.

Such research opens up all kinds of questions for educators, particularly art teachers, who help children and adolescents understand how they use space and become more aware of how the qualities of space affect the quality of their lives. Much more research is needed to find out how children in these different situations think of themselves in relation to space and to other people.

Children's Uses of Play Space

Studies of children's use of play equipment, for example, must be undertaken in terms of their culturally learned spatial habits before generalizations can be made about which kinds of equipment produce the most creative play. Hayward, Rothenberg, and Beasley (1973) did an extensive observational and interview study of children using a traditional, a sculptured, and a junk playground. They found that the kind of play was related to the kind of environment, the junk one stimulating the most varied responses. Their study should be replicated with students from different cultural-spatial backgrounds to see if difference in background affects responses to play equipment.

PSYCHOSOCIAL BEHAVIOR AND ART

A third area of research in psychology, with implications for art, relates personality as it is developing in the child to ability to respond to the environment through art.

Wallach and Thomas (1963) asked the following questions. (1) Does the nature of an individual's environment—isolated or not—change the expansiveness or constriction of his or her drawings? (2) Do individuals with some types of personality traits react through their drawings more strongly to one type of experience than another?

Effects of Environment on Drawing

Eighty freshman college women served as subjects in an experiment. They listened to music, wrote stories related to the music, and drew pictures related to the stories. Then they doodled to the same music. Three samples of doodles were obtained from each woman. Then they were randomly assigned to two groups. Group one women were isolated in an almost bare sound-resistant room, without a timepiece, for one hour. Then they repeated the doodling-to-music sequence. Group two spent the hour in smaller groups of six, discussing rules in their dormitories; then they repeated the doodling test. Later, the women were tested on the Mudsley Personality Inventory to see how they scored on extroversion-introversion and on their degree of anxiety. (These two dimensions have little relation to each other; one finds both high- and low-anxiety introverts and high- and low-anxiety extroverts.) A comparison showed that group two had twice as much expansiveness (amount of space used) in their drawings after the social interaction situation.

When the scores on the anxiety scale were compared to the two social situations,

isolation and interaction, quite different results were shown. Low-anxiety women showed little or no increase in expansiveness after isolation, but low-anxiety women who were in the social interaction situation increased seven times in expansiveness. By contrast, high-anxiety women showed almost as much expansiveness after isolation as after interaction, but much less than the low-anxiety women. This indicates that expansive behavior of low-anxiety people is more affected by the immediate environment than is the expansive behavior of highly anxious people. One suggested reason may be that anxious people's anxiety is operating so strongly that their expansive behavior is little affected by these particular variations in the environment.

When the more extroversive and the more introversive women's graphic responses were compared, strong differences appeared. The extroverts were almost two-and-one-half times as expansive after being in the interaction situation than after being in isolation. The introverts were only slightly more expansive in their drawings after being in the interacting situation than after being in isolation. This indicates that introverts were less affected by the environment.

There has been an assumption among art educators that an art room where pupils are allowed freedom to talk and move about is more conducive to creativity than a room where everyone works alone and does not talk. If we believe that more expansive expression usually tends to be more creative than restrictive expression and that all our pupils are extroversive, this assumption might be valid. This study leads us to question whether one kind of environment is best for everyone.

When the groups of women as a whole were compared in the two situations, the socialization was more effective in modifying them toward more expansive drawing.

But the introversive women were the least affected. A teacher should not be surprised if his or her efforts to motivate introversive pupils through social interaction are not effective.

Another assumption among art teachers is that it is good for children to work big. They should have large sheets of paper and be encouraged to fill all the space. Whether this kind of expansiveness leads to any specific aesthetic or educational goal needs investigation. But if a teacher has such a goal, then the teacher should use different motivations for the high-anxiety children. Further, a teacher may think a low-anxiety child is developing very fast in art because he or she is working bigger and bigger, when actually it is the social situation that is changing and influencing the child's behavior. If the same child were working alone, he or she might make smaller art products again.

Understanding some of the effects of anxiety on art-related behaviors can help teachers find better ways of encouraging anxious children who are little affected by changes in the classroom environment.

Effects of Anxiety

There is a considerable body of research that indicates that people use fewer cues in situations where anxiety is aroused (Knights, 1965). In a study of children's anxiety and ability to discriminate, Knights gave a test of anxiety to 197 eight- and nine-year-old, third-grade boys from three elementary schools. He selected 66 boys representing the extremes and the middle of each test. His purpose was to find out whether the highly anxious boys would be less accurate in visual discrimination because of test situations or because of the content of what is presented. The boys were shown four slides:

three had social scenes, one representing aggression (a boy kicking a man), another nurture (a man hugging a boy), and another neutrality (a man and a boy walking); the fourth slide showed geometric shapes. After each showing of a slide, the boys were briefly shown four slides simultaneously, in four degrees of variation from the original. The task was to select the one most like the original. Scores were determined by whether the response was correct or, if incorrect, how far from the original slide picture the error was. High-anxiety children were *much less accurate* and *made larger errors* than either the average-anxiety or low-anxiety children. When they made errors, they tended to pick the pictures *most unlike the original.* The nature of the picture, whether it was aggression, nurture, neutrality, or the geometric shapes, made little difference in performance.

When a longer or shorter period was given for the testing, the highly anxious children made more mistakes under the *longer situation* while the less anxious children improved their scores with more time.

McCoy (1965) tested 28 high-anxiety and 28 low-anxiety fourth-grade boys on two hypotheses: (1) that highly anxious children tend to see all tasks more as test situations and (2) that fear of failure is basic to the anxiety aroused by test situations.

On the first test, the boys were given simple tracing tasks. One half of each group received the instructions as if the task was a game to play; the other half was told that it was a test of their ability. The low-anxiety boys made fewer mistakes when they thought it was a test than when they thought it was a game. *No differences between situations were found for the high-anxiety students,* supporting the first hypothesis.

In the second test, a two-part drawing assignment, the children were asked to make a "picture" and draw a "Poskon," a

nonsense title for an ambiguous task. Again, half the group was told that the task was a game, the other half that it was a test. No differences were found between the game and test situations for the "picture" task for the high-anxiety students. But in the "Poskon" task, they drew much smaller drawings and did less talking. In the test situation of the ambiguous task, they switched colors and materials more than in the game situation. The low-anxiety children used more colors and materials in the game situation. This study supports the second hypothesis in part: when the task is ambiguous and the students are high anxiety, fear of failure is greater.

Penny (1965) compared fourth-, fifth-, and sixth-grade children's scores on tests of reactive curiosity (the seeking of varied stimulation in a variety of experiences) with anxiety. He found that children who seek novelty of experience in many situations are generally less anxious. The trend was particularly evident at fourth grade, though the direction was similar at grades five and six.

Several children's tendencies are important for teachers to know. High-anxiety children's multiple use of colors and materials may be a more desperate attempt to solve a problem by *changing those things available* while low-anxiety children's similar behavior may be a more playful creative expression. If we were to judge children's drawings, we would have to know the nature of the situation in which they performed them as well as their *anxiety level* before we could even begin to find out what the drawings meant in terms of creative or artistic ability.

How a person with an identifiable trait performs depends on the situation and his or her other traits as well. Anxiety may be a temporary response in a strange environment that changes as the environment becomes familiar, or it may be the result of

long experience in anxiety-producing situations and may have become a habit. Teachers should delay their categorization of a child until they have ample information.

McCoy's study would indicate that a play situation does not motivate low-anxiety boys as much as does a test situation. This finding may explain the lack of growth in art by boys who are not challenged in a classroom where art is considered "play."

These three studies with school-age children indicate that highly anxious children who have learned that school situations are threatening or who bring their anxieties with them from situations in the home or outside the school are not performing as well as less anxious children. Not only do they get less visual information from their environment, but what they do get is less likely to be correct. Further, their errors are greater than are those of low-anxiety children. Whether school tasks are presented as tests or as play, these children see them as threatening.

Up to this point we have discussed differences in cognitive styles that can influence the ways children respond in art activities. Now we consider learned response sets: ways a child's learning in the past operates to direct the way he or she learns in the present.

What we know about a thing operates as a control over the way we can see it. This body of knowledge has built a response set. The way we perceive the qualities of an object, its usefulness, is affected by the "set" of prior training.

Effects of Prior Habits on Problem Solving

Birch and Rabinowitz (1951) directed experiments on functional fixedness, comparing two groups of students in their use of a switch and a relay. A switch and a relay have practically the same function (to make, break, or change the connections in an electrical circuit). They are about the same size, although they look different. In this training, one group examined a switch, learned what it would do, and learned to recognize it as an object having a definite use. The other group did the same with the relay. After this initial training, the students were tested individually with the two-string problem—tying together two strings and hanging them from the ceiling too far apart to be reached at the same time. The purpose was not to see how they would solve the problem, but rather which of the two objects on the table, the switch or the relay, they would use. (The solution is to tie an object on one string and swing it like a pendulum so that both strings can be brought together.) Most of the students used as a weight the piece of equipment that they *had not* learned about. If they learned what a switch was, they knew it was a switch, not a weight. A third group, all engineering students who had used both kinds of equipment, were almost equally divided in their choice of switch or relay. After the test, the students were asked why they had chosen one piece or the other. They gave many rationalizations, and some students were vehement about the correctness of their solutions. This type of response set is called *functional fixedness*.

In another experiment, students were asked to match the colors of cut-out shapes with colors on a color wheel. The subjects watched as the shapes were cut out of the *same sheet of orange paper*. When presented with the paper figure of a banana and then asked to turn away and select the matching color on the wheel, the students tended to choose the yellow hues. With other objects, including figures of a carrot and a tomato, they selected a color on the wheel near the

color of the real object as learned from past experience, even though the task was to match the exact color of the shape which they had seen cut from the same orange paper. In this case, the immediate prior learning (that all the paper shapes were the same color) was not as cogent as was the life-long learning about the objects (Bruner, et al., 1951).

The two studies indicate that, when prior learnings conflict, the stronger habitual learning tends to prevail. With the switch and the relay, all the students had the same visual image of the two instruments reflected in the retinas of their eyes. Point I of the P.D. process was in operation in their choice of qualities to respond to. Their preparation for the task was different. Knowledge of the mechanical parts identified (and limited) the uses students could see in one object. Size and weight (qualities needed to construct a pendulum) were easier to identify with the object that was unfamiliar, whose specific qualities and functions were less well known.

In the second experiment, the well-known shapes of familiar objects appeared to be the most important factor in identifying them, even when the color was the visual quality to be matched. Point IV was in operation when the students grouped the visual information into categories they knew best.

Another learned habit is assuming that a certain pattern of lines means a certain shape. At the Hanover Institute there is a wall with three peepholes. People who look through the holes see cubes, and all the cubes look alike. Yet, when they go around to the back of the wall, they see what they have been looking at: (1) a wire cube-shape, (2) a drawing of a cube on a board, and (3) a construction of wires and strings that does not resemble a cube from any viewpoint except that of the peephole (Lawrence, 1949, pp. 67–69).

The revelation that their perceptions are not always adequate is disturbing to some of these observers; they have always depended on their perceptions to tell them how to respond or to behave. They discover that their perceptions can be unreliable.

As teachers, we can recognize several major implications from these experiments: (1) Children handle differently the visual information they receive in the classroom. (2) Since these differences appear to be learned, more adequate means of handling visual information can be taught. (3) Teachers can prepare children for more complex visual tasks by helping them to understand the nature of new things in terms of what they already know.

If a teacher should ask children to respond through art to an object that is new to them, they might respond in the same way that the students trained to use the switch responded to the relay. They might ignore many of its properties. If they had explored the functions of the object, learned a great deal about it, they would tend to be prepared to look for more details in it. Also, if they learn to look for many possible uses of things, they will not be so likely to experience functional fixedness (being limited to the uses one has learned).

CREATIVITY

Helping children and adolescents become more creative has been a central value in art education theory and practice for many years. The term has been interpreted in many ways. Often work was called creative because the students' perceptions, relationships to space, and culture was different from the teacher or other students.

There are many ways that an art work can be considered creative. The message could be unique or different from what is

expected from students of a given background or experience. The message or the objects depicted could be familiar, but the way of looking at or interpreting them is different. Both the message and the way of looking could be common, but the organization of visual elements in presenting the message could be more original. The creativity could be in the ways materials are used to produce the effects. Any combination or all of these could be developed in unique, original ways. Teachers who are more concerned about message than design or use of media than interpretation might reward as creative those students who were creative in the way they valued most important. The word *creative* has many meanings; we must know how others use the term to communicate.

Social Needs for Creativity

Psychologists have helped us understand what some of the traits are that lead to creativity in perceptions, in ideas, in drawing and design, and in problem solving. The capacities to be independent, flexible, fluent, playful, to be open to new experience all provide children and adults with the attributes needed to be creative, but do not necessarily ensure it unless avenues to explore, invent, manipulate, and solve problems are available. Research in this area was highly developed in the 1950s and early 1960s, but like many trends in the social sciences, it has not received the attention it should have since then. Surely the need for people to creatively solve the problems of decreased resources and to create more humane environments with available, ecologically sound resources is needed as never before. The kinds of creativity most needed in this age are: (1) *Seeing new relationships between conditions and qualities*

such as those found in art and in our environment, social needs and aesthetic needs, individual needs for identity as expressed in art and environment, and the shared needs for identity of community groups. (2) *Seeing the flow of people, events, environments as they interact and affect each other through time and space* and finding ways to modify behavior and environments to serve people more humanely, and aesthetically. (3) *Preserving and developing individuality through expression of individual experience in a period when survival is so dependent on group processes and decision making.* (4) *Using materials for given purposes in terms of their functional, social, and ecological costs.*

Never have we needed creative problem-solving abilities so much. Never have we needed to recognize the interdependence of the economic, social, political, physical, and aesthetic more than now. Creativity is needed to see the relationships and their impact to solve the complexities of human-environment problems. We need to refocus creativity onto restructuring, reusing, adopting, and synthesizing instead of always producing and extending.

This may seem like a large order to a teacher; yet, when you look at your curriculum, you are helping students understand in broad areas. Ask yourself: How much am I helping my students build bridges among these areas? Do I encourage them to creatively look for relationships among subjects? Do I give them opportunities and rewards for solving problems in new and original ways that draw upon the different content areas in the whole curriculum? If you rigidly separate the areas by time and by method of study, you decrease students' opportunities for creative multivariant problem solving.

If you are a special art teacher, do you keep up with what is going on in other subject matter areas so you can help your stu-

dents see the relationships between creative work in art and other areas of the school? Is your concept of art too limited to allow students to explore the ways design strategies can be used to solve other problems as well? Are you helping your students evaluate the ecological and social impact of the materials they use and their work's influence on society? Are you helping students discover ways to be creative that are ecologically sound? Are you including activities that encourage constructive, aesthetically honest reuse of materials? Sometimes students value recycling more than creating more profound works of art. When a student solves the problem of the need to reuse but sublimates this to the quality of the art work he or she produces, a higher order of creative problem solving results.

The research on creativity will give us some help in working with individual students. Some of it has helped identify the traits, aptitudes, and personalities of creative people. These help us see what kinds of behaviors should be encouraged. Other studies have compared creativity with other aptitudes, such as the abilities measured on intelligence tests. These studies help us understand differences in students. Some research has been done to see how much creativity can be developed. These can give us leads as to strategies we could try.

Creative Children in Classrooms

Wallach and Kagan (1965) studied middle-class fifth-grade children's aptitudes for creative and intellectual activities. They defined creativity as the ability to make many unique associations in a playful, open way. Creative students were not seeking closure or "correct" answers as much as being involved with the creative process. Using this criterion, the researchers found that high

creativity did not stand in correlation with high I.Q. High creativity can be found in all normal I.Q. ranges, and high I.Q. students in all ranges of creativity. In studying these different combinations of students, Wallach and Kagan found that:

1. Children high in both areas could operate at different levels without conflict, playfully one time and seriously at others. They could exercise considerable control over what they were doing at one time and be very free at others. Thus, they could adapt more easily to different learning environments.

2. Those children who were high in creativity but less intelligent had a difficult time in traditional schools. This probably tended to make them feel unworthy and inadequate. But in less stressful situations, where they had more freedom to work, the researchers found they could develop cognitively. One wonders if their mode of solving problems—more openly and creatively—was the reason they measured lower on I.Q. tests. The tests did not measure this kind of response.

3. Children whose creative ability was limited but who had a high aptitude for school achievement (in those areas tested by I.Q. tests) were most devoted to achieving in school and most intolerant of failure.

4. Those children who had not developed either an aptitude for achieving in school or a playful creative mode for learning and solving problems did not appear to understand what school was about and spent their time in either intense physical activity or in passive retreat from the situation.

Getzels and Jackson (1962) found that teachers tend to like the high I.Q., less creative students because they caused less trouble in the classroom. The teachers not knowing their students' scores on creativity tests ranked this group as the most outstanding. Students of not extremely high I.Q. but still in the upper ranges who were also highly creative were ranked much lower by

teachers, apparently because of their independence.

Creativity in Adults

In his study of creative architects, MacKinnon (1961) found that in their childhood they had been encouraged to be independent and had had many opportunities to explore. They reported that they had had little pressure to conform. They were exposed to different kinds of environments to which they learned to adapt. Also, most of these highly creative architects were often alone as children and they were encouraged to develop at their own pace.

From this last study we can surmise that these architects had parents and teachers who encouraged their independent, creative problem solving at their own pace. This finding, like the group two children in the Wallach and Kagan study and the high creatives of moderate high I.Q. in the Getzels and Jackson study, may indicate a group of students who have problems in traditional learning situations but who, if given opportunities to learn and study in their more creative mode, may become adults who can help society solve some of its most critical problems.

The creative people studied by MacKinnon and his colleagues preferred perceptually complex and asymmetrical rather than symmetrical things. This can be as much the result of opportunities to see as to an inherent capacity. They quickly made unusual associations to words presented them; that is, they quickly saw a broader range of relationships than less creative people. This trait could have been developed in their childhood when they could see and identify things more openly rather than always seeking the most right answer or label. They had learned to value the theoretical

and aesthetic more than other people. Here again, environment and opportunity to learn were probably big factors. These creative people also showed an openness to experience and enjoy perceptual complexity outside of their own inner experiences and feelings.

Guilford and associates' more statistically based study (1956) of creativity identifies fluency, flexibility, and originality as the key factors among creative people. People who have many ideas (are fluent) and who are not rigidly patterned in their thinking processes (are flexible) have more opportunity to be original than people who have fewer ideas in the same amount of time, and think in fixed categories.

All of these traits are in part learned. So we can ask ourselves if we are encouraging students' creative behavior by:

1. Asking them to find many workable answers to problems rather than single, most right ones.

2. Encouraging them to explore more complex visual things as they are ready.

3. Exploring the effects of symmetry and asymmetry.

4. Helping them learn to be playful and open to experience sometimes and rigorous and specific other times; helping them to learn that both experiences are valuable and useful in solving problems.

5. Looking at things in many ways—at different angles, distances, and lights, touching and feeling.

Those children who are highly creative and intelligent need challenging opportunities to solve problems both ways. Those highly creative but of moderately high intelligence need more open experiences and time to develop both ways. Children and adolescents who are not so creative need many more experiences that encourage their

openness and awareness. Children who are low in creativity and intelligence (as measured by academic subject aptitude for school) need experiences that are related to their background. The environment in which children learn strongly affects their perceptual development, and if the environment for learning becomes more stimulating, students' learning increases, but they will not necessarily proceed at the same rate as students who have been in that environment longer. Their slower rate does not mean they are less able, only that their experience in learning has been in a different context. Kagan and Klein (1973) eloquently describe the situation: "There are few dumb children in the world if one classifies them from the perspective of the community of adaptation, but millions of dumb children if one classifies them from the perspective of another society" (p. 161). It seems reasonable to assume from the evidence that creative behavior is, at least in part, learned and it depends on opportunities, rewards, and encouragement. This learning takes place in the home and in school.

Developing Creative Ability

Few studies have been made to see if creativity can be taught or if creativity-stimulating learning environments can be developed which will stimulate creativity. A study was conducted on the effects of such a curriculum on academically superior junior high school students (McFee, 1968). McFee assumed that creative behavior is a complex of abilities that most people have in some degree, depending upon both their unique potential and their opportunity for development.

Design, rather than drawing and painting, was selected for the course because the researchers believed that the students would have less resistance to the "designer" than

to the "artist" stereotype. Finally, the designing process appeared to be more easily analyzed, so that tasks could be formulated that involved the kinds of abilities identified in studies of highly creative scientists and architects, the subjects of most of the prior research.

The subjects were ninth-grade students who scored above the ninetieth percentile on the School and College Ability Tests. An experimental group was made up of those students who elected to take the test, whose parents approved, and whose schedules allowed. The controls were matched by SCAT and grade scores. They included students who were eliminated by choice, by parents' concern about an art class, or by scheduling programs.

A four-unit guide was developed for the course. The *first* unit introduced students to open-ended problem solving. The researcher presented some practical activities in order to stimulate initial involvement as the students discovered their need for flexibility in solving problems in unique ways. For example, students were asked to explore multiple goals while using limited tools and materials. In other instances, the goals, tools, and materials were limited, but students could explore the uses of the materials to reach the goal. In still other activities, a specific goal was identified and multiple materials were made available for reaching it. The *second* unit explored the dynamics of perceptual organization: proximity, similarity, closure, continuity, and figure and ground (as they are related to the interaction of form, line, and color in design). Open-ended problems in design were assigned using these principles of interaction.

The *third* unit was designed to increase students' awareness of three-dimensional space, to help them overcome the limitations of conceptual reality (seeing things in terms of their knowledge and conceptual stereo-

typing), and to help them to develop a more flexible awareness of changing spatial relationships, the size and shape of form and the value of intensity of color. Tasks were assigned in which creative manipulation of space was the goal.

The *fourth* unit, more open-ended, drew upon abilities it was hoped had been developed in the three prior units. The final task was selected, planned, and developed by the students.

Another section in the guide was a supplementary source of information for the teacher. It consisted of specific materials from the research on creativity, which could be used for class discussion and student reading. The then current books on creativity were made available to students. Twenty books of biography and autobiography of men and women of recent times whose generally acknowledged creative brilliance in the sciences and arts were made available, and reading assignments were made. The students examined these last materials in order to identify the motivations and behaviors that appeared to lead these people to creativity.

The curriculum included the guide and its assignments, the readings, and lectures by resource people throughout the four units. These people were selected for the excellence of their creative work. They included an internationally known mathematician, a contemporary painter, a leading physician, a philosopher-chemist, and an electronics engineer who had made major inventions.

All three modes of cognition and expression were used — conceptual and linguistic, perceptual, and iconic and manipulative. Children read, listened, looked, and solved problems mentally and physically.

There were pre- and post-tests on creativity of the experimental group and the control group at the beginning and end of the six-month period. The experimental group participated in the creativity class, but otherwise joined the control group for classes designed for upper-ability groups. The evaluation was made on the difference in degree and direction of change between the two groups.

The tests measured the students in the three traits of creativity: Guilford's tests of fluency, flexibility, and originality (Guilford et al., 1956). In the *fluency* category, there were two tests in which the experimental group improved significantly more than did the control group. The associational fluency test requires speed in making meaningful relationships — a stimulus word is given and the subject gives as many associated words as possible. The word fluency test requires that the subject produce as many words as possible within a letter class.

Adaptive *flexibility* was the second general trait of the creativity that Guilford identified in a factor analysis on all his tests with ninth-grade students (Guilford et al., 1961). Guilford found that his test, Match Problems II, was the most effective in identifying this ability. A great deal of flexibility is needed to overcome the sets that are presented so that the problem can be solved. The experimental group's improvement was significantly greater than the control's.

In the third trait, *originality*, Guilford found Plot Titles High and Alternate Uses the strongest tests. In the Plot Titles High Test (write unique titles to a paragraph story), the experimental group made a significant improvement; the control group did not. In the Alternate Uses Test (many alternatives are identified), the experimental group again made a significantly greater improvement than did the control group.

It is interesting to note that, in some measure, in each of the major areas of crea-

tive behavior that Guilford has identified, the experimental group improved significantly over the control group. One of the important implications of these findings in this experimental class, in which a large part of the activities involved manipulation of tools and materials and the creation of visual symbols and organizations, is that significant changes on conceptual tests of creativity resulted. This result would lead us to consider that some degree of transfer of training from one kind of activity to another may have taken place.

With the creativity measures, a personality inventory, the Myers-Briggs Type Indicator (Myers-Briggs, 1962), was given. This inventory is designed to measure four dimensions of personality: introversion-extroversion, sensory-intuitive, thinking-feeling, and perceptual-judgmental. No significant differences were found in the first dimension—shifts to or from introversion or extroversion.

In the second dimension of the personality test, an interesting shift was found. It concerned the use of sensation or intuition as a preferred mode of becoming aware. The individual who uses sensory (S) cues depends upon direct evidence. The one who relates and associates in the perceptual process is more intuitive (called the N dimension). A significant increase in N was found in the experimental group compared to the control group. This result indicates growth in more open use of perceptions, allowing the students' visual awareness to become the means for their seeing remote relationships, more possibilities from what they perceive, than they would find if they used only direct sensory information.

In the third dimension, which concerns the use of feeling (F) in contrast to thinking (T), significant shifts were again found. The experimental group had greater increase in the use of feeling. The dependence on reason

appeared to be strong in most of these students in the pretest situation. During this same period, the control group went down in the use of feeling.

In the fourth dimension, the effects of the perceptual training in the experimental class seem to be evidence. They increased very significantly while the controls decreased slightly. This dimension is an analysis of whether an individual becomes aware of an object by referring to its perceptual (P) qualities or by simply making a judgment (J) about it. When the P trait is combined with the use of intuition (N), a more creative response to experience can be expected. On the basis of the second, third, and fourth parts of the Myers-Briggs test, the experimental group became more intuitive, more dependent upon feeling, and more aware of perceptual qualities.

MacKinnon's comparison (1961) of creative and less creative architects is interesting in terms of the students in the creativity class. MacKinnon says of creative architects that they require both scientific and artistic creativity. There may be some parallel with the experience of academically successful students going into a creative design class. Most of the students had little or no prior art training. According to their answers in a questionnaire, these students rated their preferences for classes in the following order: reading, social studies, science, mathematics, and languages. Art was their sixth choice. If these students showed increased strengths in the personality dimensions that are characteristic of the most creative architects, the study lends credence to the possibility that the students' problem-solving and perceptual experience in design contributed to their NP development.

The most creative architects had much higher preference for the use of perception than judgment in the JP area of the Myers-Briggs test. This was the one area in the

MacKinnon study of creative persons in which a strong preference was found. In other groups in his study, the proportion of J's to P's was about the same. The use of P more than J indicates an openness to perceptual experience, looking for possibilities and relationships rather than coming to a judgment which tends to stop the perceiving.

The second parallel found between the creative architects and the students in the experimental group was in the intuitive compared to the sensory response. The students increased significantly in the N dimension. MacKinnon found a high use of intuition in all of the creative persons in all fields as well as among the architects.

These findings, along with student reports, lead us to believe that creativity can be developed and in line with the traits found among creative people generally, not just in the arts.

Cooke (1974) recently reanalyzed the original data of McFee's study of creativity to compare those students who scored high on assessments of their creative art work with scores on the creativity tests. Art objects done throughout the course were rated on the use of invention, asymmetry, integration, and sensitivity. She found that students whose work was not judged as high creative did improve on scores of creativity indicating the experience contributed to their creative development. Further, she found that within the whole experimental group there were wide differences in how much and on which tests students became more creative or less so. The number of subjects was too small to generalize about any one type of student, but it is clear that, even among academically superior students, those high or low in creative art work, and males and females, responded to the learning situation differently even though the group as a whole made significant progress on several creativity measures.

CULTURAL DIVERSITY IN PUBLIC SCHOOLS

We have seen how much physical environments and cultural values affect how people learn to see, whether they live in urban or rural areas, whether they come from groups that expect children to grow up fast or slow, and whether children are encouraged to be independent or dependent. We stressed the variety of kinds of values about art we have in different social groups in our society. We have some idea about how cultural styles of body language, gesture, status and role, and relations among peoples affect how families adapt to the spaces in which they have to live.

Now we must think some about the cultural traditions that contribute to this rich diversity of national character. Unfortunately, there is not nearly enough study except to describe generally. We have studies of so-called minority groups, groups that vary from those people who consider themselves in the dominant culture. But the dominant group seldom studies itself.

Also, the dominant group is still recovering from the turmoil of seeing itself challenged by the counterculture in the 1960s and from the disclosure of malpractice at the highest levels of government. This, coupled with the increased awareness that progress, in the traditional sense, cannot continue with limited resources, and economic change has produced greater flux than perhaps ever before. The recognition of civil rights has created a new resurgence in pride and self-worth in people of many different races and in women across many socioeconomic levels.

If pride and sense of self-worth can be maintained through periods of economic upheaval, we can expect that during the late twentieth century, considerable restructur-

ing of the patterns of cultural and social organization will develop.

Ethclass Differences

It will be increasingly more difficult to categorize people by sex or by ethnic origin or by social class, in terms of traits, interests, or abilities. Milton Gordon's concept (1964) of *ethclass*, which helped us identify differences in culture among people of the same ethnic groups at different socioeconomic levels, will probably become more difficult as the focus of limited resources on a worldwide scale causes a restructuring of the whole society. More than ever, we as teachers must work with individuals who have come from a great variety of backgrounds. We must see our students as people in process of change rather than in set categories. If we know that their experience or combinations of experiences can influence them to see and think in different ways, we have to try to understand how each one sees and thinks as a result of these experiences.

Children from street-corner societies may feel locked into closed school environments and their strongest motivation may be to get out. Certainly not to learn in such a restrictive, physical place. But some street-corner-conditioned children may long for an ordered, safe, contained place.

This knowledge should help us to be more flexible as we try to find ways to motivate, interest, and challenge students who do not respond when we treat them according to our stereotypes of sex, culture, or social class.

There will be students among any socioeconomic or subculture group who are at very different points in their acceptance or rejection of changing social mores concerning drug and alcohol use, sex practices, and sex role identification. Degge's study (1975)

of a junior high school art class shows the extremes as well as many variations found in one learning situation.

IMPLICATIONS FOR THEORIES OF CHILD DEVELOPMENT IN DRAWING

Theories of child development in art have focused on some aspects of development but not others. People who base their study on Piaget's theories are able to see relations between children's average drawing and his theories of cognitive development (Gardner, 1973; Lansing, 1969). But Hess-Berens, (1973), in a cross-cultural study relating Piaget's theory to children's drawings from different areas of the world, finds it is not universally supported. Also, she found wide ranges of variability at every age and the effects of culture and environment strong. Arnheim (1971) develops his psychology of art on the basis of perceptual development largely from Gestalt theories. Lowenfeld's theory is based on study of children's art development with assumptions about drawing as primarily based on stages of chronological development with environment playing a secondary role (Lowenfeld and Brittain, 1975). Eisner (1972) is more eclectic, considering socioeconomic as well as maturational factors in child development that affect performance in art. Harris' comprehensive study (1963) of child art is in relation to personality and intellectual growth. Lark-Horovitz, Lewis, and Luca (1967) assume that drawing is a genetically encoded development process rather than a process modified by experience.

All these theorists make contributions to our understanding, but no one theory can cover all the variables that influence development. Dennis (1960) found that in societies where drawing the human figure had strong

negative values, children's ability to draw the human figure decreased the older they became — the longer they were exposed to this value. This indicates that environmental factors were much stronger than biological development or age. The Orotchen children's drawings of humans were years behind their drawings of reindeer. Those objects that required their perceptual development were highly developed, those that did not were drawn most immaturely (Schubert, 1930). In cross-cultural analysis of children's drawings Anastasi and Foley (1936, 1938) found that children tended to learn the symbolic realism of their culture's art. The Orotchen children had no art to learn from, so they developed toward photographic realism of things they had to observe.

To adequately develop a theory of child development in art, cognitive, perceptual, cultural, and environmental factors must be considered, as well as biologically encoded development patterns. It is questionable whether it is possible to separate encoded from learned patterns, as learning starts at least at birth (Dobzhansky, 1962). To assess a child's development in art, we are safer to see where the child starts and see how he or she develops in terms of background experience in relation to the school environment. We certainly cannot evaluate a child's potential in art by comparing present work with other children's unless the opportunities to learn from their environments have been similar.

Then we would still have to find out if differences resulted from differences in cognitive style, being more analytical or global, impulsive or reflective, perceptual or verbal, dependent or independent. We would have to find out when the child learned the perceptual constancies and if he or she had perceptual training in three-dimensional space. Then we can see which students need help in learning to see, to be more

analytical or global as the art expression they seek may require, to be more reflective or more independent of the influences of others.

All the factors we have studied before influence how children and adolescents will see and draw. Though there has been a long-standing effort to categorize how children draw according to age, we now know that many experiential factors influence development as well as the child's own potential to learn. Children's and adolescents' drawings have been collected and categorized by ages to find average development without recording the kinds of environments and learnings they have experienced. We do not know if the drawings were made from memory or from looking at objects. Without this information, the averages are clusterings of so many kinds of information they actually have little meaning.

Children's scores on the Draw-a-Man Test correspond with intelligence. Since both intelligence test scores and Draw-a-Man Test scores are a ratio between mental age and chronological age, it would follow that there is considerable variability in drawing at every age. Harris (1963) also found that different norms had to be used in different cultures to score the test.

Lovano-Kerr (1969) tested children's drawing abilities at grade two through grade six. She found that, while average scores increased with age, so did variability. There was a greater range at third grade than second, fourth than third; at fifth grade it only decreased slightly, but by grade six the range was even greater. The lowest scores were only one point above the lowest second grades.

To understand a child's development, one would have to go far beyond his or her drawing to estimate the particular variation from "age-based norms." One would have to understand how the following variables had influenced his or her work:

1. The way the culture has directed his or her attention.

2. Cognitive style in handling information: more analytic or global, more reflective or impulsive.

3. How he or she learned to relate to three-dimensional space.

4. Development of and dependence on the perceptual constancies.

5. How home and school environment encouraged the child to develop the creative traits of fluency, flexibility, originality, playful attitudes, and independence of conformity.

6. The learned concepts and how visual information is related to these concepts.

7. The percepts he or she is aware of, ability to manipulate forms in space, and analyze relationships.

8. The richness or dullness of visual environment. Whether there are drawings in his or her environment.

9. Past experiences in art, whether supportive, encouraging, defeating, or inhibiting.

10. Adaptation to the school environment as contrasted with the spatial environment at home.

11. Attitudes toward art activities compared to the kinds of art in his or her background culture.

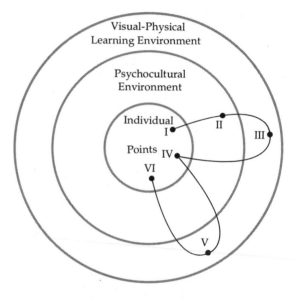

Figure 6.5 *Perception-Delineation III: a double feedback interaction system.*

SUMMARY OF PERCEPTION-DELINEATION III

Point I:
Readiness of Individual Students

Individual Differences in Modes of Knowing
cognating
perceptualizing
conceptualizing
manipulating
transacting
image making
verbalizing
affecting
communicating

Differences in Cognitive Styles
analytical-global
reflective-impulsive
field dependent-independent
visual-conceptual memory

Creative Aptitudes
fluency
flexibility
originality
playfulness
independence

openness to perceptions
intuitive
feeling

Cultural Effects on Abilities
kinds of I-spaces and shared spaces experienced
cultural values toward change, affect and
 emotion, art styles
concepts of what is art
preferences for order and variety
preferences for amount of visual detail
preferences for kinds of space
preferences for different design elements

Art Development
drawing dependence on spatial realities or
constancies
intuitive of analytic modes in using proximity,
 similarity, closure, figure and ground, environ-
 ment

Point II
Psychocultural Classroom Environment

between:
 teacher-students
 students-students
 home culture-school culture
 positions in culture change

Point III
Visual-Physical Learning Environment

cultural meaning of spaces and objects
individual and group spaces
order and variety
physical conditions

Point IV
Information Handling

in terms of individual:
 readiness
 psychocultural environment
 the visual-physical environment
 acceptance of new information

Point V
Delineating and Responding to Art

translating percepts and concepts into communi-
 cable visual images and symbols:
 giving form to design
 creating affect
 choosing appropriate tools and materials
 expressing responses to art
 evaluating environments
 critiquing art

Point VI
Feedback

of student development
of teaching effectiveness
assessing changes in readiness

TEACHING AND ASSESSMENT

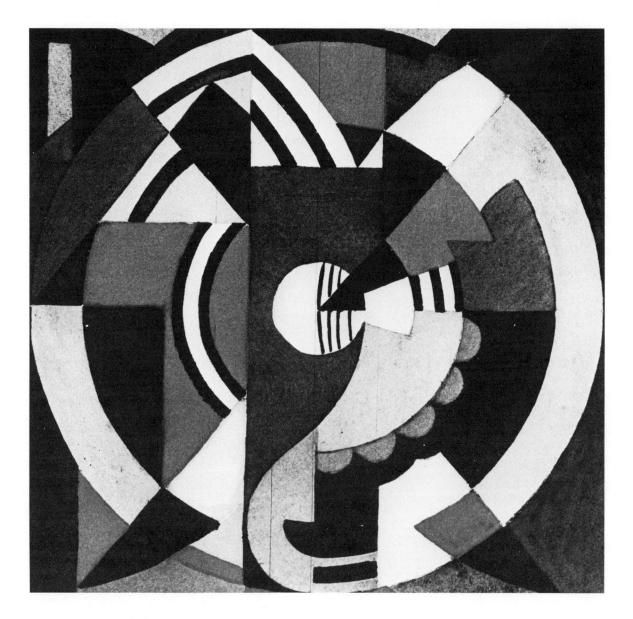

P.D. III AS A TEACHING THEORY

To bring the material of this book into focus for use in the classroom, we must look at the P.D. III theory as a teaching theory for reaching art education objectives. The theory will help you get information about your students at each point: (1) as you assess their readiness, (2) as you try to create a classroom psychosocial environment that is encouraging and supportive of children from different cultures, (3) as you select things to stimulate their interest in art and create with them a workable physical environment, (4) as you help them use the new information in terms of their readiness, (5) as you provide means for them to express and create through art or critique art and environments, and (6) as you and they assess what they have learned, how their readiness has changed so you can plan with them their next activities.

You and the students will be continually getting feedback about your effectiveness as a classroom coordinator, orchestrating readiness with environment and opportunities to express, create, and get feedback about progress. This process can then be measured against general objectives in art to see how your individualized instruction is helping students' progress.

POINT I
ASSESSING READINESS

Preferred Mode of Learning and Interacting

As your students work at Level 1 of each of the areas of art, watch for students who pre-fer to manipulate, to look, or talk about what they want to do. Highly verbal students may keep talking because they are insecure in manipulating and may need your special help and encouragement as they first try to draw or design. They may be conceptually able to handle more complexity than the task but not be able to manipulate tools well enough to satisfy themselves. You can try finding easier tools to use with ideas that challenge them, but encourage their verbalizing so they can continue to operate in a way in which they have been successful. Students who are highly developed perceptually usually have an easier time using tools to express the details they see and are more analytic of design. Some manipulative students do not like using pens or chalks. Instead, they want to move more concrete things and work in three dimensions. Success in the preferred mode is usually most important, but when that is established in a given area, the other two modes need development.

Students unevenly developed in these three modes will probably prefer to symbolize ideas through language or through icons and symbols. Visualizers and manipulators tend to prefer visual images (nonlinguistic); verbalizers write or talk about their ideas and feelings. Verbalizers would often rather read what someone wrote about a painting or a place than analyze it visually themselves. They prefer to respond to the art form after it has been translated into concepts.

Cognitive Styles

Watching students work and keeping a log during art classes every so often helps you see where students are in cognitive style and how they may be changing. A log will help you see which students have very short attention spans and quickly come to conclusions without analyzing things; which ones take more time.

Students' drawings or painting, if consistent over time, give clues to which students are analytical or global. Analytical students may want to create fresh first impressions achieved by global students; global students may question their work, not liking it but now knowing why.

Analytic students can be helped in making more global, fresh impressions by giving them sets to look at. Rather than reflecting on all the details, they can be encouraged to become more impulsive and just look at patterns of color, line, patterns of dark and light. Encourage them to use tools that can be used quickly and easily, so that they are not inhibited by having to analyze how the tool works. Their lack of skill may inhibit them at first but encourage them to keep trying until they get some results that please them. You may have to help them recognize their own progress.

Global students need time and encouragement to observe in more detail. Their globalness may be due to their dependence on authority figures and their inability to separate figure from ground or separate themselves from their environment. If they continually ask for help and directions, this may be the case. Drawing blindfolded or drawing to music with their eyes closed to become aware of inner kinaesthetic feelings may gradually help them become more independent. Dependent students may also see things as they know them to be, and may be less willing to see things change in space and light and angle. They may need much more time than other students to see these differences and be able to accept them.

Creativity

It requires considerable self-awareness on your part to see how you influence the creative development of your students.

There are many kinds of creative behavior and students have such a variety of background experiences, that what may be creative for one student may be only repetitious for another. The following questions can help you see your role in teaching for creativity more clearly.

If I am a creative person, are my students being creative like I am or are they taking off in their own directions?

Am I able to see my own limitations in creative behavior and try not to impose my limitations on my students?

Do I only tolerate the high creatives in my classes? Can I allow enough psychological freedom for these students and still retain some helpful boundaries for less creative students?

Am I willing to recognize and encourage the beginnings of creative behavior in what appear to be very rigid, unoriginal students?

Can I develop a playful attitude in my classes that encourages creativity and still have input of concepts, ideas, percepts, technical experiments?

Can I help students deal with ideas through inquiry where many possible answers would work?

Can I analyze individual student work to see how it is changing?

Are students developing and amplifying the symbols they use?

Does student work indicate that they are looking at things from more varied viewpoints?

Do students continue to use the same kind of design or organization for the work they do?

Are students repeating the same message in the same way? Or are they repeating the message or the design style or viewpoint but enriching or simplifying it so a new impact is emerging?

By watching your students work, you can identify which ones need more time, or less time to create more fully. Some students need encouragement to be reflective, to let creative ideas emerge; some need to be encouraged to stop before they overdo a fresh impression. As you collect this kind of information, it helps you individualize your instruction. Instruction in art includes modifying and changing the kinds of rewards and encouragements you give individual students to help each one extend the range and degree of creativity she or he has.

Finally, we all need to ask ourselves how we are adapting our creative ability to the current needs of humankind to reuse, restructure, and conserve our resources and to find ways to preserve individual environments and diverse cultures in less space and with less resources.

Cultural Influences

The spatial experiences of students in their background cultures do affect their concepts of themselves in space. It is not just the size or kind, but the values, body language, person to person relationships, in a student's home that affects a student's sense of self in space.

You will need to assess how much adaptation they will have to make from where they came from to the spaces in the school. Help them try to understand each other's needs for space, and design with each other's needs in mind.

The *cultural values* of some students are to express how they feel about things, or to be expressive about some emotions and not others. Other cultures discourage expression of emotion generally or by males and not females. Students come to your classes somewhere along this continuum. Some may have only learned the shallow emotionalism induced by mass media and some may have deeply humanistic concerns for the qualitative aspects of human existence.

Students' responses to the affective qualities of art will be influenced by the kinds of attitudes they have. They will be having very different experiences in using art to express their own responses, and in being willing to experience the effect of the art around them.

By asking students to write free responses to different forms of art, we can find out which ones are dealing with *concepts* of things, *precepts of their visual qualities, organization, and design, media and techniques,* and which ones are concerned with the *emotional impact* that these elements give them. Ideally students should be able to respond to all of them. You cannot assume that students are not making emotional responses if they cannot write about them. It may be that they are consciously aware of

their feelings but cannot express them. You can get other clues by watching how attentive they are, how long they stay with looking at things, and watch to see if qualities from this exposure are shown in their own work.

Subculture art values also show up in students' likes and dislikes. As we discussed before, all groups have art forms, even if they do not fit into our concepts of what is art. The huge industry built around people's needs for quick art—predesigned kits—have a place in many people's sense of art. Many art teachers deplore their use because they do not allow the individual the self-development we believe comes through individual designing and creating. Perhaps our role in a multicultural society is to provide people with the opportunity to make a choice. We can help students develop broader criteria for making choices. But we need to be sensitive to the possibilities that we may have third and fourth generation kit-makers in our classes, that the values are deeply entrenched, and that we should proceed with caution. Without attacking and ridiculing what they value, we can help them extend their capabilities. They may become dissatisfied with their prior activities.

Readiness in Drawing and Design

Students' readiness to draw depends upon their past experience in learning to see, as well as their cognitive style and background culture. At all grade levels, teachers must find out whether students learn best with concepts or with percepts. Unless both avenues of learning are included, one or the other kind of student may be turned away. Perceptual students can be encouraged to verbalize about what they see as well as find more ways to express what they see in visual forms. Conceptual students need

continuous opportunities to learn to see and to be rewarded for their visual discoveries by drawing them as well as talking about them.

You will need to know how dependent your students are on the perceptual constancies, which they need to function conceptually, and the awareness of objects in visual space and light to help them function perceptually. Your students' drawings will help you identify which they are using and which they need to learn.

Design tasks quickly show which students haven't developed either intuitive or analytical processes in design and need help in recognizing design functions. Almost all students can increase their designing aptitudes through analysis, but some may be so skilled intuitively that you may not want to interfere with that process except to encourage it and give them many opportunities to exercise their ability.

Each of the following points in the theory directly relates to point I.

POINT II
PSYCHOSOCIAL ENVIRONMENT

At point II you will need to watch how your students behave in terms of your cultural values and personality and in relation to each other. If one cultural group is dominant in numbers or in overt activity, that group will change the freedom of choice of the others. This requires sensitivity on your part, and a willingness to try ways to make the classroom more psychologically and culturally workable for the students. There are no clear directives for you except that the more you are aware of cultural differences, the more understanding you will become. Thus, you will have more chances of finding workable solutions for helping the group work together.

POINT III
VISUAL-PHYSICAL LEARNING ENVIRONMENT

At point III you work with the students in designing culturally satisfying work spaces to carry on their art activities. The classroom itself as well as the tools and materials, stimulating art forms, books, films, and furniture are all part of your teaching resources. They create an environment for learning. The meaning they have for students will depend on the students' prior experiences. The number, kind, and range of the art resource materials you select for them to use needs to be made on the basis of students' psycho-cultural readiness.

This includes your students' creativity levels and their needs for more order or more variety. You may need some highly ordered areas in your classroom and some highly varied, some activity centers, quiet centers and individual retreat places. If your room has looked the same for some years, it may fit your life style but be foreign to your students.

POINT IV
INFORMATION HANDLING

At point IV you are comparing the readiness of students with their responses to the social and physical environment in order to help them use more information. Your task is to help the different students in terms of their readiness to extend the range of things and experiences they can respond to. Sometimes you may introduce very new things in order to better understand student tolerance for new and novel things. Those who express hostility or rejection of them or who only respond conceptually or perceptually, emotionally or rationally, analytically or globally, need your help. For some you can go back

to more familiar things, for others you can encourage them to reflect, to analyze until the new becomes more familiar or more acceptable. You can help by identifying as many familiar things about the new item as you can. How its form, technique, organization, or meaning is like what they already know. Your skill as a teacher is particularly helpful here.

POINT V
DELINEATING AND RESPONDING TO ART

At this point you have several roles. If the task is responding to art or critiquing art, your understanding of readiness and their readiness to handle information is critical. The students need assurance that you will accept their efforts to express their analysis and feelings about the things they are responding to. That you are not seeking a correct or right response but a more thoughtful, more aware response, in terms of their own readiness to respond. As this continues, their readiness will change.

If the response to experience is to create art works or redesign environments, then your role is to encourage their explorations with creating symbolic meanings, organizing and designing messages, and manipulating media whether they select to create art for themselves or for others, or redesign environments for themselves and others.

POINT VI
FEEDBACK OF CHANGE IN READINESS

Point VI is an evaluation of your teaching and your students' progress. It evaluates or identifies changes in readiness, new possibilities for modifying the psychological environment, particular needs students have

for help in information handling, and new or modifications needed in the range of activities and art criticism you need to develop.

If you can get a sense of process, a feeling for flow of systems, security that you do not need everything in your head at once, and that you can venture on to a more complex teaching strategy in which you are not responsible for making "acceptable" outcomes but are the orchestrator of processes, your varied students will change and develop from where they are to more varied, more expansive and extended possibilities for being through art.

PERFORMANCE OBJECTIVES IN ART

These objectives are not based on grade level so much but provide guidelines for assessing how much a child, adolescent, or even adult moves from one level of complexity to another in art. The objectives should help you identify where students are in their art learning development and then assess how much they have grown during a period of time. Also, you can assess the work of your class on a given assignment to see how much and in what ways the students are alike and in what ways they are different. This assessment will help you see how much instruction can be done in groups and how much must be individualized.

Early in the year, you should give students activities in each of the areas, drawing, design, creating art, art in environment, and understanding art, to see where the class is as a whole, as well as where individuals are in development. You may find all your class needs much work in understanding art in culture, some need a great deal of help in learning to see, others can see and draw but are at Level 1 in designing. Some of your students may be advanced in creating art for themselves but have little understanding of its impact on others. You may also find some students needing much longer to stay at one level than others in order to learn the concepts, and develop the percepts and the motor cognitive skills to move to the next level. You will have a basis to work with each student to see how much progress he or she has made.

The levels of creative behavior can be applied to each of the areas of art. Some students may be creative in design but quite restricted in drawing or creating art. Some may have many ideas for developing change in their environment but be quite rigid in using tools and materials. Some students will be creative in most things they do, while others will be quite rigid about all their art. This information will help you recognize which students need particular encouragement in being more flexible, less fearful, and and freer to be original.

When students stay with the same mode a long time, the material on individual and cultural differences should help you help the student extend the range of his or her abilities. The objectives will tell you where a student or a class is in art and art behaviors, but not about specific individual cognitive styles, cultural differences, attitudes and prior experience that need to be assessed to see where specific students need more extensive experience or help to develop readiness for more complex activities. Finally, the art objectives should help you assess the progress of your students.

DEVELOPING CREATIVE TRAITS AND ATTITUDES

These traits are used in all areas of art and this set of performance objectives can be used in assessing students' progress in all of them. Students who are encouraged to investigate varied rather than single solutions to problems, to express ideas and feel-

ings with varied tools and materials, and to find individual ways to symbolize through art have more opportunities to develop creative traits than children who are only encouraged to conform.

Students who are rewarded for curiosity and inquisitiveness in their search for workable solutions to problems and who can maintain a playful attitude even when their efforts are not successful will have more opportunities to develop creative attitudes because their responses are encouraged and their occasional failures are not used to punish but to learn. The following objectives are developed in the first five parts of the book.

Level 1

Students will:

Tend to use familiar tools rather than new ones.
Repeat the same symbols over and over.
Use the same messages through most work.
Use line, form, color, texture the same ways.
Use the same materials to make things.
Organize symbols in the same way over time.
Draw objects from the same viewpoint, size, color.

Level 2

Students will:

Begin to experiment with tools and materials in more than one way.

Begin to change the ways symbols are used to express familiar things, such as symbols for people, houses, the sun.

Change messages or keep the same message and express it differently.

Begin to vary the use of line, form, color, texture over a period of time.

Increase the variety of materials used to make or construct things.

Begin to use familiar things in unfamiliar ways.

Try more than one kind of design organization.

Look at things from different perspectives.

Level 3

Students will:

Continue to develop Level 2 aptitudes into more varied responses.

Be willing to adapt and change things that they have already done.

Be able to flexibly shift styles of observing of things in detail, or for overall effect, depending on the purpose.

Be willing to observe things in the environment from varied viewpoints.

Be able to change their sets of looking for varied art qualities, lines or shapes, or colors or textures.

Develop more than one style of working—work in more varied media or use fewer media in more ways.

Be able to identify both when they have individually been more creative and when they have not.

Level 4

Students will:

Continue development in the creative traits and attitudes, developing clear strengths in some as well as a broader use of more of the creative traits and attitudes.

Maintain an independence in discussion of the art of other people during periods of peer pressure to conform.

Be able to see and report more remote relationships among things.

Be flexible and inventive in using art in solving many kinds of environmental problems.

The following sets of performance objectives are organized in relation to the first five parts of the book, dealing with seeing and drawing, design, creating art and critiquing art, understanding the environment, and art and culture.

LEARNING TO SEE AND DRAW

Level 1

Students can:

Draw recognizable symbols of familiar things.

Order parts in general relation to each other.

Make some use of detail as well as large shapes.

Use line or shape in making symbols.

Develop some individual characteristics in drawing.

Draw objects in simple organizations—on a line as in reading or within a space.

Level 2

Students can:

Increase the number of familiar things they can draw from memory. Drawing from memory will show the effects of drawing from observation.

Increase the number of new things they can draw through observation.

Increase use of the art elements of line, color, shape, as well as texture and space in drawing.

Show distance by overlapping shapes.

Symbolize things in space nearer or farther away by changing size and/or color.

Make some more observable proportions between parts of things.

Level 3

Students can:

Increase the complexity of detail in the drawings of familiar things.

Increase the use and complexity of the art elements of line, color, shape, or form. Also, they can increase the use and complexity of texture in their drawings.

Abstract the simple structure or form of things to create symbols of them.

Indicate change in viewpoint by changing the shape of symbols.

Draw things in varied distances within one drawing or painting.

Organize several objects on a two-dimensional plane to appear as if they were on a three-dimensional one.

Use simple perspective systems for symbolizing what they see.

Be more intense in the adaption of color, shape, form, size, line to express feelings and values in drawing.

Level 4

Students can:

Use complex perspective systems to illustrate three-dimensional space.

Use drawing as a tool for detailed recording as well as expressing.

Use drawing to explore the uses of space and the structures within things.

Use drawing for planning, organizing, and analyzing.

Draw three-dimensional models for objects they wish to produce.

Solve structural and design problems in three-dimensional drawings prior to constructing objects.

Use drawing for creating new ideas, relationships, structures.

Use drawing for subjective analysis of their own experience.

STUDENTS' ABILITIES TO DESIGN

Level 1

Students will be able to:

Make visual order out of collections of miscellaneous objects by grouping things that are alike by kind of line, or size, or shape, or color, or texture.

Regroup the collection of things by similar functions (fasteners, markers, measurers, cutters, or roots, stems, leaves, branches, buds).

Put some order in things they make by making lines, shapes, forms, colors, or textures the same.

Make order by grouping things nearer or farther apart.

Level 2

Students will be able to:

Regroup abstract shapes into similar kinds of order by selecting from cut papers of varied sizes, shapes, colors, and textures and sorting them into groups such as red, small, rough, yellow, smooth, big.

Transfer this learning process to making bulletin boards, organizing storage areas or science displays.

Show some order in designing their drawings, paintings, and products by repeating qualities, or by grouping different things in clusters.

Observe and describe order in nature, where forms, shapes, colors, textures, and lines are grouped together in close relation or are repeated.

Show where other artists have used order by repeating things in their paintings.

Describe how straight and curved lines, rectangular shapes, colors, textures can be used to make order in the human-made environment.

Level 3

Students will be able to:

Make order and variety out of a collection of various objects by varying *one* of the visual elements—line, size, shape, color, or texture—by introducing new objects or by changing some objects.

Make order by changing some element of all the objects so they are alike in that one way (color, texture, lines of color, dots of color, can be used where the object's size and shape are not changeable).

Create variety in ordered objects by varying line, color, shape, and/or texture.

Group abstract shapes into varying degrees of order with variety, using other art media to modify and change their texture, color, and sometimes their shape or form.

Make order and variety by grouping things, as well as by repeating visual qualities using real objects and abstract forms.

Transfer this learning process to make objects appear more interesting.

Direct the viewer's attention with the use of variety.

Observe and describe the effects of order and variety in nature and human-made objects.

Solve design problems using the processes in composing a painting, designing a display, designing a craft (two- and three-dimensional art).

Analyze and describe which media will help order ideas with the most appropriate degree of order and variety.

Use this knowledge of design to evaluate the effectiveness of the design of paintings, drawings, sculpture, and arts.

Evaluate the design of their own work.

Level 4

Students will be able to:

Create a design for one purpose and then modify and change it for another.

Discuss the decisions as to which elements to change for what purpose.

Solve similar design problems by adapting them to different media.

Analyze three-dimensional design solutions from multiple visual viewpoints.

Analyze the affects of their own and others' designs of objects on the uses people will make of the objects.

Analyze the affects of the design organization of their own and others' paintings, drawings, sculptures, or photographs on the environments in which they are displayed.

Try multiple solutions to problems using their creative ability to suspend judgment until they have "played" with varied combinations to reach the effects they want.

USING DRAWING AND DESIGN TO RESPOND TO ART

Level 1

Students will be able to:

Identify the different sizes, colors, shapes, and lines used by an artist in a painting, sculpture, photograph, or crafted object.

Describe how artists repeat sizes, colors, shapes, or forms and textures to make order in an art work.

Respond to some symbolic meaning in works of art.

Level 2

Students will be able to:

Compare differences in similar shapes of different sizes, different values of the same color used by the artist.

To point out the sizes, shapes, colors, textures, forms, and spaces of three-dimensional objects (sculpture, crafts).

Point out when the artist has symbolized space by making some objects appear farther away by changing sizes, color values, textures, shapes, or forms and the spaces between things.

Creatively use many ways of looking at an art work from what it symbolizes to the ways it is designed, to the way it is made, to the people and times in which it was created, to what it means to them.

Be independent of others in their decisions about why they prefer one art form over another.

Describe how different artists make order and variety in their art work in using line, color, shape, form.

Interpret the meaning in the symbols and in the quality of the design in works of art, from their own point of view.

Evaluate the appropriateness of media to the design and the symbolic meaning.

Describe their general affective response to a work of art using the above learning as well as their emotional responses.

Level 3

Students will be able to:

Point out if the artist has indicated a light

source in his or her work and name the kind and direction of the light source by the way the artist used colors, showed shadows, and changed textures.

Describe the changes they observe in the art elements as they move around a piece of sculpture, through a building, or hold a crafted object at different angles from themselves.

Change their ideas about a work of art as they learn more about art and/or that particular work of art.

Describe how different artists use all the art elements to create various proportions of order and variety in an art work (line, color, shape, or form as well as texture, space, and size), describe small detail as well as overall impact in works of art.

Evaluate the selection of media and the skill of the artist in using media.

Evaluate the relationship of the design and symbolism of a work of art to the environment in which it is displayed.

Relate the use of symbolic meaning, design, and composition to the meaning and organization used in the other arts—music, theater, poetry, creative writing, dance.

Evaluate the design quality in advertising, television, graphics, automobiles.

Level 4

Students will be able to:

Evaluate a work of art as communication of symbolic meaning, as design or composition, as a technically constructed object.

Evaluate the overall affect of a work of art emotionally, organizationally, structurally, in relation to the message in a given situation.

Identify the creative decisions an artist may have made—unusual things that are related, unusual perspectives, uses of design, uses of materials.

Evaluate the impacts between meaning and design and choice of materials.

Evaluate the relationship of advertising and product design to the environment.

Evaluate the use of design in mass media, graphics, industrial design, product design, in terms of quality of design, use of materials, and its function for individual and group uses.

CREATING ART

Students may either create art for themselves or for others. Some will do both. Some students will work in a few media in depth, other in more varieties of media. Students will also change from one mode to another over a period of time, but all these students can grow in their work in art.

Level 1

Students will:

Make art for their own pleasure (art for oneself).
or
Make art to tell stories, describe situations, or things (art for others).

Create symbols for things that may or may not be recognizable to others (art for oneself).
or
Create recognizable symbols (art for others).

Select tools and media they can manipulate.

Not be stopped for lack of skill.

Select among their works things they prefer (art for oneself).
or
Select among their works things others will prefer (art for others).

Level 2

Students will:

Make art that has emotional or descriptive meaning about their own experience.
or
Make art that conveys emotional and descriptive meaning to others.

Create symbols that have personal meaning for them.
or
Create symbols that convey more details of things.

Experiment with different kinds of organizations.

Select tools and media that help express their ideas.

Work at developing skills so art is more satisfying to them.

Select which of their works they prefer because of the expressive quality or the symbols.
or
Select which of their works most clearly conveys messages or feelings.

Level 3

Students will:

Make art for themselves that draws upon different kinds of experience.
or
Make art to express to others a different idea and feelings.

Develop and amplify their symbols in design and in expressive quality.

Experiment freely with different organizations, compositions, or designs to express ideas.

Experiment with different tools and materials to find the most appropriate for expressing a specific idea or feeling.

Be able to critique their own and others' art in terms of affective meaning and the quality of symbols, composition or design, selection and use of media.

Level 4

Students will:

Create art that, though created for themselves,

has emotional and content meaning to other people.
or
Create art that affects others with the qualities of their messages.

Invent, amplify, search out images that express ideas, feelings uniquely.

Be able to work in a different or modified style as the message requires.

Be fluent in changing kinds of organization, composition, or design to achieve expressive quality.

Use a variety of tools and materials or a limited number of tools and materials in various ways to achieve specific, desired effects.

Be able to evaluate their work in comparison with other more subjective artists and craftspersons.
or
Be able to evaluate their work in comparison with other artists who work to communicate with others.

Be able to select and analyze the more and less effective parts of their work.

TRENDS IN LEARNING ABOUT THE ENVIRONMENT THROUGH ART

Level 1

Students can:

Explore how they use different kinds of spaces as they work and play in school and use the school building.

Explore how they order the space they use and the environment they create with the colors and textures they choose to wear, the ways they organize their work stations at school.

Explore how they use their neighborhood by the routes they take to and from school.

Describe why they like to walk or ride some routes more than others.

Level 2

Students can:

Explore how their use of space helps or hinders how others use space.

Solve problems in groups so each student can have the space she or he needs to work and play while the whole group works or plays together.

Explore how they and the group can use design to order and vary their spaces so they will be more interesting places to work.

Relate how social rules for playing games are related to the spaces, equipment, and symbols used to play games.

Identify places in the school that are crowded and plan ways to solve the crowdedness.

Create symbols (signs) that will direct traffic, identify places, and create order and variety in the halls, entrances to the school, playground, and cafeteria.

Evaluate how the maintenance of the school communicates how the students value it.

Design plantings that would reduce noise, divide spaces, and create order and variety.

Level 3

Students can:

Explore how one group's use of space helps or hinders how others use space.

Solve problems in groups to preserve the space and symbols needed for one group's activities so it will not be destructive of another group's use of space and symbols, with concern for the physical factors of noise, proximity.

Identify the physical and visual factors that can change how a space can be used and how people will feel in being there.

Analyze a neighborhood for: visual symbols that have different societal/cultural meaning; variations in order and variety; places where the order and variety of one building or place interfere with the order and variety of another, what design decisions could be made to improve them so they could be used; places that are not used and try to understand why; ways people get from one place to another in the neighborhood; what places need more order and why; what places need more variety and why.

Level 4

Students can:

Relate learnings in art, social studies, and ecology to understand environmental problems.

Relate social, aesthetic, physical values in proposing needed changes in the environment.

Analyze situations to identify many factors that influence different people's experience in them.

Analyze how well communities provide for individual, group, cluster, and network spaces.

Analyze the impact of the visual environment on the quality of people's lives.

Describe the landmarks, parts, and networks of a town or small city.

SEQUENTIAL TRENDS IN LEARNING ABOUT ART IN CULTURE

Level 1

Students can:

Recognize and describe what cultural values are expressed in objects with which they are familiar.

Recognize differences in dress that communicate different roles by the people wearing the clothes in their own society.

Describe how objects with similar uses are made differently by people from different cultures.

Level 2

Students can:

Recognize ways that sculpture, painting, prints from societies with different cultures are different.

Recognize differences in buildings and public places that communicate the importance and kind of social activities that go on in the building or place in terms of the amount of space, the kinds of materials used, and the general form of the building or place.

Compare differences in design from simple to complex as used by people with different cultural patterns.

Compare more or less use of kinds of line, color, texture, shape, or form as found in these designs from different cultures.

Observe an art form and describe what they see in it that tells them how people in the other culture live in terms of their style of living, what is important to them, how they use objects, how they value objects.

Be able to differentiate and describe how they react to sculpture, painting, prints from societies with different cultures in terms of their own different background.

Level 3

Students can:

Identify differences in art forms from very different cultures through the ways the artists and designers organize line, color, shape, or form and space to express important values or describe status and role.

Recognize and describe differences in the use of symbols in terms of the ways order and variety are created generally in different societies.

Compare objects with similar uses from their own and another society in terms of the way the

design of the object tells us how much the use of the object is valued in the two societies.

Recognize and describe differences in symbols and their use in larger art forms through design to communicate a society's cultural values, beliefs, statuses, and roles of peoples.

Identify differences in the use of perspective space in art as related to the values of the people's culture.

Identify what the art communicates about what is important for those people to observe.

Observe art forms from other societies and their apparent cultural meaning and then observe similar objects in their own society and identify their cultural meaning.

Level 4

Students can:

With this background be ready to do extensive research comparing what they know through art and what they know through social studies about different societies past and present. They can study the cultural history of art and architecture by comparing the values and ideas expressed in art as they change with those found in history. They can assess the relationship of art and values today.

Relate the use of the order and variety in architecture, sculpture, and painting.

Evaluate their responses to the arts of other people in terms of the other culture.

Check their assessment of the cultural values in other societies' art forms by studying reports on the culture's values and social system.

Analyze the role of the artist in different societies and see how the cultural values encourage and reward the artist.

See likenesses among the arts in their own multicultural society that can be used as a basis for order in the environment—and the differences that can be used for variety.

BIBLIOGRAPHY

PART ONE

Braizell, M. "Grant Wood Revisited." *Art Journal* (Winter 1966–67): 116–212.

Bruner, Jerome L., Olver, Rose R.; Greenfield, Patricia M.; et al. *Studies in Cognitive Growth.* New York: John Wiley & Sons, 1966.

Carroll, Lewis. *Alice in Wonderland and Through the Looking Glass.* Illustrated by John Tenniel. New York: Grosset & Dunlap, 1946.

de la Faille, J. B. *Vincent Van Gogh.* New York: French and European Publications, 1939.

Dennis, Wayne. "Goodenough Scores, Art Experience, and Modernization." *Journal of Social Psychology* 68 (1966): 213–215.

Doblin, Jay. *Perspective, a New System for Designers.* New York: Whitney Library of Design, 1956.

Dubin, Elizabeth R. "The Effects of Training on the Tempo of Development of Graphic Representation in Preschool Children." *Journal of Experimental Education* 15 (1946): 163–173.

Escher, M. C. *The Graphic Work of M. C. Escher.* New York: Ballantine Books, 1973.

Goldstein, Nathan. *The Art of Responsive Drawing.* Englewood Cliffs, N.J.: Prentice-Hall, 1973.

Haber, R. N.; and Haber, R. B. "Eidetic Imagery: I. Frequency." *Perceptual Motor Skills* 19 (1964): 131–138.

Haftmann, Werner. *Painting in the Twentieth Century.* New York: Praeger, 1971.

Harris, Dale. *Children's Drawings as Measures of Intellectual Maturity.* New York: Harcourt, Brace & World, 1963.

Lansing, Kenneth. *Art, Artists, and Art Education.* New York: Holt, Rinehart and Winston, 1969.

Lark-Horovitz, Betty; Lewis Hilda; and Luca, Mark. *Understanding Children's Art for Better Teaching.* Columbus, Ohio: Charles E. Merrill Books, 1967.

Longstreet, Stephen. *A Treasury of the World's Great Prints.* New York: Simon & Schuster, 1961.

Lowenfeld, Viktor; and Brittain, W. Lambert. *Creative and Mental Growth,* 5th ed. New York: Macmillan, 1975.

McFee, June K. "Children and Cities: An Exploratory Study of Urban, Middle, and Low Income Neighborhood Children's Responses in Studying the City." NAEA *Studies in Art Education* (Fall, 1971).

Mendelowitz, Daniel M. *Drawing.* New York: Holt, Rinehart and Winston, 1967.

Rock, I. "Adaptation to Minifield Image." *Psychonomic Science* 2 (1965): 105–106.

Sendak, Maurice. *Where the Wild Things Are.* New York: Harper & Row Publishers, 1963.

Turnbull, Colin. *The Forest People.* New York: Doubleday, The American Museum of Natural History, 1962.

Zemach, Harve; and Zemach, Margot. *Duffy and the Devil.* New York: Farrar, Straus, and Giroux, 1973.

PART TWO

Anderson, Donald M. *Elements of Design.* New York: Holt, Rinehart, and Winston, 1961.

Cataldo, John W. *Graphic Design and Visual Communication.* London: International Textbook Company, 1966.

Collier, Graham. *Form, Space and Vision,* 3rd ed. Englewood Cliffs, N.J.: Prentice-Hall, 1972.

Dondis, Donis A. *A Primer of Visual Literacy.* Cambridge, Mass.: M.I.T. Press, 1973.

Koffka, K. *The Principles of Gestalt Psychology.* N.Y.: Harcourt, Brace, 1935.

McKim, Robert H. *Experiences in Visual Thinking.* Monterey, Calif.: Brooks/Cole, 1972.

PART THREE

Baker, Elizabeth C. "The Chamberlain Crunch." *Art News* (February, 1972): 26–31.

Barnett, Homer. "Laws of Socio-Cultural Change." *International Journal of Comparative Sociology* (September, 1965): 207–230.

Burgess, David Lowry. *Listening for Light Hinge.* Illustration in "It Reaches a Desert in Which Nothing Can Be Perceived But Feeling" by David Antin. *Art News* (March, 1971): 41.

Burnam, Jay. "Corporate Art." *Art Forum* (October, 1971): 66–71.

Callas, Nicolas. "John Tinguely: The Sphinx." *Arts* (November, 1970): 24–26.

Christo, Javochef. *Wrapped Coastline at Little Bay, New South Wales: One Million Feet.* Illustration in "Sydney's Power Institute of Fine Arts" by Berard Smith. *Studio International* (October, 1970): 144.

Degge, Rogena M. "A Case Study and Theoretical Analysis of the Teaching Practices in One Junior High Art Class." Unpublished Ph.D. dissertation, University of Oregon, 1975.

Doerter, James. "Influences of College Art Instructors upon Their Students' Painting Styles." *Studies in Art Education* (Spring 1966): 46–53.

Doty, Robert. *Human Concern/Personal Torment: The Grotesque in American Art.* New York: Whitney Museum of Art, 1969.

Escher, M. C. *The Graphic Work of M. C. Escher.* New York: Ballantine Books, 1973.

Haftmann, Werner. *Painting in the Twentieth Century.* New York: Praeger, 1971.

Hanson, Duane. *Race Riot.* Illustration in "Verist Sculpture: Hanson and De Andrea" by Joseph Mascheck. *Art in America* (November/December, 1972): 94.

Haskell, Barbara. *Claes Oldenberg: Object into Monument.* Pasadena, Calif.: Pasadena Art Museum, 1971.

Jocopetti, Alexandra. *Native Funk and Flash: Emerging Folk Art.* San Francisco: Scrimshaw Press, 1974.

Kienholz, Edward. *The State Hospital.* Illustration in "Violence and Art" by Charlotte Willard. *Art in America* (January/February, 1969): 39.

Laury, Jean Ray; and Aiken, Joyce. *Creating Body Coverings.* New York: Van Nostrand Reinhold, 1974.

Lippard, Lucy R. "Eva Hesse, The Circle." *Art in America* (May, 1971): 68–73.

Meiss, Millard. *The Great Art of Fresco.* New York: George Braziller, 1970.

Reed, Alma. *The Mexican Muralists.* New York: Crown Publishers, 1960.

Rose, Barbara. *American Art Since 1900.* New York: Praeger, 1975.

Spector, Jack. *The Murals of Eugene Delacroix at Saint-Sulpice.* New York: College Art Association of America, 1967.



Bibliography383

Tooker, George. *Subway.* Illustration in "The Haunted Mind" by Henri Dorra. *Art in America* (Summer, 1959): 36.

PART FOUR

Ewald, William R., Jr., ed. *Environment and Policy: The Next Fifty Years.* Bloomington: Indiana University Press, 1967.

Forrester, Jay. *Urban Dynamics.* Cambridge, Mass.: M.I.T. Press, 1969.

Gutman, Robert, ed. *People and Buildings.* New York: Basic Books, 1972.

Ittelson, William H., et al. *An Introduction to Environmental Psychology.* New York: Holt, Rinehart and Winston, 1974.

Laury, Jean Ray; and Aiken, Joyce. *Creating Body Coverings.* New York: Van Nostrand Reinhold, 1973.

Lynch, Kevin. *The Image of the City.* Cambridge, Mass.: M.I.T. Press, 1960.

McFee, June K. "Children and Cities: An Exploratory Study of Urban, Middle, and Low Income Neighborhood Children's Responses in Studying the City." NAEA *Studies in Art Education* (Fall, 1971).

Sommer, Robert. *Design Awareness.* San Francisco: Rinehart Press, 1972.

_____. "Looking Back at Personal Space." *Designing for Human Behavior.* Edited by J. Lang, C. Burnette, W. Moleski, and D. Vachon. Stroudsburg, Pa.: Dowdon, Hutchison, and Ross, 1974.

PART FIVE

Bohannon, Paul. "Rethinking Culture." *Current Anthropology* 14 (October, 1973): 357–372.

Fried, Mack. *The World of the Urban Working Class.* Cambridge, Mass.: Harvard University Press, 1973.

Geertz, Clifford. *The Interpretation of Cultures.* New York: Basic Books, 1973.

Gordon, Milton. *Assimilation in American Life.* New York: Oxford University Press, 1964.

Gould, Peter R. "Our Mental Maps." *Image and Environment.* Edited by Roger M. Downs and David Stea. Chicago: Aldine Publishing, 1973, 182–220.

Grebler, Leo; Moore, Joan W.; and Guzman, Ralph C. *The Mexican-American People: The Nation's Second Largest Minority.* New York: The Free Press, 1970.

Hall, Edward T. *The Hidden Dimension.* Garden City, N.Y.: Doubleday, 1966.

Hardy, Kenneth R. "Social Origins of American Scientists and Scholars." *Science,* 185 (August 9, 1974): 497–506.

Howell, Joseph T. *Hard Living on Clay Street: Portraits of Blue Collar Families.* Monograph, Center for Urban and Regional Studies, University of North Carolina. New York: Anchor Books, 1973.

Jones, Jean Ellen. "A Descriptive Study of Elderly Art Students and Implications for Art Education." Unpublished Ph.D. dissertation, University of Oregon, 1975.

Meyers, Bernard S. *Art and Civilization.* New York: McGraw-Hill, 1967.

Roszak, Theodore. *The Making of a Counter Culture.* New York: Anchor Books, 1969.

Weller, Allen S. *Contemporary American Painting and Sculpture.* Urbana: University of Illinois Press, 1963.

PART SIX

Anastasi, Anne; and Foley, John P., Jr. "An Analysis of Spontaneous Drawings by Children of Different Cultures." *Journal of Applied Psychology* 20 (1936): 689–726.

_____ and _____. "A Study of Animal Drawings

of Indian Children of the North Pacific Coast."
Journal of Social Psychology 9 (1938): 363–374.

Arnheim, Rudolph. *Visual Thinking.* Berkeley:
University of California Press, 1971.

Birch, H. G.; and Rabinowitz, H. S. "The Negative
Effect of Previous Experience on Productive
Thinking." *Journal of Experimental Psychology*
41 (1951): 121–125.

Bruner, Jerome S. "An Overview." *Studies in
Cognitive Growth.* From J. S. Bruner, R. R. Olver,
and P. M. Greenfield, et al. New York: John Wiley
& Sons, 1966.

————; Olver, Rose R.; Greenfield, Patricia M.;
et al. *Studies in Cognitive Growth.* New York: John
Wiley & Sons, 1966.

————; Postman, L. J.; and Rodrigues, J. "Ex-
pectation and the Perception of Color." *American
Journal of Psychology* 64 (1951): 216–227.

Cooke, Josephine. "Behavior, Value, and Per-
sonality Measures of Academically Superior
Adolescents in a Creatively Oriented Art Curricu-
lum." Unpublished Ph.D. dissertation, Univer-
sity of Oregon, 1974.

Dawson, J. L. M. "Cultural and Physiological
Influences upon Spatial-Perceptual Processes in
West Africa—Part I." *International Journal of
Psychology,* 2 (1967): 115–128.

Degge, Rogena M. "A Case Study and Theoretical
Analysis of the Teaching Practices in One Junior
High Art Class." Unpublished Ph.D. dissertation,
University of Oregon, 1975.

Dennis, Wayne. "Goodenough Scores, Art Ex-
perience, and Modernization." *Journal of Social
Psychology* 68 (1966): 213–215.

————. "The Human Figure Drawings of
Bedouins." *Journal of Social Psychology* 52 (1960):
209–219.

Dobzhansky, Theodosius. *Mankind Evolving:
The Evolution of the Human Species.* New Haven:
Yale University Press, 1962.

Eisner, Elliot. *Educating Artistic Vision.* New York:
Macmillan, 1972.

Gardner, Howard. *The Arts and Human Develop-
ment: A Psychological Study of the Artistic Process.*
New York: John Wiley & Sons, 1973.

Getzels, J. W.; and Jackson, P. W. *Creativity and
Intelligence.* New York: John Wiley & Sons, 1962.

Gibson, J. J. *The Perception of the Visual World.*
Boston: Houghton Mifflin, 1950.

Golen, Eugene S.; and Moody, Mack. "Develop-
mental Psychology." *Annual Review of Psychology*
24 (1973): 1–52.

Gordon, Milton. *Assimilation in American Life.*
New York: Oxford University Press, 1964.

Guilford, J. P.; Kettner, N. W.; and Christensen,
P. R. *A Factor Analytic Study across Domains of
Reasoning, Creativity, and Evaluation, II: Adminis-
tration of Test and Analysis of Results.* University
of Southern California Laboratory Report no. 16,
1956.

————; Merrifield, P. R.; and Cox, A. B. *Reports
from the Psychological Laboratory: Creative Think-
ing in Children at the Junior High School Levels.*
Los Angeles: The University of Southern Cali-
fornia Press, 1961.

Hadamard, J. *Psychology of Invention in the Mathe-
matical Field.* Princeton, N.J.: Princeton Univer-
sity Press, 1949.

Harris, Dale. *Children's Drawing as Measures of
Intellectual Maturity.* New York: Harcourt, Brace
& World, 1963.

Havighurst, Robert J.; and Neugarten, Bernice L.
American Indian and White Children. Chicago: The
University of Chicago Press, 1955.

Hayward, D. G.; Rothenberg, M.; and Beasley, R.
School-aged Children in Three Urban Playgrounds.
Report to National Science Foundation (Grant
no. GZ-2562), City University of New York, En-
vironmental Psychology Program, 1973.

Hess-Berens, Nancy Nan. *The Development of the
Concept of Space as Observed in Children's Draw-
ings: A Cross-Nation/Cross-Cultural Study.* Na-
tional Center for Educational Research and De-
velopment (H.E.W. RO 2–0611), 1973.

Hudson, W. "Pictorial Depth Perception in Sub-

cultural Groups in Africa." *Journal of Social Psychology* 52 (1960): 182–208.

Kagan, Jerome; and Klein, Robert E. "Cross-Cultural Perspectives on Early Development." *American Psychologist* 28 (1973): 161, 947–961.

————; Rosman, B. L.; Day, D. A.; and Phillips, W. "Information Processing in the Child: Significance of Analytic and Reflective Attitudes." *Psychological Monographs* 578 (1964): 1–37.

Kennedy, John M. "Perception." *Elements of Psychology*, 3rd ed. Edited by David Krech, R. S. Crutchfield, and Norman Linson. New York: Alfred A. Knopf, 1974.

Knights, Robert M. "Test Anxiety and Visual Discrimination of Social Scenes." *Child Development* 36 (1965): 1083–1090.

Kuhlman, K. C. "Visual Imagery in Children." Unpublished Ph.D. dissertation, Radcliffe College, 1960.

Lansing, Kenneth. *Art, Artists, and Art Education.* New York: Holt, Rinehart and Winston, 1969.

Lark-Horovitz, Betty; Lewis, Hilda; and Luca, Mark. *Understanding Children's Art for Better Teaching.* Columbus, Ohio: Charles E. Merrill Books, 1967.

Lawrence, Merle. *Studies in Human Behavior.* Princeton, N.J.: Princeton University Press, 1949.

Lovano-Kerr, Jessie. "The Relationship of Graphic Style and Mode of Perception to Graphic Expression." Unpublished Ph.D. dissertation, University of Oregon, 1969.

Lowenfeld, Viktor; and Brittain, W. Lambert. *Creative and Mental Growth,* 5th ed. New York: Macmillan, 1975.

MacKinnon, Donald W. "Creativity in Architects." *The Creative Person.* Proceedings of a conference, the Institute of Personality, Assessment, and Research. Berkeley: University of California, 1961.

McCoy, Norma. "Effects of Test Anxiety on Children's Performance as a Function of Instructions and a Type of Task." *Journal of Personality and Social Psychology* 2 (1965): 634–641.

McFee, June K. *Creative Problem Solving of Academically Superior Adolescents.* Monograph, National Art Education Association, 1968.

————. *Preparation for Art,* 2nd ed. Belmont, Calif.: Wadsworth, 1970.

Myers-Briggs, Isabel. *Manual for the Meyers-Briggs Type Indicator.* Princeton, N.J.: Educational Testing Service, 1962.

Neisser, U. *Cognitive Psychology.* New York: Appleton-Century-Crofts, 1967.

Penny, Ronald K. "Reactive Curiosity and Manifest Anxiety in Children." *Child Development* 36 (1965): 697–702.

Price-Williams, D.; Gordon, W.; and Ramirey, M., III. "Skill and Conservation: A Study of Pottery Making Children." *Developmental Psychology* 1 (1969): 769.

Scheflen, A. E. "Living Space in an Urban Ghetto." *Family Process* 10 (1971): 429–450.

Schubert, Anna. "Drawings of Orotchen Children and Young People." *Journal of Genetic Psychology* 37 (1930): 232–234.

Slobin, D. I. *Psycholinguistics.* Glenview, Ill.: Scott, Foresman, 1971.

Sommer, Robert. "Looking Back at Personal Space." *Designing for Human Behavior: Architecture and the Behavioral Sciences.* Edited by J. Lang, C. Burnette, W. Moleski, and D. Vachon. Stroudsburg, Pa.: Dowdon, Hutchison, and Ross, 1974.

Turnbull, Colin N. *The Forest People.* New York: Doubleday, The American Museum of Natural History, 1962.

Wallach, M. A.; and Kagan, N. "A New Look at the Creativity Intelligence Distinction." *Journal of Personality* 33 (1965): 348–369.

————; and Thomas, Helen L. "Graphic Construction and Expansiveness as a Function of

Induced Social Isolation and Social Interaction: Experimental Manipulation and Personality Effects." *Journal of Personality* 31 (1963): 491–509.

Witkin, H. A. "Perception of the Upright." *Scientific American* (February, 1959): 50–56.

_____ et al. *Psychological Differentiation.* New York: John Wiley & Sons, 1962.

_____ et al. *Personality through Perception: An Experimental and Clinical Study.* New York: Harper & Row Publishers, 1954.

ARTIST INDEX

INDEX

Abstraction: in expressing experiences, 191–96

Affective domain: relationship to cognitive domain, 335–37

Age: importance to society, 322; relationship to drawing, 81, 84–85, 360–61

Alternate Uses test, 358

Analytic behavior: relationship to personality, 340–42. *See also* Cognitive style

Anastasi, Anne: cross-cultural analysis of children's drawings (1936, 1938), 361

Animation: activities analyzing space through, 35; activities relating design to, 140–42

Anxiety: effects on use of color and materials, 351; importance in responding to environment, 265–67; relationship to drawing, 348–51; relationship to visual discrimination, 349–51

Appearance: relationship to function, 111–14, 115

Aptitude tests: importance in student evaluation, 334

Arch, 71

Arnheim, Rudolph: theory of psychology of art (1971), 360

Art, 276–77; activities in conveying ideas and feelings through, 178–80; activities in recognizing cultural effects on, 308–11; attitudes toward, 6; differences in student response to, 329–30; dynamic quality of, 272; dynamics in cultural groups, 279; as expression of personal reality, 293–94; evaluation criteria for, 276–79; impact of, 273–80; importance of culture in evaluating, 279–80, 297; importance of student response to, 330; as motivation in art creation, 161–62; performance objectives for creating, 377–78; performance objectives in responding to, 376–77; problems in teaching, 329; as reflection of beliefs and values, 7–10; as related to environment,

10, 154, 287–89; relationship to cultural values, 114, 279–80; relationship to science, 322–23; as self-expression, 154–55; student needs in creating, 155–56; as universal language, 279–80

Art awareness, 162

Art behaviors: importance of studying, 322–23

Art as communication, 6–10, 154–55, 272–80; activities in discovering, 178–80; importance in relating cultural values, 293–94; importance to artist, 273–76

Art creation: activities for relating words and feelings, 175–76; affective forces as motivation for, 201–2; as communication, 159–61, 165; impact of environment on, 208; impact of society on, 207–8; motivations for, 157–62; role of classes in, 156; as self-expression, 157–59, 162–65

Art culture: current trends in, 294–96

Art education: goals of, 92, 322; importance of psychology to, 323; importance of understanding science and art, 322; importance to society, 323; relating goals to environment, 210; relationship to student's cultural variability, 10; research in, 322–23

Art forms: interrelationships among, 154–55

Art programs: limitations of, 207

Art teachers: allowing student flexibility, 155–71; assumptions of, 349; and creativity, 352–54, 355–59, 367–68; importance of flexibility in, 157, 159, 167–71, 206–8; and Perception-Delineation III model, 324–31, 343–46, 366–71; recognizing cultural diversity among students, 312, 360

Art teacher's role: in assessing cultural influences on student art, 368–69; in cognitive development, 341; in creating motivation, 157–62; in determining cultural relevance of art, 294; in developing children's learning aptitudes, 336; in develop-